THE ARTS& CRAFTS COMPANION

THE ARTS & CRAFTS COMPANION

· PAMELA TODD ·

PALAZZO

This paperback edition first published
in the United States in 2008
by Palazzo Editions Ltd
2 Wood Street, Bath, BA1 2JQ, United Kingdom

www.palazzoeditions.com

Text copyright © 2004 by Pamela Todd

Art Director: David Fordham

ISBN 10-digit: 0-9553046-7-9
ISBN 13-digit: 978-0-9553046-7-5

Printed and bound in Singapore by Imago.

CONTENTS

Above: *Front, back, and end elevation plans for a house at Frinton-on-sea, Essex by C.F.A. Voysey.*

o valiant earth o happy year
that works the threat of winter year

INTRODUCTION

Left: *Detail from William Morris's "Orchard" tapestry, c. 1863. (For complete reproduction of tapestry see page 313.)*

A BOOK OF VERSE

BY

WILLIAM MORRIS

WRITTEN IN LONDON

1870

PHILOSOPHY & BACKGROUND

"What business have we with art at all, if we all cannot share it?"

WILLIAM MORRIS

Above: *A ceramic bread plate designed by A.W.N. Pugin and made by Minton's in the encaustic process, c. 1850. The ethical message is made clear in the proverb "Waste Not, Want Not" around the rim.*

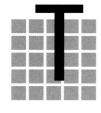

THE ARTS AND CRAFTS MOVEMENT, founded in the late nineteenth century by a group of British artists and social reformers inspired by John Ruskin, A.W.N. Pugin, and William Morris, sought to stem the tide of Victorian mass production, which its adherents believed degraded the worker and resulted in "shoddy wares." The movement redefined the role of art and craftsmanship, sought to restore dignity to labor, created opportunities for women, and underpinned many social reforms. At its most romantic and intense it offered a complete, if rigorous, model for living, as mapped out in Morris's Utopian novel *News from Nowhere*, and put into practice by, among others, Charles Ashbee in the Cotswolds in England and Elbert Hubbard in East Aurora, New York. The movement was attractive to many who were disenchanted by rapid industrialization; its influences—both social and aesthetic—were felt in Europe, where the ideas cross-fertilized and returned to Britain enriched and enlivened, and in the USA, where its ideals were enthusiastically embraced and adapted. Despite faltering after World War I, it has emerged as a major force in the history of design during the last hundred years and is enduringly popular today.

The movement acquired its name in 1888, when William Morris's tapestries, William De Morgan's tiles, Walter Crane's wallpapers, and Edward Burne-Jones's stained-glass designs went on show on October 4 at the New Gallery in London, along with other work by the newly formed Arts and Crafts Exhibition Society. The show was a success and drew enthusiastic reviews. *The Builder* reported that it was "full of things which seem to have been done because the designer enjoyed doing them…" even if it found some of the exhibits a little "outré and eccentric." Walter Crane set out the Society's mission statement—"to turn our artists into craftsmen and craftsmen into artists"—in the catalog to that first exhibition.

Far left: *Title page of* A Book of Verse *by William Morris. Morris put together this illustrated collection of fifty-one of his own poems as a thirtieth birthday present for his dear friend Georgiana Burne-Jones. He was responsible for all the calligraphy and most of the border decorations, though various friends helped, and Charles Fairfax Murray was responsible for the portrait of Morris at the center of this page.*

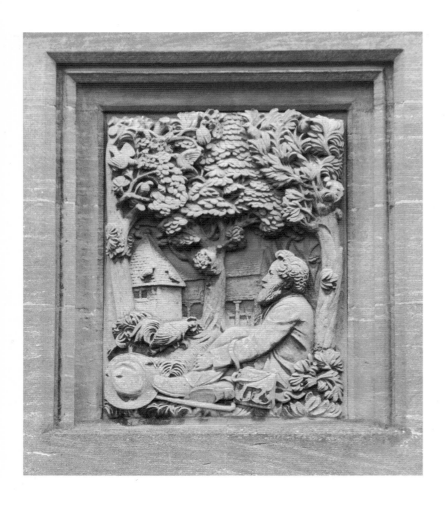

Above: *"Morris in the Home Mead"—a carving by George Jack, from a sketch by Philip Webb, on the pair of semidetached cottages designed by Webb and built in Kelmscott village for Jane Morris in 1902 as a memorial to Morris.*

However, to trace the roots of the movement it is necessary to go back to the Great Exhibition held at Crystal Palace in London in 1851 and to the dismayed and disgusted reaction of the young William Morris and his friends to the "wonderful ugliness" of the mass-produced exhibits, which seemed to them devoid of any soul, dehumanizing the workers who made them. What began as a return to the styles and manners of the medieval period—its cathedrals, furnishing, costumes, and, crucially, its workers' guilds—developed, under the inspiration and guidance of William Morris, to embrace more day-to-day handmade crafts. Unashamedly "artistic," the homes, gardens, and products of the Arts and Crafts movement celebrated the individuality of the craftsmen and craftswomen who made them. For them it was not merely a style, it was a way of life, based on frankly Utopian models. Humble, plain, honest furniture, like that made by Ford Madox Brown for Morris, Marshall, Faulkner & Co., sold alongside more ornate "Arthurian" pieces, but all had in common the individuality of craftsmanship and the vision behind it of beauty and harmony that harked back to the rules and methods of the medieval guild system. Arts and Crafts practitioners truly believed that everyone's quality of life would be improved if only integrity could be restored to objects in daily use.

The Arts and Crafts movement elevated and ennobled the artisan, and many followed William Morris's moral crusade along the path of socialism and political activism, aiming to restore dignity and satisfaction to workers who had been robbed of all joy in their work by the Victorian doctrine of progress and industrialization. The movement's inclusivity also created opportunities for women, who found in its revival of traditional techniques—such as embroidery, weaving, and enameling—an outlet for their creativity and a respectable way of earning a living. Gender still determined the division of labor, however, with men dominating fields such as metalwork, furniture, and architecture and women working hard to create a niche for themselves in areas like needlework, bookbinding, and pottery.

In the chapters that follow, each dealing with a different aspect of the movement, William Morris emerges as the towering personality and inspiration: a father-figure whose writings, lectures, and practical example had a tremendous and lasting influence on a younger generation of architects, craftsmen, and decorators. Along with men like W.R. Lethaby, A.H. Mackmurdo, Philip Webb, Walter Crane, Ernest Gimson, and the Barnsley brothers, Morris wanted to revitalize native English

traditions, always stressing the importance of honesty to function and local materials. Appalled by Sir Giles Gilbert Scott's recent restoration of Tewkesbury Abbey in Gloucestershire, Morris founded the Society for the Protection of Ancient Buildings, known affectionately as "Anti-Scrape," on March 22, 1877, "for the purposes of watching over and protecting these relics." Webb, Gimson, and the Barnsleys were all active members of the Society, which championed protection rather than restoration. Morris was prepared to prop up a tumbling church but not to tamper with the fabric or ornament of the building as it stood: a principled standpoint that cost him money, for it meant his firm had to stop accepting lucrative stained-glass commissions from churches undergoing restoration.

Morris's defense of medieval craftsmanship was part of his romanticized concept of the rural idyll. "Suppose," he wrote to Edward Burne-Jones's sister-in-law, "people lived in little communities among gardens and green fields, so that you could be in the country in five minutes' walk, and had few wants, almost no furniture for instance, and no servants, and studied the (difficult) arts of enjoying life, and finding out what they really wanted: then I think that one might hope civilisation had really begun." In the face of encroaching urbanization, a vigorous "back to the land" movement,

Above: *"Summer" and "Winter" from a set of tiles depicting the Four Seasons designed by Walter Crane and produced by Maw & Co., c. 1880.*

linked to a revival of English folk music and entertainments, had begun to emerge and identify itself strongly with the Arts and Crafts movement. A number of Arts and Crafts guilds were founded in the 1880s, with varying degrees of success. Ruskin's experimental St. George's Guild, designed as a Utopian society—"in essence a kind of enlightened feudalism"—was intended to implement his ideal of a just society, though it was perhaps a little too medieval in scope to offer a serious alternative to the rising tide of capitalism. Other communities were longer-lived if not, ultimately, entirely successful. In his influential book *The Stones of Venice* (1851–3), Ruskin had called for sweeping social change and an end to the illogicality of a situation in which "we want one man to be always thinking and another to be always working, and we call one a gentleman, and the other an operative; whereas the workman ought often to be thinking, and the thinker often to be working, and both should be gentlemen in the best sense.... In each several profession, no master should be too proud to do its hardest work. The painter should grind his own colours; the architect work in the mason's yard with his men; the master-manufacturer be himself a more skilful operative than any man in his mills." Such progressive notions became the cornerstone and creed by which the new guilds operated.

In 1882 Ruskin's ex-pupil A.H. Mackmurdo collaborated with the artist Selwyn Image to form a loose collective of designers into one of the first of the new craft guilds—the Century Guild. It was set up with the aim of supplying all the furniture and furnishings necessary for a house and, most importantly, involving artists in areas of work previously considered the realm of mere tradesmen. Mackmurdo had trained as an architect in the London office of the Gothic revivalist James Brooks, who had inspired him to try to master several crafts himself, including brasswork, embroidery, and cabinet-making, and instilled in him a reforming passion. Mackmurdo saw the Arts and Crafts movement "not as an aesthetic excursion; but as a mighty upheaval of man's spiritual nature" and differed from Morris in this important respect: Morris had aimed to level the disciplines of painting and sculpture to the rank of democratic handicrafts; Mackmurdo wanted to raise the status of crafts to that of "fine art." Century Guild members, including William De Morgan,

Below: *"Peacock" printed cotton designed for the Century Guild by Arthur Heygate Mackmurdo in 1883.*

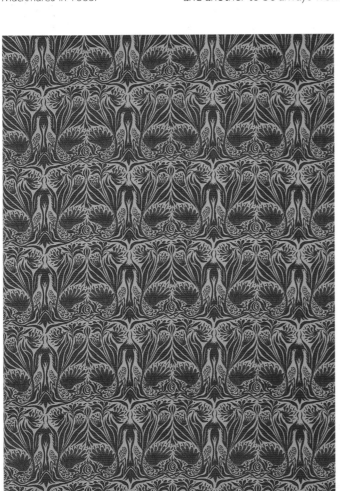

W.A.S. Benson, Herbert Horne, Clement Heaton, Benjamin Creswick, and Heywood Sumner, carried out decorative work of various kinds, much of it to Mackmurdo's design but in a cooperative spirit, collaborating on the design of a home and its contents. They also produced the influential journal *The Hobby Horse*, illustrated with woodcut decorations by Selwyn Image and Herbert Horne. Members socialized and met regularly at Mackmurdo's house at 20 Fitzroy Street, London, to hear early English music performed on the viol, lute, and harpsichord.

Further impetus to the craft revival movement came from the Art Workers' Guild (which is still in existence), founded in 1884 by a group of architects and designers including William Lethaby, a pivotal figure in the Arts and Crafts movement. Once again the stated aim of the Guild was to break down barriers between artists and architects, designers and craftsmen, leading to a goal of decorative unity. At their meetings in Queen Square, London, Guild members sat on traditional rush-seated ladderback chairs made by a sixty-seven-year-old carpenter called Philip Clissett, who never joined the movement but whose influence can be seen in the later work of Ernest Gimson, the Barnsley brothers, and Ambrose Heal, all of whom would have sat on Clissett's chairs as they attended lectures.

Then, in 1888, a splinter group from the Art Workers' Guild, including Walter Crane, W.A.S. Benson, Lewis F. Day, and T.J. Cobden-Sanderson, came together to arrange a large exhibition initially to be called "The Combined Arts," a title dropped in favor of "Arts and Crafts." And so the Arts and Crafts Exhibition Society, with Walter Crane as its first chairman, and a committee including William Morris and Edward Burne-Jones, came into being. The Society organized annual exhibitions in the New Gallery in Regent Street, London, providing a useful shop window for the products of the Arts and Craft movement. These included not just the designs of its own members but contributions from Morris & Co., the Century Guild, and C.R. Ashbee's newly formed Guild and School of Handicraft. All exhibitors had to satisfy strict criteria, the most important of which was that their work was entirely handmade. The Society also presented practical demonstrations and accompanying lectures from luminaries like William Morris

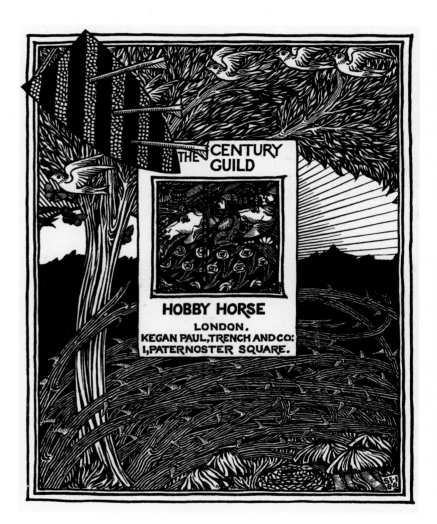

Above: *Frontispiece from* The Hobby Horse *by Selwyn Image, 1888.*

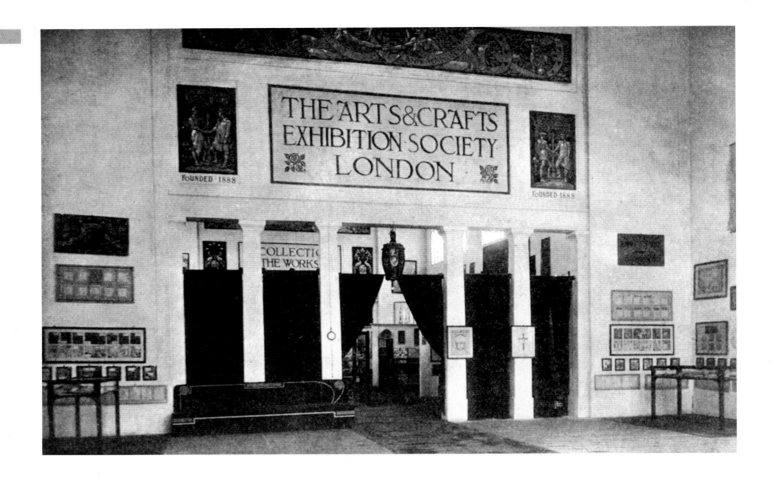

Above: *A photograph from* The Studio *showing the Arts & Crafts Exhibition Society stand at the Turin Exhibition in 1902.*

(on tapestry weaving), T.J. Cobden-Sanderson (on bookbinding), Halsey Ricardo (on furniture), Selwyn Image (on designing for the art of embroidery), and Walter Crane (on design).

It is apparent that the figures who did most to shape the fortunes of the Arts and Crafts movement, after Ruskin and Morris, had their roots in architecture: designers such as Mackmurdo, Horne, Philip Webb, Charles Voysey, Norman Shaw, J.D. Sedding, M.H. Baillie Scott, Charles Rennie Mackintosh, Reginald Blomfield, and Lethaby. One architect, however, who felt that the Arts and Crafts movement had taken a wrong turn and was in danger of becoming "a nursery for luxuries, a hothouse for the production of mere trivialities and useless things for the rich," was C.R. Ashbee.

Ashbee had begun with the highest ideals, setting up his Guild of Handicraft in the underprivileged East End of London in 1888 with a starting capital of only £50. By 1902 business was flourishing, and he decided to implement his ambitious plans to relocate to rural Chipping Campden in the Cotswolds, not far from the small but thriving Arts and Crafts group composed of the families of Ernest Gimson and the Barnsley brothers. The town, formerly a center for the wool and silk trade, had fallen on hard times, and the impact of such a large enterprise was tremendous. Ashbee accommodated his Guild members in the local cottages, many of which lay empty, though, controversially, many that did not were emptied of their occupants to make way for the incomers,

who could be charged a higher rent. The old silk mill was pressed into service to provide the Guild with silver and jewelry studios, and workshops for woodcarving and cabinet-making. In 1904 Ashbee opened the Campden School of Arts and Crafts at Elm Tree House, where practical lessons in gardening, cookery, and laundry work were given as well as crafts, literature, music, and history. Walter Crane and the poets John Masefield and Edward Carpenter were among the invited lecturers. In keeping with William Morris's Utopian ideals, Ashbee ran the Guild on democratic principles and aimed to promote "a higher standard of craftsmanship, but at the same time … protect the status of the craftsman." He had explained in a pamphlet published in 1902: "The Guild endeavours to steer a mean between the independence of the artist which is individualistic and often parasitical and the trade shop where the workman is bound to purely commercial and antiquated traditions, and has as a rule neither stake in the business nor any interest beyond his weekly wage."

Devoted to social reform, Ashbee provided his craftsmen with not just homes, but gardens, a swimming pool, and communal activities including amateur theatricals and musical evenings. The impact of a hundred and fifty Londoners arriving *en masse* in a small rural community caused some tensions but gradually, especially after the school was established, the two sides accepted one

Below: *Craftsmen at work in the Guild of Handicraft's metalwork shop at Essex House, before their move to Chipping Campden in 1902.*

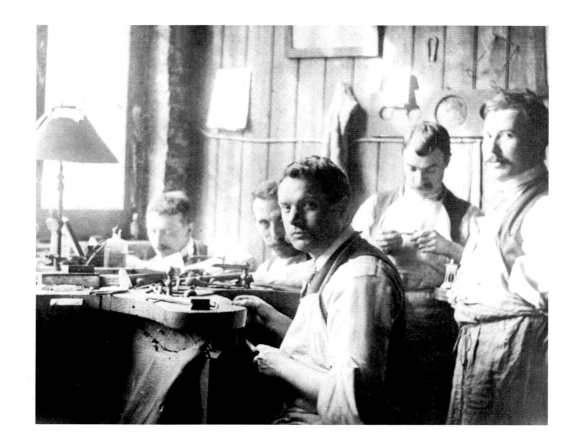

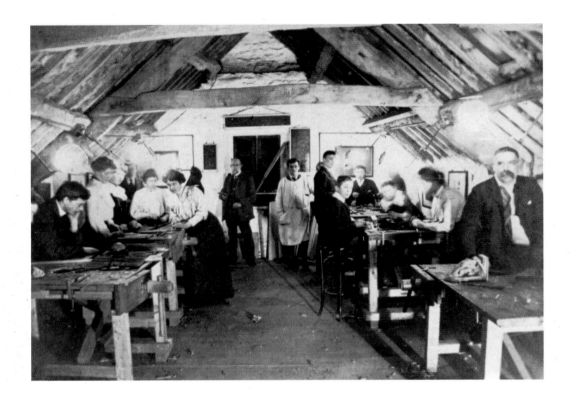

Above: *Men and women attending a Guild of Handicraft carving class at Chipping Campden in 1906.*

another and co-existed harmoniously until Ashbee's democratic notions were sabotaged by the market forces that forced him into voluntary liquidation in 1907.

In an article in *House Beautiful* Ashbee defined Arts and Crafts as "occupations or pursuits in the practice of which the individual comes into direct contact with his material, and is enabled to give expression to his own fancy, invention, imagination." That he failed to translate this to a wider public was a source of great sadness to him. Writing to his old friend, the illustrator and etcher F.L. Griggs, he admitted, "We both wanted a better world and were both quite out of touch with the one provided us, while the beauty of life—expressed in that Gloucestershire village—was lost all in all to us."

By 1907, however, the aesthetic ideas behind the movement had taken hold. Many important Arts and Crafts practitioners had taken up positions in the new art colleges being set up around this time and were able to preach their Arts and Crafts message from these prominent platforms, as well as through the established art schools, including the Royal College of Art, which moved swiftly in step with the progressive times. W.R. Lethaby's inspirational philosophy reached a wider audience through his work as co-director of the new Central School of Arts and Crafts in London, of which

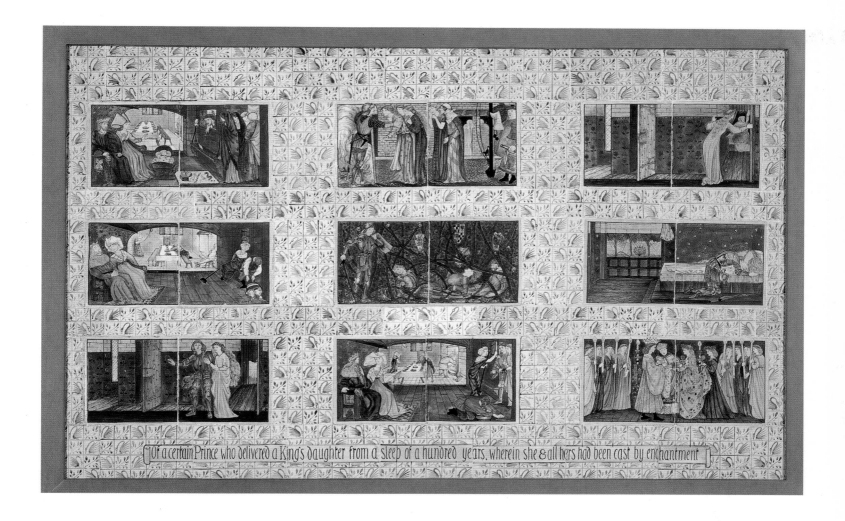

Of a certain Prince who delivered a King's daughter from a sleep of a hundred years, wherein she & all hers had been cast by enchantment

he eventually became principal in 1911. He wanted to raise the standard of the crafts while creating a training ground for designers able to meet the demands of commercial companies like Wedgwood, and he made a practice of placing highly skilled practitioners, rather than teachers, in key posts. For example, he made Halsey Ricardo head of architecture at the school, Christopher Whall head of stained glass, and the sculptor and silversmith Alexander Fisher head of enameling. Meanwhile, in Birmingham and Glasgow, other Arts and Crafts groups bloomed, once again around the focus of an art school sympathetic to their ideals that quickly became the home of the local style. The Birmingham Group included artists and designers such as Arthur Gaskin, Henry Payne, Charles March Gere, Bernard Creswick, the enamelists Sidney Meteyard and his wife Kate Eadie, and Mary Newill, a designer of embroideries and stained glass. All were teaching at the Birmingham School of Art's "Art Laboratories" in the mid-1890s. Inspired by the writings of Ruskin and the work of the English Pre-Raphaelites, especially the Birmingham-born Burne-Jones, they drew on late-romantic poetry and medieval romances for the subject-matter of their mural decorations, book illustrations, embroideries, and lovely Limoges enamel plaques, experimenting with the Renaissance technique

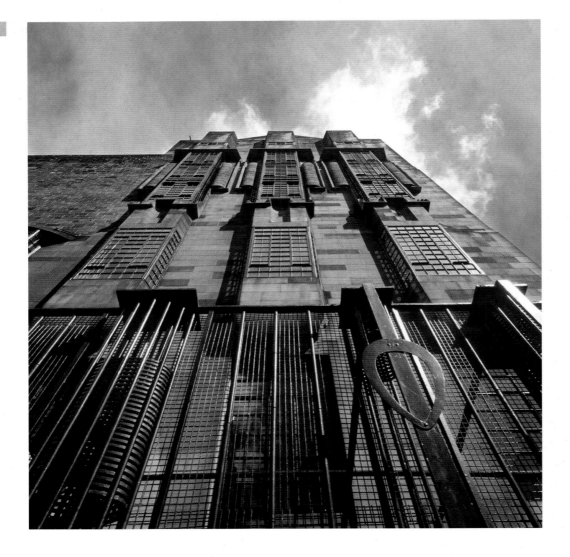

of tempera. Like the Century Guild, Ashbee's craftsmen, and Morris's circle, decorative unity was a paramount concern for the newly formed Birmingham Guild of Handicraft.

In Scotland an artistic revolution was taking place. At Edinburgh the new School of Applied Art offered classes for engravers, plasterers, and cabinet-makers as well as architects, but Glasgow was the real epicenter. Charles Rennie Mackintosh was the most famous member of the circle of artists and architects to emerge from the cutting-edge Glasgow School of Art, which had, in Francis Newbery, a progressive and enlightened director. Newbery introduced technical art studios where artist-craftsmen gave artisans a "technical artistic education" in commercial crafts such as stained glass, bookbinding, metalwork, illumination, and ceramics—even lead plumbing. His wife, Jessie Newbery, taught embroidery at the school and through her teaching, and her own highly creative designs, popularized Glasgow embroidery and brought on some richly talented pupils. Among them were Ann Macbeth and the Macdonald sisters, Frances and Margaret; the Macdonalds, together with

Herbert MacNair and Mackintosh, became known as the "Glasgow Four." The Four pioneered Art Nouveau designs and formed strong links with the Viennese Secessionists, who admired and emulated their extreme modernism. They found an active champion in the German architect and writer Hermann Muthesius, who claimed they were "a seminal influence on the emerging new vocabulary of forms, especially and continuously in Vienna, where an unbreakable bond was forged between them and the leaders of the Vienna Movement." Other leading figures to come out of the Scottish school were the architect George Walton, the designer and illustrator Jessie M. King, and her husband Ernest A. Taylor, the furniture and stained-glass designer.

A similar revival was taking place in the USA, for, although predominantly British, the ideas and ideals of the Arts and Crafts movement soon crossed the Atlantic and found fertile soil in which to take root. An American Arts Workers' Guild was founded in 1885 by the painters Sidney Richmond Burleigh and Charles Walter Stetson, together with the industrialist John Aldrich. Its members designed buildings, silverware, and other metalwork, along with furniture with panel paintings similar in style to that of Morris. The Society of Arts and Crafts, modeled on the British Arts and Crafts Society, was founded in Boston in 1897 by the architects Ralph Adams Cram and Bertram Grosvenor Goodhue, together with Charles Eliot Norton, an art critic of enormous influence—the American equivalent of John Ruskin—and the first professor of fine arts at Harvard. The Society offered lectures, classes, and social gatherings designed to bring together craftsmen, architects, and enthusiastic amateurs. It published a journal, *Handicraft*, and ran a saleroom where work—after a jury selection process—could be sold. New Arts and Crafts academies, such as the Manual Training High School in St. Louis run by Calvin Milton Woodward, which produced such quintessential Arts and Crafts designers as Charles and Henry Greene, were starting to spring up, leading to a rapid expansion of the craft movement.

Just as, in Britain, the Great Exhibition of 1851 had acted as a catalyst for Morris and Ruskin, so the Centennial Exposition in Philadelphia in 1876 revealed the lamentable lack of any truly American style. The industrial arts were dominated by shoddy, machine-produced goods in Empire style and, with a few notable exceptions like handcrafted Shaker furniture, lacked any American cultural identity of their own. The work of Arts and Crafts practitioners like William Morris and Walter Crane on show at the Exposition seemed to offer a way forward.

As in Britain, amateur groups were encouraged to flourish in American mission halls, school classrooms, and at evening classes. Books and manuals were published to satisfy this new consumer market, and magazines and journals such as *House Beautiful* and *Art Workers' Quarterly* appeared, offering practical advice to a largely middle-class market. Pioneering figures such as Elbert Hubbard and Gustav Stickley promoted the movement with a passion, and Arts and Crafts communities

Above: *A color print of the Roycroft shops at Elbert Hubbard's crafts community in East Aurora, near Buffalo, New York.*

similar to those founded in Britain were started in America. The best known of these was undoubtedly the Roycroft craft community in East Aurora, near Buffalo, founded by Hubbard in 1892 after a trip to England and a meeting with William Morris.

Hubbard's vision was of a return to the simple community life of pre-industrial America. Paralleling Ashbee's Chipping Campden experiment, the Roycrofters set up their own shops, farm, bank, smithy, and printing plant, and built houses on communal living lines, attracting such interest that they also had to build a Roycroft Inn to house the throng of curious visitors. Hubbard provided a library and playgrounds and set up a lecture series for his workers, who spent their eight-hour working days in good, well-ventilated conditions, able and encouraged to try their hands at different tasks, and so relieve boredom and explore possibilities: "When a pressman or typesetter found his work monotonous … he felt at liberty to leave it and turn stonemason or carpenter." In 1901 Hubbard extended the operation, adding furniture to the leather and metalwork gifts his designers were already producing, along with ceramics and household items. Other Utopian craft communities sprang up, including the Rose Valley Arts and Crafts Colony, set up in Philadelphia by the architect William Lightfoot Price, and the Byrdcliffe Colony, started by Ralph Radcliffe Whitehead and his wife Jane Byrd McCall in rural Woodstock, New York State (which is still a thriving summer home to

artists, writers, and composers). In Chicago in 1889, Jane Addams and Ellen Gates Starr founded Hull-House which, like Toynbee Hall (the settlement house established in Whitechapel, London, in 1884) provided immigrants with craft skills to lift them out of poverty.

Gustav Stickley, who might be said to have done the most to disseminate the Arts and Crafts message throughout the USA, was, like Hubbard, inspired by a trip to England in 1898, and established his own guild of artisans, United Crafts. Like the British model, he set up a profit-sharing scheme for his craftsmen (though this was soon abandoned) and held regular workshop meetings "to secure harmony and unity of effort." His magazine *The Craftsman* publicized both his products and his philosophy. The first issue contained a monograph on William Morris, the second an appreciation of Ruskin, and the next hailed Morris as "a household name throughout America." Stickley used machinery to liberate his workers from tedious and unnecessary labor but also to maximize production. "As a matter of fact," he insisted, "given the real need for production and the fundamental desire for honest self-expression, the machine can be put to all its legitimate uses as an aid to, and a preparation for, the work of the hand, and the result be quite as vital and satisfying as the best work of the hand alone … the modern trouble lies not with the use of machinery, but the abuse of it." By taking this position, of course, he ran counter to the central tenet of the British Arts and Crafts movement that work should be handmade, yet his aim of "a simple, democratic art" was undeniably realized in his determinedly simple furniture, which drew on the Shaker ideal of functional beauty.

Both sides of the Atlantic were experiencing an unprecedented rise in the middle classes, which led to a building boom and created a huge new pool of consumers interested in interior decoration and the statement and status "artistic" choices could confer. Designers such as Walter Crane, Lewis F. Day, Christopher Dresser, A.H. Mackmurdo, Louis Comfort Tiffany, and Candace Wheeler met this need by redefining and revolutionizing interiors. Manufacturing firms and department stores were quick to respond to the demand, employing leading Arts and Crafts architects like Voysey and Baillie Scott in Britain, and Frank Lloyd Wright and Charles and Henry Greene in America, who

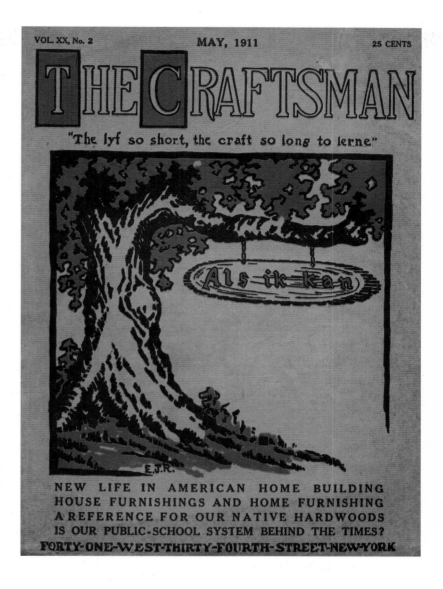

VOL. XX, No. 2 MAY, 1911 25 CENTS

THE CRAFTSMAN

"The lyf so short, the craft so long to lerne"

Als-ik-kan

E.J.R.

NEW LIFE IN AMERICAN HOME BUILDING
HOUSE FURNISHINGS AND HOME FURNISHING
A REFERENCE FOR OUR NATIVE HARDWOODS
IS OUR PUBLIC-SCHOOL SYSTEM BEHIND THE TIMES?
FORTY-ONE-WEST-THIRTY-FOURTH-STREET-NEW-YORK

Above: *Front cover of* The Craftsman, *published by Gustav Stickley's United Crafts in May 1911.*

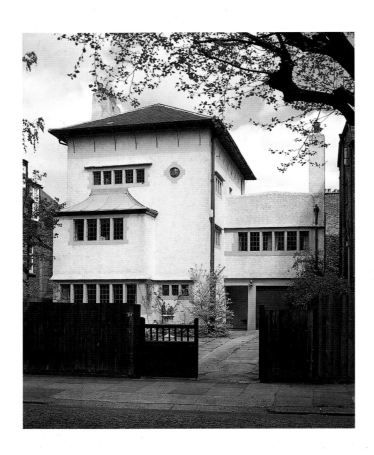

Above: *Tower House, Bedford Park, west London, designed by C.F.A. Voysey in 1891.*

designed not just the house but the furniture and furnishings to go inside it. Many Arts and Crafts architects also worked as freelance designers for firms such as Liberty's, producing textile patterns and specially tailored ranges of furniture.

The buoyant economy provided a steady stream of commissions for Arts and Crafts architects for large or small homes for the better-off (many of which, like Philip Webb's Standen in West Sussex, Mackintosh's Hill House in Helensburgh, Baillie Scott's Blackwell in Cumbria, and the Greene brothers' Gamble House in Pasadena, have been preserved and stand as living monuments to the Arts and Crafts movement). As home ownership became an achievable aim for the burgeoning middle class in Britain, it fueled a building boom that spread beyond the towns and encouraged an enlightened and innovative group of architects to envision and implement plans for "Garden Cities" in the suburbs surrounding London. The prototype for these had been the development at Bedford Park, just north of Chiswick in west London, near the then-new underground railway station at Turnham Green. It was the brainchild of an idealistic entrepreneur named Jonathan Carr, who, in 1875, started to develop the open fields around his father-in-law's eighteenth-century house, creating a suburban village of small detached and semidetached villas in the Queen Anne style for the artistic middle class. His first choice of architect, E.W. Godwin, was replaced by Richard Norman Shaw, who improved on Godwin's designs and supervised the building of five hundred houses, each with "A Garden and a Bath Room with Hot and Cold Water." The 1881 prospectus declared Bedford Park to be "The Healthiest Place in the World" and it attracted an artistic—if somewhat bourgeois—clientele of actors, artists, and Russian émigrés, who sent their children to the two specially built schools and availed themselves of the daringly unisex tennis club and the cooperative store.

Later Garden City developments combined social principles with early 1900s Arts and Crafts design. The intention was to dissolve the differences between town and country and create an ideal setting in which people could live and work in harmony, happiness, and a healthy environment. These housing experiments were based on Ruskin's model of the fourteenth-century village settlement where working class misery, unemployment, and bad housing could be things of the past. In *Sesame and Lilies*

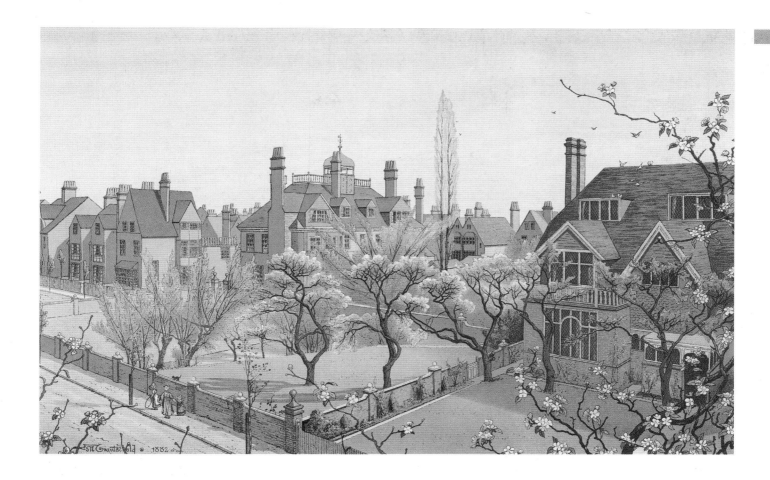

(1865) Ruskin had called for the building of new homes "strongly, beautifully, and in groups of limited extent, kept in proportion to their streams and walled round, so that there may be no festering and wretched suburb anywhere, but clean and busy street within and the open country without."

Ebenezer Howard, who coined the term "Garden City," was a non-architect theorist influenced by Walt Whitman, Ralph Waldo Emerson, and Ruskin, who wanted to create "a new civilization based on service to the community." In 1898 he wrote an influential book called *Tomorrow: a Peaceful Path to Real Reform*, which was revised as *Garden Cities of Tomorrow* in 1902. The architects Raymond Unwin and Barry Parker, whose extensive work in the the Garden City movement made them enormously influential pioneers of town planning as social engineering, won the competition to plan the first Garden City: Letchworth in Hertfordshire. Ruskin's vision of a "belt of beautiful garden and orchard round the walls, so that from any part of the city perfectly fresh air and grass and sight of far horizon might be reachable in a few minutes' walk" was realized at Letchworth, which was swiftly followed by Dame Henrietta Barnett's Hampstead Garden Suburb in north London and Gidea Park in Romford, Essex. Parker and Unwin were involved in all of them, as were Halsey Ricardo, Edwin Lutyens, and Baillie Scott, who in 1910 designed a pair of show houses at Gidea Park that were filled with furniture and fabrics from Heal's and the Deutsche Werkstätte, made to his designs.

Above: *A chromolithograph showing the houses on the Bedford Park Estate in London, 1882.*

Right: *A picturesque example of the cottages the Quaker Cadbury family provided for their factory workers at Bournville, a low-density housing development designed as a model village.*

A few philanthropic industrialists in northern England had blazed the trail, including men and women like Robert Owen, Sir Titus Salt (whose model estate Saltaire, near Bradford, had been planned and started as early as 1850), and Quakers George and Elizabeth Cadbury (who built the model garden village of Bournville near Birmingham for the workers in Cadbury's chocolate factory in 1895). William Hesketh Lever (later Lord Leverhulme) built Port Sunlight on fifty-two acres on the south bank of the River Mersey in 1889 to provide both a soap factory and a model village of houses "in which our workpeople will be able to live and be comfortable … in which they will be able to know more about the science of life than they can in a back slum and in which they will learn that there is more enjoyment in life than in mere going to and returning from work." Lever wanted three-bedroomed houses, with parkland, playing fields, bath houses, and almshouses for the elderly. One thousand red brick houses were built around a town center laid out with wide avenues and parks. They had all the Arts and Crafts details of white-painted casement windows, tile-hangings, and gables.

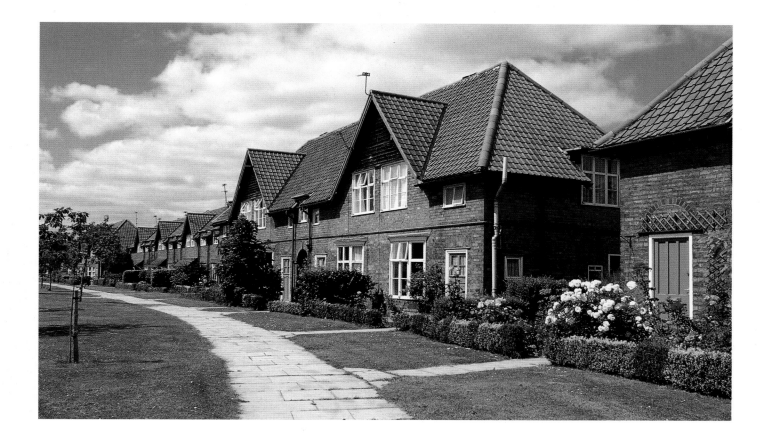

These model villages were often arranged around a "village green," with perfectly scaled public buildings, schools, a Friends' Meeting House, bandstands, and churches, though rarely inns, for their philanthropic supporters were often active members of the Temperance movement. Though small in scale, the houses tended to be immensely varied in design, involving characteristics of sixteenth-, seventeenth- and eighteenth-century domestic style in brick, timber, and stone. Individual gardens, shared recreation spaces, and plenty of allotments were important features.

Joseph Rowntree, another Quaker chocolate manufacturer, founded the village of New Earswick in Yorkshire and employed Parker and Unwin to lay out and design each house from 1902 onward. Rowntree wanted houses that were "artistic in appearance, sanitary, well built, and yet within the means of men earning about twenty-five shillings a week." And Parker and Unwin supplied them, grouping a variety of cottages, some of brick, others with roughcast exteriors, and all with gardens, around a triangular village green.

Above: *New Earswick, York— the model factory village by Parker and Unwin, c. 1902, houses "artistic in appearance, sanitary, well-built."*

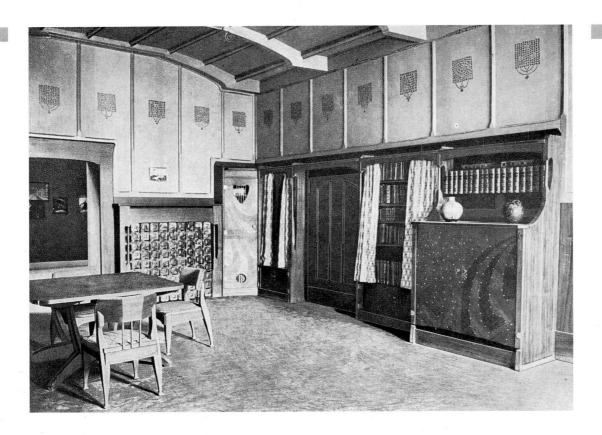

Above: *European Arts and Crafts in this interior by the German designer and founder of the Dresden and Munich Werkstätten, Richard Riemerschmid, dating from 1904.*

A similar experiment in workers' housing was unfolding in Europe in the Voysey-influenced rising terraces of Richard Riemerschmid's Hellerau and Hermann Jansen's Berlin projects. They incorporated laundries, a training school, a theater, and workshops for the newly amalgamated Dresden and Munich Werkstätten. In the USA the garden suburb idea was implemented in projects such as Forest Hills Gardens in Queens, New York (planned in 1909 by Frederick Law Olmstead Jr. and Grosvenor Atterbury), Philadelphia's Germantown, and Virginia's Hilton Village (designed in 1918 by Henry Vincent Hubbard and Joseph D. Leland III, to accommodate shipyard workers, and clearly inspired by the published works of Baillie Scott and Parker and Unwin for Letchworth Garden City and Hampstead Garden Suburb).

In Britain, firms like Liberty's and Heal & Son responded to these new homes by creating affordable "cottage" furniture alongside their more expensive and elaborate ranges. They capitalized on the visual appeal of the Arts and Crafts movement without necessarily subscribing to its social aims. Ambrose Heal was a shrewd businessman and talented furniture designer who may have been in tune with the ideals of Arts and Crafts, but was unafraid of employing modern methods. He maintained that "the machine relieves the workman of a good deal of drudgery, and legitimately cheapens production." This was an important point for—despite their best intentions—the insistence on the handcrafting of artefacts meant that most pieces by Arts and Crafts designers were beyond the means of the very people they hoped would benefit from their "improving" presence in their homes.

Liberty's introduced the work of some of the period's best designers, including Voysey, Baillie Scott, Arthur Gaskin, Bernard Cuzner, Oliver Baker, and Jessie M. King, to a mass market. However, because of their strict rule that artists should not mark their work, some, like Archibald Knox, their most prolific and innovative designer, remained largely and unfairly obscure for more than half a century. The firm's founder, Arthur Lazenby Liberty, set out to satisfy the seemingly insatiable appetite of the middle classes for fashionable "Aesthetic" interiors. He did sell one-off items but much of the work was machine-made with the odd finishing touch by hand, leading Ashbee to call them "Messrs. Nobody, Novelty and Co." and to blame them for the failure of his Guild of Handicraft. Certainly, Liberty's "Cymric" venture undercut his more expensive, handmade Guild work and accelerated the demise of the silver workshop. Liberty, a clever businessman, completely ignored the social and ethical side of Arts and Crafts while trading on its spirit, visual appeal, and the current fashion for Aesthetic style. While he succeeded in reaching a wider public with his fabrics, metalwork, and furniture than Morris & Co. or any of the Guilds, his policy of anonymity for his designers succeeded in stifling or suppressing the impulse toward celebrating the individual that had been at the heart of the movement at its outset.

As the twentieth century progressed, cracks appeared in the Arts and Crafts movement prompted, once again, by the debate over machines. Some, like Gimson and Ernest Barnsley, argued passionately against any involvement whatsoever with machines or industry, while Lethaby steered a middle course, urging designers to be motivated by a sense of social purpose and responsibility, not just commercial success. In 1913, in his essay on "Art and Workmanship" in *The Imprint*, he wrote: "Although a machine-made thing can never be a work of art in the proper sense, there is no reason why it should not be good in a secondary order—shapely, smooth, strong, well fitting, useful; in fact, like a machine itself. Machine work should show quite frankly that it is the child of the machine; it is the pretence and subterfuge of most machine-made things which make them disgusting." European designers were never as troubled by this dilemma. The essential difference between the British and European Arts and Crafts designers was the latter's readiness to embrace industrialization and harness the machine. By applying

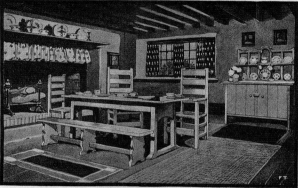

Above: *Advertisement from* The Studio *yearbook of 1907 promoting Heal & Son's "Country Cottage" look.*

Arts and Crafts values to machine production, preserving integrity in the use of materials, revering the crafts ethic and the ideal of design unity, they sought to reform industrial design. The founders of the Deutsche Werkbund—Hermann Muthesius, Friedrich Naumann, and Henry van de Velde—stressed the need to restore the dignity of labor but in alliance with, rather than in opposition to, the machine. In common with Josef Hoffman and Koloman Moser at the Wiener Werkstätte, they shared the social vision of the founding members of the Arts and Crafts movement and insisted that art and architecture should be put in the service of society in order to create a nobler environment for contemporary humanity. They rejected the *l'art pour l'art* philosophy of the late nineteenth century, turned their backs on the past, and set out to create a new ornament and style appropriate to the machine age. (In this, revolutionary figures such as Christopher Dresser were already ahead of them.)

The central differences between the British and American movements are threefold. First, the USA did not have quite the same class issues as Britain, so there was less of an ideological component; second, the foremost American Arts and Crafts exponents were unembarrassed about promoting, marketing, indeed, commercializing their product; third, their attitude to the machine was in marked contrast to that of their British counterparts. First Stickley and then Frank Lloyd Wright openly designed for machinery and delighted in the new possibilities it provided. "The machine is capable of carrying to fruition high ideals in art, higher than the world has yet seen!" Wright proclaimed in a landmark lecture entitled "The Art and Craft of the Machine." Inevitably this meant that Morris's ideas were diluted, yet paradoxically they reached a wider audience and were made to work in a way that he himself had failed to achieve because of his insistence on expensive handcrafting and his unwillingness to market himself.

By 1915, the wider aims of the Arts and Crafts movement had shrunk. The socialist impulse to change society was no longer driving the movement forward, and what remained had been distilled to individual expression and creativity. For Ashbee the dream had been unraveling for some time. "We have made of a great social movement, a narrow and tiresome little aristocracy working with great skill for the very rich," he wrote despondently in his private journal.

In Britain the movement never really recovered from the impact of World War I, and in the USA it was left reeling from the effects of the Wall Street Crash in 1929. European designers were already responding to Modernism's siren call, although in Scandinavia the Arts and Crafts dream was successfully and perhaps more enduringly accomplished by using the region's rich natural resources to realize Morris's idea of a "decorative, noble, popular art." Gradually, however, the Arts and Crafts movement atrophied in Britain. Its insistence on handcrafting had made its products desirable but prohibitively expensive. Commercial concerns like Liberty's, Pilkington's, Minton, and Wedgwood had been quick to commission Arts and Crafts artists to come up with designs they could mass-produce

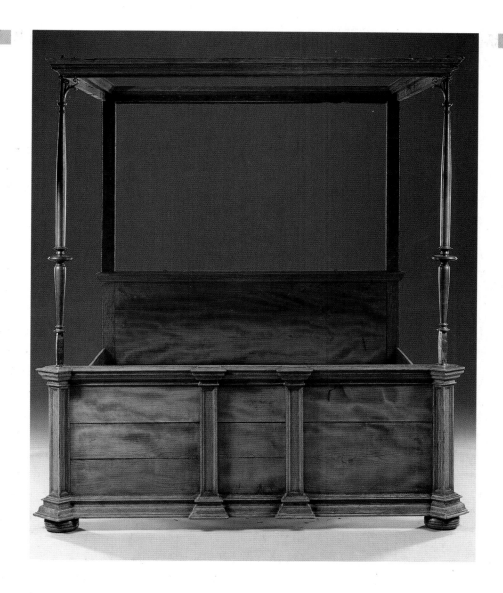

cheaply to satisfy the public appetite; they were quicker still to dance to the Modernist tune when the quaint cosy cottageyness of the Arts and Crafts movement began to appear outdated.

Now, Arts and Crafts artefacts are highly prized and often very expensive. Sotheby's recently sold a paneled oak double bed designed by Edwin Lutyens for a sum that would, when it was made, have secured the architect's services and covered the building costs of a sizable country house, with a Gertrude Jekyll garden thrown into the bargain. It is perhaps ironic that today's price for a single Stickley settle sold at auction in America would have cleared its creator's debts and saved him from sliding into bankruptcy. The revival in popularity of the Arts and Crafts style is easily accounted for. Besides being beautiful and simple in form, much of the work celebrates domesticity and we find it easy to identify with its lack of pretension and robust solidity. Yet, as this book sets out to show, there is a great deal more to the movement than the beguiling warmth and homeliness of familiar details of design.

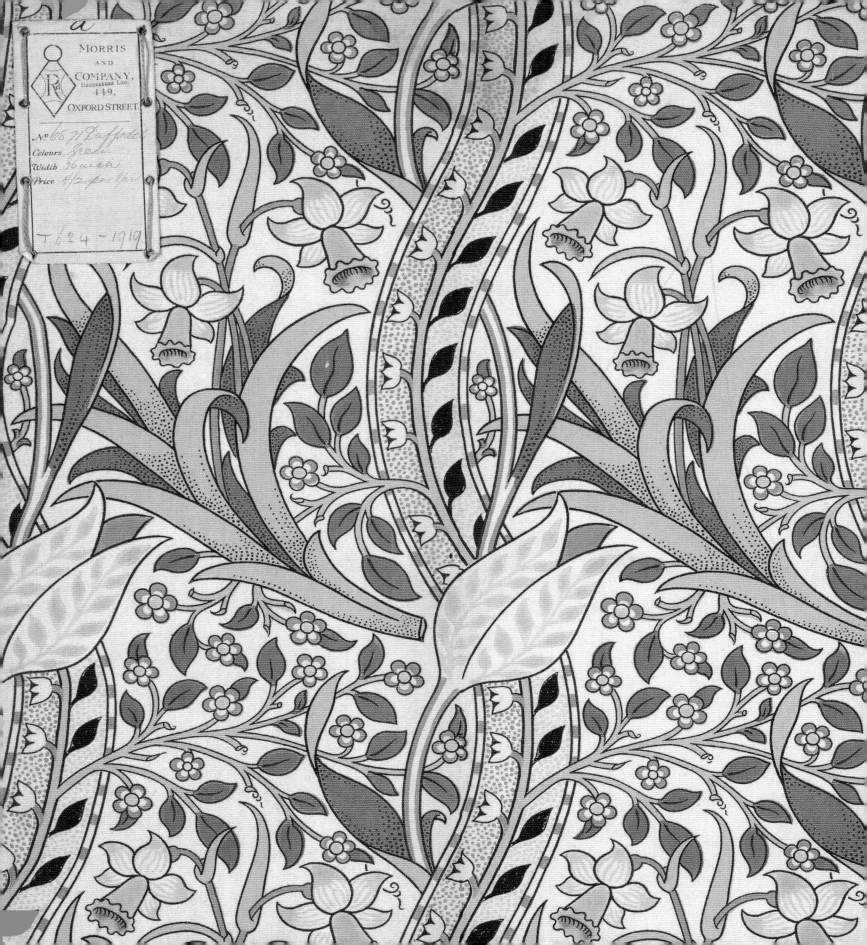

THE MAKERS OF THE MOVEMENT

Left: *J.H. Dearle designed this "Daffodil" printed cotton as a furnishing fabric for Morris & Co. in 1891.*

1

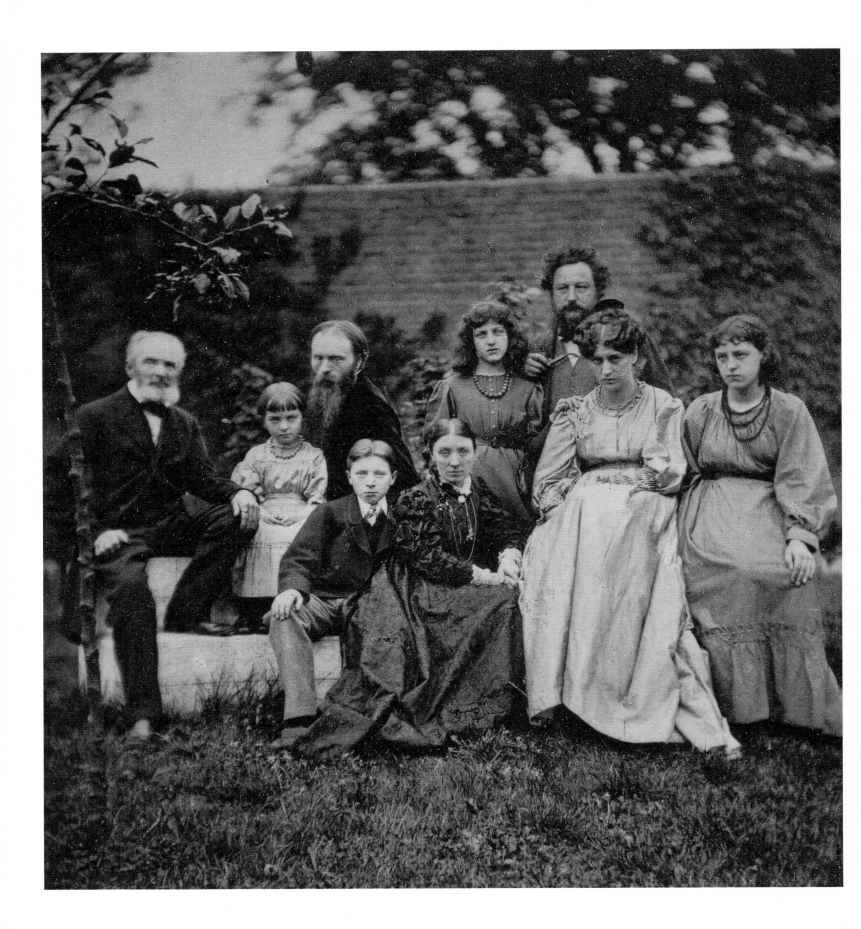

WHO WAS WHO

ADDAMS, Jane (1860–1935), American philanthropist. With Ellen Gates Starr (1859–1940), she established the Chicago settlement house Hull-House, modeled on Toynbee Hall, in 1889. She was elected first president of the Women's International League for Peace and Freedom in 1919, and was awarded the Nobel Prize for Peace in 1931.

ASHBEE, Charles Robert (1863–1942), English architect, romantic socialist, and Utopian. Much influenced by William Morris, John Ruskin, and Walt Whitman, Ashbee devoted himself to social reform through craft while still an architecture student (articled to G.F. Bodley) in London. Having been brought up in "discreet luxury," the experience of living in the pioneering settlement house Toynbee Hall, in London's East End, where he taught art to some of London's poorer residents, led him to form the Guild of Handicraft in 1888. The combined school and workshop was devised along the lines of the medieval guild system. In 1890 the Guild expanded and moved to Essex House in the Mile End Road, and in 1902 moved out of London to rural Chipping Campden in the Cotswolds, where Ashbee hoped that by giving his workers their own homes and gardens, with recreational and intellectual facilities (a swimming pool as well as a library), they would live healthier, happier lives. Guild craftsmen were renowned for their work in copper, brass, and iron; they made silver and jewelry, often enameled; they excelled as cabinet-makers and carried out restoration as well as decorative schemes. In 1904 Ashbee opened the School of Arts and Crafts, which operated until 1916 under the sponsorship of Gloucestershire County Council, where Guild members and local people were able to mix in a wide variety of

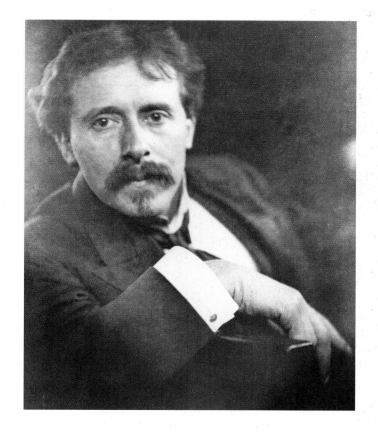

Far left: *The Morris and Burne-Jones families photographed at the Grange, Fulham, in 1874. The gentleman on the left is Burne-Jones's father.*

Above: *C.R. Ashbee, photographed by Frank Lloyd Wright in 1910.*

BAILLIE SCOTT, Mackay Hugh (1864–1945), influential English architect. He was the eldest of fourteen children, and attended the Royal Agricultural College at Cirencester with a view to taking over the management of the family's Australian sheep farm, but abandoned these plans to become an architect and was articled to Major Charles Davis, the Bath city architect, in 1886. Following his marriage to Florence Nash in 1889, he moved to Douglas on the Isle of Man where he met the designer Archibald Knox. The two collaborated on the design of stained glass, iron grates, and copper fireplace hoods, which were installed in the houses built by Baillie Scott on the island. He became known for his suburban houses in red brick or stucco, planned around spacious living areas with highly decorated interiors, often using elm and oak. His "House for an Art Lover" design won the highest prize in a competition organized by the Zeitschrift für Innedekoration in 1901, though it was not built. From 1898, Baillie Scott designed furniture for John P. White at the Pyghtle Works, Bedford, whose 1901 catalog included 120 of his pieces. The furniture was also sold through Liberty's. He and his family left the Isle of Man in 1901 and moved to Bedford, where his architectural practice flourished. Seemingly never short of clients, he did not retire until 1939. He divided his remaining years between Ockhams, a Kentish farmhouse

classes aimed at meeting both their practical and spiritual needs. For over two decades Ashbee's democratically run Guild of Handicraft provided a model of communal living, profit sharing, and joyful labor (though with a bias toward craftsmen rather than craftswomen) that was an inspiration to Arts and Crafts idealists worldwide. Sadly, the dream of the simple life in idyllic surroundings came to an end in 1907 when the Guild, which had been experiencing financial difficulties for some time, went into liquidation. Ashbee stayed on in Chipping Campden with his wife Janet and their four daughters until 1919, after which they moved to Kent. Ashbee's furniture and metalwork were exhibited and much admired in Vienna, Munich, and Brussels. His influence extended to the USA, where he had laid the groundwork in 1900 when he visited fourteen American states on a lecture tour, meeting Frank Lloyd Wright in his home on his last day in Chicago. "The real thing is the life," he wrote—and lived up to it.

Above left: *M.H. Baillie Scott was destined to make a major contribution to the Arts and Crafts movement. and his work gained international acclaim.*

Above right: *A bedroom at Upper Dorvel House, the home of Ernest and Alice Barnsley, photographed by Ernest's brother Herbert, c. 1905.*

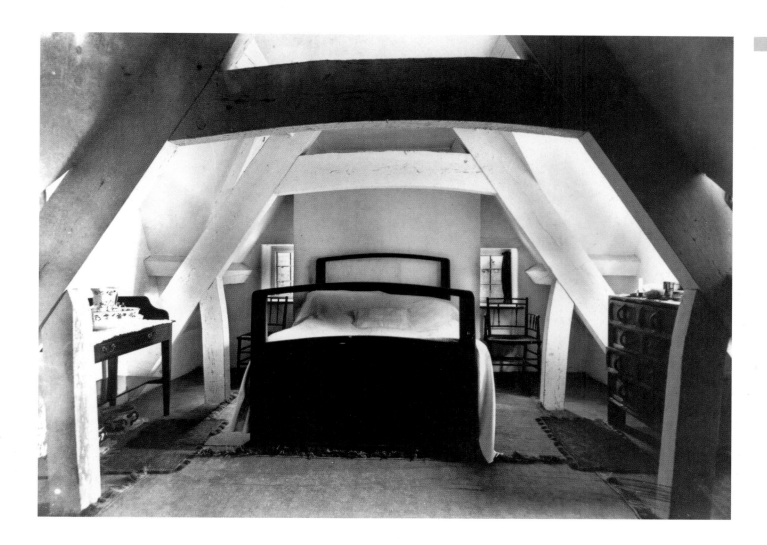

near Edenbridge, and rooms at the Kensington Palace Mansions Hotel in London.

BARNSLEY, Ernest (1863–1926), English architect and furniture designer. After training with J.D. Sedding in London, he established his own architectural practice in Birmingham in 1892, prior to joining his shyer brother Sidney Barnsley and Ernest Gimson in the Cotswolds in 1893. Affable and enthusiastic by nature, he set up a craft workshop in 1900 but concentrated mostly on his architectural work, much of which was for the Society for the Protection of Ancient Buildings founded by William Morris.

BARNSLEY, Sidney (1865–1926), English furniture designer and maker. Born in Birmingham, he trained as an architect in the London office of Richard Norman Shaw. With Ernest Gimson, Reginald Blomfield, Mervyn Macartney, and W.R. Lethaby, he established the London firm of Kenton & Co., designing furniture according to basic construction principles. Decoration, if used at all, was inlaid, using materials such as mother-of-pearl or ivory. After the collapse of the company, he moved to Gloucestershire and set up a workshop with Gimson and his brother Ernest Barnsley. Sidney married his cousin, Lucy Morley, in 1895. Deaf from the age of nineteen, she was nevertheless practical and efficient, and the Barnsleys lived a rural life following their avowed principles; they baked their own bread, chopped their own wood, kept hens and goats, brewed cider, and made sloe gin. Sidney made his own furniture, working alone, because he enjoyed the making as much as the designing. He sent his two children, Grace and Edward, to Bedales in Hampshire, and in 1910 the school commissioned a new assembly hall from Ernest Gimson and ten years later a library, which was built under the supervision of Sidney Barnsley after Gimson's death. Sidney died in 1926 within months of his brother

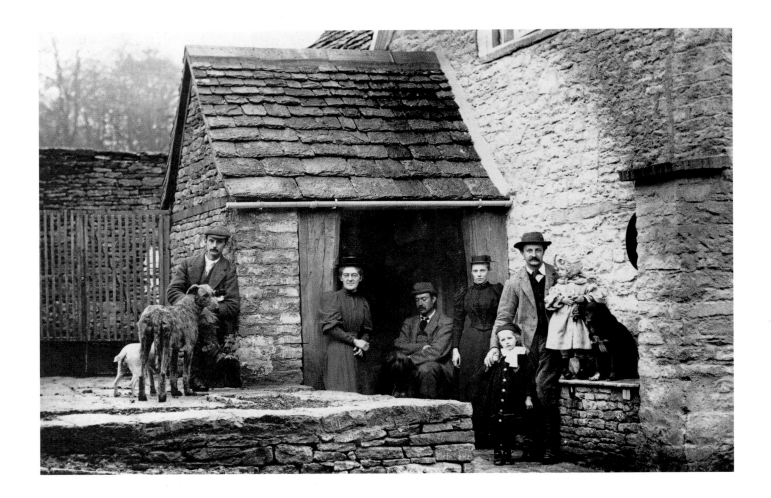

and the two are buried, alongside Gimson, at the village of Sapperton, where they lived and worked for so many years. Their graves are marked with plain granite slabs.

BATCHELDER, Ernest Allan (1875–1957), American ceramic artist, design theorist, and teacher. After a period of study at the School of Arts and Crafts in Birmingham, England, he established his own school and tile factory in Pasadena in 1909, producing molded tiles with strong relief designs. The factory produced major ceramic installations for churches and commercial buildings, as well as architectural tiles for bungalow fireplaces that were sold throughout the USA.

Above: *This group photograph taken outside Gimson's Cotswold cottage around 1895 shows, from the left, Sidney Barnsley, his fiancée Lucy Morley, Ernest Gimson, Alice and Ernest Barnsley with their two daughters, Mary and Ethel.*

Right: *An elaborate mahogany and boxwood music cabinet and stand with wax inlaid scene of Orpheus charming the animals, designed by W.A.S. Benson and G.H. Sumner, c. 1889.*

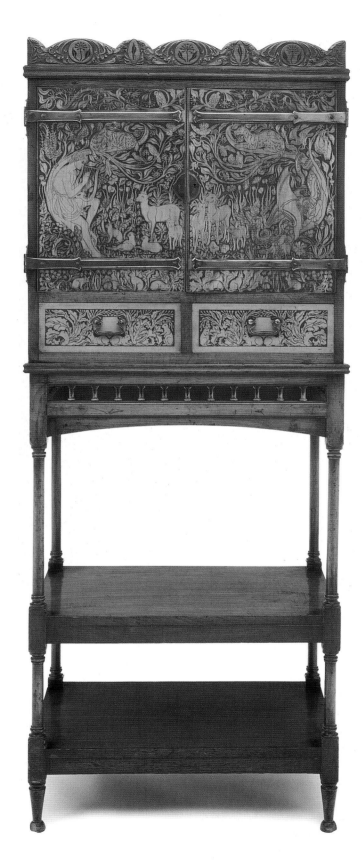

BEHRENS, Peter (1868–1940), German architect and industrial designer. He was a founder of the Dresden and Munich Werkstätten, and later came to be influential in the development of Modernism.

BENSON, William Arthur Smith (1854–1924), English architect, metalworker, and furniture designer. He also designed wallpapers and the silver mounts and hinges of cabinets for Morris & Co., of which he became chairman in 1896 after William Morris's death. He had his own metal workshop in St. Peter's Square, Hammersmith, London, and opened showrooms in Bond Street in 1887. He was a founder member of the Art Workers' Guild in 1884 and the Design and Industries Association in 1915. He retired in 1920.

BIDLAKE, William Henry (1861–1938), English architect and honorary director of the Birmingham Guild of Handicraft. He taught at Birmingham's architecture school for ten years and was, according to The Studio, responsible for influencing and guiding a whole generation of younger architects.

BING, Samuel (formerly Siegfried) (1838–1905), German writer and entrepreneur whose Paris shop, La Maison de l'Art Nouveau, gave its name to Art Nouveau style and had a profound impact on Arts and Crafts designers.

BLOMFIELD, Reginald Theodore (1856–1942), English architect. He was much involved as a young man with the Arts and Crafts movement, founding Kenton & Co. with W.R. Lethaby and others, but moved away to mature along classical lines, building up a highly successful architectural practice and becoming president of the Royal Institute of British Architects in 1912.

BLOUNT, Godfrey (1859–1937), British artist and craftsman. He set up the Haselmere Peasant Industries in Surrey in 1896, as an artistic community with the same idealist aims as C.R. Ashbee's, to combine work—treadle weaving, appliqué embroidery, and making handknotted carpets—and leisure with the "revival of a true country life where handicrafts and the arts of husbandry shall exercise body and mind and express the relation of man to earth and to the fruits of earth." With his wife, Ethel Hine, Blount was a great advocate of

the simple life and belonged, as did Ashbee and his wife Janet, to the Healthy and Artistic Dress Union, founded in London in 1890 to promote the wearing of comfortable, loose-fitting, hand-woven clothes.

BLOW, Detmar Jellings (1867–1939), English architect. He began his career by apprenticing himself to a mason in Newcastle-upon-Tyne, eventually becoming assistant to Ernest Gimson and working on a series of Cotswold commissions, including Stoneywell Cottage. In 1900 he designed Happisburgh Manor in Norfolk on a butterfly plan like that of E.S. Prior's architecturally significant house The Barn at Exmouth (1897), though Blow claimed that his inspiration came from an idea seeded by Gimson. Between 1895 and 1914 he had one of the largest country-house practices in Britain and earned over £250,000. In 1910 he married the daughter of Lord Tollemache and bought a thousand-acre estate in Gloucestershire, on which he built his own country house, Hilles. His fortunes declined, along with his commissions, following World War I.

BODLEY, George Frederick (1827–1907), English Gothic architect and one of the first patrons of Morris & Co. In 1874 he started his own firm, Watts & Co., with Thomas Garner and George Gilbert Scott Jr., to make hand-blocked wallpapers and textiles in the Queen Anne revival style. He was important to the Arts and Crafts movement because he produced some of its leading architects, including C.R. Ashbee, who joined him as a pupil in 1886, and the Scottish architect Robert Lorimer, who spent a short time in the Bodley office in 1889.

BRADLEY, Will (1868–1962), American typographer, printer, and illustrator. He founded the Wayside Press in Springfield, Massachusetts, in 1896. His illustrations of the "Bradley House" presented the Arts and Crafts ideal in a series of articles for Ladies' Home Journal (1901–2) intended to promote good domestic architecture throughout the USA. Readers were told that, "Mr. Bradley will design practically everything in the pictures," which included furniture, tapestries, wallpapers, and murals and drew heavily on the influences of M.H. Baillie Scott, C.F.A. Voysey, and Frank Lloyd Wright. None of the furniture he illustrated is known to have been executed although he did design and have built three houses for his family.

BRANGWYN, Frank (1867–1956), British artist and etcher, designer of furniture, pottery, metalwork, jewelry, rugs, embroideries, and fans. Largely self-taught, when in his teens he secured a job at Morris & Co., enlarging the designs for tapestries, through the influence of A.H. Mackmurdo. In 1895 he contributed to the decoration of Samuel Bing's Maison de l'Art Nouveau in Paris,

and in 1899 he designed stained glass for Louis Comfort Tiffany. His work on major decorative commissions included the British Rooms for the Venice Biennale exhibitions of 1905 and 1907 and murals in the Rockefeller Center in New York (in collaboration with Jose Maria Sert and Diego Rivera). He was knighted in 1941.

BROWN, Ford Madox (1821–93), British painter and mentor to the Pre-Raphaelites. Brown was a founding member of the Firm, for whom he designed furniture and stained glass, though he fell out with Morris over the restructuring of the business. Twice married and a committed socialist, he was dogged in his early years by poverty and anxiety, and never gained the recognition he deserved. In later years he toiled over a series of important murals depicting local history in Manchester Town Hall for the paltry sum of £300 a year, suffering a stroke that affected his painting arm, but going on to finish the series with his left hand.

BURDEN, Elizabeth (b. 1842), sister to Morris's wife, Janey, and known as Bessy, Burden lived with the family and became a skilled embroiderer, going on to teach at the Royal School of Needlework and becoming an adviser to schools in the London area.

BURGES, William (1827–81), English architect and designer. A disciple of A.W.N. Pugin, he was a leading Gothic revivalist. He also designed ornate and flamboyant furniture in painted and gilded wood, and was well known for his eccentric and playful silver designs featuring otters, mermaids, mice, and spiders.

BURNE-JONES, Edward (1833–98), English artist and member of the Pre-Raphaelite Brotherhood. Born in Birmingham, he met William Morris when they were both theology students at Oxford. Their lifelong collaboration—through the Firm and the Kelmscott Press, on designs for tapestries, tiles, book illustrations, and decorative schemes—was extraordinarily fruitful. Burne-Jones became one of the most important painters of his age and exerted a strong influence on younger artists.

BUTTERFIELD, William (1814–1900), English architect. He is best known for his ecclesiastical buildings, schools, and colleges, including St. Saviour's Church, Coalpit Heath, near Bristol (1844–5),

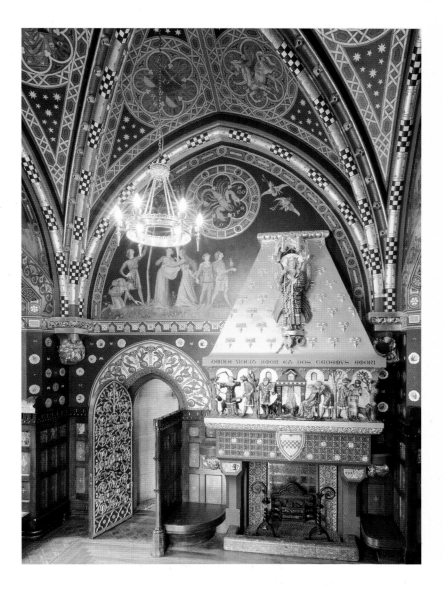

All Saints Church, Margaret Street, London (1849–59), and Keble College, Oxford (1867–83). Imaginative in his use of materials and Gothic details, he was concerned to integrate the design of the building and its furnishings and gave practical consideration to function.

CARPENTER, Edward (1844–1929), influential English poet, farmer, and romantic socialist. He encouraged "the absence of things" and helped to form Arts and Crafts ideals and practice. He promoted the simple life and the beauty of comradeship, together with the idea of "homogenic love," which transformed his homosexual urges into the pure love of comrades working together for the common good. Exposure to the ideas of Ralph Waldo Emerson and Walt Whitman went hand in hand with a concern for the plight of the working poor.

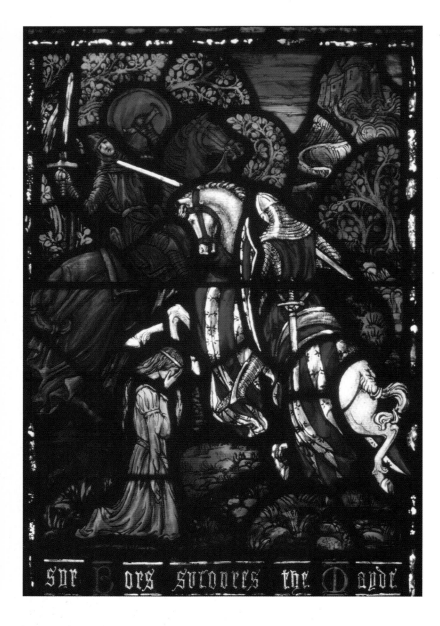

SUR GORS SUCCORES THE MAYDE

of which were made by Ernest Gimson (who learned the craft from Clissett), C.R. Ashbee, and Ambrose Heal. Clissett's traditional chairs were used in the hall of the Art Workers' Guild and were therefore seen by influential people.

COBDEN-SANDERSON, Thomas James (1840–1922), English book-designer and binder. A neighbor and friend of William Morris, he was a member of the Art Workers' Guild and founded the Doves Bindery in 1893. In 1900, together with Emery Walker, he set up the Doves Press in Hammersmith Terrace, London, one of the finest and best known among the many British private presses of the early twentieth century.

COCKERELL, Douglas (1870–1945), English bookbinder. A former Doves Bindery apprentice, he taught bookbinding at the Central School of Arts and Crafts in London from 1896.

CONNICK, Charles (1875–1945), leading American stained-glass artist. He ran his Boston studio on a medieval guild system and produced some of the finest stained glass in America, largely Gothic in style.

COOMARASWAMY, Ananda (1877–1947), Anglo-Sinhalese geologist and anthropologist. He commissioned C.R. Ashbee and the Guild of Handicraft to restore and convert a Norman chapel in Chipping Campden for himself and his wife, Ethel Partridge (later Ethel Mairet). He also bought shares in the failing Guild in 1907 and bought one of Ashbee's Essex House presses on which to print his own book, *Medieval Sinhalese Art* (1909).

COOPER, John Paul (1869–1933), English architect, designer, goldsmith, silversmith, and jeweler. Born in Leicester, he began his working career in the office of J.D. Sedding, where he was apprenticed on the advice of W.R. Lethaby. An interest in ornamental plasterwork led to his working with gesso and precious metals, and in 1901 he took up an appointment as head of the metalwork department at the Birmingham School of Art, a post he held for five years. Extraordinarily talented, he made nearly fourteen hundred pieces of jewelry, gesso-work, silverwork, and other metalwork in the workshop he designed himself, along with his house, at Westerham in Kent.

CHARLES, Ethel Mary (1871–1962), first woman member of the Royal Institute of British Architects (1898). She trained in the office of Ernest George and Harold Peto and submitted an entry to the Letchworth Cheap Cottages Exhibition in 1905, carrying on a flourishing practice in Letchworth with her sister Bessie Ada, who in 1900 was elected the second woman member of the RIBA. Ethel also designed a number of houses and cottages in an understated vernacular style in Falmouth, Cornwall.

CLISSETT, Philip (1817–1913), English carpenter responsible for the West Midlands-style rush-seated ladderback chair, variations

Far left: Sir Bors Sucoures the Mayde, c. *1919, a panel from the Holy Grail window by Charles Connick Associates for Proctor Hall at Princeton University. The window was designed to represent the quest for wisdom and understanding.*

Right: *Walter Crane has chosen to present himself as a fine artist—albeit one in a stiff Victorian collar—in this self portrait with palette; the irises and exotic tower in the background hint at the motifs that influenced him as a designer.*

CRANE, Walter (1845–1915), English artist, muralist, illustrator of children's books, craftsman, designer of wallpapers, textiles and tiles, frieze painter and mosaicist, socialist, writer, and committee man. A friend and disciple of William Morris, he believed "the true root and basis of all Art lies in the handicrafts." He was the son of the portrait painter Thomas Crane, and first exhibited at the Royal Academy at the age of seventeen, but became well known as a nursery book illustrator with the "Toy Books," which began to appear in 1865 and led to his being approached by Jeffrey & Co. to produce designs for nursery wallpapers. His first pattern, "The Queen of Hearts," went into production in 1875 and was followed by over fifty other designs. He devised decorative schemes for private homes and wrote and lectured extensively on home decoration. A crucial meeting with Morris led to Crane joining the Socialist League in 1883 and later the Fabian Society. He was among the founders of the Art Workers' Guild, and became master of the Guild in 1888 and president of the Arts and Crafts Exhibition Society in the same year. He toured the USA in 1891, accompanying an exhibition of his own work and giving lectures. In 1893 he became director of design at Manchester Municipal College and in 1898 was appointed principal of the Royal College of Art, then the leading school of design in Britain.

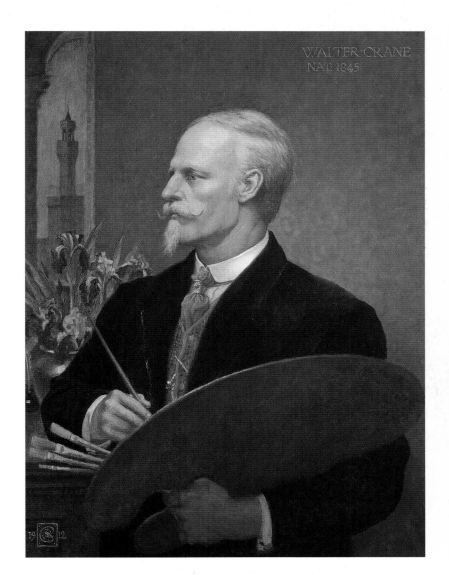

CRESWICK, Benjamin (1853–1946), British sculptor, metalworker, and Century Guild designer, who taught at the Birmingham School of Art from 1889–1918.

CUZNER, Bernard (1877–1956), English silversmith. The Redditch-born son of a watchmaker, he served his silversmithing apprenticeship with his father and at the Redditch School of Art before moving to Birmingham where he worked and studied under Arthur Gaskin at the Vittoria Street School, later becoming head of the metalwork department at the Birmingham School of Art. He designed for Liberty's "Cymric" range of silver and jewelry.

CZESCHKA, Carl Otto (1878–1960), Austrian architect, painter, designer, and member of the Wiener Werkstätte.

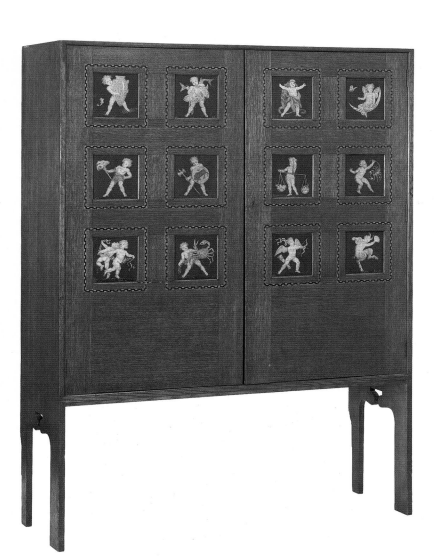

Workers' Guild in 1884. He was a founding member of the Arts and Crafts Exhibition Society in 1888, a regular lecturer, author, and contributor to the *Art Journal*. Day's political and social ideas were very different from those of William Morris, though he was influenced by his example.

DEARLE, John Henry (1860–1932), British textile designer. He was taken on as William Morris's first apprentice tapestry weaver in Queen Square, London, because Morris was "influenced by the evident intelligence and brightness of the boy." Dearle went on to supply his own textile designs for Morris & Co., including "Daffodil," one of the Firm's most popular fabrics, and "Persian Brocatel," a loom-woven silk and wool fabric designed specifically for wall-covering at Stanmore Hall, Middlesex. He became art director of the Firm after Morris's death in 1896.

DE MORGAN, William Frend (1839–1917), influential English potter, designer, and novelist. An exceptional colorist, he trained first as a painter at the Royal Academy Schools, where he became part of the Pre-Raphaelite circle and began designing stained glass and tiles for Morris & Co. He set up a kiln in the basement of his own home in Fitzroy Square, London, experimenting with luster decoration for his pottery and eventually blowing the roof off the house. In 1872 he moved to 30 Cheyne Row, which he used as showroom, studio, and workshop. In 1882 he moved the business to Merton Abbey, close to William Morris's new workshops, but found traveling to and from Chelsea time-consuming and deleterious to his health so transferred the works to Fulham in 1888 and entered a ten-year partnership with the architect Halsey

DAWSON, Nelson (1859–1942), English enameler and silversmith. After studying enameling under Alexander Fisher he set up a workshop in Chiswick, London, with his wife Edith Robinson in 1893, carrying out enameled decoration that often took the form of delicate jewel-like flowers and insects. In 1900 the Dawsons showed 125 pieces of jewelry at an exhibition at the Fine Art Society in Bond Street. He set up the Artificers' Guild in 1901, which was later acquired by Montague Fordham, first director of the Birmingham Guild of Handicraft.

DAY, Lewis Foreman (1845–1910), leading English designer of textiles, carpets, wallpapers, stained glass, embroidery, pottery, tiles, book covers, and furniture. He brought together a group of artists interested in design, known as "The Fifteen," who joined with the pupils and assistants of Richard Norman Shaw to form the Art

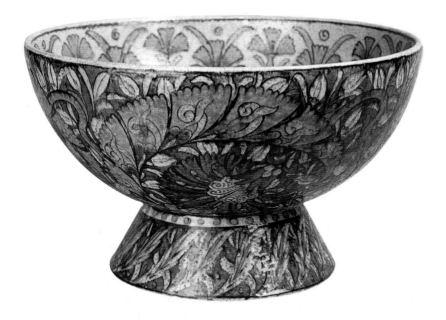

Ricardo. He married the artist Evelyn Pickering in 1887. Although he was a great friend of Morris and a supplier of tiles to the Firm, De Morgan never joined a "collaborative" and was not a member of the Art Workers' Guild. "I could never work," he wrote, "except by myself and in my own manner." He took his inspiration from Iznik wares of the fifteenth to seventeenth centuries and produced "Persian" ceramics in ruby reds, delicate golds, and bluish grays, decorated with birds or plants. Nikolaus Pevsner called him "the great English potter of his age." Although he sometimes decorated ready-made factory blanks, he despised the machine as used in industry. His assistants, Fred and Charles Passenger, remained with him for thirty years, becoming his partners in 1898 and eventually taking over when he retired from the business in 1905. He spent a considerable amount of time in Florence and in his later years became a bestselling novelist.

DEVEY, George (1820–86), English architect. He designed more than twenty country houses and estate cottages, and provided sympathetic additions to Elizabethan or Jacobean buildings. He had first trained as an artist under the Norwich School watercolorist John Sell Cotman, and was one of the first Victorian architects to design new buildings based on the local vernacular, thus ensuring that his new designs harmonized with older buildings. C.F.A. Voysey was one of his assistants from 1880–2.

DIXON, Arthur Stansfield (1856–1929), English architect and designer. Based in Birmingham, he was responsible for much of the design work at the Birmingham Guild of Handicraft, established along similar lines to C.R. Ashbee's idealistic Whitechapel school, where Dixon had worked for a year in 1890.

DOAT, Taxile (1851–1938), French ceramicist who moved from Sèvres to teach at the University City Pottery, St. Louis, Missouri, in 1909. His designs had a lasting influence on American art pottery.

DRESSER, Christopher (1834–1904), Scottish pioneer of modern product design, which he elevated to the status of art. Born in Glasgow, he trained as a botanist and led a counterattack on John Ruskin in his book *The Art of Decorative Design* (1862) arguing, as a scientist, that design should represent the laws of natural growth, not its appearance. Prolific, radical, and decidedly ahead of his time as a designer, he worked in a wide range of materials, styles, and technique, and designed ceramics, glass, metalwork, furniture, carpets, textiles, wallpapers, and other interior decorations. A great innovator and an enthusiastic advocate of the machine, he came under the influence of William Dyce, Henry Cole, and Matthew Digby Wyatt as a student and later lecturer at the Government School of Design. More an admirer of Owen Jones than William Morris, he was greatly influenced by Japanese art following a visit to Japan in 1877, and Tiffany & Co. commissioned him to design a collection of Japanese-style artefacts. While visiting the USA on his way to Japan, he lectured at the new Pennsylvania School of Industrial Art. On his return to London, he set up Dresser & Holme in Farringdon Road, selling Oriental goods, but the business failed. In 1880 he was appointed art

Above: *The Islamic influence is evident in this bowl from the Fulham period by William De Morgan, c. 1890.*

Right: *A kettle made from spun copper and cast brass with an ebony handle, designed by Christopher Dresser, c. 1880, and made by Benham & Froud.*

manager of the Art Furnishers' Alliance, which had a showroom and shop in New Bond Street where his metalwares, pottery, glass, and fabrics were displayed and sold. This venture also failed. By the 1890s, having been design director for both Minton and the Linthorpe Pottery, Dresser was back in Glasgow designing glass for James Couper & Sons. He married Thirza Perry in 1854 and had thirteen children, five of whom died in childhood. He himself died in relative obscurity in France.

EASTLAKE, Charles Locke (1836–1906), English architect and writer. He was the author of the bestselling and influential *Hints on Household Taste* published in 1868 in Britain and 1872 in the USA, which promoted a single, cohesive style in the home.

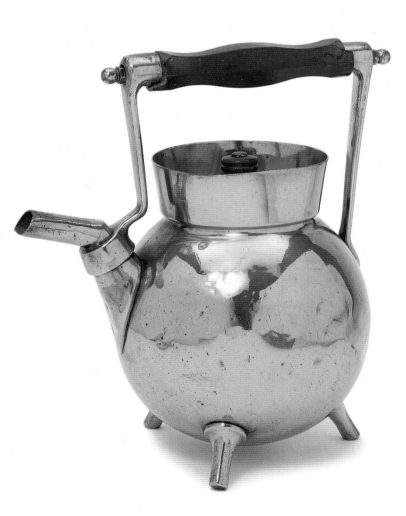

ELLIS, Harvey (1852–1904), American architect. An immensely talented designer, he trained under Arthur G. Gilman in New York and his own work in Rochester, New York, was inspired by the Romanesque style of Henry Hobson Richardson. A founding member of one of the earliest Arts and Crafts societies in the USA, he joined Gustav Stickley's Craftsman Workshops in 1903 making, in less than a year, an indelible impression on the American Arts and Crafts movement.

ELMSLIE, George Grant (1869–1952), Scottish-born American architect and interior designer. He entered the Chicago offices of J.S. Silsbee (who was responsible for introducing the Shingle style to the American midwest) in 1887 where he met Frank Lloyd Wright. After twenty years working with Louis Sullivan, he set up his own practice in partnership with William G. Purcell and George Feick in 1909. For his most important interiors he also designed oak furniture, together with leaded glass, terracotta ornaments, carpets, and textiles.

FAULKNER, Charles (1834–1892), highly original mathematician and founder member of Morris, Marshall, Faulkner & Co., who followed Morris in his espousal of socialism and led the Oxford branch of the Socialist League.

FISHER, Alexander (1864–1936), British sculptor, enameler, and silversmith. He is widely acknowledged as the master of the revived jewel-like "Limoges" technique of enameling, which he learned from the French enameler Louis Dalpayrat who lectured at the Royal College of Art in 1885. Fisher became head of the enamel workshop at the newly founded Central School of Arts and Crafts in 1896. The most influential enameler in Britain, he promoted enamel paintings as jewels or art objects set in gold, silver, or steel. In 1904 he set up a school of enameling in his studio in Warwick Gardens, Kensington, attracting aristocratic pupils including the Hon. Mrs. Percy Wyndham, chatelaine of Clouds in Wiltshire, who encouraged her friends to commission enameled pieces and portraits from Fisher. He wrote extensively and his work influenced many artists involved in enameling.

FORDHAM, Montague (1869–1942), first director of the Birmingham Guild of Handicraft. He later acquired the Artificers'

MONTAGUE FORDHAM, LTD.
9 MADDOX STREET, LONDON, W.

Directors:

MONTAGUE FORDHAM. CHARLES WAINWRIGHT.
EDWARD SPENCER. H. FRANKS WARING.

IRON AND BRASS GRILLE.

METAL WORK.
IRON AND BRONZE CASEMENTS.
STAINED GLASS LEADED WINDOWS.
CHURCH METAL WORK.
PRESENTATION CUPS AND CASKETS.

Guild, set up by Nelson Dawson in 1901, and established it in his gallery at 9 Maddox Street, London. There he sold and popularized the best contemporary decorative work executed by Arts and Crafts practitioners such as Henry Wilson and J. Paul Cooper— rather as the dealer Samuel Bing encouraged Art Nouveau through his Maison de l'Art Nouveau in Paris.

GASKIN, Arthur Joseph (1862–1928), English painter, illustrator, jewelry designer, and enameler. He studied at the Birmingham School of Art, where he subsequently taught, and provided wood-engravings for a number of books produced by William Morris at the Kelmscott Press, including Edmund Spenser's *The Shepheardes Calender* (1896). He married fellow student Georgina (Georgie) Cave France in 1894 and they worked together designing and making jewelry and silverwork inspired by the natural world. In 1902 he became head of the newly founded Vittoria Street

School for Jewellers and Silversmiths in Birmingham. He later worked in the Cotswolds and died in Chipping Campden.

GATES, William Day (1852–1935), American founder of the Gates Pottery of Terra Cotta in Illinois in 1885. From 1900 it produced a line of ceramic vases and garden ornaments called Teco Art Pottery, commissioning designs from, among others, Frank Lloyd Wright.

GILL, Eric (1882–1940), English typographer, calligrapher, letter-cutter, wood-engraver, and sculptor. He began his career in London but, like C.R. Ashbee and Ernest Gimson, abandoned the city for the "sweetness, simplicity, freedom, confidence and light" promised by the English countryside. At Ditchling, Sussex, from 1907 he strove toward a close, classless (though male-dominated) community and in his *Autobiography* (1940) hoped that he had "done something towards re-integrating bed and board, the small farm and the worship, the home and the school, earth and heaven."

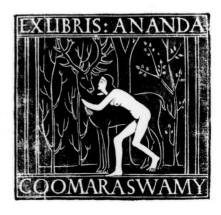

Right: *This page from Ernest Gimson's sketchbook of 1886, drawn at the Manor House Inn, Ditcheat, Somerset, shows his early interest in furniture design.*

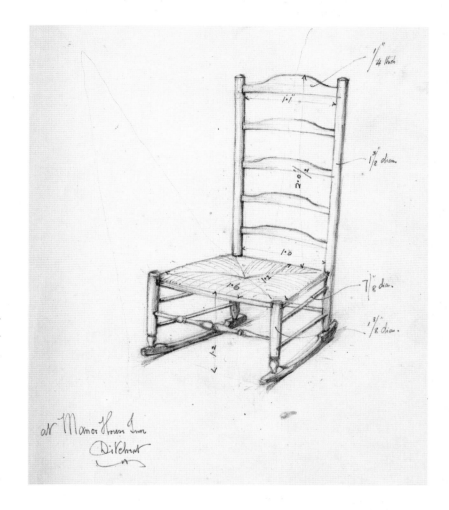

GILL, Irving (1870–1936), American architect. In California he pioneered an Arts and Crafts-based style that owed much of its inspiration to the Spanish missions, demonstrated in houses such as the Laughlin (1907) and Dodge houses (1916), both in Los Angeles.

GIMSON, Ernest (1864–1919), English architect and designer of furniture and metalwork. On the personal recommendation of William Morris, a family friend, he moved from his native Leicester to London to enter the office of J.D. Sedding, where he met Ernest Barnsley and through him his brother Sidney, who was working in the office of Richard Norman Shaw. Gimson interested himself in traditional crafts such as decorative plasterwork, woodturning and rush-seated chair-making, and brought these skills with him to Kenton & Co., a youthful furniture-making enterprise he embarked on with W.R. Lethaby, Sidney Barnsley, and two slightly older architects, Reginald Blomfield and Mervyn Macartney, in 1890. Following the collapse of the company two years later he moved with the Barnsleys to Gloucestershire, setting up a workshop in Pinbury Park, which later moved to Daneway House, where he forged his design style, characteristic geometry, and style of surface decoration. He married Emily Ann Thompson, a Yorkshire vicar's daughter, in 1900. He remained committed to the ideal of the simple life in the Cotswolds, working on local architectural commissions and overseeing the craftsmen he employed to implement his furniture and metalwork designs—including Peter van der Waals and Alfred Bucknell, a talented blacksmith. He died of cancer on August 12, 1919, aged only fifty-five, leaving much work unfinished.

GLEESON, Evelyn (1855–1944), founder of the Dun Emer Guild in Dublin in 1902. The Guild was a focus for home industries, including lacemaking, embroidery, and woodcarving. She worked with professionals like Oswald Reeves, an enameler and former pupil of Alexander Fisher, and the stained-glass artists Harry Clarke, Alfred Child (a former apprentice of Christopher Whall), and Sarah Purser. Discussions with Emery Walker and W.B. Yeats led to the foundation of the Dun Emer Press (1903–7) and Dun Emer Industries (1904–8). The latter was run by Yeats's sisters Elizabeth, a bookbinder, and Lily, a former embroidery student of May Morris.

Right: A watercolor drawing by E.W. Godwin showing a desk and double hanging bookcase. Godwin's impetus, like Morris's, came from needing to furnish his own house and failing to find anything suitable on the market.

GLESSNER, Frances Macbeth (1848–1932), American philanthropist, silverworker, and needlewoman. Her keen enthusiasm for the Arts and Crafts movement is reflected in Glessner House, Chicago—which she and her husband John commissioned from H.H. Richardson—and its contents.

GODWIN, Edward William (1833–86), English Gothic architect, architectural journalist, and stage and furniture designer. He was born in Bristol, where he established an architectural practice. In 1861 he won the competition for the design of the new Northampton town hall, including its interior decorations, which show the Japanese influence he was coming under. He was retained for several years at £450 a year (in addition to payments for furniture designs) by the London firm of Collinson & Lock, "Art Furnishers," for which he provided designs for furniture, fireplaces, gas brackets, carpets, lockplates, and iron bedsteads. Godwin's light, elegant furniture sometimes incorporated painted panels by friends such as Edward Burne-Jones, Albert Moore, and James McNeill Whistler. He also designed wallpapers with an evident Japanese influence for Jeffrey & Co., as well as tiles for Minton, and was the original architect for Jonathan Carr's Bedford Park estate before being replaced by Richard Norman Shaw in 1877. He lived with the actress Ellen Terry for many years and was described by Max Beerbohm as "the first of the aesthetes."

GREEN, Arthur Romney (1872–1945), self-taught British designer and cabinet-maker. He set up a workshop, first in Surrey and then at Hammersmith, along cooperative lines influenced by the ideas of William Morris, producing furniture very much in keeping with the style of Ernest Gimson, Sidney Barnsley, and other Arts and Crafts designers.

GREENE, Charles Sumner (1868–1957) and **GREENE, Henry Mather** (1870–1954), quintessential American Arts and Crafts architects and designers. They attended the Manual Training High School in St. Louis, one of the first Arts and Crafts academies in the USA, run by Calvin Milton Woodward, followed by architectural training at the Massachusetts Institute of Technology. They established an architectural practice in Pasadena in 1893 and were responsible for iconic buildings such as the Gamble House (1908–9) for which they also designed the garden, furniture, lighting fixtures, and stained glass—as they did for other commissions. The discovery of Japanese prints and Oriental gardens was a revelation to them and they brought some of the same spare elegance and love of the pastoral to their work, which was much admired by C.R. Ashbee. Charles, who

Left and right: *Charles Sumner Greene (left) and his brother Henry Mather Greene (right) were hugely influenced by the Japanese exhibit at the World's Colombian Exposition in Chicago in 1893.*

was generally considered the more artistic of the pair, married Alice Gordon White, an Englishwoman, in 1901, two years after his brother had married Emeline Augusta Dart. After 1909 their work lost much of its Arts and Crafts simplicity, though they continued working until 1923 for rich Californian clients.

GRIGGS, Frederick Landseer Maur (1876–1938), English illustrator, etcher, and conservationist. He joined C.R. Ashbee's Chipping Campden community in 1903, settling there with his wife Nina. From 1902 he illustrated the series Highways and Byways Guides published by Macmillan, a commission that occupied him for the rest of his life.

GROPIUS, Walter (1883–1969), German architect. He studied under Peter Behrens and became leader of one of the most important design schools to follow on from the Arts and Crafts movement: the Bauhaus, founded in Weimar in April 1919, which came to exemplify the Modern movement and the functionalist design ethic—essentially more modern, less machine-averse, and firm in the revolutionary belief that good design served the needs of the ordinary people, the workers. Its early emphasis on guild structure and ideals paralleled C.R. Ashbee's experiment in creating a working community of craftsmen.

GRUEBY, William Henry (1867–1925), American founder of the Grueby Faience Company. Its pottery was recommended through Gustav Stickley's *Craftsman* as "perfectly complementing a Craftsman Home." Grueby began working in the pottery trade at thirteen, for Fiske, Colman & Co. He popularized a matt dark-green glaze on clearly handmade pottery and used simple, restrained leaf and flower motifs.

HEAL, Ambrose (1872–1959), English furniture designer and entrepreneur. He studied at the Slade School of Art and learned his craft as an apprentice cabinet-maker in Warwick, before joining the family firm as a bedding designer in 1893. In tune with the ideals of the Arts and Crafts movement, he was nevertheless one of the first British designers to overcome the movement's dislike of modern methods. He created a strong identity for Heal & Son, using Eric Gill to design the company's brochures and the lettering for its London store. He was a founder member of the Design Club, formed in 1909, and treasurer of the Design and Industries Association, formed in 1915 and inspired by the example of the Deutscher Werkbund to promote cooperation between workers, designers,

Right: *Heal's trademark "At the Sign of the Four Poster."*

distributors, manufacturers, educationalists, and the public in general, and to raise and improve the standards of design in industry. Although it promoted the best of British design through exhibitions, its acceptance of the necessity of the machine effectively signaled the end of the Arts and Crafts ideal as envisaged by William Morris and John Ruskin.

HEATON, Clement John (1861–1940), English stained-glass artist and metalworker. After training in his father's firm, he became a Century Guild associate. He carried out a number of A.H. Mackmurdo's designs in cloisonné enamels and set up his own firm, Heaton's Cloisonné Mosaics Ltd., in 1885. After 1887 he worked mainly in Switzerland, until moving to the USA in 1912.

HOFFMANN, Josef (1870–1956), Austrian architect, designer, and founder member of the Vienna Secession, along with Koloman Moser, Otto Wagner, Joseph Maria Olbrich, Gustav Klimt, and Egon Schiele. Deeply influenced by William Morris, John Ruskin, and Charles Rennie Mackintosh, Hoffmann visited C.R. Ashbee's Chipping Campden community in 1902 and returned to Austria to

found the Wiener Werkstätte in imitation of the Guild of Handicraft, with the aim of creating "an island of tranquility in our own country, which, amid the joyful hum of arts and crafts, would be welcome to anyone who professes faith in Ruskin and Morris." He designed furniture, metalwork, glass, jewelry, and textiles for the Wiener Werkstätte, until the workshops went into liquidation in 1931, and gained the admiration of Le Corbusier.

HOLIDAY, Henry George Alexander (1839–1927), English mural artist and stained-glass designer. He worked for Powells of Whitefriars, the glass manufacturers, as a stained-glass cartoonist and also designed mosaics, enamels, and embroideries, often in collaboration with his wife Catherine, who executed a number of embroidered panels for Morris & Co.

HORNE, Herbert Percy (1864–1916), English architect, designer, poet, and art historian. Articled to A.H. Mackmurdo in 1883, he went on to become a major figure in the Century Guild, editing their journal, *The Hobby Horse*. A prodigious worker, he acted as an agent for designer-craftsmen and for some firms, including Morris & Co. In 1900 he settled in Florence, eventually leaving his considerable collection of Renaissance art to the city, along with the Palazzo Fossi, now the Museo Horne.

HORSLEY, Gerald Callcott (1862–1917), English architect. He was articled to Richard Norman Shaw in 1879 and was a founder member of the Art Workers' Guild in 1884. His commissions, often for churches, are characterized by carved and applied decoration.

Below left: *A hammered silvered metal coupe by Josef Hoffmann for the Wiener Werkstätte, c. 1910.*

Right: *"The Angel with the Trumpet," designed by Herbert Horne for the Century Guild and block printed by Simpson & Godlee from 1884.*

HUBBARD, Elbert Green (1856–1915), American Arts and Crafts practitioner. As a partner in the Larkin soap company in Buffalo, New York, he pioneered mass-marketing techniques, but in 1892, prompted by a meeting with William Morris, he established the Roycroft Press and the quasi-religious Roycroft craft community in nearby East Aurora, seeking a return to the simple community life of pre-industrial America. The Roycrofters—numbering 175 in 1900—built their own shops selling china, glass, ironwork, furniture, and leather goods, as well as their own houses and even a Roycroft Inn for guests, who included C.R. Ashbee and his wife Janet, while the press published Hubbard's books and periodicals. In 1915 Hubbard and his wife were drowned aboard the *Lusitania*, but the shops continued under the management of their son Bert until the community closed in 1938.

HUNTER, Dard (1883–1966), American furniture, lighting, and book designer who studied in Vienna from 1908–9 and worked for Elbert Hubbard, bringing a distinctively European aesthetic to his Roycroft pieces. After 1911 he specialized in papermaking.

IMAGE, Selwyn (1849–1930), important English Century Guild designer along with Herbert Horne and A.H. Mackmurdo. Ordained as a curate in 1872, the influence of John Ruskin led him to leave the church in 1882 to become an artist. He provided graphic designs and woodcuts for the Guild's *The Hobby Horse* and a number of independent publications, as well as designing mosaics, stained glass, and embroideries for the Royal School of Needlework. In 1900 he became master of the Art Workers' Guild and in 1910 Slade Professor of Fine Art at Oxford. Together with Mackmurdo he founded the Fitzroy Picture Society to distribute prints of great paintings to schools.

JACK, George (1855–1932), American-born furniture designer. He came to London in 1875 and became chief assistant to Philip Webb in 1880. As principal furniture designer to Morris & Co. he was responsible for many of the monumental mahogany pieces with inlaid decoration made around the 1890s, including the bookcase in the billiard room at Standen. In 1900 he took over Philip Webb's architectural practice.

Left: *The title-page for Elbert and Alice Hubbard's* Justinian and Theodora *(1906), designed by Dard Hunter for the Roycroft Press.*

JARVIE, Robert Riddle (1865–1941), American metalworker noted for his stylish brass, copper, and bronze candlesticks and lanterns, which he modeled in forms suggestive of tall flowers.

JAUCHEN, Hans W. (1863–1970), German-born founder in 1922 of the art metal shop Old Mission KopperKraft in San Jose, California, in partnership with Fred T. Brosi (d. 1935), an Italian immigrant.

JENSEN, Georg (1866–1935), Danish silver and jewelry designer, with a highly recognizable geometric style. First apprenticed to a goldsmith, he studied sculpture before opening his own silver workshop in Copenhagen in 1904. He employed a number of Arts and Crafts-influenced craftsmen, including Johan Rohde.

JEKYLL, Gertrude (1843–1932), leading English garden designer. Born in London to a wealthy family, she went to the South Kensington School of Art at eighteen, met John Ruskin and William Morris in 1869, and turned to embroidery, designing patterns that were heavily influenced by Morris. She also mastered the art of silver repoussé work. She brought her artistic training and knowledge of color theory to the gardens she started designing in her thirties when her eyesight began to fail and the death of her father occasioned a move, with her mother, to Munstead Heath in Surrey. At the age of forty-six she formed a fruitful partnership with the twenty-year-old Edwin Lutyens, and they worked together on more than one hundred British gardens and houses.

JEWSON, Norman (1884–1975), English architect, wood- and stone-carver, lead and plaster worker. He married Ernest Barnsley's daughter, Mary, after joining Ernest Gimson and the Sapperton group of architects and craftsmen in the Cotswolds, where he lived all his life.

Right: *Edwin Lutyens commissioned Sir William Nicholson to paint this portrait of Gertrude Jekyll, his great friend and collaborator, in 1920.*

Left: *A page from Owen Jones's The Grammar of Ornament showing Celtic knot designs.*

Right: *Clock with enameled dial, designed by Archibald Knox, part of Liberty's Tudric range, c. 1903.*

taste. William Morris had a copy in his library though Owen's sober, mathematical, geometric patterns were at odds with his own style, which drew freely on nature.

KING, Jessie Marion (1875–1949), Scottish book, textile, and jewelry designer and illustrator. She overcame parental opposition to study at the Glasgow School of Art, where she later became a lecturer in book decoration. She won a gold medal at the Esposizione Internazionale in Turin in 1902. She exhibited with the Scottish Guild of Handicraft (founded in 1905) and also worked for Liberty's, designing for the "Cymric" silver range and providing fabric designs and hand-painted pottery. She married the furniture designer Ernest Taylor and in 1911 they set up a studio in Paris, but they were forced by the outbreak of World War I to return to Scotland, where she continued to work and exhibit until her death.

KIPP, Karl E. (1882–1954), American designer. He ran Elbert Hubbard's Copper Shop in the Roycroft community until 1912, when he left to found his own firm, the Tookay Shop in East Aurora, returning to Roycroft in 1915 after Hubbard's death.

KNOX, Archibald (1864–1933), Isle of Man-born designer of silver, pewter, jewelry, carpets, textiles, and pottery. He studied at Douglas School of Art, specializing in Celtic ornament. Through M.H. Baillie Scott he came into contact with Liberty's and became one of its most prolific, imaginative, and innovative designers (though, like all Liberty designers, anonymous). He produced some of the earliest designs for Liberty's "Cymric" range and was the

JOHNSTON, Edward (1872–1944), Scottish calligrapher and typographer who taught lettering and illumination at the Central School of Arts and Crafts (1899–1913), where Eric Gill was one of his students. He later achieved fame as a designer for the London Underground.

JONES, Owen (1809–74), Welsh designer of furniture, wallpaper, textiles, books, and complete interiors, and superintendent of works for the Great Exhibition of 1851. His book *The Grammar of Ornament* (1856)—the first to have full-color plates printed by chromolithography—became a pattern book for British design and

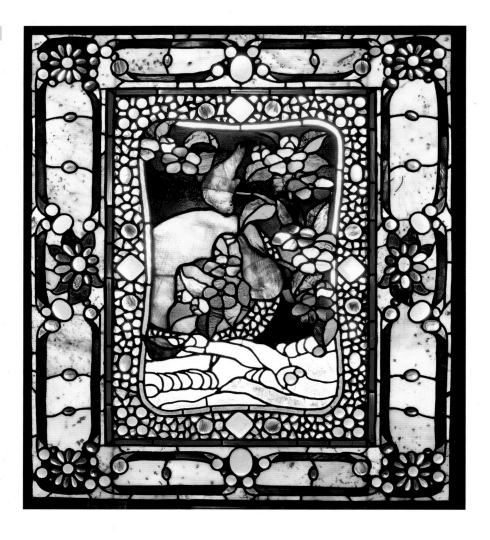

inspiration behind the company's "Celtic Revival," enthusiastically supported by its Welsh managing director, John Llewellyn. Knox was influenced by Christopher Dresser.

LA FARGE, John (1835–1910), American painter and stained-glass artist. He was taught by his father, a fresco painter, after which he studied in Paris. Influenced initially by the Pre-Raphaelite painters and William Morris, he identified with the ideals of the Arts and Crafts movement and did much to introduce current European decorative style to the USA. In 1880 he patented a method for producing opalescent glass that became desirable and fashionable among wealthy American collectors, including the Vanderbilts and the Whitneys.

LARSSON, Carl (1853–1919), Swedish artist. His country house, Sundborn, came to epitomize Swedish domestic ideals and set the Arts and Crafts style for a generation through the publication of his book *Ett Hem* ("A Home") in 1898.

LEACH, Bernard (1887–1979), English potter born and brought up in the Far East. On his return from studying pottery in Japan in 1920, he established the Leach Pottery in St. Ives, Cornwall, where he used local clays and natural glazes.

LESSORE, Ada Louise (1882–1956), English ceramic artist and embroiderer. She studied art at the Slade and was a pupil of Edward Johnston at the Central School of Arts and Crafts, collaborating with the calligrapher Graily Hewitt on Virgil's *Aeneid*. She also studied embroidery at the Central School and established herself as a needlewoman, becoming closely associated with May Morris and the Royal School of Needlework. She married Alfred Powell in 1906 and the couple became successful designers for Wedgwood.

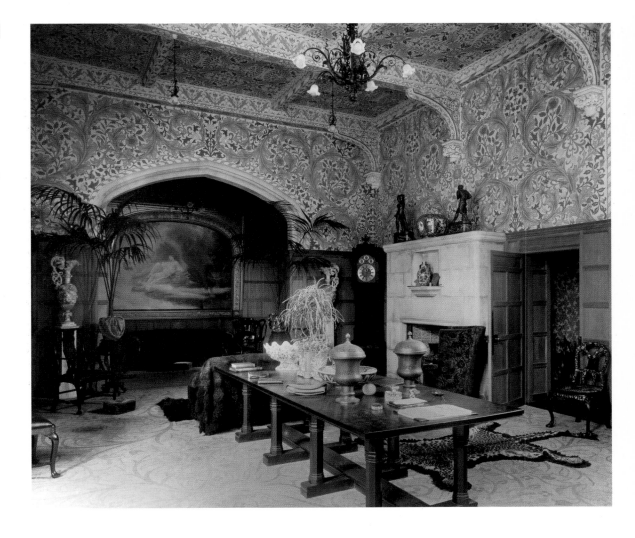

Left: *Birds and flower-laden boughs are silhouetted against the moon in this fine leaded-glass window designed by John La Farge in 1884.*

Right: *W.R. Lethaby was responsible for the fireplaces and paneling in the interior of Stanmore Hall, decorated for William Knox D'Arcy by Morris & Co. The Kenton & Co. table in the hall was also probably designed by Lethaby.*

Her younger sister, Therese, who also designed for Wedgwood, was on the fringe of more avant-garde art movements and married two painters: first Bernard Adeney, a founder member of the London Group, and then, in 1926, Walter Sickert.

LETHABY, William Richard (1857–1931), English architect, designer, writer, socialist, educationalist, and pivotal figure in the Arts and Crafts movement. The son of a framemaker in Barnstaple, Devon, he was apprenticed to a local architect and won the RIBA Soane medallion and the Pugin traveling scholarship. He made his way to London in 1879 and became chief clerk to Richard Norman Shaw, working alongside E.S. Prior and Mervyn Macartney, with whom he formed the short-lived furniture company Kenton & Co. He set up his own architectural office in 1889. Lethaby helped to establish the Art Workers' Guild in 1884 (becoming its master in 1911), and embarked on a public

promotion of the crafts through exhibitions run by its offshoot, the Arts and Crafts Exhibition Society. He joined the Society for the Protection of Ancient Buildings in 1893 and became the co-director and principal of the Central School of Arts and Crafts, which was dominated by his inspirational philosophy, when it opened in 1896. He appointed highly skilled craftsmen rather than professional teachers, and aimed to raise the standards of the crafts while creating a training ground for designers able to meet the needs of industry. He was a founder member of the Design and Industries Association formed in 1915 and Philip Webb's first biographer. "A work of art is a well-made boot," he once claimed. When he died in 1931 his gravestone in Hampshire was inscribed "Love and labour are all."

LIBERTY, Arthur Lazenby (1843–1917), English founder of the Regent Street, London, store that bears his name. He was the

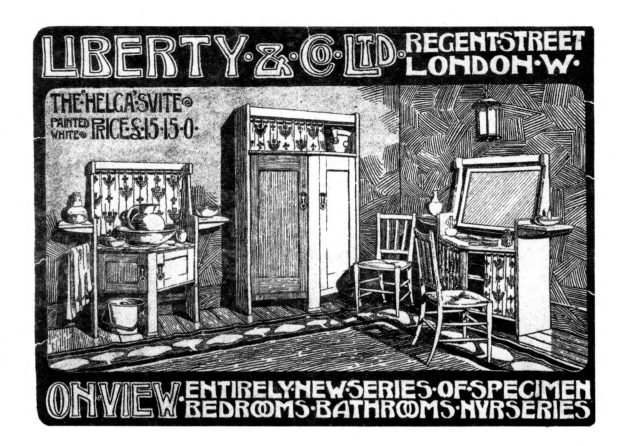

eldest of eight children born to a draper in Chesham, Buckinghamshire. His interest in design was stimulated by the International Exhibition of 1862 and the following year, aged twenty, he joined Farmer & Rogers Great Shawl and Cloak Emporium in Regent Street as manager of their "Oriental warehouse." He divorced his first wife, Martha Cotham, and became engaged to Emma Louise Blackmore in 1874. With funding from her father, a tailor from Devon, he leased a half-shop directly opposite Farmer & Rogers at 218A Regent Street, which he named East India House. Liberty & Co. opened on May 15, 1875, with a staff of three. It specialized in Oriental art and artefacts—silver kettles, cutlery, and smaller pieces of furniture—which were sold overstamped with the appropriate Liberty & Co. mark and label, a company policy that continued until his death in 1917. He repaid his father-in-law within eighteen months and acquired the second half of the premises at 218 Regent Street. In 1890 Maison Liberty opened in Paris at 38 avenue de l'Opéra, moving to grander premises at 3 boulevard des Capucines fairly swiftly (it closed in 1932). Despite employing some of the period's best designers, among them C.F.A. Voysey, Archibald Knox, Arthur Gaskin,

Bernard Cuzner, Olive Baker, and Jessie M. King, much of the work Liberty's sold was machine-made with the odd finishing touch by hand. The company catered to an affluent clientele who, after 1910, included the residents of the new garden cities as well as the London suburbs. It reached a wide public and introduced the work of some important Arts and Crafts designers (though anonymously, for Liberty policy was that most designers and craftworkers did not mark their work), but it undercut the guilds and contributed to their demise, trading on the visual appeal of Arts and Crafts style while ignoring the social and ethical message of the movement.

LIMBERT, Charles, P. (1854–1923), American furniture manufacturer. Having joined the industry as a salesman, he started a manufacturing company in Grand Rapids, Michigan, in 1894, and launched a range of "Dutch Arts and Crafts" furniture in 1902. In 1906 he relocated to Holland, Michigan, and opened his Holland Dutch Arts and Crafts factory in a scenic lakeside location, to provide pleasant and healthy conditions for his workers: "attractive summer cottages and quaint houses with fertile gardens and well kept lawns." He drew inspiration from Japan, the Austrian

Secessionists, and Britain, particularly the geometric furniture of Charles Rennie Mackintosh.

LOGAN, George (1866–1939), Scottish furniture designer who worked with E.A. Taylor at the long-established firm of Glasgow cabinet-makers Wylie & Lochhead.

LOOS, Adolf (1870–1933), innovative Austrian architect and theorist of modern functionalism.

LORIMER, Robert Stodart (1864–1929), Scottish architect who devoted a substantial proportion of his career to restoration

and alteration and remained faithful to traditional seventeenth- and eighteenth-century styles.

LUMMIS, Charles Fletcher (1859–1928), American writer who founded the Landmarks Club with the aim of restoring the Spanish missions in California and promoting the appreciation of Spanish, Mexican, and Native Indian culture.

LUTYENS, Edwin Landseer (1869–1944), English architect. Named after his sporting artist father's hero, Lutyens was an almost exact contemporary of Frank Lloyd Wright. Ambitious and precocious, he spent a scant year in the office of Sir Ernest George

Right: *This poster for the Glasgow Institute of the Fine Arts, 1896, was a collaborative effort by Margaret Macdonald, her sister Frances, and Herbert MacNair, who, together with Charles Rennie Mackintosh, developed a whole new vocabulary of decorative arts.*

when he was eighteen, before setting up in practice on his own. A meeting in 1889 with Gertrude Jekyll led to a long and close collaboration on over one hundred country houses and gardens. He designed the Viceroy's House in New Delhi and, after World War I, became one of the principal architects to the Imperial War Graves Commission, designing both the Cenotaph in Whitehall and the Memorial to the Missing of the Somme at Thiepval in France, among other monuments.

MACARTNEY, Mervyn Edmund (1853–1932), English architect and co-founder of the Art Workers' Guild. He met W.R. Lethaby in Richard Norman Shaw's office, where they both worked, and became involved with him in Kenton & Co., after which he designed furniture for Morris & Co., working with George Jack and W.A.S. Benson. In 1906 he was appointed surveyor to St. Paul's Cathedral and took over the editorship of *The Architectural Review*.

MACBETH, Ann (1875–1948), Scottish designer of bold embroideries and a member of the Glasgow School. She taught at the Glasgow School of Art for many years and executed a number of ecclesiastical commissions for embroidery. She published, with Margaret Swanson, the influential instructional manual *Educational Needlecraft* (1911) and established an embroidery class for children at the School of Art.

MACDONALD, Frances (1873–1921), Scottish designer of furniture, textiles, enamel jewelry, and silverwork. She studied at the Glasgow School of Art with her sister Margaret Macdonald and

Right: *Margaret Mackintosh, photographed by James Craig Annan in the drawing room at 120 Mains Street, Glasgow, c. 1903.*

Far right: *Charles Rennie Mackintosh—"every bit the turn of the century dandy"—photographed by James Craig Annan, 1893.*

they, together with Charles Rennie Mackintosh and Herbert MacNair, formed the group known as the Glasgow Four. The sisters set up a studio in 1894, embracing all manner of crafts, with contributions from Mackintosh and MacNair, whom Frances married in 1899. The Glasgow Four made extensive and valuable contacts abroad—particularly in Europe—where their sparsely furnished white interiors and the ethereal quality of their furnishings was much admired, resulting in a rich cross-fertilization of ideas between them and the Secessionists in Vienna.

MACDONALD Margaret (1864–1933), Scottish designer, artist, and embroiderer. She studied at the Glasgow School of Art where she met, and in 1900 married, Charles Rennie Mackintosh. Their long artistic collaboration appears to have been as harmonious as their marriage. Hermann Muthesius, who visited the newlyweds in their studio-flat home at 120 Mains Street, Glasgow, described them as the *kunstlerpaar* ("the artist-couple"). They had no children. Together they collaborated on the designs of several interiors, including Hill House, Helensburgh, for which Margaret designed the textiles and gesso panels.

MACKINTOSH, Charles Rennie (1868–1928), Scottish architect and designer. The second son in a family of eleven, his father, a police superintendent, instilled in him a deep appreciation of Scotland's cultural heritage and fostered his love of horticulture. He was articled at sixteen to John Hutchison, and left when his apprenticeship ended in 1889 to join the newly founded firm of Honeyman & Keppie as a draftsman. He attended evening classes at the Glasgow School of Art from 1884 where he met the Macdonald sisters—his future wife, Margaret, and Frances—who, together with Mackintosh and Herbert MacNair, formed the Glasgow Four. They pioneered Art Nouveau designs, drawing loosely on ancient Celtic ornament and the economy of Japanese art, and were invited to send their work to the Arts and Crafts Exhibition Society in 1896. That same year Mackintosh won the competition for the design of the new Glasgow School of Art building which, together with his ambitious interior designs for the Glasgow tea-room entrepreneur, Catherine Cranston, became his best-known work in the city. He was extraordinarily influential in Europe and the USA, though recognition in his home town was slow to come. Despite his startling originality, a reputation for

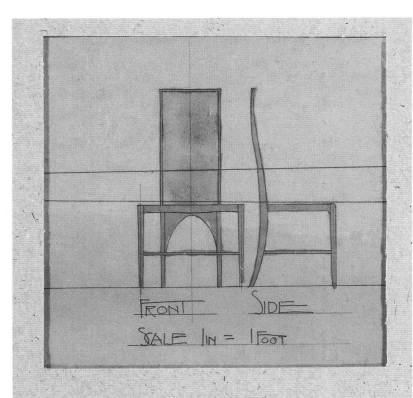

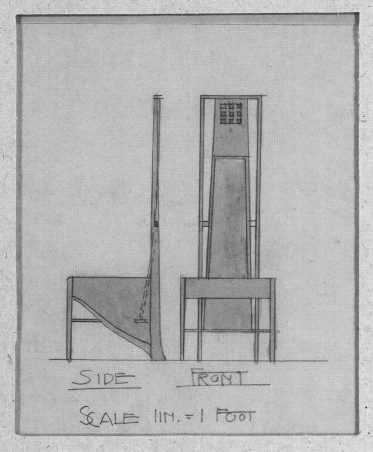

Left: *Charles Rennie Mackintosh's designs for chairs, shown in front and side elevation, for the Room de Luxe in Miss Cranston's Willow Tea Rooms, 1903.*

unreliability, eccentricity, and drinking sparked his professional decline. In 1914 the Mackintoshes left Glasgow. Before settling in London they lived for a year in Walberswick, Suffolk, where their "foreign" accents and correspondence with Viennese and German nationals drew the attention of the police. A continuing versatile creativity is evident in his few later commissions, but it was to be stifled by desperate financial insecurity and illness. Mackintosh never regained his professional status after World War I. Evicted from his Hampstead lodgings, he died in a London nursing home in December 1928, aged sixty, and his death was little remarked in the profession or the press. His architectural drawings, furniture, sketches, watercolors, and flower paintings were deemed practically worthless, valued at £88 16s 2d by the assessor of his Glebe Place studio. Once spurned by his native city, he is now a valuable figurehead for Glasgow's renaissance, his familiar motifs adorning a wide range of profitable merchandise.

MACKMURDO, Arthur Heygate (1851–1942), English architect and designer and prominent figure in the Arts and Crafts movement. He was instrumental in the setting up in 1882 of the Century Guild, a loose collective of designers "to render all branches of art the sphere no longer of the tradesman but of the artist" and to restore building, decoration, glass painting, woodcarving, metalwork, and pottery "to their rightful places beside painting and sculpture." Mackmurdo began his architectural training in London, in the office of the Gothic revivalist James Brooks, an architect he described as a craftsman who designed "every detail to door hinge and prayerbook marker." He taught with John Ruskin at the Working Men's College in London and went on to design

Right: *This MacNair table was exhibited at the Turin Exhibition of 1902 and illustrated in* The Studio *the same year.*

furniture, metalwork, and textiles, employing sinuous motifs and interlaced curves that influenced European Art Nouveau and C.F.A. Voysey, to whom he taught the rudiments of drawing up a repeat pattern for wallpaper or fabric. He was responsible for a number of extremely striking buildings, including the Savoy Hotel (1889).

MACNAIR, James Herbert (1868–1955), Scottish furniture designer and painter, and member of the Glasgow Four. He met Charles Rennie Mackintosh when working in the offices of Honeyman & Keppie, and his future wife Frances Macdonald and her sister Margaret at the Glasgow School of Art, where he was attending evening classes as part of his architectural training. He opened his own business at 227 West George Street in Glasgow, offering furniture design, book illustration, and posters, but in 1897 moved to Liverpool to take up the post of instructor in decorative design at the School of Architecture and Applied Art. He continued with his interior decorating work, in collaboration with his wife, and designed the Writing Room for the Scottish pavilion at the Esposizione Internazionale in Turin in 1902. The Studio published illustrations of the interior of his own house at 54 Oxford Street, Liverpool. In 1908 he returned to Glasgow but, like Mackintosh, found work difficult to come by and eventually died in complete obscurity.

MAHONY, Marion Lucy (1871–1961), American architect. Born in Chicago, she was the second woman to graduate in architecture from Massachusetts Institute of Technology (1894). She worked with Frank Lloyd Wright at his Oak Park office, alongside Walter Burley Griffin, whom she married in 1911, emigrating with him to Australia after his prize-winning plan for Canberra was accepted in 1912.

MAIRET, Ethel (1872–1952), née Partridge, English textile designer. She married the Anglo-Sinhalese geologist and anthropologist Ananda Coomaraswamy and lived in Ceylon and India from 1903–7. On their return to England she and her husband moved into the Norman chapel at Chipping Campden that he had commissioned C.R. Ashbee and the Guild of Handicraft to restore, convert, and decorate. After her divorce she married the Guildsman Philippe Mairet and set up a weaving workshop at her home, Gospels, at Ditchling in Sussex, where she revolutionized the craft of handloom weaving and researched and popularized natural vegetable dyes, becoming a role model for the women she trained there. Her home became the nucleus of a new Arts and Crafts community, which included her brother, the

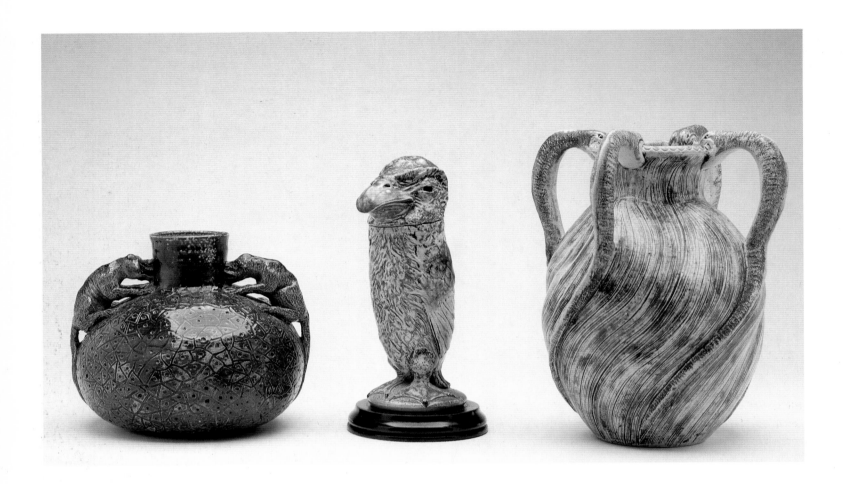

jeweler Fred Partridge, and was described by Ashbee as "a very alive and happy community with a lot of old Campden and Essex House spirit in it."

MAIRET, Philippe (1886–1975), French illustrator, stained-glass craftsman, actor, author, and translator. He worked with C.R. Ashbee in London and Chipping Campden.

MALMSTEN, Carl (1888–1972), Swedish craftsman, designer of textiles, fabric, and furniture, and teacher. Trained as a cabinet-maker, he subsequently established his own workshop and school for designers and craftsmen in Stockholm.

MARTIN, Robert Wallace (1843–1923), English potter. With his brothers Charles Douglas (1846–1910), Walter Frazier (1857–1912), and Edwin Bruce (1860–1915) he set up the Martin Brothers pottery in Fulham, London, in 1873, moving to Southall in Middlesex in 1877. They became famous for their grotesque but fashionable salt-glazed stoneware.

MATHEWS, Arthur Frank (1860–1945), American muralist and designer. The Wisconsin-born architecture and art student spent five years studying in Paris at the Acadèmie Julien and taught in the Mark Hopkins Institute of Art, San Francisco, on his return to the USA, becoming dean of the School of Design. There he met and married his pupil Lucia Kleinhans and together they opened the Furniture Shop at 1717 California Street, San Francisco, after the great earthquake and fire of 1906. They employed a workforce of between twenty and fifty craftsmen to meet the huge demand for furnishings from wealthy San Francisco residents during the rebuilding of the city. They also founded the Philopolis Press, which published works on city planning and art, including the monthly magazine *Philopolis*, which ran for ten years from 1906. The Furniture Shop closed in 1920.

MAYBECK, Bernard (1862–1957), American architect. He studied architecture at the École des Beaux-Arts in Paris, graduating in 1886, and was concerned to integrate all his buildings with their sites in design and materials. He is best known for the First Church

Left: *A trio of pieces from the Martin Brothers' workshop, featuring, on the vases, handles modeled as grotesque hounds and serpents and, in the center, an example of the birds, for which they became best known.*

Right: *A detail from William Morris's bed curtains at Kelmscott Manor, embroidered by May Morris and helpers, 1891–4.*

of Christ Scientist (1910) in Berkeley, California, and the simple wooden chalets and bungalows he built in the Berkeley Hills and San Francisco Bay area.

MCLAUGHLIN, Mary Louise (1847–1939), American ceramicist. She formed the women's Cincinnati Pottery Club in 1879 and exhibited in the USA and Paris. Her work was known as "Cincinnati Limoges."

MORGAN, Julia (1872–1957), American architect. She was mentored by Bernard Maybeck after studying civil engineering at the University of California at Berkeley, and trained as an architect at the École des Beaux-Arts in Paris, becoming its first woman graduate. She was responsible for over eight hundred buildings, including the Williams house in Berkeley, California, and William Randolph Hearst's palatial home at San Simeon, to which she devoted much of her life from 1919–42.

MORRIS, Janey (1840–1914), daughter of a stablehand in Oxford and statuesque beauty who captivated the hearts of Dante Gabriel Rossetti and William Morris, whom she married in 1858. A skilled embroideress, she aided Morris in his work and collaborated with him on decorative schemes for Red House and Kelmscott Manor.

MORRIS, May (1862–1938), English textile and wallpaper designer, lecturer, and writer. The younger daughter of William Morris, from whom she received her artistic education, May took over the management of the embroidery section of Morris & Co. in 1885 and produced many designs herself, usually depicting flowers or trees. Her *Decorative Needlework* was published in 1893. A participant in her father's political activities, she lectured in London, Birmingham, and the USA, and became a founder member of the Women's Guild of Arts in 1907. She devoted much of her time to editing her father's writings, which appeared in twenty-four volumes between 1910 and 1914. Her "mystic betrothal" to George Bernard Shaw did not result in marriage and, though she was briefly married to Henry Halliday Sparling, she spent the last years of her life in devoted companionship with Mary Lobb at Kelmscott Manor, Gloucestershire.

MORRIS, William (1834–1896), great English polymath and, with John Ruskin, founding father of the Arts and Crafts movement. The eldest son and third child of wealthy parents, he attended Marlborough College, where he acquired a love of landscape and medieval architecture, and Exeter College, Oxford, where he made a lifelong friend in Edward Burne-Jones. He abandoned plans to enter the church in favor of architecture (entering the office of G.E. Street in 1856, where he met Philip Webb) then, on meeting Dante Gabriel Rossetti, he abandoned architecture for art. He married Jane Burden in 1858 and collaborated with Webb on the design of Red House at Upton in Kent. His frustration at failing to find suitable decoration for the house, his "palace of art," led directly to his founding Morris, Marshall, Faulkner & Co. (known as "the Firm") in 1861. It sold furniture designed by Philip Webb, Ford Madox Brown, and later, George Jack, stained glass, painted tiles, wall paintings, embroidery, tapestries and woven hangings, carpets, table glass, metalwork, wallpapers, and chintzes, designed by Burne-Jones, William De Morgan, Walter Crane, and others. Morris's first wallpaper, "Trellis," was produced in 1862. In 1865 the Firm moved from 8 Red Lion Square to 26 Queen Square, London. Showrooms were acquired in Oxford Street in 1875 and the Hammersmith workshop for hand-knotted rugs moved to Merton Abbey in Surrey in 1881. However, by 1875, increasingly bitter and overworked, Morris had reorganized the Firm as Morris & Co. with much acrimony and sundered friendships, to reflect what had always been the case—Morris's main role. He founded "Anti-Scrape," or the Society for the Protection of Ancient Buildings, in 1877 and the Kelmscott Press in 1891, turning in later life increasingly to politics, although he continued to write poems, weave tapestries, design wallpapers, and produce and promote some of the most enduringly lovely Arts and Crafts artefacts. He never visited the USA but he had a profound impact on American culture. The Firm continued in business after his death until World War II, going into voluntary liquidation in 1940.

MOSER, Koloman (1868–1918), Austrian painter and designer, closely involved in the founding of both the Vienna Secession and the Werkstätte.

THE SUSSEX RUSH-SEATED CHAIRS

MORRIS AND COMPANY

449 OXFORD STREET, LONDON, W.

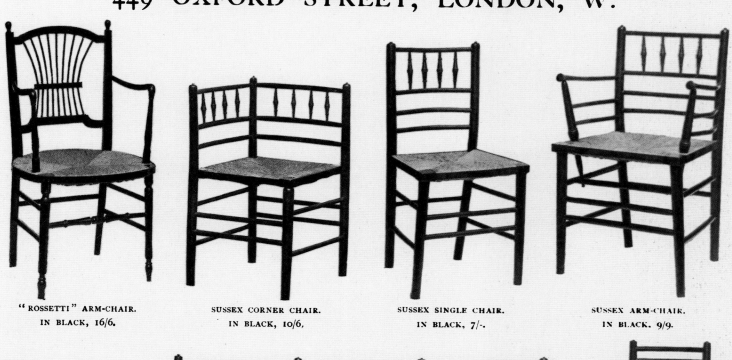

"ROSSETTI" ARM-CHAIR.
IN BLACK, 16/6.

SUSSEX CORNER CHAIR.
IN BLACK, 10/6,

SUSSEX SINGLE CHAIR.
IN BLACK, 7/-.

SUSSEX ARM-CHAIR.
IN BLACK, 9/9.

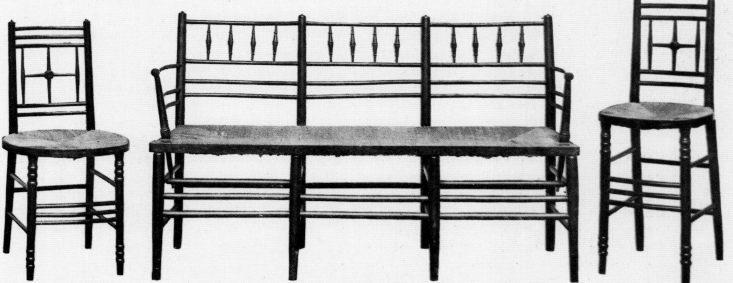

ROUND-SEAT CHAIR.
IN BLACK, 10/6.

SUSSEX SETTER, 4 FT. 6 IN. LONG.
IN BLACK, 35/-.

ROUND SEAT PIANO CHAIR.
IN BLACK, 10/6.

STORMIE S EAS DOES GREATLY PL EASE

Left: *One of a pair of stained-glass panels by Mary Newill, probably produced at the Bromsgrove Guild, c. 1905. Newill began with painting and embroidery before designing domestic and ecclesiastical stained glass, winning the first prize in* The Studio *competition in 1897.*

MUNTHE, Gerhard (1849–1929), Norwegian craftsman who pioneered a revival of tapestry weaving, drawing on Norwegian sagas and folk tales, but rendering them in a modern, linear style.

MUTHESIUS, Hermann (1861–1927), German architect and critic. He was cultural attaché to the German embassy in London from 1896–1903 and his book, the monumental *Das englische Haus* ("The English House," 1904–5), provides a definitive contemporary analysis of the domestic scene at a pivotal moment in the history of Arts and Crafts. He wrote about the emergence of "free architecture" in British domestic buildings, admired W.R. Lethaby and the "young generation who now stood upon Morris's shoulders," and actively championed Charles Rennie Mackintosh and the Glasgow Four. Muthesius was a crucial figure in the Deutscher Werkbund, founded in Germany in 1907 and inspired by the British Arts and Crafts movement. It accepted the need to design not just for handcraft but for mass production and its artists, architects, and craftsmen were concerned to refine an object down to its essentials, believing that "machine work may be made beautiful by appropriate handling." The success of the Werkbund contributed to the German national economy and prompted moves toward design reform in Britain, with the formation, a year after a Werkbund exhibition in London, of the Design and Industries Association.

NEWBERY, Francis Henry (1855–1946), the progressive director of the Glasgow School of Art from 1885–1918. In 1892 he introduced technical art studios in which artist-craftsmen gave artisans a "technical artistic education" in commercial crafts.

NEWBERY, Jessie Rowat (1864–1948), Scottish needlework designer and influential and inspiring figure for women. Charles Rennie Mackintosh decorated the family house (her father, William Rowat, was a manufacturer of Paisley shawls) around the time of her marriage to Francis Newbery. She taught embroidery at the Glasgow School of Art from 1894, introducing simple methods and often working with inexpensive fabrics such as calico and flannel. She championed the need for modernity and the availability of quality needlework to all classes and, although her pattern designs were bold and complex, she used the simplest possible stitching.

NEWILL, Mary (1860–1947), versatile and prize-winning British artist, book illustrator, and embroiderer. Part of the Birmingham Group and a member of the Arts and Crafts Exhibition Society, her work shows the strong influence of Edward Burne-Jones.

NEWTON, Ernest (1856–1922), English architect and founder member of the Art Workers' Guild. He studied with Richard

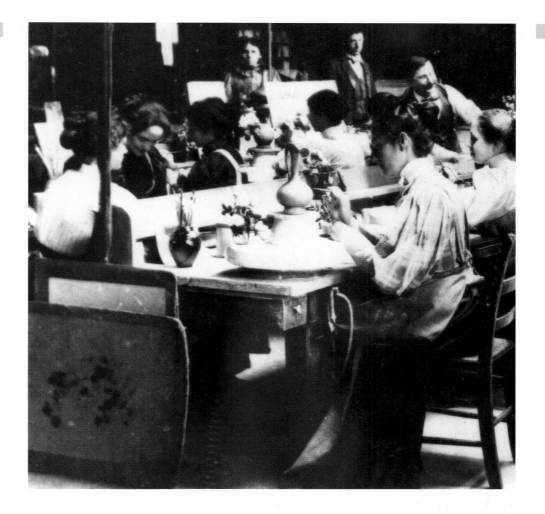

Right: *Women decorators working at the Rookwood Pottery c. 1890, almost ten years after the Cincinnati pottery was founded by Maria Longworth Nichols.*

Norman Shaw and left to found a flourishing country-house practice of his own, building Buller's Wood at Chislehurst, Kent (1889), for the Sanderson Family and a series of stone, brick, and tile cottages for the Lever Brothers at Port Sunlight, Cheshire (1897).

NICHOLS, Maria Longworth (1849–1932), American potter. In 1880 she founded the influential Rookwood Pottery in Cincinnati, set up specifically for constructing and decorating art pottery by hand, usually with naturalistic landscapes and flower designs. Rookwood became commercially successful and received widespread international acclaim. It employed many renowned ceramicists, including Artus Van Briggle, William P. MacDonald, Albert Valentine, and the Japanese ceramicist Kataro Shirayamadani (1865–1948), who became one of the company's principal designers.

NORTON, Charles Eliot (1827–1908), American art critic and Professor of History of Art at Harvard. An American equivalent to John Ruskin, whom he had met, along with William Morris, his influence was enormous. He founded the Boston Society of Arts and Crafts in 1897.

OHR, George Edgar (1857–1918), American potter. He was responsible for some of the most radical and eccentric art pottery of the Arts and Crafts period: he would fashion perilously thin pots and then crumple, twist, or pinch the design into abstraction. He consciously cultivated his image as the "mad potter of Biloxi" in Mississippi and made his shop—called Pot-Ohr-E—into a minor tourist attraction.

OLBRICH, Joseph Maria (1867–1908), Austrian architect and leader of the Secessionists, who aimed to give applied arts the same status as fine art. They staged their first exhibition in 1898 and featured the work of C.R. Ashbee, the Guild of Handicraft, the Glasgow Four, and other leading British Arts and Crafts designers in

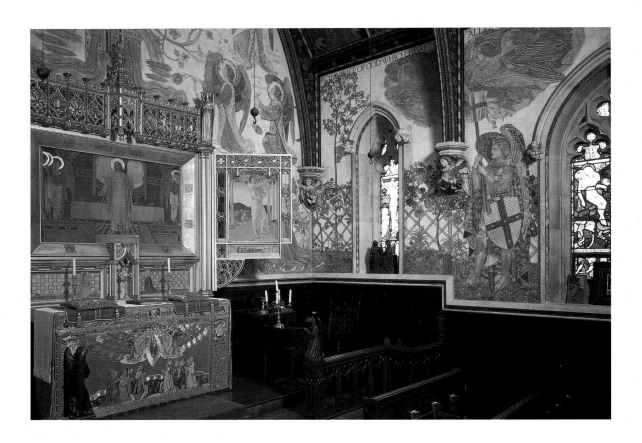

their eighth exhibition, in 1900. The Secessionists assimilated the ideals of William Morris and Ashbee but in a more stylized framework of aesthetically acceptable decorative design.

PABST, Daniel (1826–1910), German furniture designer influenced by Christopher Dresser, who settled in Philadelphia in 1849 and opened his own shop and workshop, employing fifty men.

PARKER, Barry (1867–1947), English architect and visionary town planner. In partnership with his second cousin and brother-in-law, Raymond Unwin, he was responsible for much that was good in the Garden City movement in Britain in the early twentieth century. They co-authored *The Art of Building a Home* (1901) and complemented each other as architectural partners. Both socialists (and teetotalers), they wanted to "bring brightness and cheeriness and airiness right into the midst of the house." Their philosophy extended beyond individual house design to embrace the model village of New Earswick in Yorkshire, built in

1902 for the Rowntree family, and garden cities at Letchworth, Hertfordshire (1904–14) and Hampstead Garden Suburb in London (1905–14).

PAYNE, Henry (1868–1940), English landscape, portrait, and stained-glass artist. Based in Birmingham, he was responsible for many important commissions, among them the large five-light Ascension window in E.S. Prior's Arts and Crafts gem, St. Andrew's, Roker, Sunderland, and the seven-light Resurrection window at W.H. Bidlake's St. Agatha's, Birmingham. Payne moved, like many other Arts and Crafts practitioners, to the Cotswolds in 1909 where he built a stained-glass workshop in the garden of his sixteenth-century schoolhouse at Amberley, Gloucestershire, and formed the St. Loe's Guild to promote various Arts and Crafts activities.

PEACH, Harry (1874–1936), enlightened Canadian-born founder, with designer Benjamin Fletcher, of the Leicester-based

cane furniture firm Dryad. It produced chairs in modern shapes prompted by the work of Richard Riemerschmid. Peach encouraged his workers to study at art school and take part in social activities. In 1912 he diversified, starting the Dryad Metal Works and Dryad Handicrafts. The latter, supplying materials and tools for a wide variety of craft activities, is still in existence. Peach was a founder member of the Design and Industries Association in 1915.

POWELL, Alfred Hoare (1865–1960), English architect and ceramic artist who studied at the Slade School of Art, joined J.D. Sedding's practice in 1887, and attended W.R. Lethaby's Central School of Arts and Crafts, where he studied calligraphy. He was a close friend of Sidney Barnsley and Ernest Gimson, and joined them in Sapperton, Gloucestershire, in 1901, dividing his time between architectural commissions and making chairs by hand using a primitive pole lathe. A true Arts and Crafts practitioner, he mastered weaving, wood-engraving, and working in metals, stone, and wood before turning to ceramics. He married Louise Lessore in 1906 and together they set up a studio for the painting of ceramics in Red Lion Square, London, working for Wedgwood. Powell's success in this field encouraged Lethaby to invite him to set up a class in china painting at the Central School. He was also closely associated with May Morris and the Royal School of Needlework. Sidney Barnsley's daughter Grace trained with the Powells, going on to work for Wedgwood.

PRICE, William Lightfoot (1861–1916), American architect and founder of the Rose Valley Arts and Crafts Colony, set up in Philadelphia in 1901 to produce furniture in the Gothic revival style.

Left: *The decoration of Madresfield Chapel was commissioned in 1902. All the painting, stained glass, and metalwork was carried out by the Birmingham Group. The tempera-painted frescoes and stained glass are by Henry Payne. The triptych was designed by William Bidlake, painted by Charles Gere, who also designed the altar frontal.*

Right: *A Wedgwood punchbowl by Alfred Powell, decorated with Cotswold scenes and, at the center, Daneway House, c. 1928.*

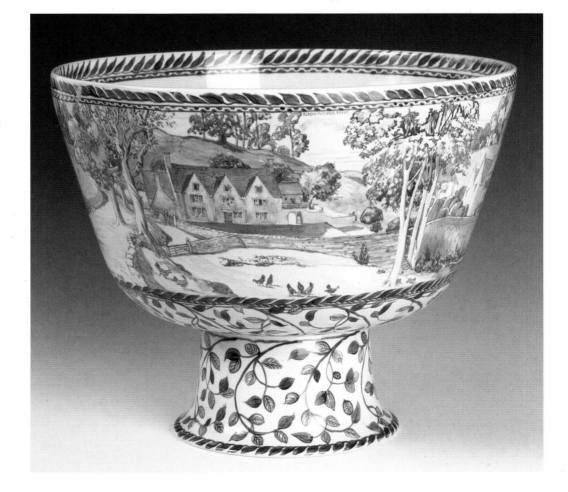

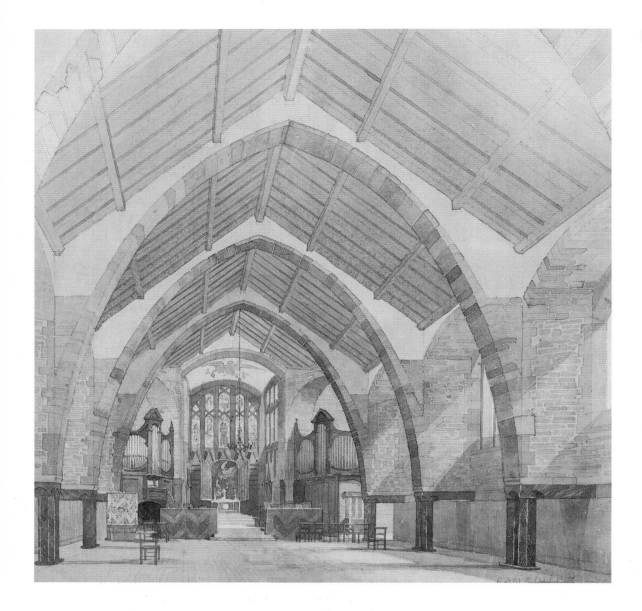

Left: *A pencil-and-sepia wash drawing showing the interior perspective of E.S. Prior's Church of St. Andrew, Roker, Co. Durham.*

PRIOR, Edward Schroeder (1852–1932), English architect. An ardent disciple of William Morris, Prior was educated at Harrow and Cambridge, joined the office of Richard Norman Shaw in 1874, and set up his own practice in 1880. He was one of the founders of the Art Workers' Guild and held the Slade chair of Fine Art at Cambridge until his death. The "butterfly" plan, which he devised, offered an alternative to the popular L-shaped house: the resulting front elevation, as at The Barn in Exmouth, Devon (1907), formed two arms curving toward each other in a symbolic embrace of welcome.

PUGIN, Augustus Welby Northmore (1812–52), crucial English architect and design theorist. He revitalized the crafts of stained glass, ironwork, and ceramics and wrote a number of books, including *The True Principles of Pointed or Christian Architecture* (1841), which provided the foundation from which the moral aesthetics of Arts and Crafts evolved during the latter half of the nineteenth century. He was married three times, fathered eight children, and designed more than a hundred buildings—mostly churches, with the notable exception of the Houses of Parliament. He converted to Catholicism at twenty-two and died at forty. A passionate advocate of the asymmetry of Gothic architecture, he argued that English architects should abandon classical models in favor of Gothic examples—which he considered more suitable to Christianity—from the late Middle Ages. An ardent sailor, he once

Below: *Armchair, from* Gothic Furniture in the Style of the Fifteenth Century, *designed and etched by A.W.N. Pugin, published in 1830 by Ackermann & Co.*

exclaimed that "There is nothing worth living for but Christian architecture and a boat."

RATHBONE, Richard Llewellyn (1864–1939), leading British metalworker and teacher, who worked on projects with C.F.A. Voysey and A.H. Mackmurdo, and set up a workshop in Liverpool producing metal fittings and utensils.

RHEAD, Frederick Hürten (1880–1942), influential English-born art potter. He emigrated to America in 1902 and was associated with the University City Pottery, St. Louis, Missouri; Roseville in Zanesville, Ohio; and the Arequipa Pottery, located in a sanatarium for working-class tubercular women in California "to give these people interesting work." He proved a better potter than businessman.

RICARDO, Halsey (1854–1928), English architect and designer. He was active in the Art Workers' Guild and was heavily influenced by the theories of John Ruskin. He formed a partnership with William De Morgan in 1888 and often used Persian-style colored glazed tiles in his work—both inside and as facings on the exteriors of his buildings—as in his design for 8 Addison Road, Kensington, London, for Sir Ernest Debenham. He taught architecture at the Central School of Arts and Crafts from 1896.

RICHARDSON, Henry Hobson (1838–86), New England architect and interior designer responsible for introducing romanticism into American architecture. He studied at Harvard University and the École des Beaux Arts, Paris, and spent time in England, where he met William Morris, William Burges, Edward Burne-Jones and William De Morgan. Regarded as America's first "signature" architect, he is best known for the Trinity Church on Copley Square in Boston, the Glessner House in Chicago, and the Marshall Field Wholesale Store, also in Chicago, which sold Morris & Co. products.

RIEMERSCHMID, Richard (1868–1957), German designer and one of the founders of the Dresden and Munich Werkstätten (along with Peter Behrens, Bernhard Pankok, Bruno Paul, and Hermann Obrist). He trained as a painter in Munich and produced sinuous Art Nouveau-inspired designs for metalwork, as well as porcelain, glass,

cutlery, light-fittings, carpets, and furnishing textiles. He became a founding member of the Deutscher Werkbund and worked on the plans for Germany's first Garden City at Hellerau near Dresden. Embracing the modern age, he took inspiration from everything from liners to locomotives. "Life, not art, creates style," he wrote, "it is not made, it grows."

ROBERTSON, Hugh Cornwall (1845–1908), American ceramicist. With his father, James, and two brothers, Alexander and George, he ran the Chelsea Keramic Art Works in Massachusetts, making classically inspired vases and art pottery. Following the death of his father and his brothers' move to California in 1884, he abandoned the elaborate decorative format and turned to a more Oriental style, developing his famous Japanese red glaze, known as *sang-de-boeuf* ("bull's blood") and his blue-decorated white Chinese crackle glaze which became very profitable for the now renamed company—Dedham Pottery—which continued in business under his son's care until 1943.

ROBINEAU, Adelaide Alsop (1865–1929), outstanding American ceramicist. China decorator, perfectionist, maker of complicated porcelain pieces, and teacher, she founded, with her French-born husband Samuel, the influential magazine *Keramic Studio* in Syracuse, New York, in 1899, with the aim of providing good designs for other potters. She studied watercolor with William Merritt Chase in New York, but specialized in painting on porcelain, and worked with the celebrated potter Taxile Doat of Sèvres. In 1911 she won the Grand Prix at the Esposizione Internazionale at Turin for her "Scarab Vase," which she made at the University City Pottery, St. Louis, Missouri, founded by the entrepreneur and patron of arts and education Edward Gardner Lewis (who also founded the American Women's League). For four years from 1912 she developed and ran an Arts and Crafts-based summer school specifically for women with children, at her studio, Four Winds.

ROBINSON, William (1838–1935), pioneering Irish garden designer and journalist. Moving to England in his twenties, he wrote *The Wild Garden* (1870) and the extremely popular *The English Flower Garden* (1883), and founded periodicals—*The Garden* (from 1871) and *Gardening Illustrated* (from 1879)—aimed at the new

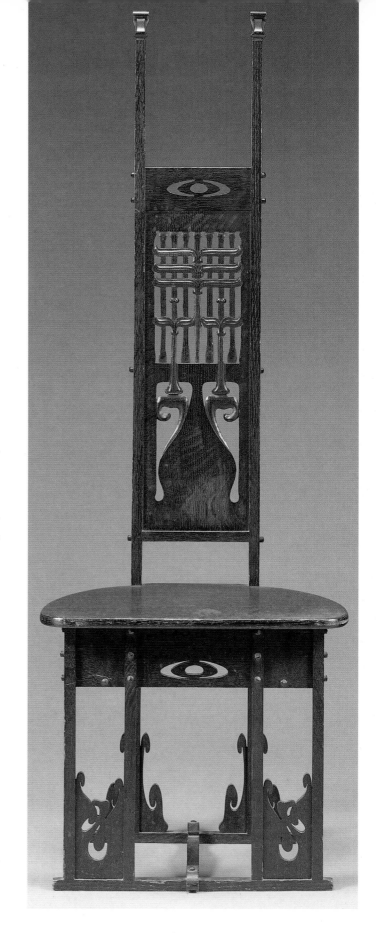

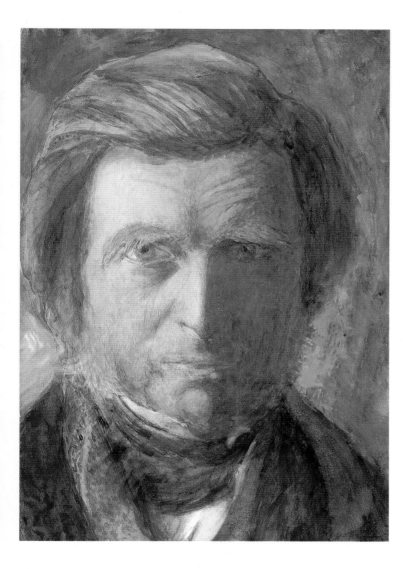

type of garden owner then residing in the suburbs. His naturalistic style of planting was taken up by Gertrude Jekyll and other Arts and Crafts gardeners reacting against the excessive artificiality of much of the gardening of the latter half of the nineteenth century. He created his own famous garden at Gravetye Manor, West Sussex, in 1885.

ROHLFS, Charles (1853–1936), American furniture designer. Turning his back on a successful acting career, he set up his workshop in Buffalo, New York, in 1891. His designs combined the sturdy shapes of Arts and Crafts furniture with the sinuousness of Art Nouveau decoration and ornament, and he was commissioned to design furniture for Buckingham Palace.

ROSSETTI, Dante Gabriel (1828–82), precociously talented artistic son of an Italian political exile living in London. Rossetti was a founder member of the Pre-Raphaelite Brotherhood and of the firm of Morris, Marshall, Faulkner & Co., for whom he designed stained glass, furniture, and decorative painted panels. He married Elizabeth Siddal in 1860 and, following her suicide, began an intimate relationship with Janey Morris.

RUSKIN, John (1819–1900), precociously brilliant English writer and social reformer. Advising that "to teach taste is to form character," he became the philosophical inspiration behind the Arts and Crafts movement on both sides of the Atlantic, although he never visited the USA (a country he characterized as full of unbridled competition and relentless ugliness), and his own Utopian experiment, the Guild of St. George, was a failure. He became Slade Professor of Fine Art at Oxford in 1870, and his views on industrialization and the education of working people underpinned the British Labour movement.

SCHULTZ, Robert Weir (1860–1951), Scottish architect who trained in Edinburgh before joining Richard Norman Shaw in 1884, where he met W.R. Lethaby and was introduced to Ernest Gimson and the Barnsley brothers.

SEDDING, John Dando (1838–91), leading English ecclesiastical architect and key figure in the Arts and Crafts movement. In his

Left: *A carved oak "Hall Chair" by Charles Rohlfs, c. 1900. "My feeling was," he stated, "to treat my wood well, caress it perhaps, and that desire led to the idea that I must embellish it to evidence my profound regard for a beautiful thing in nature."*

Above: *"Self portrait with blue neckcloth", c. 1873; John Ruskin was one of the giants of the Victorian age and exerted a powerful influence on English art, economics, and the social thinking that underpinned the Arts and Crafts movement.*

illumination. In 1880 he was appointed diocesan architect of Bath and Wells. In 1885 he designed the richly decorated Holy Trinity Church in Sloane Street, London, and in 1886, in a contrasting severely classical style, the Church of the Holy Redeemer in Clerkenwell. His sudden death from pneumonia in 1891 left a void.

SHAW, Richard Norman (1831–1912), leading British architect. An exponent of the Queen Anne style, and an almost exact contemporary of Philip Webb, Shaw is famous for fostering a number of important Arts and Crafts figures including Mervyn Macartney, E.S. Prior, W.R. Lethaby, Sidney Barnsley, and Robert Weir Schultz. Born in Edinburgh, he trained under the Scottish classicist William Burn and became chief clerk to G.E. Street, where he met Webb in 1859. He went on to set up an office that became a nursery of Arts and Crafts talent, though his own claim to fame is as "the last great Gothic country house architect." Unlike Webb, who shunned publicity and survived on the patronage of a few sympathetic clients, Shaw's output was huge, and he brought his eclectic visual vocabulary to a wide range of commissions. His strong sense of the picturesque is evident in his design for the Bradford Exchange (1864) and the artist Kate Greenaway's house in Frognal, London (1884), which includes a top-floor studio set at an ingenious angle to maximize the north light. In 1877 Jonathan Carr asked him to improve on E.W. Godwin's designs for a development of small detached and semidetached villas at Bedford Park, west London. Alongside his architectural work, Shaw also designed furniture and wallpapers.

SILVER, Arthur (1853–96), English fabric designer. He founded the Silver Studio and supplied Liberty's with some of its most

office at 447 Oxford Street, London, a number of important Arts and Crafts figures first worked, including Alfred Powell, Ernest Gimson, Ernest Barnsley, J. Paul Cooper, Henry Wilson, and W.R. Butler. While articled to G.E. Street (1858), where he worked alongside William Morris, Philip Webb, and Richard Norman Shaw, Sedding developed his understanding of Gothic architecture and ornament, which would later underscore the movement. He also designed wallpapers, embroidery, and church metalwork and was proficient in various other traditional building crafts, including stone-carving and ironwork. He emphasized the interdependence of design and craftsmanship and had a radical vision of "the ideal factory ... where the artist-designer is a handicraftsman and the handicraftsman is an artist in his way." He communicated and promoted his passion for the ideal of medieval craftsmen to others and was instrumental in the revival of weaving, embroidery, and

successful and characteristic fabrics (including "Peacock Feather") until the outbreak of World War II. His son Reginald (Rex) Silver (1879–1965) took over the running of the studio on his father's death and, while continuing to supply fabric designs, also designed for Liberty's silver "Cymric" line and "Tudric" pewter range.

SPENCER, Edward (1872–1938), British designer and metalworker. He became a junior designer in the Artificers' Guild, when it was founded in 1901, and chief designer when it transferred to Maddox Street, London. His metalwork was widely publicized through *The Studio*.

SIMMONDS, William George (1876–1968), British painter influenced by Walter Crane. He studied at the Slade School of Art and married Eveline (Eve) Peart (1884–1970) in 1912. Eve Simmonds was a skilled embroiderer and worked closely with Louise Powell (née Lessore), with whom the Simmonds shared a house in Hampstead before moving to the Cotswolds.

STABLER, Harold (1872–1945), British craftsman. He studied woodwork and stone-carving at the Kendal School of Art, helped to found the Design and Industries Association in 1915, and co-founded the Carter, Stabler, Adams pottery in Poole, Dorset, in 1921. He collaborated with his wife, the ceramic and bronze sculptor Phoebe McLeish, on elaborate metalwork and jewelry designs, often embellished with painted enamel panels.

STICKLEY, Gustav (1858–1942), American furniture-maker. With Elbert Hubbard, Stickley was the main promoter of Arts and Crafts style and ideals in America. Born in Wisconsin to German immigrant parents, he trained as a stonemason before going to work at his uncle's furniture factory. He was profoundly influenced by the writings of William Morris and visited England in 1898, where he saw work by and met a range of Arts and Crafts designers, including A.H. Mackmurdo, C.F.A. Voysey, C.R. Ashbee, and M.H. Baillie Scott. In 1899 he established his own guild of artisans, United Crafts, near Syracuse, New York, and soon Americans could order a whole range of products through his mail order catalogs—from comfortable plain oak furniture to textiles, lamps, and carpets—for the home. Before

very long they could even order the home—a bungalow in kit form. In 1902 he opened a metalwork shop. Stickley's magazine *The Craftsman* (published 1901–16) publicized both his products and his philosophy. He attempted to combine the high ideals of British craftsmanship with the more pragmatic necessities of industrial production methods, but he over-extended the company and went bankrupt in April 1915. The Craftsman Workshops were taken over by his brothers' firm, L. & J.G. Stickley (which also made furniture designed by Frank Lloyd Wright) and amalgamated as the Stickley Manufacturing Co.

STICKLEY, Leopold (1869–1957) and STICKLEY, John George (1871–1921), two of Gustav Stickley's brothers who left his United Crafts workshop to set up the L. & J.G. Stickley Furniture Company in 1902, producing machine-aided solid oak furniture.

STREET, George Edmund (1824–81), English architect and designer of exceptional architectural fittings and furniture. A strong supporter of traditional building crafts, he believed that an architect should be multitalented: a builder, a painter, a blacksmith, and a designer of stained glass. He had a profound effect on William

Morris, who was articled to him for a short while, and Philip Webb, who spent rather longer in his Oxford offices.

SULLIVAN, Louis (1856–1924), American architect. Considered to be the father-figure and spiritual leader of the Prairie school of American architecture, he established his practice in Chicago with Dankmar Adler in 1883. He is best known for commercial rather than domestic buildings, and for mentoring Frank Lloyd Wright.

SUMNER, George Heywood (1853–1940), English wood-engraver and muralist, an associate of the Century Guild (also W.A.S. Benson's brother-in-law) and a member of the Art Workers' Guild.

TAYLOR, Ernest Archibald (1874–1951), Scottish furniture and stained-glass designer. Taylor studied at the Glasgow School of Art before joining the well-established Glasgow cabinet-making firm of Wylie & Lochhead Ltd. He exhibited with the other Glasgow School artists at the 1902 Esposizione Internazionale in Turin, winning a medal and a diploma. He married the textile and jewelry designer Jessie M. King and moved to Manchester where he worked for the decorating firm George Wragge Ltd., becoming very involved in the design of stained glass. In 1911, he and his wife established the Shealing Atelier of Fine Art in Paris, though the outbreak of World War I forced their return to Scotland.

TIFFANY, Louis Comfort (1848–1933), American artist, glass designer and entrepreneur. The son of Charles Tiffany (the owner of New York's Fifth Avenue Tiffany & Co., which specialized in silver and jewelry), he trained first as a painter, then as a glassmaker,

studying medieval stained-glass panels. He founded Louis Comfort Tiffany & the Associated Artists in New York in 1879, with the cooperation of Lockwood de Forest, Samuel Colman, Candace Wheeler, and the Society of Decorative Art. In 1882–3 they were commissioned to decorate the White House for President Arthur, and other clients included Mark Twain, Cornelius Vanderbilt II, and the British actress Lillie Langtry. Tiffany broke with the Associated Artists in 1885 and set up the independent Tiffany Glass Company. He established Tiffany Studios in 1892 in Corona, New York, as a foundry to supply metal fittings and bases for his glass company, which made lamps, desk sets, candlesticks, metalwares, enamels, and pottery, as well as cut glass. His experiments in glass led him to develop an iridescent satin finish for which he coined the term "Favrile" in 1893. In the same year he won an amazing fifty-four medals at the World's Columbian Exposition held in Chicago. Heavily influenced by William Morris, he wanted his studio—on the top floor of his father's mansion—to be a cross between a European atelier and an Arts and Crafts guild modeled along medieval lines. His trademark electric table, floor, and ceiling lamps sold through Tiffany & Co. in America, Samuel Bing's Maison de l'Art Nouveau in Paris, and the Grafton Gallery in London.

TRAQUAIR, Phoebe Anna (1852–1936), Irish muralist and needlewoman. Born and trained in Dublin, she moved to Edinburgh on her marriage and there expressed the polymath ideal, working as an illuminator, mural decorator, bookbinder, enameler, and embroiderer. An exceptional colorist, she wanted to make her walls "sing" and executed decorations for buildings and furniture by the Scottish Arts and Crafts architect Robert Lorimer.

Right: *An enamel tryptich in silver with abalone shell, designed by Phoebe Anna Traquair, c. 1902.*

THE EARTH UPHOLDER

UNWIN, Sir Raymond (1863–1940), English architect and father of town planning. In his book *The Art of Building a Home* (1901), co-authored by his partner and brother-in-law Barry Parker, Unwin equated design with problem-solving: "The essence and life of design lies in finding that form for anything which will, with the maximum of conveniences and beauty, fit in for the particular functions it has to perform, and adapt to the special circumstances in which it must be placed." Pre-eminent proponents of the Garden City movement, Parker and Unwin were instrumental in planning Letchworth in Hertfordshire and Hampstead Garden Suburb in London, and also designed twenty-eight houses in the garden village they prepared for Rowntree factory workers at New Earswick, near York, in 1902.

VAN BRIGGLE, Artus (1869–1904), American painter, sculptor, and ceramicist. He worked for Rookwood Pottery from 1887–99 (during which time he was sent to Paris to study for three years from 1893). Ill health forced him to move to Colorado Springs where his style developed to embrace Art Nouveau forms.

VAN ERP, Dirk (1860–1933), Dutch-born American metalworker. While working in a naval shipyard, he began hammering vases out of brass shell casings. He opened the Copper Shop in Oakland, California, in 1908, moving in 1910 to San Francisco, where he produced hammered copper lamps with mica shades and other handcrafted metalwork.

designed aristocratic mansions like Edwin Lutyens, he was eager to reinstate architecture as the mother of all arts. Voysey was known for the subtlety of proportion and simplicity of form in his work, and for his rigorous attention to detail. He might design every element in a house from the letterplate on the front door to the kitchen fittings, and this rigor also extended to his own appearance, for he liked to wear a special suit of clothes, of his own design, that did away with cuffs and lapels—"dust-traps," he believed—with shirts of "butcher's blue" similar to those worn by William Morris, although Voysey's were set off by a Liberty silk cravat held with a simple gold ring. His designs used plain, good-quality materials made to high standards. His wallpaper designs were sold through Essex & Co. and his fabrics were designed for Alexander Morton & Co. and, of course, Liberty & Co. His work was well known in Europe, where his designs were reproduced and his influence was great.

VELDE, Henry van de (1863–1957), Belgian architect and designer. An admirer of William Morris, he ran a craft-oriented workshop in Berlin and in 1902 founded a school for the applied arts in Weimar, which became the precursor of the Bauhaus. On his resignation as head of the school in 1914, he recommended Walter Gropius, another admirer of Morris, as his successor, and Gropius founded the Bauhaus in Weimar in 1919.

VOYSEY, Charles Francis Annesley (1857–1941), English architect and one of the most prolific designers of the Arts and Crafts period. He was educated at Dulwich College, after which he worked for the architect J.P. Seddon and then for George Devey. He joined the Art Workers' Guild in 1884 and established himself as a designer of wallpapers and furniture before receiving his first building commissions in the early 1890s. He became a master of "artistic" cottages and smaller country houses and, though he never

WAALS, Peter van der (1870–1937), Dutch-born English furniture-maker. Recruited by Ernest Gimson and Ernest Barnsley as foreman for their Sapperton workshop in 1901, Waals had previously worked in Brussels, Berlin, and Vienna. Following the death of Gimson in 1919 he set up his own workshops in an old silk mill at Chalford, Gloucestershire, producing his own designs and some of Gimson's, for clients such as W.A. Cadbury, whose house at King's Norton, near Birmingham, was furnished with many examples of Waals's work.

WALTON, George (1867–1933), Scottish architect and interior designer. He attended evening classes at the Glasgow School of Art before setting up his own business—George Walton & Co.

Above: *"Swallows flying round a tree"—a textile design by C.F.A. Voysey, 1899.*

Right: *C.F.A. Voysey designed and painted the gilded mahogany case for this charming clock in 1895–6. The brass and steel movement was made by Camerer, Cuss & Co.; the case by F. Coote.*

Ecclesiastical and House Decorators—at 150–2 Wellington Street, Glasgow, in 1888. He exhibited with the Arts and Crafts Society in 1890 and moved to London (setting up a showroom at 16 Westbourne Park Road) in 1897. He designed the furniture, fittings, and storefronts for branches of the Kodak camera company in Glasgow, London, Milan, Moscow, Vienna, Leningrad, and Brussels and a number of idiosyncratic private houses for directors of Kodak. He also designed the silk hangings used in the Buchanan Street tea-rooms in Glasgow, where Charles Rennie Mackintosh made his name.

WARDLE, Thomas (1831–1908), dyer and printer in Leek, Staffordshire. He helped William Morris with his early experiments in dyeing and worked with Arthur Liberty to introduce "art" or "Liberty" colors to silks and other fabrics from the East.

WATTS, Mary Seton (1849–1938), British painter and craftswoman. The wife of the painter G.F. Watts, she was the director of the Compton Potters' Art Guild in Surrey, a women's guild established in 1896.

WEBB, Philip Speakman (1831–1915), English architect, socialist and designer. He met William Morris when both were briefly working together in the offices of G.E. Street and designed Red House, which has been called the first Arts and Crafts building, for Morris and his wife, Janey, at Upton in Kent in 1859. He designed furniture for Morris's Firm from 1861, as well as glassware and embroidery. Arguably the architectural father-figure of the Arts and Crafts movement, his influence as a designer on those who followed was considerable. A lifelong socialist, modest and shy in public, he had a reputation for highmindedness and high standards. During much of the 1880s and 1890s—during which he was working on a number of country house commissions, including Clouds in Wiltshire (1886) and Standen in Sussex (1891), both decorated by Morris & Co.—he earned less than £320 a year, only slightly more than a master mason. He designed Morris's gravestone and almost his last commission was the memorial cottages to William Morris at Kelmscott, built in the Cotswold tradition, with a relief carved by George Jack, his chief assistant, who after his death wrote: "It is like trying to remember past sunshine—it pleases and it passes, but it

also makes things to grow and herein Webb was like the sunshine, and as little recognized and thanked.''

WELLES, Clara Barck (1868–1965), American promoter of women's causes, teacher, employer, and owner of the Kalo Shop in Chicago, which she founded in 1900. Run on the lines of C.R. Ashbee's Guild of Handicraft, it made and sold handcrafted silverware and jewelry influenced by Art Nouveau.

WHALL, Christopher Whitworth (1849–1924), leading English designer in the field of architectural glass. He taught stained-glass work at the Central School of Arts and Crafts in London from its foundation in 1896.

WHEELER, Candace (1827–1923), American textile designer and interior decorator, who founded the New York Society of Decorative Art in 1877. She was one of eight children, brought up in a strict

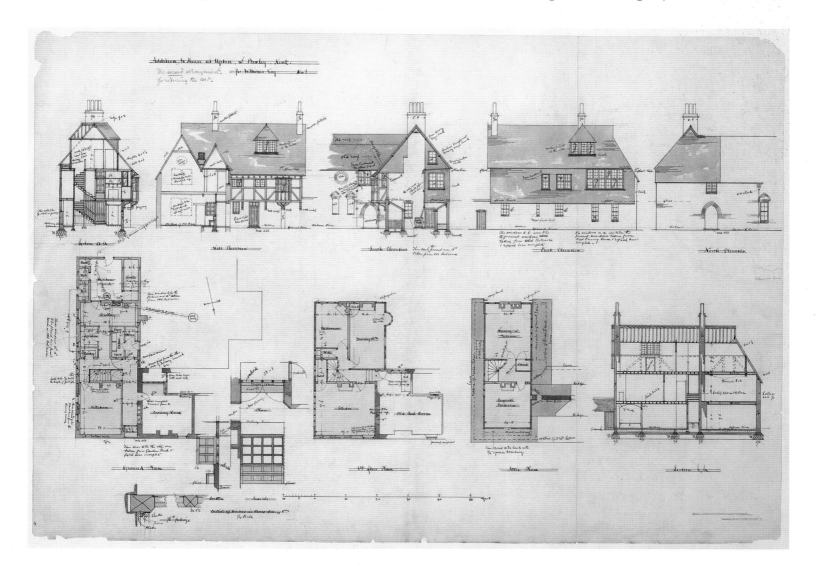

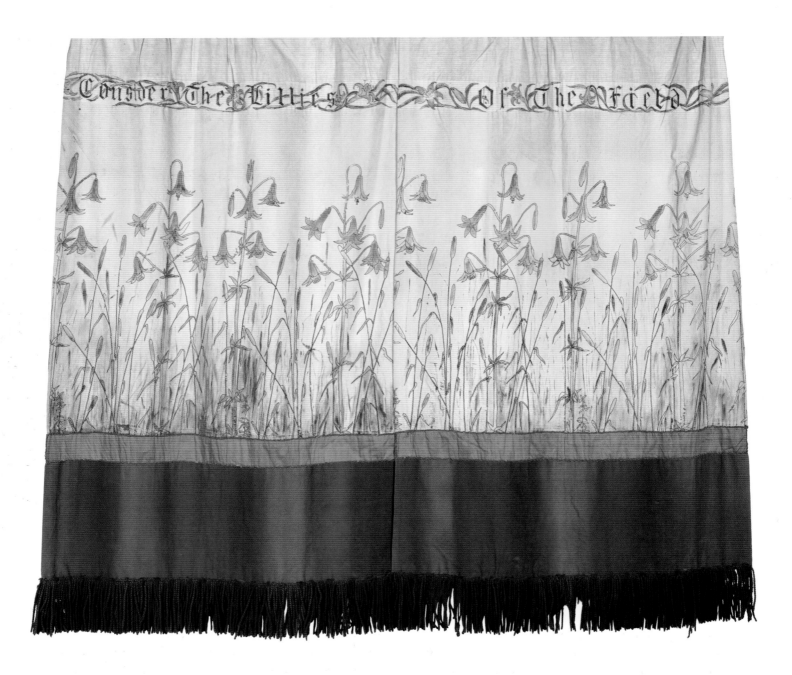

Puritan household in which her mother wove the family's clothes and made their candles. Her marriage at seventeen to Thomas Wheeler, an engineer from New York, introduced her to literature and art. They lived in Brooklyn, then Long Island, and had four children, including a daughter, Dora, who studied at the Acadèmie Julien in Paris and was, like her mother, an admirer of Walter Crane. Both won prizes for their wallpaper designs. When Louis C. Tiffany left Associated Artists, in which Wheeler was a partner, in 1883, she continued the company as an all-female textile design firm until 1907.

WHITEHEAD, Ralph Radcliffe (1854–1929), English-born, Oxford-educated founder, with his wife Jane Byrd McCall, of the American Byrdcliffe Arts Colony in 1902—a Utopian craft community in rural Woodstock, New York, inspired by John Ruskin and devoted to pre-industrial ideas. It produced furniture, metalwork, pottery, and textiles and offered an annual summer school for artists until 1912.

WILDE, Oscar Fingal O'Flahertie Wills (1854–1900), Irish writer and aesthete. In 1882 he embarked on a wildly successful

eighteen-month lecture tour of the USA, promoting the aesthetic ideal of art and decoration.

WILSON, Henry (1864–1934), English architect, designer, metalworker, and enameler. He wrote in 1898 that the architect "should be the invisible, inspiring, ever active force animating all the activities necessary for the production of architecture." He inherited J.D. Sedding's practice after Sedding's sudden death in 1891. In 1895 he set up his own metalworking shop in a house at Vicarage Gate in Kensington where for a brief, unsuccessful period he entered into partnership with Alexander Fisher. J. Paul Cooper learnt jewelry-making in Wilson's workshop. From 1896 he taught at the Central School of Arts and Crafts and from 1901 at the Royal College of Art. A member of the Art Workers' Guild from 1892, he became president of the Arts and Crafts Exhibition Society in 1916. His

Silverwork and Jewellery (1903) was considered one of the best practical manuals on the subject.

WOODROFFE, Paul Vincent (1875–1954), English book illustrator, heraldic artist, and stained-glass designer who set up a stained-glass studio at his house at Westington, Gloucestershire, reconstructed for him by C.R. Ashbee.

WRIGHT, Frank Lloyd (1867–1959), prolific, avant-garde, Wisconsin-born, American architect, furniture, stained-glass, and textile designer. He began work in the office of Dankmar Adler and Louis Sullivan and his long career spanned seven decades and two centuries, during which he received more than a thousand commissions and executed over half of them, most of which still stand today. Much influenced by his mother, Anna Lloyd Wright, a

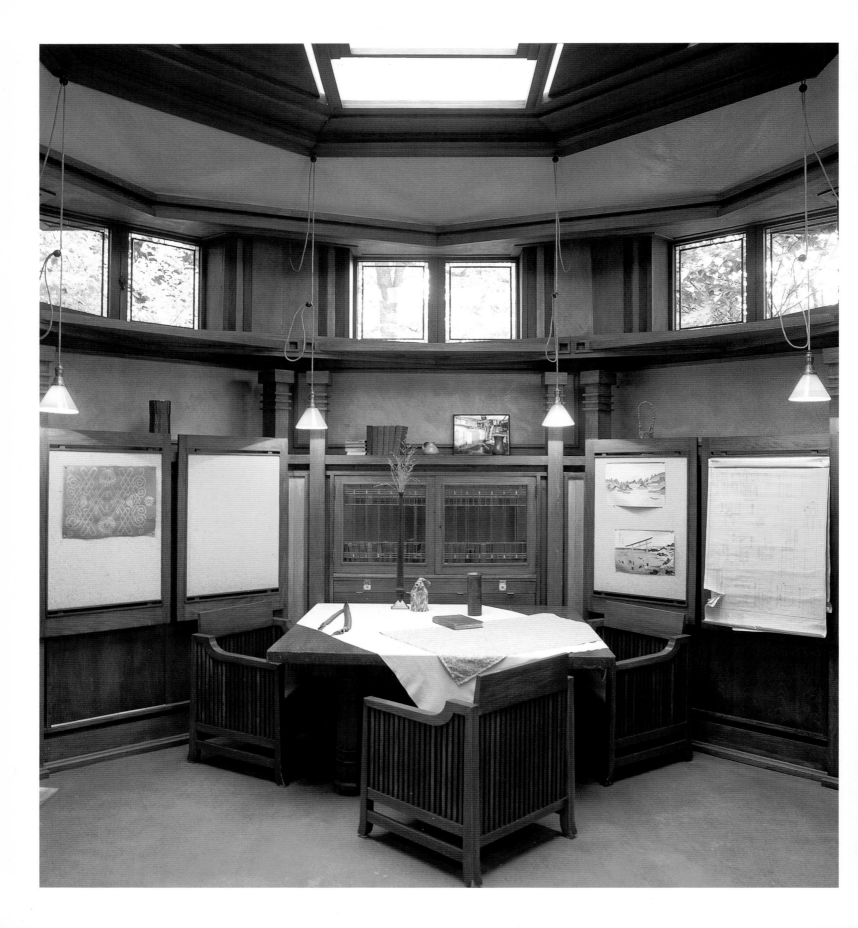

Unitarian with Welsh roots whom he described as being "in league with the stones of the field," he drew inspiration from nature for what he called his "organic architecture." Wright believed that "the horizontal line is the line of domesticity" and revolutionized the single-family private house by destroying "the box" and opening the house "within itself and out to nature." Nikolaus Pevsner called him "a poet of pure form" in whose "gigantic visions, houses, forests, and hills are all one." The genius of the Prairie school of architecture, his work draws on the economy and grace of Japanese art, and continues to exert enormous influence today. He was a founding member of the Chicago Society of Arts and Crafts at Hull-House in 1897, met C.R. Ashbee in 1900, and was influenced by the ideas of Otto Wagner in Vienna. In his later buildings, such as Fallingwater in Pennsylvania (1935–9), and the Guggenheim Museum in New York, he moved toward a more Modernist style.

YEATS, Lily (1866–1949) sister of the Irish poet William Butler Yeats. She was a close friend of May Morris and was employed from 1866–94 as an embroideress by Morris & Co. Subsequently, she managed the textile section of the Dun Emer Guild, which she co-founded in Dublin in 1902 together with her sister, Elizabeth, and Evelyn Gleeson.

YELLIN, Samuel (1885–1940), Polish-born metalworker who opened a shop in Philadelphia in 1909, where he specialized in hand-hammered repoussé designs for architectural practices.

Left: *The octagonal library in Frank Lloyd Wright's home and studio in Oak Park, Illinois, created an immediate and lasting impression on the clients invited to sit at the oak table and look over presentations for their own houses.*

Right: *This embroidered panel showing an orchard of apple trees in blossom was made by Lily Yeats in 1926, and has a linen label sewn onto the reverse reading "Picture by sister of poet Yeats, Wedding present from Mary Geoffrey Holt (cousin of Yeats)."*

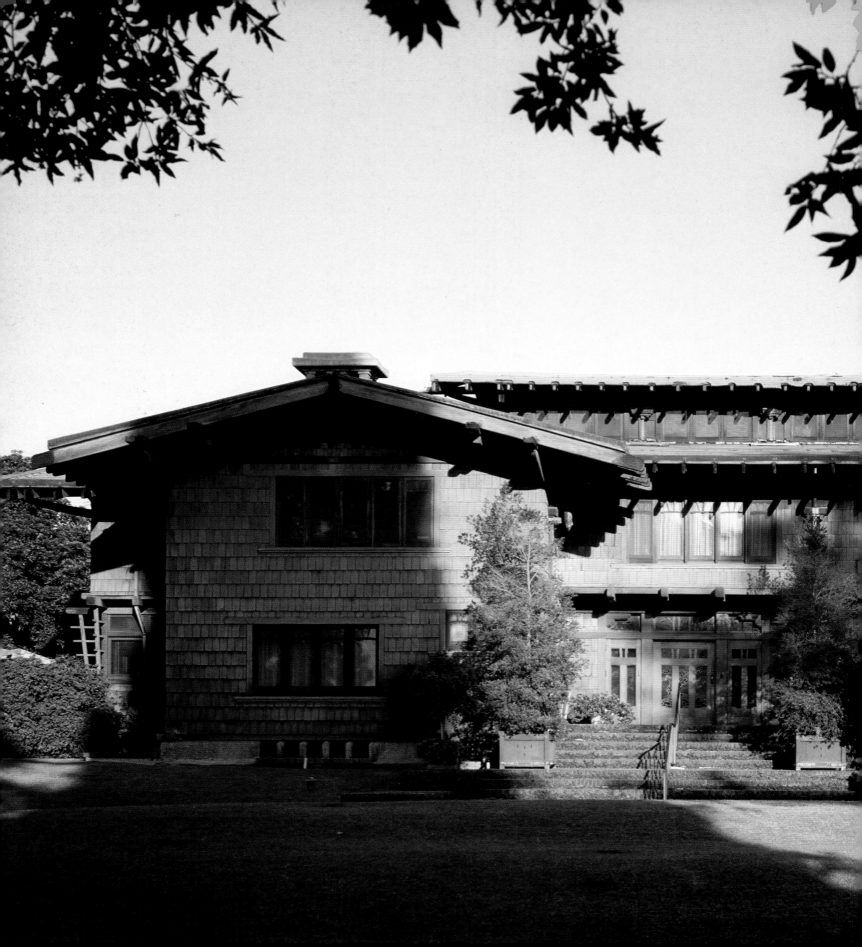

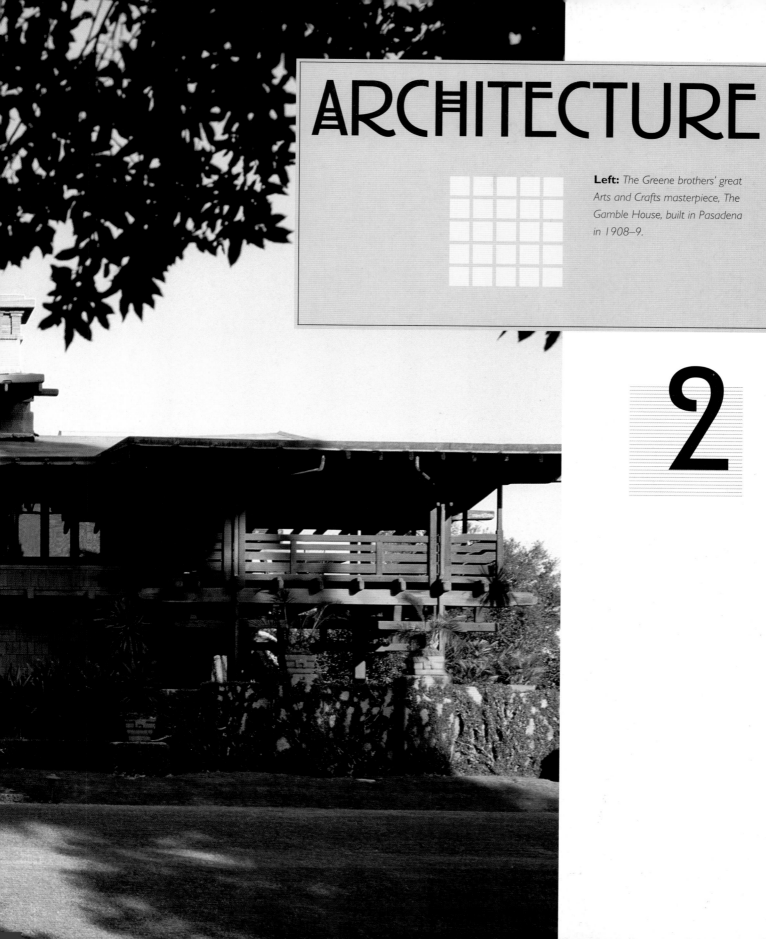

ARCHITECTURE

Left: *The Greene brothers' great Arts and Crafts masterpiece, The Gamble House, built in Pasadena in 1908–9.*

2

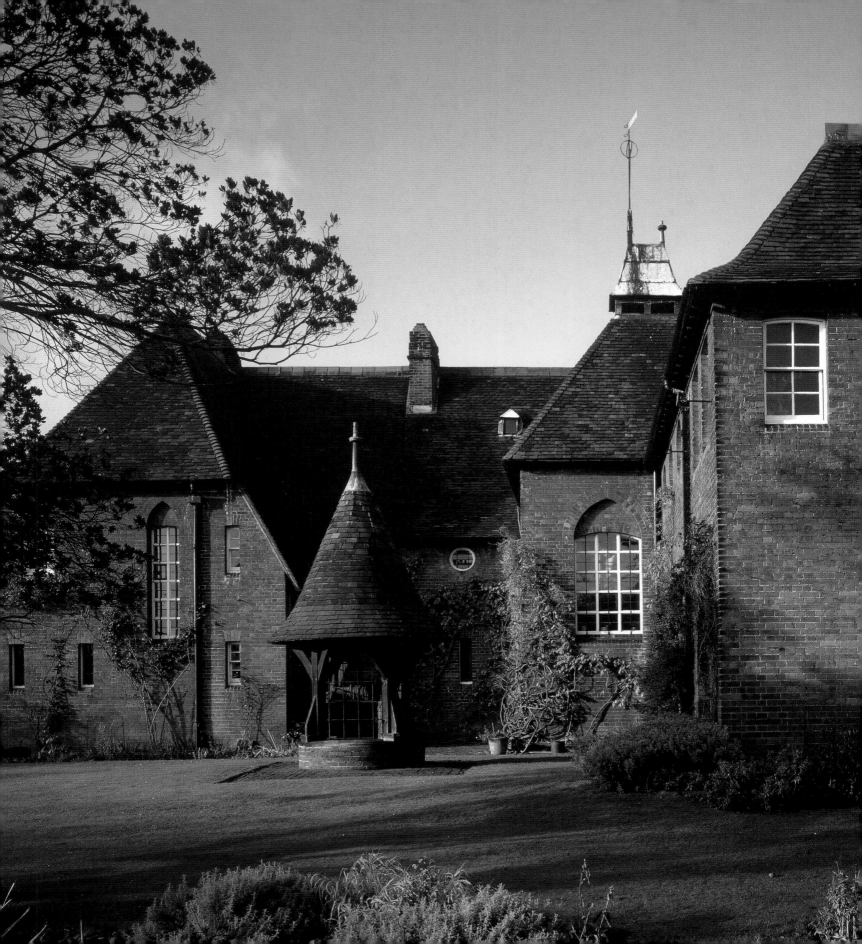

EMBRACING THE VERNACULAR

"The Englishman builds his house for himself alone. He feels no urge to impress, has no thought of festive occasions or banquets and the idea of shining in the eyes of the world through lavishness in and of his house simply does not occur to him. Indeed, he even avoids attracting attention to his house by means of striking design or architectonic extravagance, just as he would be loth to appear personally eccentric by wearing a fantastic suit. In particular, the architectonic ostentation, the creation of 'architecture' and 'style' to which we in Germany are still so prone, is no longer to be found in England. It is most instructive to note … that a movement opposing the imitation of styles and seeking closer ties with simple rural buildings, which began over forty years ago, has had the most gratifying results."

HERMAN MUTHESIUS, *The English House*, 1905

Above: *Lead hopper at Baillie Scott's Blackwell, showing the date 1900, and the initials of his client, Edward Holt.*

THE ARTS AND CRAFTS MOVEMENT was initially founded upon a strong love of England and all things English, and nowhere is this more readily apparent than in the architecture of the period. A single house—Red House, built at Upton in Kent in 1859 for William Morris by his friend Philip Webb—broke the classical mold, embraced the vernacular, and began a revolution in domestic architecture. For the next half century it pointed the way for succeeding generations of architects who were keen to put function first, to relate their buildings to the landscape, and to build them from carefully selected, often local, materials.

Red House is a deeply pleasing, asymmetrical, L-shaped house, built of warm red brick in a scaled-down Gothic style. It incorporates a great arched entrance porch and steep irregular gabled roofs topped with tall idiosyncratic chimneys and a weathervane ornamented with the initials W M. It was never a grand house, but capacious and comfortable, with a hint of fantasy. Webb's design provided four good bedrooms, another tiny one, and a partitioned dormitory for the cook and two maids at the far end of the western wing. Narrow stairs led down from this to the kitchen and scullery, while a magnificent oak staircase with tapered newelposts guided guests up from the deep expansive

Left: *"More a poem than a house"—Red House, designed by Philip Webb in collaboration with William Morris in 1859, helped to change the direction of English domestic building and proved enormously influential.*

entrance hall to the upper rooms, including the drawing room with its high arched ceiling, ribbed with beams, that extended right up into the roof space, and the adjacent light-flooded studio, with its views across orchards and the rolling Kent countryside.

The house represents a stunning collaboration between an architect and an artist and has been called the first Arts and Crafts building, designed by the man credited with having provided "the movement's morality and theory." Webb designed his buildings "as they should be" from the inside out, considering first the functional interior relationships of rooms to corridors and stairwells. He adhered to Pugin's principle of fidelity to place, linking it with the Ruskinian notion of fidelity to function to form the basis for a new national style.

The importance of Augustus Welby Northmore Pugin in tracing the trajectory of Arts and Crafts architecture cannot be overestimated. "But for Pugin," the architect John Dando Sedding admitted in 1888, "we should have had no Morris, no Street, no Burges, no Shaw, no Webb, no Bodley, no Rossetti, no Burne-Jones, no Crane." Though he died at the early age of forty, Pugin designed more than a hundred buildings, most of them churches. A passionate Catholic convert, his vision of Christian architecture, which harked back to the Middle Ages and Gothic asymmetry, came to underpin the Arts and Crafts style. The beauty of a building depended for Pugin on "the fitness of the design to the purpose for which it is intended." His three basic rules for architecture were: structural honesty, originality in design, and the use of regional materials or character.

The writings of Pugin and Ruskin had a profound effect on mid-Victorian architects such as William Butterfield and George Street, in whose Oxford office Philip Webb trained as an architect, forged his friendship with William Morris, and developed the understanding of Gothic architecture and ornament that would characterize his work. Street's office proved an important seed-bed for the movement, fostering not just Webb, but also John Dando Sedding, the leading ecclesiastical architect, and Richard Norman Shaw, the pioneer of the Queen Anne style, whose separate practices provided stimulating starting points for a number of important Arts and Crafts figures. Sedding could boast a roll call at his Oxford Street office that included Henry Wilson, Arthur Grove, W.R. Butler, Alfred H. Powell, and two members of the Cotswold group: Ernest Barnsley and Ernest Gimson. Meanwhile Shaw, who encouraged individuality and was generous about setting his former pupils up with work when they were ready to leave, provided the platform for Mervyn Macartney, William Lethaby, Sidney Barnsley, E.J. May, Ernest Newton, Gerald Horsley, Robert Weir Schultz, and Edward Prior, an ardent disciple of Morris. Prior was responsible for the highly original Arts and Crafts masterpiece of St. Andrew's church at Roker, Sunderland, and for introducing the "X" or "butterfly" plan in his layout of The Barn, a house built on a hill overlooking Exmouth, Devon, in 1897. Prior's curving plan offered an alternative to the popular L-shape and became an important feature of Arts and Crafts

Above: *E.S. Prior used a "butterfly" layout for The Barn at Exmouth in Devon in 1897, curving the front of the house in an open-armed welcoming gesture.*

architecture, adapted most notably by Edwin Lutyens in Papillon Hall in Leicestershire (1903–4). It was also used to great effect by Detmar Blow at Happisburgh Manor in Norfolk (1900).

Shaw—almost an exact contemporary of Webb—had a huge output and often pandered to the tastes and fashions of the *nouveaux riches*, producing dramatic and impressive country houses in a deliberately asymmetrical "Old English" style and elegant London town houses in a broad "Queen Anne" style, with elegant Palladian touches or Dutch gabling. He thought Webb—who shunned publicity and survived on the patronage of a few sympathetic clients—"a very able man indeed, but with a strong liking for the ugly."

Standen, a gracious country house built near East Grinstead in Sussex in 1894 for the successful solicitor James Samuel Beale, is generally considered to be Webb's masterpiece, but before that came Clouds, the "palace of art" he designed as a country seat for the Conservative MP and aristocrat Percy Wyndham and his wife Madeline at East Knoyle in the south-west corner of Wiltshire. Famously conscientious about his work, and busy at the time with Rounton Grange for Sir Isaac Lowthian Bell, Webb was at first reluctant to accept the commission. As his assistant, George Jack, explained, "He would never undertake more work at one time than he could personally supervise in every detail," even though "had he desired he might have built many more houses." Money was never a motivation; his average earnings over forty years, during which time he completed between fifty and sixty buildings, totaled a mere £380 a year. "I do not lay myself out to work for people who do not in any

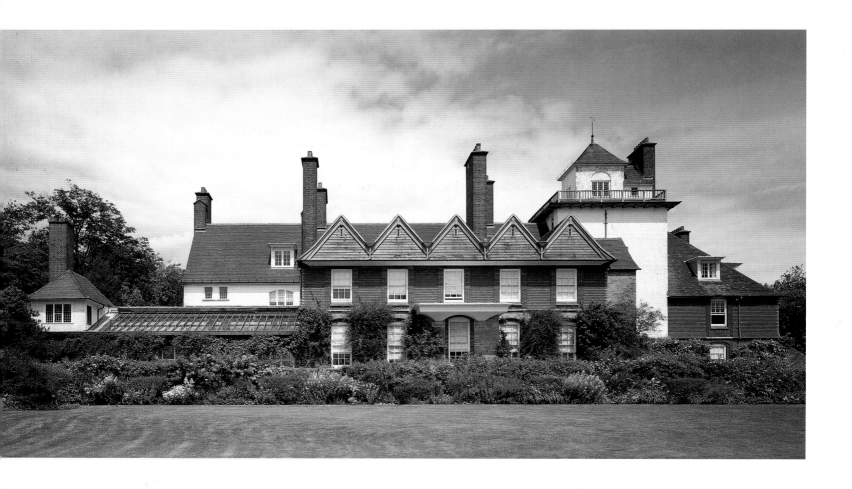

Above: *Standen in West Sussex, designed by Philip Webb for the solicitor James Beale in 1891–4.*

degree want what I could honestly do for them," he wrote warningly to Wyndham, who knew of his work through the tall red-brick town house at 1 Palace Green, Kensington, which Webb had designed for his friends George and Rosalind Howard. Wyndham believed that in Webb he had found the architect for his "house of the age" and would not accept no for an answer.

The relationship between a house and its setting was a matter of paramount importance to all Arts and Crafts architects. Webb wanted Clouds, despite its monumental size, to appear as if it grew up out of the landscape. He ended up working on it for almost ten years, a period extended by the disaster that befell it soon after its completion when—owing to the carelessness of a maid who had left a lighted candle in a cupboard—the house burned down. It was rebuilt, again by Webb, within two years of the tragedy. His attention to detail was famous. He even made a note of the height of the Wyndhams' head gardener—an exceptionally tall man called Harry Brown—so that he could take this into consideration when designing the doors in the garden walls at Clouds. A committed socialist like William Morris, Webb allowed for coal bunkers on the first- and second-floor landings

of the house to make the lives of the servants easier. Owing to the wildly fluctuating fortunes of the Wyndham family after World War I, "the house of the age" has had a rather checkered history, serving at different times as a home for unmarried mothers and a center for the treatment of alcohol and drug dependency. Although much reduced, the ornate plasterwork ceiling, the fireplaces, dadoes, and Della Robbia plaques all survive, incongruous among the institutional furniture.

Standen has fared rather better and, under the careful stewardship of the National Trust, has become a much-visited shrine to the Arts and Crafts movement. More modest in style and form than Clouds, and much less formal, it is built on a long, thin L-shaped plan and assumes an almost "cottagey" simplicity through its use of local materials and techniques, varied coloration, textures, and tidy, weatherboarded, gabled roofs. Webb linked the new house to an existing fifteenth-century farmhouse, Hollybush Farm, and one of its timber barns, using a prominent tower to serve as a transition between the rambling service wing and the symmetrical main block, and planned the gardens and grounds with the same careful attention he gave to the house, preserving as many old trees as possible. "To Webb," wrote W.R. Lethaby, his first biographer and great admirer, "the fields and old buildings of England were a question of quite religious moment."

Below: *Arthur Melville's watercolor of the garden front at Standen, painted in 1896.*

Above: *Melsetter House, Hoy, designed by W.R. Lethaby for the Birmingham businessman Thomas Middlemore in 1898.*

Soft, creamy Sussex stone was quarried from the estate and interspersed with gray Portland stone, which Webb used for the window sills, and the hard red Keymer bricks framing the arches and window surrounds. The result was a house that appeared "to have been built up bit by bit, almost unconsciously."

"Architecture to Webb," Lethaby explained, "was first of all a common tradition of honest building. The great architectures of the past had been noble customary ways of building, naturally developed by the craftsmen engaged in the actual works. Building is a folk art. And all art to Webb meant folk expression embodied and expanding in the several mediums of different materials. Architecture was naturally found out in doing...."

W.R. Lethaby, a pivotal figure in the Arts and Crafts movement who left Shaw's office in 1889 to set up on his own, greatly admired Webb's respect for tradition, functional form, and treatment of materials. He, however, strove to combine romanticism with traditional design and achieved it at Melsetter House, built for a retiring Birmingham businessman, Thomas Middlemore, on Hoy, Orkney, in 1898. Morris's daughter May described Melsetter as "a sort of fairy palace on the edge of the great northern seas, a wonderful place ... remotely and romantically situated with its tapestries

Left: *The exterior of the Church of All Saints, Brockhampton, Herefordshire, by W.R. Lethaby, 1901–2, hailed by Nikolaus Pevsner as "one of the most convincing and most impressive churches of its date in any country";* **Below:** *The uplifting interior of the church.*

and its silken hangings and its carpets … the embodiment of some of those fairy palaces of which my father wrote with great charm and dignity. But, for all its fineness and dignity, it was a place full of homeliness and the spirit of welcome, a very lovable place. And surely that is the test of an architect's genius: he built for home life as well as dignity."

Hermann Muthesius, the German cultural attaché who made a particular study of Arts and Crafts buildings, was a great admirer of Lethaby. "The number of his houses is not large," he remarked, "but all appear to be masterpieces." Lethaby's last work, the Church of All Saints, Brockhampton, Herefordshire (1901–2) has been called "one of the greatest monuments of the Arts and Crafts movement." It is a deeply romantic, thatched, barnlike building, constructed of local red sandstone with a weatherboarded bell tower and a square stone crossing tower. Inside, the high pointed arches of the concrete vaulted nave spring from just above floor level, creating a scaled-down cathedral-like sense of calm and beauty. Lethaby, like other progressive Arts and Crafts architects, sought and found inspiration in traditional buildings that were not designed by architects—"old work" as Baillie Scott described them, that embodied "a certain aesthetic rightness and beauty expressed in practical ways."

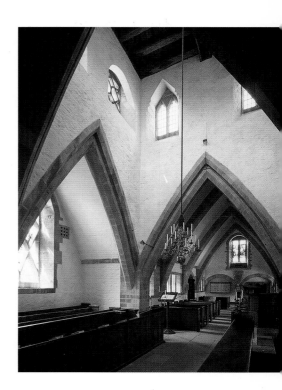

"It is not until we get back to the work of the earlier builders," M.H. Baillie Scott wrote, "that our hearts are touched and thrilled by the strange charm of the building art as then practised." He and other leading Arts and Crafts architects, such as Charles Voysey, C.R. Ashbee, Edwin Lutyens, Raymond Unwin, and Barry Parker, stressed the need for simplicity and aimed to design houses and churches that enhanced rather than dominated their surroundings, combining features from old work found in houses, museums, and churches with contemporary design. They chose to make their buildings from indigenous materials and strove above all to follow local traditions—using stonework in the Cotswolds, pargetted plasterwork in Essex, tile-hanging in Kent, and roughcast in the Lake District—for both economic and aesthetic reasons. They also spearheaded a revival of traditional construction methods, interesting themselves in the details and techniques of crafts such as ornamental plasterwork, ironwork, carving, and sculpting so that their designs could be fully integrated. Unpretentious simplicity and harmony were the keynotes of the Arts and Crafts house.

Plainly, it was an exciting time to be an architect. In Britain, the doubling of the population during the reign of Queen Victoria, rapid strides in industrialization, and the burgeoning of the middle classes had prompted a building boom and ushered in a golden age for architecture. Commissions for all sorts of houses, from gracious country homes to a new form of housing—the semidetached villa—were plentiful. Between 1898 and 1903 an average of 150,000 houses were built each year. Most of these were standard Victorian terraces, much reviled by Baillie Scott who suggested that they should be renamed "The Crimes" for their lack of imagination, light, and cramped conditions. However, the Garden City movement offered a more attractive counterbalance and plenty of work for socially minded progressive young architects.

Architecture was, above all, a respected and valued profession, conferring a privileged status in British society and attracting many able, public-spirited recruits. The usual method of training was the pupilage system, whereby artistically and technically inclined young men (women were very rare, although two—Ethel Mary Charles and her sister Bessie Ada—trained in the office of Ernest George and Harold Peto and became the first women members of the Royal Institute of British Architects in 1898 and 1900 respectively) were placed in the architectural offices, generally in London, of established practitioners. If they were lucky, they were encouraged "to look beyond the confines of the drawing board," but were certainly urged to visit museums and churches, and to spend their weekends and free time touring the Kent, Sussex, Gloucestershire, and Shropshire countryside, gathering ideas and inspiration by filling their sketchbooks with vernacular subjects: traditional brick and tile-hung buildings, hipped-roofed cottages, sundials, oak pegging, and architectural details on old churches. It was common practice for articled pupils to attend lessons three evenings a week at the South Kensington Schools, Royal Academy Schools, or the Architectural Association.

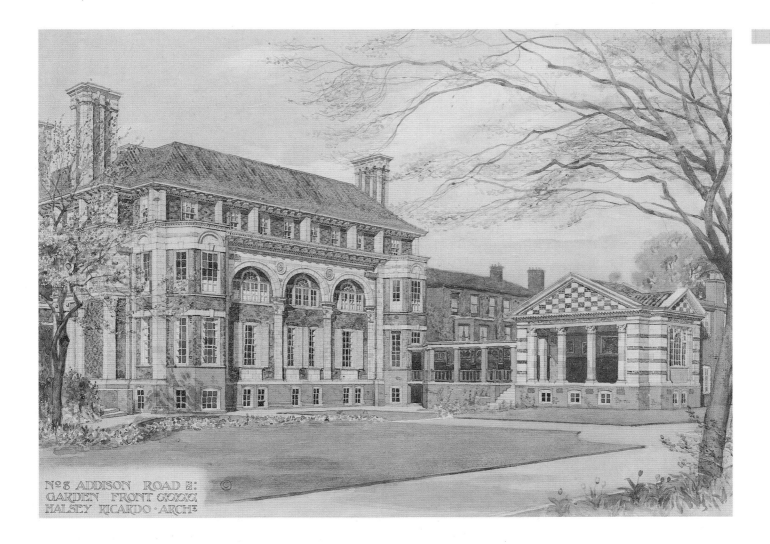

No 8 ADDISON ROAD W:
GARDEN FRONT
HALSEY RICARDO · ARCHTS

It was William Morris himself who advised the young Ernest Gimson to move to London, giving him a letter of introduction to J.D. Sedding, who accepted him at once. Sedding communicated his enthusiasm for a range of activities—he also designed wallpapers, embroidery, and church metalwork, and was proficient in various other traditional building crafts—to the young Gimson and to Ernest Barnsley (whose brother was learning his trade in that other Arts and Crafts nursery, Richard Norman Shaw's office).

Gimson was always interested in traditional crafts, including decorative plasterwork, woodturning and chair-making. He carried out a complex scheme of plaster decoration in the main rooms of two houses designed by Lethaby: Avon Tyrrell in Hampshire (1891) and The Hurst, near Sutton Coldfield (1893). His friendship with the architect Halsey Ricardo also provided him with plasterwork commissions, including the ceiling decorations for the dazzling new department store of Debenham & Freebody's in Wigmore Street, London, and the exotically decorated Arts and Crafts house at 8 Addison Road, Kensington, for which Gimson provided the plasterwork, William

Above: *A pencil and watercolor sketch by Thomas Hamilton Crawford, 1907, of 8 Addison Road, Kensington, London, designed by Halsey Ricardo for Sir Ernest Debenham.*

De Morgan the ceramic tiles, E.S. Prior the stained glass, and the Birmingham Guild of Handicraft the ironwork. Gimson's sketchbooks from the 1880s show details of traditional farm buildings and furniture as well as measured drawings of churches and country houses. Committed to the ideal of the simple life, Gimson, like Morris, believed in "doing not designing" and his stone cottages in Leicestershire and the Cotswolds demonstrate his commitment to forging a new architecture that used local building traditions. They remain, for some, the most perfect realization of Arts and Crafts theory. In 1915 he built a pair of cottages at Kelmscott in Oxfordshire for May Morris and also designed the village hall—though it was not actually built until 1933. He was also responsible for the library and hall at Bedales School in Hampshire (to which Sidney Barnsley sent his children).

Ernest Barnsley, who also built his own home at Sapperton, is best known architecturally for Rodmarton Manor in Gloucestershire, a honey-colored, multigabled, mullioned, Arts and Crafts masterpiece that he worked on from 1909 until his death in 1926. C.R. Ashbee, who visited the works

Below: *Stoneywell Cottage, designed by Ernest Gimson for his brother Sydney, 1898–9, on an irregular plan, incorporated crooked chimneys, rough, hand-cut stonework, and a thatched roof.*

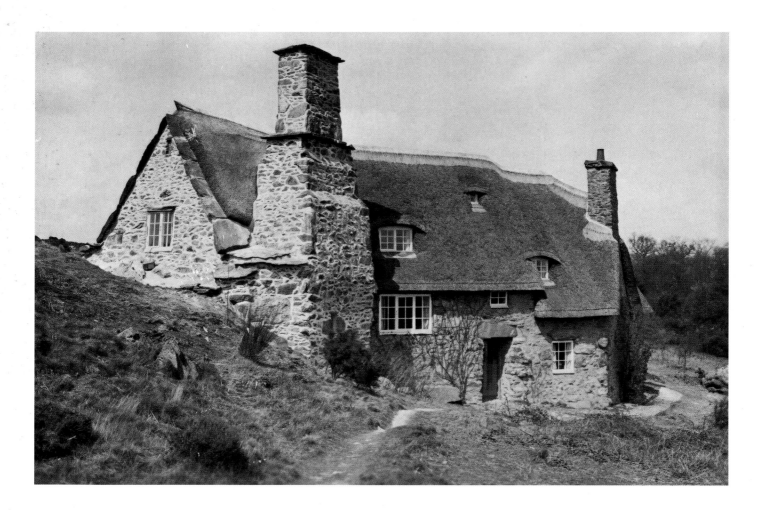

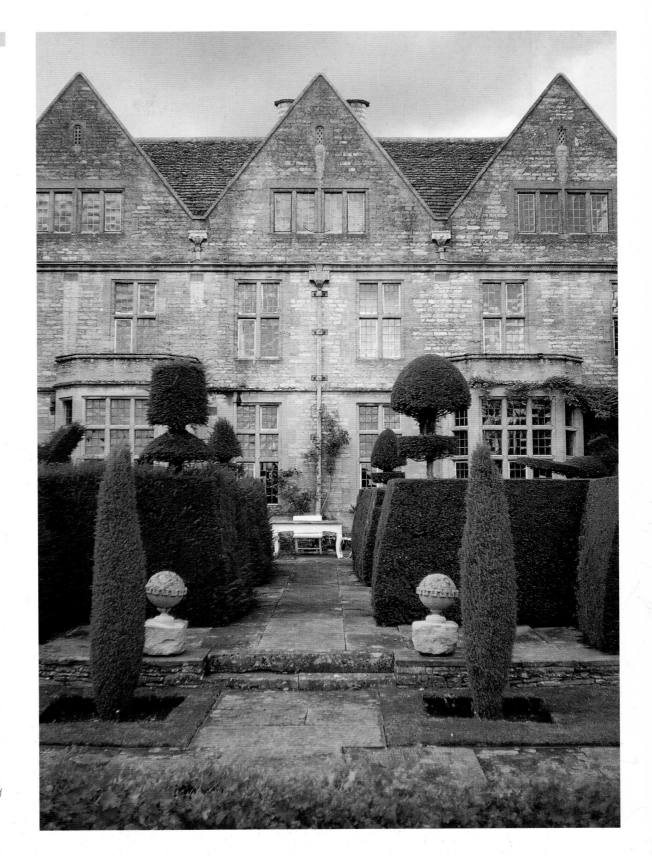

Right: *Rodmarton Manor, Gloucestershire, designed by Ernest Barnsley, was built by hand in strictest Cotswold tradition over a twenty-year period from 1909 to 1929; the house was finally completed by Norman Jewson after Barnsley's death.*

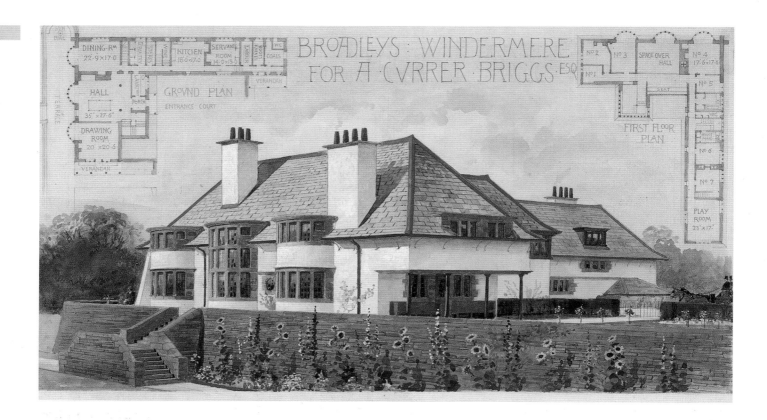

Above: A presentation drawing from 1898 by Howard Gaye, depicting Broadleys, a holiday home overlooking Lake Windermere, designed by C.F.A. Voysey for A. Currer Briggs.

in 1914, called the house "the English Arts and Crafts movement at its best." Barnsley's aim to preserve the original character of typical Cotswold buildings is evident in his design for a pair of cottages bordering Sapperton Common, and it was shared by his brother, Sidney, whose terrace of almshouses and public baths at Painswick showed the same respect for historical buildings and vernacular traditions.

Another Arts and Crafts luminary (now best known for his jewelry) who began work in Sedding's office in 1888 was John Paul Cooper. He was apprenticed there on the advice of W.R. Lethaby, who recommended Sedding to Cooper's father as "the best man in London … he's quite out of the ordinary run of architects, full of enthusiasm, very clever … your son cannot do better." That year represented the height of the Arts and Crafts movement in Britain and Cooper found Sedding's office congenial and quite different from other architectural practices. "Sedding was much too original to please the other architects," he wrote in his journal, "& we followed him in excess & looked upon the Academy [Royal Academy of Art] the Institute [RIBA] and the Architectural Association as composed of old fogies, without any life in them." It was a great blow to them all when Sedding, who is best remembered for two London buildings—the richly decorated Holy Trinity Church in Sloane Street and the Church of the Holy Redeemer in Clerkenwell—died suddenly of influenza in 1891.

One important Arts and Crafts practitioner who did not come down through the Street/Sedding/Shaw line was Charles Francis Annesley Voysey. He trained in the offices of J.P. Seddon and George Devey, but established himself first as a designer of wallpapers and furniture in

the 1880s—joining the Art Workers' Guild early in 1884—before receiving his first building commissions in the 1890s. His childhood had been turbulent and overshadowed by his curate father's trial for heresy and eventual expulsion from the church, a *cause célèbre* from which Voysey learned some valuable, if uncomfortable, lessons about press attention. In his professional life he was always careful to manipulate the press to his advantage. A clever self-promoter (the antithesis, in fact, of that other great genius Charles Rennie Mackintosh), he commissioned and directed photographs of his houses both in progress and finished, providing them at his own expense to magazine editors, whose subsequent publication of them bestowed on him a sort of celebrity status as an artist-architect. Like Mackintosh, he was ahead of his time and had definite ideas about the nature of the home and the importance of harmony and repose. He became a master of "artistic" cottages and smaller country houses. His houses—such as The Orchard (1899), which he built for himself in Chorleywood, Hertfordshire, and Broadleys (1898), built for Arthur Briggs on a spectacular site overlooking Lake Windermere in Cumbria—with their low roofs, wide eaves, horizontal windows, white roughcast walls, and exposed beams and brickwork, were built to high standards from plain, good-quality materials and were meant to look as if they were part of the natural environment. He was known for his rigorous attention to detail and for the subtlety of

Below: *Sir Edwin Lutyens' Little Thakeham in West Sussex is now a country house hotel.*

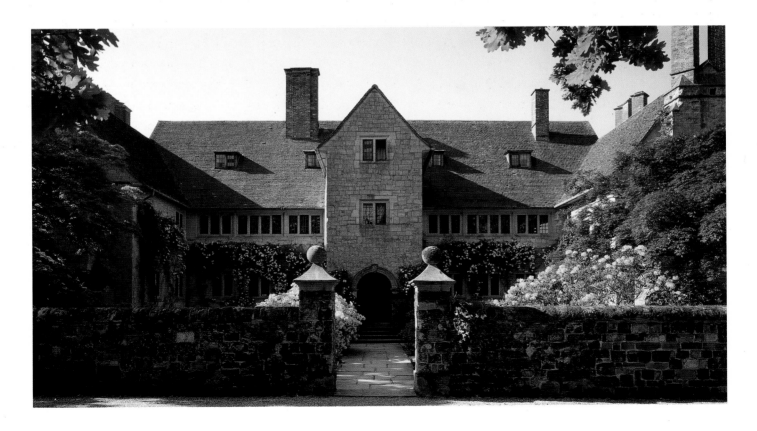

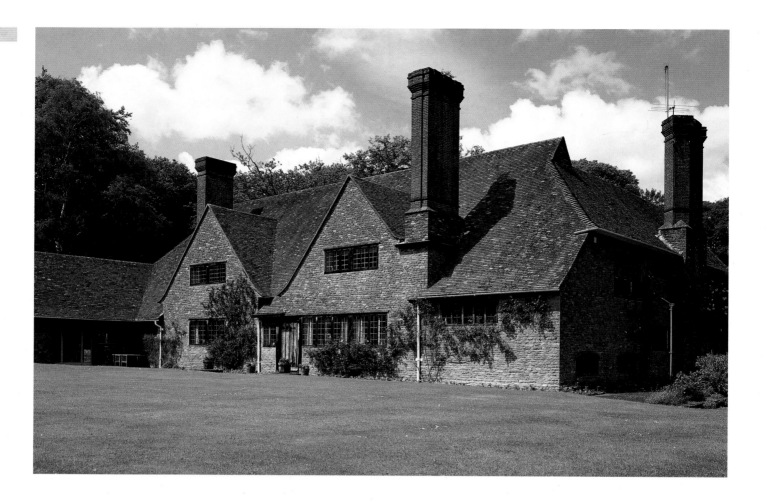

Above: *Munstead Wood, designed by Sir Edwin Lutyens for Gertrude Jekyll in 1896.*

proportion and simplicity of form in his work. Candor, comfort, restraint, and clean lines were hallmarks of a Voysey building, and he constantly repeated his view that "we cannot be too simple." He wanted his buildings "to play into the hands of nature" and, although his practice was comparatively small, the notice his work attracted—in *The Architect, The British Architect, The Studio*, and other Arts and Crafts publications devoted to the modern home and cottage—ensured it was seen by and influenced a generation of younger architects.

Young upcoming men such as Edwin Lutyens saw in Voysey's buildings "the absence of accepted forms … the long, sloping, slate-clad roofs, the white walls clear and clean … and old world made new." Hermann Muthesius also recognized his innovation: "In both interiors and exteriors he strives for a personal style that shall differ from the styles of the past. His means of expression are of the simplest so that there is always an air of primitivism about his houses."

Edwin Lutyens was fortunate in his first client, Gertrude Jekyll. They met in the spring of 1889, "at a tea-table, the silver kettle and the conversation reflecting rhododendrons," as Lutyens described it. She was forty-five, an accomplished painter, silverworker, and embroiderer whose failing eyesight had prompted a move into garden design—an area in which she was beginning to

establish quite a reputation. He was twenty and had already, a month before their meeting, precociously set up his own architectural practice. They shared a love of vernacular architecture and spent time together visiting old farms and cottages in Surrey and Sussex around Munstead House, where Jekyll was then living with her mother and just starting to lay out her famous garden on a fifteen-acre plot across the road from her family home. When, a few years later, she decided to build a house to go with the garden, Lutyens, with whom she was already collaborating, was the obvious choice. She wanted a relatively simple house "designed and built in the thorough and honest spirit of the good work of old days"—a house she could "live in and love." Lutyens gave her Munstead Wood, his finest work in a style based on the Surrey vernacular, picturesquely inspired by the cottages and farmhouses they had visited. It was relatively small by the standards of the day, with four main bedrooms upstairs and a living hall, dining room, book room, workshop, and office below. Firmly in the Arts and Crafts tradition, the walls are made of local Bargate stone and the roof of handmade red tiles. The interiors are solid and unpretentious: the ceilings are low and oak-beamed, and the windows are leaded to keep out the sunlight that was so injurious to Jekyll's eyesight. The oak staircase rises in broad, shallow steps to the half-timbered gallery that gives on to the bedrooms above.

Munstead Wood secured many future commissions for Lutyens and became "a mecca for Arts and Crafts architects." Among them was the Scottish architect Robert Lorimer, who visited in 1897 and reported on the newly completed house, "It looks so reasonable, so kindly, so perfectly beautiful that you feel that people might have been making love and living and dying there, and dear little children running about for the last—I was going to say, thousand years, anyway six hundred. They've used old tiles which of course helps but the proportion, the way the thing's built (very long coursed rubble with thick joints and no corners) suggests in fact it has been built by the old people of the old materials in the old 'unhurrying' way but at the same time 'sweet to all modern uses'."

Lutyens was a magpie, collecting and then overlaying his own designs with stylistic quotations from contemporary as well as historical sources, brilliantly synthesizing the ideas he gathered from his contemporaries, while responding to and incorporating the needs and requirements of his affluent clients. Homewood at Knebworth, Hertfordshire, for example, built in 1901 for Lady Lytton, owes much to Philip Webb's Standen period, though in his later work Lutyens moved away from the informality of Arts and Crafts toward a new, though often quirky, grandeur. His houses often have two dissimilar sides, one masking the other: a formal front perhaps with a vernacularized domestic garden side at the back—as in Tigbourne Court (1899) in Witley, Surrey, his "gayest and most elegant building"—or the weatherboarded, gabled cottage-style front at Homewood, which, from the rear, presents as a stuccoed classical villa. One way in which his work is particularly important is the way in which the house relates to the garden. He would often extend the geometric structure of the

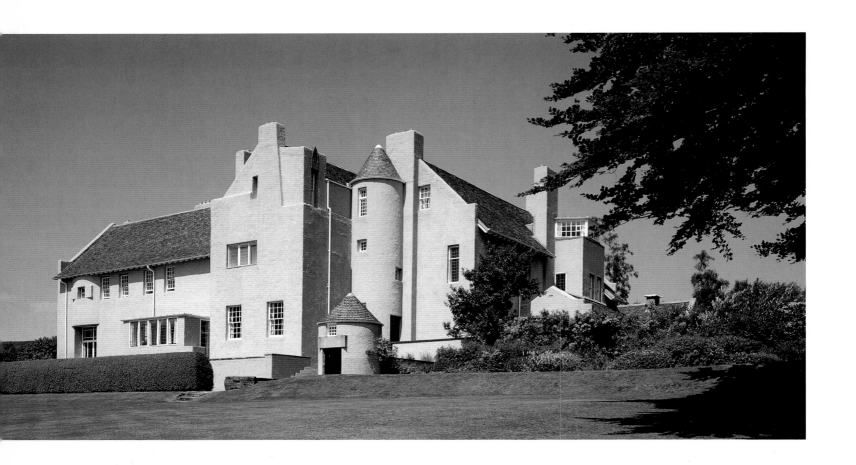

Above: *Hill House, Upper Helensburgh, designed by Charles Rennie Mackintosh for the Scottish publisher William Blackie, 1902–4.*

house out into the garden, or he might use the garden elements to fortify and ennoble the house as metaphoric castle. The influence of his early studies, in the company of Gertrude Jekyll, of vernacular buildings around his home at Thursley in Surrey, cannot be overestimated in his development as one of the most important and sought-after country-house architects of the period.

Another young architect upon whose work the influence of Voysey can be felt is Charles Rennie Mackintosh, the great architectural genius to come out of Scotland during this period. His ideas were loudly applauded abroad, especially in Europe, where his avant-garde style was best appreciated. He exhibited with the Vienna Secession artists in their eighth exhibition in 1900 and in 1902 he designed the Scottish pavilion for the Esposizione Internazionale in Turin. Yet recognition in his home town of Glasgow was slow to come. His work was considered eccentric. Some thought the tea-rooms he designed for Catherine Cranston were a joke, and found the Glasgow School of Art (1897–1909)— which has since been hailed as the first truly modern building—too extreme to comprehend. Fortunately the building had impressed the prosperous publisher William Blackie, who commissioned Mackintosh to build him a country house on a site at Upper Helensburgh overlooking the Firth of Clyde. The massive gray walls and circular tower of Hill House, punctuated by irregular windows of varying size and shape, are finished in roughcast rendering topped by roofs of dark blue-gray slate, intended to harmonize, better than any red roof tiles, brick or timber could, with the

Scottish landscape and climate. The monumental effect of the exterior is confounded by the bold geometrical elegance of the interior.

Mackintosh believed that "all great and living architecture has been the direct expression of the needs and beliefs of man at the time of its creation." He wanted to "clothe modern ideas with modern dress" and have "designs by living men for living men." Voysey's simplicity and clear lines exerted an important influence on Mackintosh's early career and the impact of Baillie Scott can also be traced, but his genius resides in his ability to create buildings and spaces that are wholly his own, expressing his own distinctive artistic language.

Tragically, Mackintosh's architectural star was to burn only briefly, eventually extinguished by the neglect that followed his professional decline, as his reputation for unreliability, eccentricity and drinking, put potential clients—already suffering the effects of the economic slump occasioned by the advent of World War I—off commissioning such an uncompromising and individual architect. Flashes of genius are glimpsed in the few commissions he did manage to attract in his later years, but he was to die in poverty and obscurity in London, unremarked by the profession or his native city.

Below: *Blackwell at Bowness on Windermere, designed by M.H. Baillie Scott as a rural holiday retreat for the Manchester brewery owner Sir Edward Holt and his family, 1898–1900.*

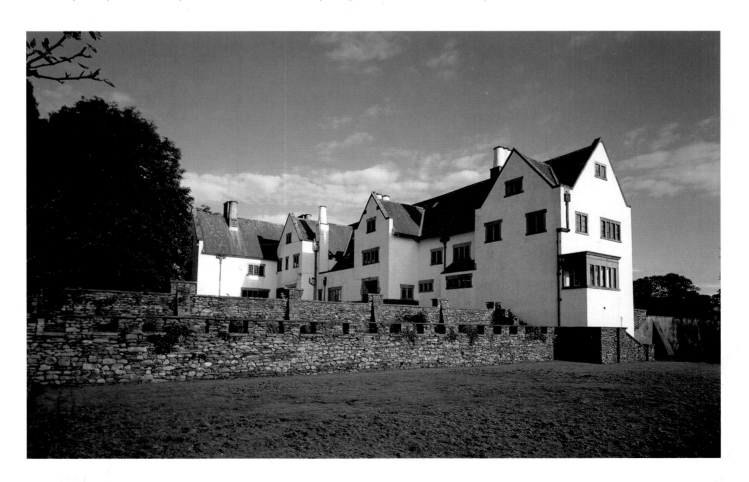

Some of the finest Arts and Crafts buildings were small-scale, livable, and affordable homes for a newly prosperous professional class. For the Arts and Crafts architect, as we have seen, beauty resided in line, proportion, texture, workmanship, and most of all in appropriateness. The importance of integrating the designs of furnishings and buildings was paramount, and indulgence in ornament for ornament's sake was anathema. One architect who concerned himself almost exclusively with the smaller country house and its furniture was M.H. Baillie Scott, that fierce critic of town housing, which he lambasted for its endless repetition of identical rooms, "so that an absent-minded occupant of one of them might be excused in entering his neighbour's house in mistake for his own, and would find little in its interior arrangements to undeceive him."

Baillie Scott did not train in an Arts and Crafts practice, he never met William Morris, and he did not belong to the Society for the Protection of Ancient Buildings or the Art Workers' Guild, but the refreshing spirit of the Arts and Crafts ideal is embodied in his country houses, such as Blackwell in Cumbria and White Lodge in Oxfordshire (1898–9), and in his Garden City cottages. Like Voysey, he was at his best when working with small buildings. He sought to achieve "a spirit of repose" in his simple and uncluttered spaces, often leading off a generously proportioned central hall with a corner fireplace inglenook and built-in seating. By reviving the idea of the hall-house, Baillie Scott reignited Morris's notion of the medieval hall "where the house itself was the hall and served for every function of domestic life." Instead of acting as an entry point giving access to the staircase, Baillie Scott made the hall "a general gathering-place with its large fireplace and ample floorspace: no longer a passage … but a necessary focus to the plan of the house." He pioneered and mastered a new flow of space, breaking down the conventional divisions and making the interior, especially in smaller houses, seem more spacious and flexible. He designed, like Webb, from the inside out, treating the garden as a continuum of the house space and integral to it.

Baillie Scott began his practice on the Isle of Man, where he built a romantic house for himself and his family that he called, in obvious reference to William Morris, the Red House. Here he explored the possibility of opening up the living space. The three main rooms are separated by movable screens that allow for flexibility and transformation. Following the Arts and Crafts model he built in local materials that he knew would mellow with age. Unusually, he was also interested in mass housing—not the terraces he railed against, but more interesting, picturesque groupings, which he explored in his designs for the Garden City movement. These were realized in Hampstead Garden Suburb and at Letchworth, Hertfordshire, where individual houses of great charm, with his signature leaded casement windows and exaggerated fall of the eave line, can still be found. The Garden City movement has been called the ultimate expression of Arts and Crafts and of the revival in English domestic architecture—and Baillie Scott was in the vanguard.

He was among a number of Arts and Crafts architects employed by Henrietta Barnett, a tireless worker in the East End slums and wife of Canon Samuel Barnett, founder of Toynbee Hall, for her pet project: Hampstead Garden Suburb. Raymond Unwin, whom she instinctively felt was "the man for my beautiful green golden scheme," was made chief planner and Edwin Lutyens was appointed the Trust's consulting architect. Henrietta Barnett was not an easy client, though Unwin dryly reported that in seven years of working together they "reached a good understanding." She summarized her aims for the Suburb in an article in *Contemporary Review*: It was important that no house should spoil another's outlook, that the estate should be planned as a whole (although not in uniform lines), that each house should be surrounded by its own garden, and that every road should be planted with trees. She made ample provision for extra allotments and put in place cooperatives from which garden tools might be borrowed, as well as other communal meeting places: houses of prayer, a library, schools, a lecture hall, clubhouses, shops, baths, washhouses, bakehouses, refreshment rooms, arbors, cooperative stores, playgrounds for smaller children (whose noise was to

Above: *Rushby Walk, pioneer cul-de-sac terrace layout by Raymond Unwin for the Howard Cottage Society, c. 1906, at Letchworth Garden City in Hertfordshire.*

Above: *Waterlow Court, an Associated Home for Ladies in Hampstead Garden Suburb, designed by M.H. Baillie Scott in 1908–9, attracted an enthusiastic review from* The British Architect: *"Mr Baillie Scott has shown that our old type of almshouse design, built in quadrangular form, may be dealt with in a sensible modern spirit so as to make economical and artistic housing a possibility."*

be "locally limited"), and "resting places for the aged who cannot walk far." There was to be no public house, because of the strong influence of the Temperance movement, whose involvement was a cornerstone in her scheme to promote the physical wellbeing and moral rectitude of the poor.

Unwin drew inspiration from the Middle Ages and signaled it in the suffixes of the street names—close, way, chase, lea, holm, and garth—as well as in the "Merrie England" arrangement of village greens and in the grander medieval style of the shops with flats above, influenced by ancient German towns like Nuremberg and Rothenburg, that served the Suburb at its edges.

Henrietta Barnett was fortunate in employing some of the most distinguished Arts and Crafts architects of the period. Consequently, her development survives as a scale model of all that was best in the movement: from the serenity of Lutyens' St. Jude's Church in the central square, through the vernacular red brick, steep hipped-roofed, mullioned-windowed semidetached houses of Parker and Unwin to the radical reforming zeal of Baillie Scott's Waterlow Court, a group of two-room flats built around a medieval-style cloistered quad and intended specifically to house "the working lady" (a revolutionary concept in 1909).

Ironically, the Arts and Crafts tradition survived longest—though vulgarized and watered down—in suburban housing schemes, in which thousands of semidetached houses with half-timbered gables, lean-to porches, tile-hanging, and hipped roofs were put up by speculative builders in the interwar period. Such houses still line arterial roads in and out of British cities, leading Nikolaus Pevsner to complain bitterly of being "haunted by miles of semidetached houses mocking at Voysey's work."

A NEW ECLECTIC STYLE

THE ARTS AND CRAFTS IDEAL as exemplified in American architecture is based on an interpretation of the vernacular that varies widely in different areas of the country, drawing on Spanish missions, colonial mansions, and horizontal Prairie houses, and synthesizing timber-based buildings, such as Swiss chalets and Norwegian cabins, with the grace, economy, and apparent simplicity of Japanese landscaping and architecture to create a new, organic style imbued with a deep sense of place. This combination can be traced from Gustav Stickley's modest Craftsman houses, through the Arts and Crafts masterpieces of Greene and Greene, to the Prairie-school architecture of Frank Lloyd Wright, all of which demonstrate the same fidelity to place.

The philosophical father of the Prairie school—"the Arts and Crafts movement's manifestation in the Midwest"—was the great American architect Louis Sullivan. Sullivan, Wright, the Greene brothers, and Henry Hobson Richardson were perhaps the most influential American architects of the period. Richardson, a larger-than-life figure, egotistical and eccentric, used natural materials in his work—mostly unadorned stone and wood—and moved toward a new style that identified strongly with nature. He is best known for the towering Trinity Church on Copley Square in Boston, the Marshall Field Wholesale Store in Chicago and the austerely dramatic Glessner House, built for the Arts and Crafts devotees John and Frances Glessner on South Prairie Avenue, Chicago, in 1885–7. Richardson visited Europe and England where, in 1882, he met William Burges, William De Morgan, Edward Burne-Jones, and William Morris on two separate occasions: once in Hammersmith and later at the Firm's Merton Abbey works in Surrey. Morris called him "one of the few modern architects anywhere who have produced a distinctively original style." Richardson, pleased with his reception, wrote back to his wife praising Morris's "straightforward manner."

The quintessential Arts and Crafts men, though, were two brothers, Charles Sumner Greene and Henry Mather Greene, who absorbed the ideals of the movement on two visits to England in 1901 and 1909 and translated them into a series of stunning buildings in California. They had trained as architects at the Massachusetts Institute of Technology, but not before an innovative period of schooling at the new Manual Training High School in St. Louis run by Calvin

Below: *The Glessner House, designed by H.H. Richardson for John and Frances Glessner in 1885, was completed after the architect's untimely death in 1887.*

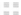

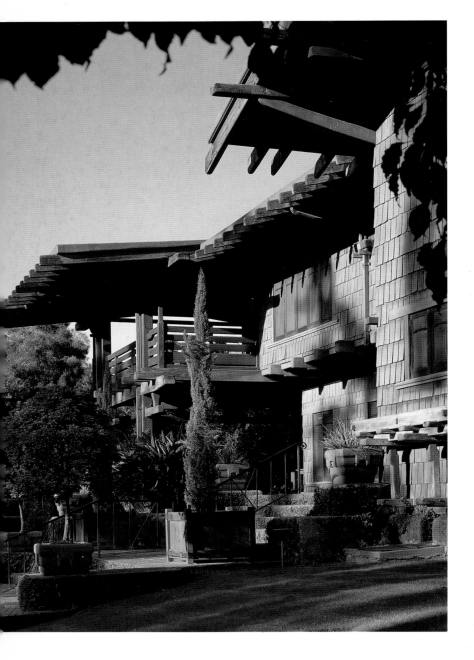

Milton Woodward, where, after a morning of academic studies, they spent the second half of each day learning metalworking, carpentry, and other trades. This stood them in good stead as both furniture designers and architects and is amply demonstrated in the visibly high quality and finish of their work. They set up their joint practice in Pasadena in 1903 at the precociously young ages of twenty-five and twenty-three respectively. By the time C.R. Ashbee paid them a visit six years later, business was flourishing and they were in a position to choose, from among a wealthy pool of queuing customers, the clients they felt would most respect their artistic vision and conviction. Ashbee thought they were "among the best there is in this country. Like Lloyd Wright," he observed in his diary, "the spell of Japan is upon him [Charles], he feels the beauty and makes magic out of the horizontal line, but there is in his work more tenderness, more subtlety, more self-effacement than in Wright's work. It is more refined and has more repose."

This serenity shines out from the "ultimate bungalows" designed between 1907–9 and in particular the Blacker (1907) and Gamble (1908) houses. There is a poetry about a Greene and Greene house: the romantic asymmetrical design, utilizing shingle, stone, and—notably—timber to create lovely buildings that sit low in the landscape, signaling their love of the pastoral. The refined simplicity of a Greene and Greene house offered its wealthy occupants sanctuary from the crude realities of industrialization. The broad overhanging roofs and generously proportioned balconies provided seclusion, shade, and subtle shadows from the projecting beams and rafters.

The New England architect Ralph Adams Cram was an enthusiast: "One must see the real and revolutionary thing in its native haunts of Berkeley and Pasadena," he wrote, "to appreciate it in all its varied charm and its striking beauty. Where it comes from heaven alone knows, but we are glad it arrived, for it gives a new zest to life, a new object for admiration. There are things in it Japanese; things that are Scandinavian; things that hint of Sikkim, Bhutan, and the vastness of Tibet, and yet it all hangs together, it is beautiful, it is contemporary, and for some reason or other it seems to fit California.... It is a wooden style built woodenly, and it has the force and integrity of Japanese

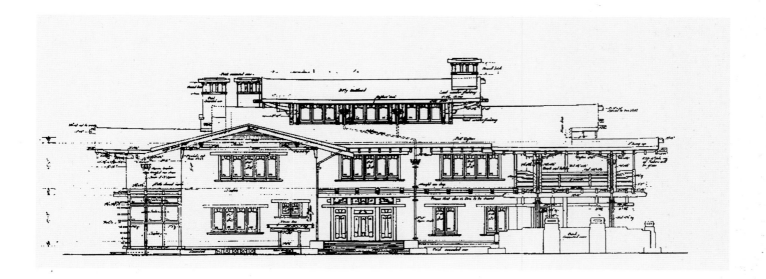

architecture. Added to this is the elusive element of charm that comes only from the personality of the creator, and charm in a degree hardly matched in other modern work."

The Gamble House, the great icon of American Arts and Crafts, was presented to the City of Pasadena and University of Southern California in 1966 and is now open to the public. Built for David Gamble (of the Proctor & Gamble Company) and his wife Mary on a secluded site on the outskirts of town, it was finished to the highest specifications. As with other commissions, the brothers also designed the garden, furniture, lighting fixtures, and stained glass, creating an astonishing and exciting monument to the Arts and Crafts movement. In March 1908 the *Pasadena Daily News* raved about the mahogany dining room, the teakwood living room, the oak used in the den, and the white cedar elsewhere. It detailed the five bathrooms, three luxurious sleeping porches, two enormous terraces, the garden, and the immense billiard room on the third floor, surrounded by windows on four sides. It salivated over "all the supplementary closets and cupboards known to modern convenience" and boasted about the large kitchen and butler's pantry.

The Greenes' houses were designed with the Californian climate in mind: cross-ventilated, with broad overhanging roofs to provide shade and wide balconies or porches for outdoor sleeping. "The idea," Henry Mather Greene explained in 1912, "was to eliminate everything unnecessary, to make the whole as direct and simple as possible, but always with the beautiful in mind as the first goal." They were fortunate in having wealthy clients, though occasionally Charles was obliged to defend his artistic decisions. "It is too much," he wrote to one client who had questioned the cost of construction of a

Above: *The drawings for the Gamble House were finalized in February 1908, work began a month later, and the house was completed in a little under a year.*

stone wall, "to expect that anyone may see the excellence of this kind of thing in a few days. The work itself took months to execute and the best years of my life went to develop this style.... Into your busy life I have sought to bring what lay in my power of the best that I could do for Art and for you."

Bernard Maybeck was another noted Californian Arts and Crafts architect, best known for the flamboyant First Church of Christ Scientist in Berkeley (1910), although his domestic buildings—Craftsman-like rustic dwellings influenced by Swiss chalets and English half-timbering—are notable examples of Arts and Crafts style. One such is Grayoaks (1906), the house he built for J.H. Hopps, a wealthy timber merchant who wanted a country house built on a heavily wooded stretch of land in Marin County. The house is relatively modest in size, with warm redwood as the dominant motif, used to panel the interior and clad the exterior. It was Maybeck, in whose office she worked, who encouraged Julia Morgan to study architecture, as he had, at the École des Beaux-Arts in Paris. One of only a handful of female American architects at the time, her version of Arts and Crafts architecture drew from a wide range of references, including Craftsman bungalows, Mediterranean influences, and Spanish colonialism.

Another Californian architect whose work owed much inspiration to the Spanish mission was Irving Gill, who was responsible for the Laughlin house (1907) and the very successful Dodge house (1916). "There is something very restful and satisfying to my mind," he wrote in *The Craftsman* in 1916, "in the simple cube house with creamy walls, sheer and plain, rising boldly into the sky, unrelieved by cornices or overhang of roof, unornamented save for the vines that soften a line or creepers that wreathe a pillar or flowers that inlay color more sentiently than any tile could do. I like the bare honesty of these houses, the childlike frankness, and the chaste simplicity of them."

In New England the Arts and Crafts message was translated by architects such as John Calvin Stevens and Albert Winslow Cobb into a free and democratized interpretation of the colonial styles of the earliest settlers. Describing a house they built in 1899 on the shore of Cape Elizabeth, near Portland, they talk of "the weathered field stone, the very color of the ledges out of which the building grows. The walls above the stone work are of shingles, untouched by paint, but toned a silvery gray by the weather." This harmonizing of a building with its surroundings is a central tenet of the Arts and Crafts creed and was taken up in Philadelphia by architects such as Wilson Eyre of the T-Square Club, who took their inspiration from Pennsylvanian farmhouses to create a new style of domestic architecture best exemplified by the William Turner house of 1907. Eyre initiated the publication of the periodical *House and Garden* in 1901 and acted as its editor for five years, featuring articles on the work of British architects including Lutyens, Lorimer, Prior, and Voysey, as well as showcasing his own work.

The Prairie school of architecture shared with the Arts and Crafts movement the idea of simplicity and respect for materials. A number of important architects are identified with the movement, which spanned the period from 1900 to World War I, including George Grant Elmslie, Walter

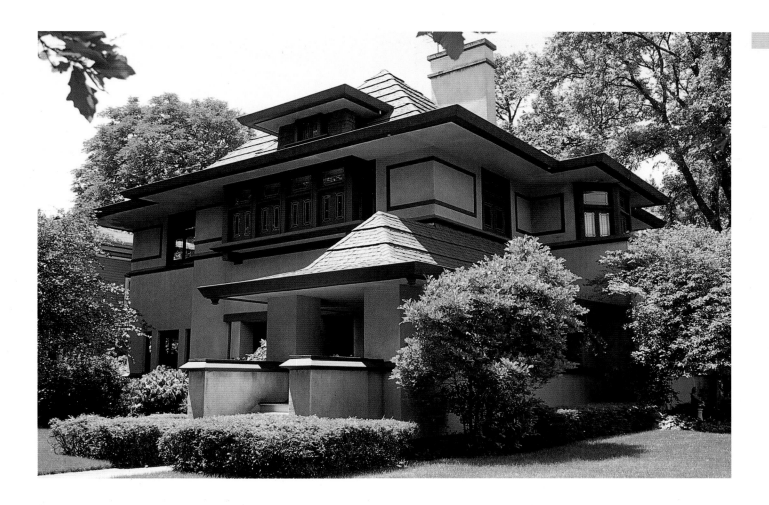

Burley Griffin, Francis Barry Byrne, Richard Ernest Schmidt, William Gray Purcell, Robert Closson Spenser Jr., William Eugene Drummond, Marion Mahony, Dwight Heald Perkins, John Shellette Van Bergen, Vernon Spencer Watson, Francis C. Sullivan, Parker Noble Berry, and Percy Dwight Bentley. Louis Sullivan, who believed in an "architecture of democracy", was its spiritual leader but Frank Lloyd Wright, the most versatile of American architects, would emerge as the genius and foremost exponent of the Prairie school. As an architect and designer he was a major influence on American Arts and Crafts architecture. Houses such as the Ward W. Willits house (1902), the Dana-Thomas house (completed in 1904 for the wealthy heiress Susan Lawrence Dana, bought by the Thomas Publishing Company in 1944, and now owned and restored by the state of Illinois), with their imaginative geometry, strong horizontals, long, ground-hugging profiles, and low overhanging roofs, reflect the flat geography of Illinois. Wright described his inspiration for the style: "We of the Middle West are living on the prairie. The prairie has a beauty of its own and we should recognize and accentuate this natural beauty, its quiet level. Hence, gently sloping roofs, low proportions, quiet sky lines, suppressed heavy-set chimneys, and sheltering overhangs, low terraces and out-reaching walls sequestering private gardens."

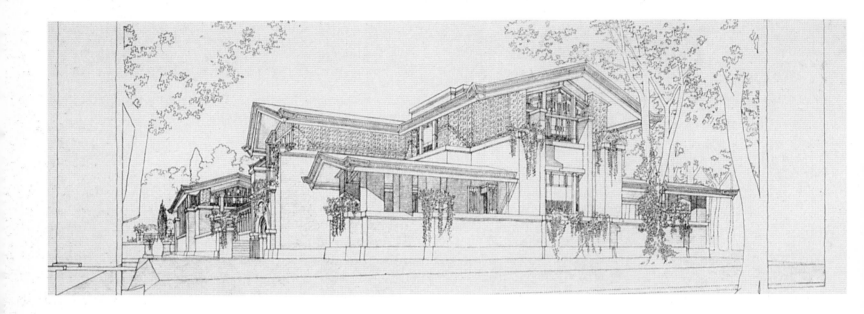

Above: *Frank Lloyd Wright's finished drawing of the east elevation of Susan Lawrence Dana's House. Construction began in the late summer of 1902, and the House was completed before Christmas 1904.*

Right: *The Dana-Thomas House, designed by Frank Lloyd Wright for Susan Lawrence Dana in 1904.*

He identified with the message of Morris—"All artists love and honor William Morris," he wrote—and, in 1897, helped to found the Chicago Arts and Crafts Society. John Ruskin's *The Seven Lamps of Architecture* was one of the first books he owned on the subject and he transmuted the Morris ideal into a twentieth-century idiom, employing a style that was starkly functional, relying on the geometry and juxtaposition of shape and form to create stunning buildings with revolutionary open-plan interiors, for which he would provide the furniture, light fittings, rugs, and patterned leaded-glass windows. Where he departed from the ideals of the British Arts and Crafts movement most markedly was in his attitude to the machine. "My God," he wrote in 1900, "is Machinery, and the art of the future will be the expression of the individual artist through the thousand powers of the machine—the machine doing all those things that the individual workman cannot do. The creative artist is the man who controls all this and understands it."

There is a masculine energy in Wright's work. Nikolaus Pevsner called him "a poet of pure form" in whose "gigantic visions, houses, forests, and hills are all one." His own home, built in Oak Park, Illinois, was a six-room Shingle-style bungalow that he designed for himself and his teenage bride Catherine Tobin in 1889, when he was just twenty-one years old, using $5,000 borrowed from his employer Louis Sullivan. By 1895, the addition of four active children encouraged him to extend the house and, along with a barrel-vaulted playroom, he added a new dining room and, three years later, a new studio complex. Designed as a showpiece to impress new clients, it had an octagonal double-

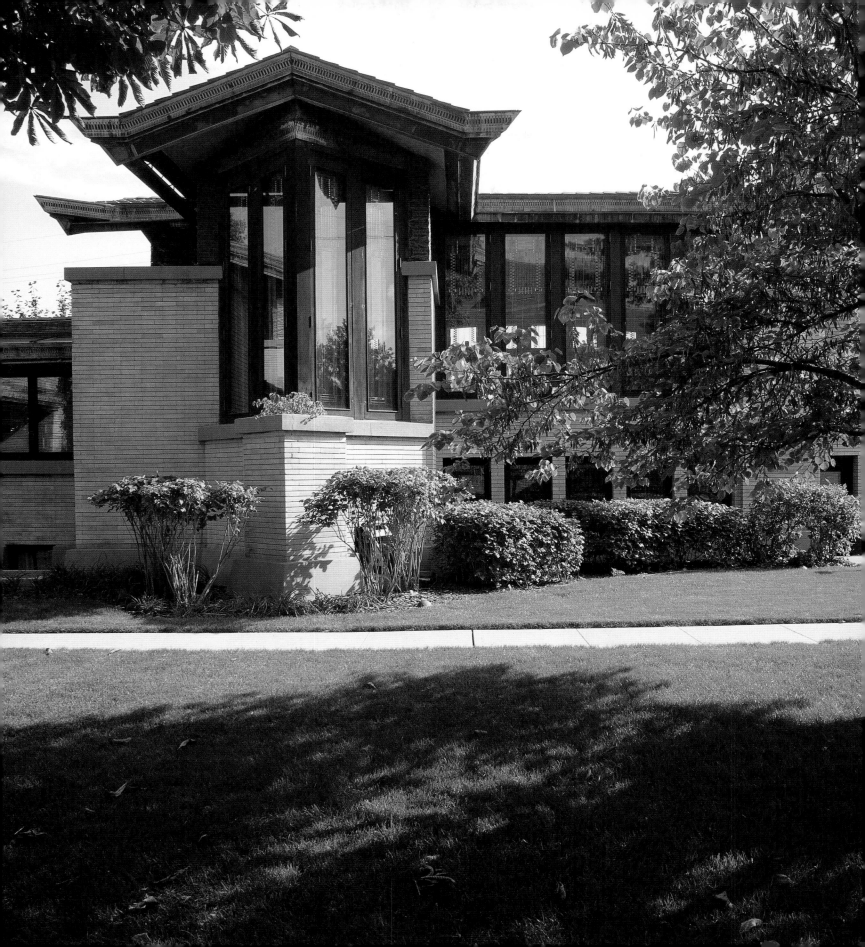

height drafting room with a balcony suspended by chains above the workspace, an office lit from above and to one side by natural light filtered through art-glass panels, an octagonal library, and a reception hall stretching along the entire façade and unifying the whole. The result was revolutionary and stunning, and provided Wright with a stimulating base from which to work on over a hundred and fifty building designs, surrounded by eager apprentices, for the following thirteen years. During this time Wright's office operated, much as Shaw or Sedding's had decades before, as a nursery for talented architects—among them Walter Burley Griffin and Marion Mahony, one of the first female architects in the USA. (The restored building is now owned by the National Trust for Historic Preservation and operated by the Frank Lloyd Wright Home and Studio Foundation.)

In 1909, four years after a visit to Japan that had a profound influence on his work, Wright's personal life suffered an upheaval when he eloped—scandalously at the time—to Europe with Mamah Borthwick Cheney, the wife of one of his clients, abandoning his family, his country, and his practice. It was not until 1911 that he returned and began plans for Taliesin, a new house to be built overlooking the Wisconsin River on property owned by his mother at Spring Green, Wisconsin.

Below: *The first house Frank Lloyd Wright designed was for himself and his family at Oak Park, Illinois in 1889. In later alterations he added a playroom, a new dining room, and a studio complex*

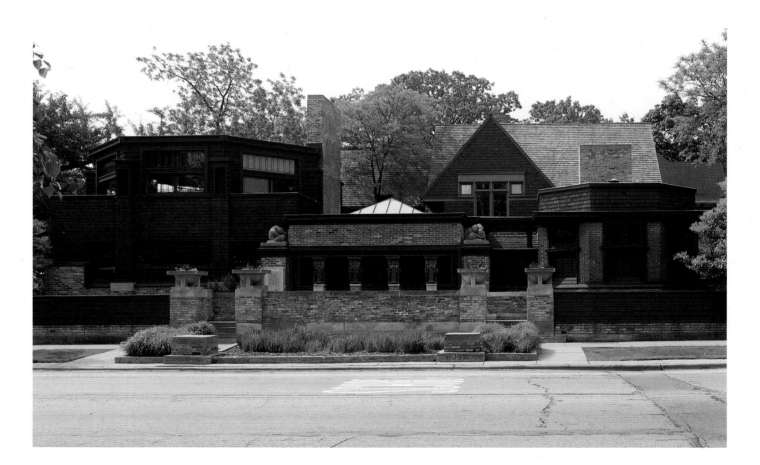

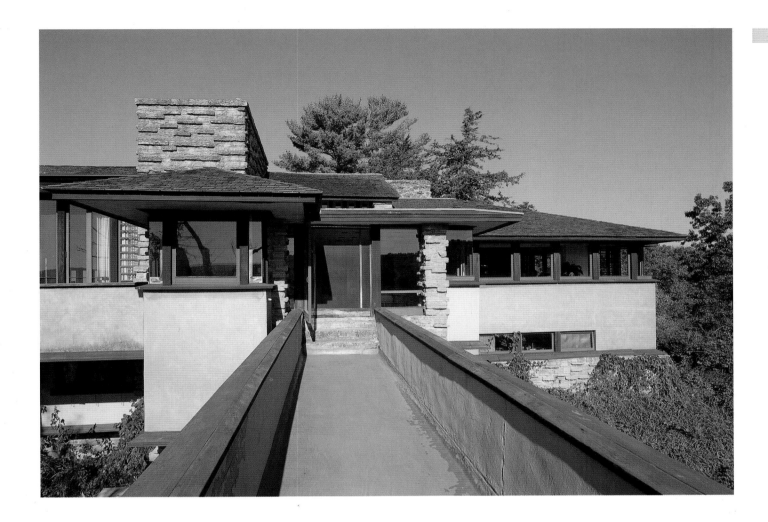

Taliesin, named after a mythical Welsh bard and whose name means "shining brow", was built from native limestone carried from a nearby quarry and intended by Wright to sit within the landscape—to be "of the hill, not on the hill." The house evolved over a long period to accommodate not just Wright and his family but the Taliesin Fellowship, a community based on craft teaching and agriculture established in the early 1930s. A series of connected buildings, linked by limestone and sand-colored stucco walled passageways, enclosing farm buildings, studio spaces, and courtyards, Taliesin stretched low across the brow of the hill. In the late 1920s it was complemented by Taliesin West, a complex of buildings that evolved over a period of years near Phoenix, Arizona, built by Wright to provide a winter base for himself and the Taliesin Fellowship.

His Prairie school period exactly paralleled the height of the Vienna Secession, when architects like Otto Wagner, Joseph Maria Olbrich, and Josef Hoffmann were making their mark in Europe. They would have a direct influence on the architecture of the 1920s, but the inspiration of Wright, who lived to be ninety-two, colored and went beyond the Modernism of Mies van der Rohe and Walter Gropius into the twenty-first century, where it continues to have relevance.

Above: *Frank Lloyd Wright's home Taliesin North in Spring Green, Wisconsin. From its windows, Wright could see across the river valley.*

3

ARCHITECTURAL INTERIORS

Right: *The White Drawing Room at Blackwell in Cumbria, designed by M.H. Baillie Scott, incorporates his trademark inglenook and is considered to be one of his finest interiors.*

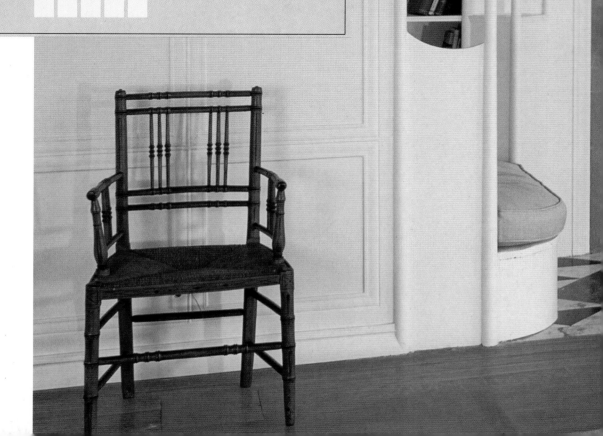

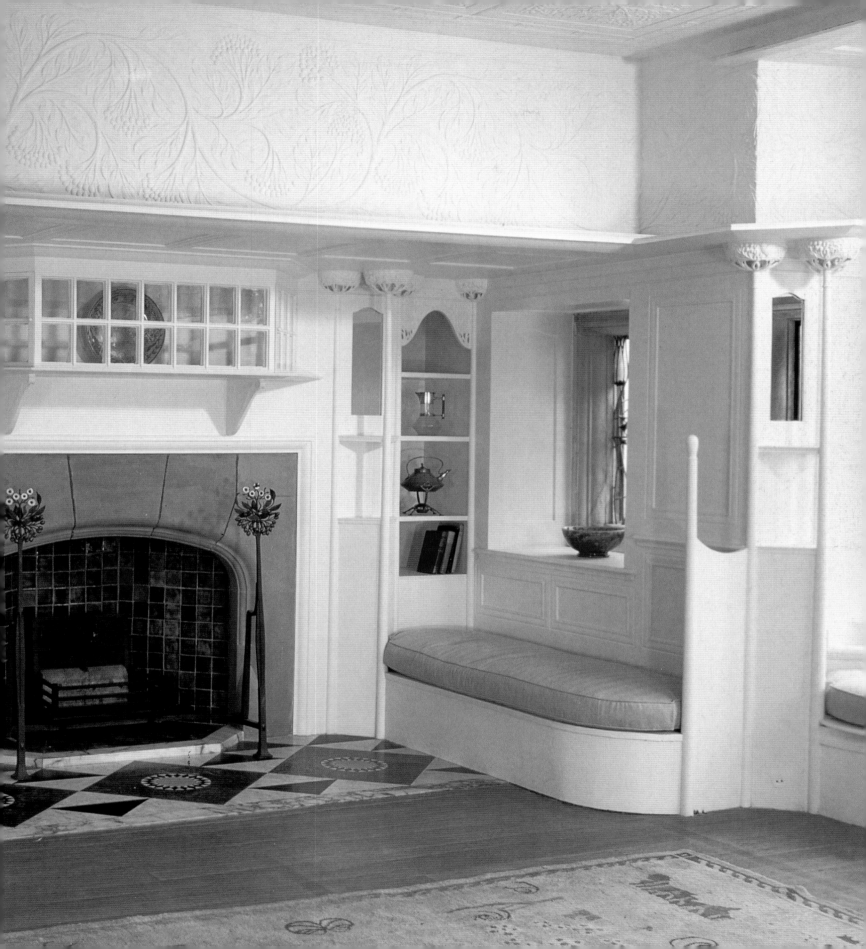

TOWARDS THE PERFECT LIVING SPACE

"Avoid all things which have no real use or meaning and make those which have especially significant, for there is no one part of your building that may not be made a thing of beauty in itself as related to the whole."

FRANK LLOYD WRIGHT, *The Architect and the Machine*, 1894

ILLIAM MORRIS'S FAMOUS MAXIM, "Have nothing in your houses that you do not know to be useful or do not believe to be beautiful"—delivered during a lecture entitled "Hopes and Fears for Art" in 1882—spoke directly to Arts and Crafts adherents and could be used to sum up a perfect Arts and Crafts interior. The range of perfection is wide, however, stretching from one of Morris's own white-paneled rooms, set off by hand-painted murals, tapestries, rich carpets, and highly patterned chintzes, to the almost spartan simplicity of Sidney Barnsley's scoured and swept spaces, dominated by a sturdy oak table, ranged about by high ladderback chairs with—against a far wall— a vast dresser filled with serviceable china.

In 1882, Morris had long since left his "palace of art" at Red House in Kent and was dividing his time between his two Kelmscotts—Kelmscott House on the banks of the Thames at Hammersmith in London, and Kelmscott Manor, a hundred and thirty miles upriver in Oxfordshire—each decorated in his highly personal style. The Manor—"a beautiful and strangely naif house, Elizabethan in appearance," boasted a romantic upstairs room filled with faded seventeenth-century tapestries and a big parlor lined with "some pleasing paneling," which he had painted white to provide a backdrop for the patterned fabric used on the armchairs and curtains. The interiors of the house in Hammersmith also expressed the extraordinary integrity of Morris's artistic taste. The long first-floor drawing room was covered in his "Bird" hangings and the dining room was papered in "Pimpernel," with a beautiful Persian carpet suspended against one wall from the high ceiling. The rooms were furnished with a vast settle that had been made for Red House, along with cabinets and wardrobes

Above: *This carved oak ceiling boss can be found in the Main Hall at Baillie Scott's masterpiece, Blackwell.*

Left: *A view through to one of the attic bedrooms at Morris's Kelmscott Manor.*

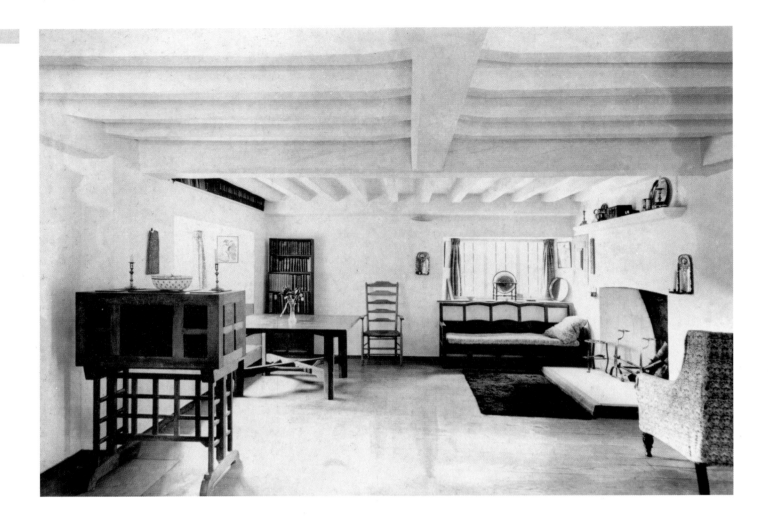

Above: *There is a modest elegance to be found in the spartan simplicity of Sidney and Lucy Barnsley's living room at Beechanger, their house in Sapperton, built in 1904.*

painted with medieval scenes by Dante Gabriel Rossetti and Edward Burne-Jones, but the long dining table was left scrubbed and bare of any tablecloth in a proper Arts and Crafts manner.

The Arts and Crafts movement fueled the new middle-class fashion for interior decoration and the last decades of the nineteenth century witnessed a conscious move away from the clutter and comparative gloom of the traditional Victorian interior toward a lighter, more rational scheme, often unified by recurring decorative motifs in the fabric, fittings, and structural decoration of a room. This was most successfully achieved in the work of innovative architects such as Charles Rennie Mackintosh, C.F.A. Voysey, M.H. Baillie Scott, and Frank Lloyd Wright, who designed from the inside out, rethinking and revolutionizing the use of space, leading to a greater sense of informality, flexibility, and ease of flow. They designed "organically," conceiving the ornamentation in the very ground plan, and were concerned to free the bulk of interior space from the cumbersome mass of furniture and the tyranny of bric-a-brac and occasional tables. They did this by creating fixed or built-in furniture, merging the horizontals and verticals created by the windows, fireplace, bookcases, and seating to create homogeneous and harmonized interiors. They were a new breed of architect-designers, who

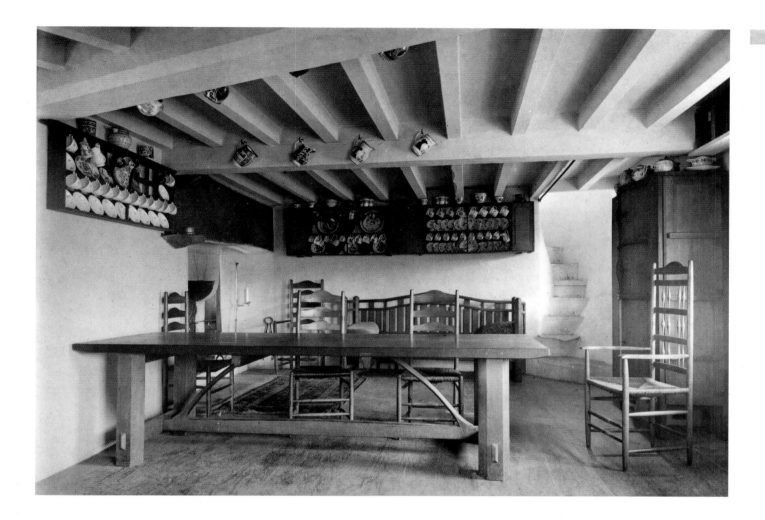

had taught themselves the rudiments of traditional crafts, and knew how to work with wood, metal, glass, and fabric to create an integrated design and, crucially, how to organize the interior space. They used local materials and local skills and concerned themselves with every aspect of the design of a house, creating coherent and deeply satisfying interiors. These ranged from the dramatic set pieces of large country houses such as Baillie Scott's Blackwell to the quieter serenity to be found in a more modest Voysey interior. In all the Arts and Crafts interiors, love of wood was on show: wooden paneling, high-backed settles made of oak built into inglenooks, distinctive freestanding pieces of furniture, and, everywhere, evidence of painstaking craftsmanship in the exposed details on wooden staircases, ceiling beams, carved panels, and studded and strap-hinged plain plank doors.

There is a warmth and welcome in an Arts and Crafts interior, a celebration of the domestic and the practical. For Baillie Scott the fireplace was crucial. "In the house the fire is practically a substitute for the sun," he wrote, "and it bears the same relation to the household as the sun does to the landscape. The cheerfulness we experience from the fire is akin to the delight which sunlight brings." He accentuated the fireplace as a symbolic focus by creating deep inglenooks lined with built-in

Above: *The interior of Stoneywell is kept determinedly plain, almost primitive, with low beams and simple whitewashed walls, though the sinuous curve of the narrow staircase draws the eye, and the jugs and china ranged about the walls and beams create a warm feeling of cozy domesticity.*

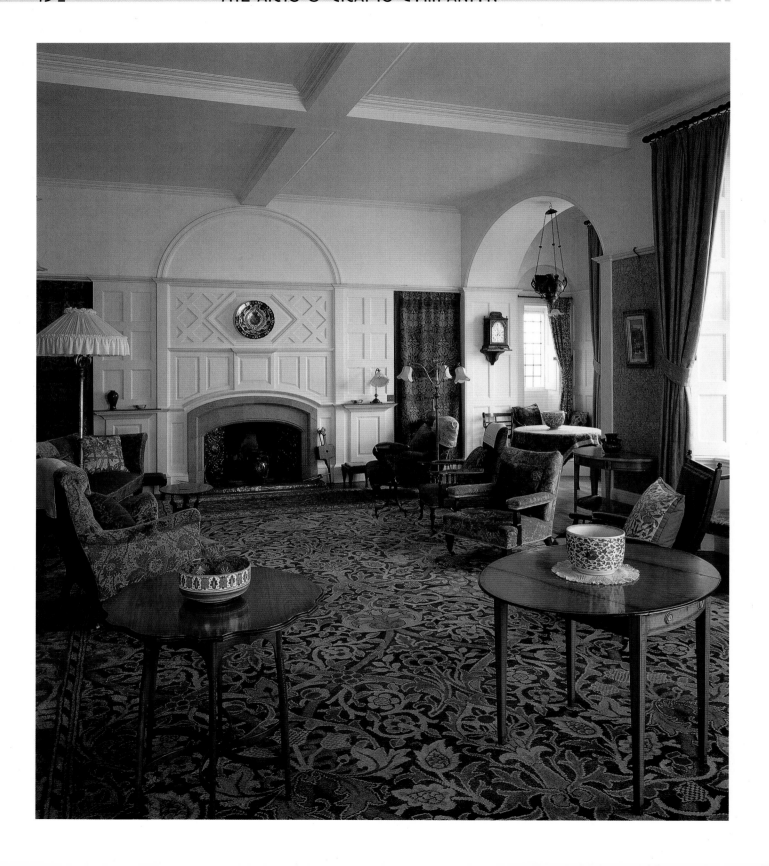

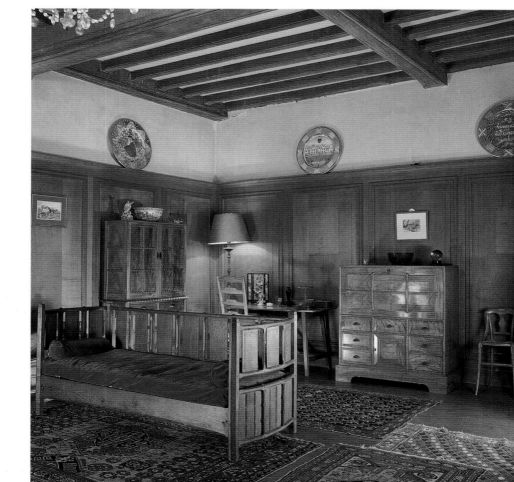

Left: *The restored Drawing Room at Standen boasts lighting fixtures by Webb and Benson, Morris's "Tulip and Rose" woven wool hangings, a particularly fine example of a hand-knotted Merton Abbey carpet (designed by J.H. Dearle), and Morris's "Sunflower" wallpaper and, though empty, seems to await the arrival of the Beale family, stylishly dressed for dinner.*

settles. They rapidly became a key feature of Arts and Crafts interiors, both in Britain and the USA, where the archetypal Arts and Crafts room—long with a low-beamed ceiling and leaded windows—combined folk and colonial American motifs to evoke the simple life, as recommended by Gustav Stickley. Stickley believed the living room to be "the executive chamber of the household where the family life centers and from which radiates that indefinable home influence that shapes at last the character of the nation and the age." Images of ideal living rooms, furnished with a Craftsman rocking chair, standing on a Navajo rug, beside a roaring fire, with a Tiffany lamp shedding its buttery light across a sturdy oak table set with art pottery, appeared in his magazine *The Craftsman*.

British architects also used magazines to put across their message. In an article written for *The Studio* in January 1895, Baillie Scott guided his readers round "An Ideal Suburban Villa," which featured a double-height hall, with built-in ingle seating before a wide brick hearth adorned by copper fire dogs: "On entering by the front door, we find ourselves in a wide and low porch from which, through an archway to the right, we catch a glimpse of the staircase which rises from a wide corridor leading to the kitchen," he wrote. "It is difficult for me to picture to you the vista-like effect

Above: *Wood—in the warm paneling, beams, and furniture—is the dominating decorative principle in the interiors at Rodmarton Manor. The pair of walnut writing tables seen here in the Drawing Room were the work of Peter Waals; the oak daybed was made by Sidney Barnsley's son Edward.*

of the broad corridor, but to get some idea of its general effect I must transport you to some old Cheshire farmhouse, somewhere in the country where people have not yet grown to be ashamed of plain bricks and whitewash." He enlarged and expanded his ideas for ideal living in later articles devoted to "An Artist's House" (October 1896), "A Small Country House" (December 1897), and "A Country House" (February 1900).

Baillie Scott wanted his buildings inside and out to be the product of a single mind—he designed furniture for most of his houses and developed the idea of the integrated interior, searching for simplicity and a sense of repose. He replaced the Victorian entrance hall with an Elizabethan-style dwelling hall (double-height where possible), half-timbered or paneled to evoke the simplicity of the medieval barn. He pioneered and mastered a new flow of space, breaking down the conventional divisions and making interiors, especially in smaller houses, seem more spacious and flexible. "The house rationally planned should primarily consist of at least one good-sized apartment," he wrote, "which, containing no furniture,

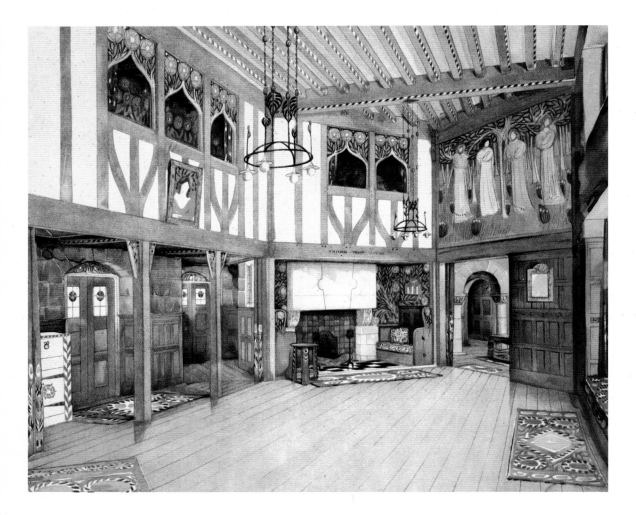

Left: *A hand-colored photo-lithograph of Hall, M.H. Baillie Scott's entry for the House for an Art Lover Competition, 1901.*

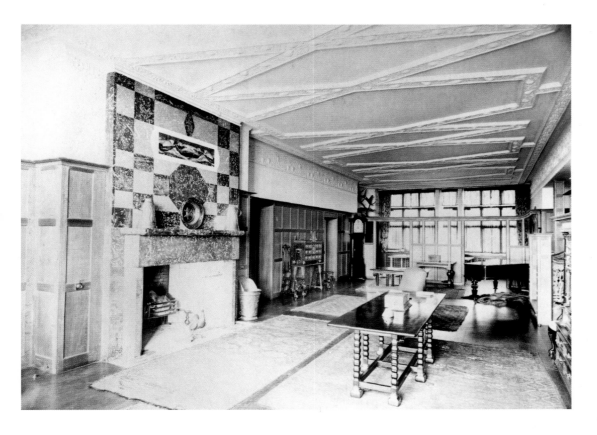

but that which is really required, leaves an ample floor space at the disposal of its occupants.… In this way, even the laborer's cottage retains its hall, which has now become the kitchen, dining room and parlour." He wanted to move away from the idea of the smaller kind of house being sub-divided to the greatest possible extent into tiny compartments and designed instead around a central space, made flexible by sliding doors and alcove-like spaces for activities such as sewing, reading or dining. These were furnished with built-in, often multipurpose, units combining bookcases, window seats, and cabinets. In his ground-breaking pair of semidetached Elmwood Cottages at Letchworth, he eliminated corridors and connected rooms laterally, increasing the space and connecting the light, airy rooms to the landscape of both the road and the garden in a manner that bears comparison with the work of Frank Lloyd Wright. Baillie Scott explored the frontiers of privacy and sociability in his book *Houses and Gardens* (1906), giving careful thought to the use of space and differentiating between rooms traditionally associated with men or women by using plain or stenciled "feminine" white walls and furniture in the bedrooms, drawing rooms, kitchen, and bathroom, and sturdy oak paneling for the masculine areas—the hall, stairwell, drinking room, smoking, and billiard rooms.

At Blackwell at Bowness, overlooking Lake Windermere in Cumbria, built in 1898 as a holiday home for Edward Holt, lord mayor of Manchester, Baillie Scott used whitewash as a background to the timbered hall and exposed joists and rafters in the dining room. Allowing his imagination full rein, he designed an extravagant double-height "hall-living-room," which contained a massive

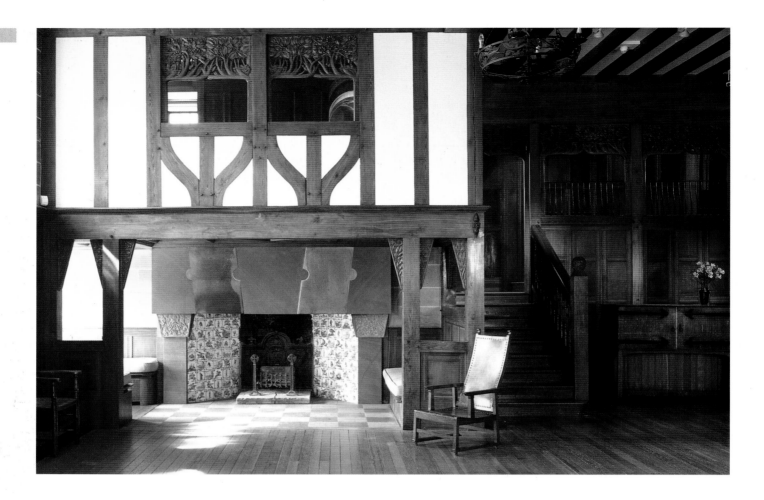

Above: *The impressive Main Hall at Blackwell, with its romantic Minstrel's Gallery above the inglenook.*

inglenook fireplace beneath a romantic half-timbered minstrel's gallery. He made the interiors sing, decorating them with exuberant plasterwork, richly carved paneling, and stone corbels, all lit by the glowing colors of stained-glass panels inspired by local wild flowers and peacocks. "Let it be vital, local and modern," he urged. The spatial play of the hall at Blackwell was so innovative that it allowed for the room to be used in multiple ways. (The house, recently restored, now boasts one of the finest Arts and Crafts interiors remaining in existence.) The German writer and architect Hermann Muthesius was in raptures, describing Baillie Scott as a poet whose "ravishing ideas of spatial organization" ensured that every part of the house "down to the smallest corner, is thought out as a place to be lived in."

Baillie Scott's reputation soared in Europe, and he has been credited with making an important contribution to the beginnings of the Arts and Crafts movement in Germany, where his elaborate and highly decorative interior designs—for which he designed not only the spaces but every element within them, including fabrics, stained glass, furniture, carpets, and light fittings—were enthusiastically reviewed in German magazines until the outbreak of the war put an end to his commissions.

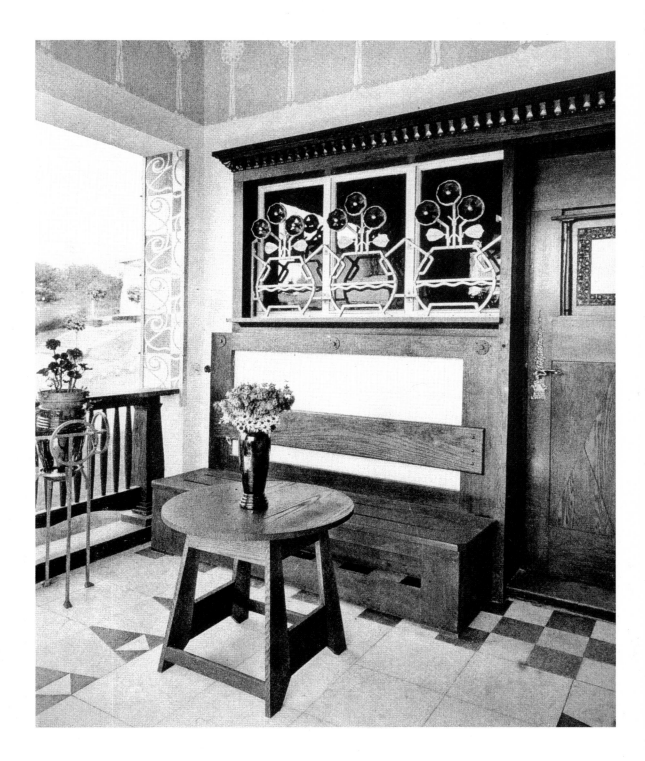

Right: *A glimpse of how European followers of Arts and Crafts lived is offered in this interior of Joseph Maria Olbrich's home in the artists' colony at Matildenhohe in Darmstadt, for which he was the chief architect in 1901.*

Above: *Voysey acts upon his belief that houses should have "light, bright, cheerful rooms, easily cleaned and inexpensive to keep" in his design for The Homestead, a green slate roofed house at Frinton-on-Sea, which he designed in 1905–6 for a bachelor client.*

Right: *A period room within Liberty's department store with original wood-paneling, furniture and metalwork from Liberty's early twentieth-century Arts and Crafts ranges.*

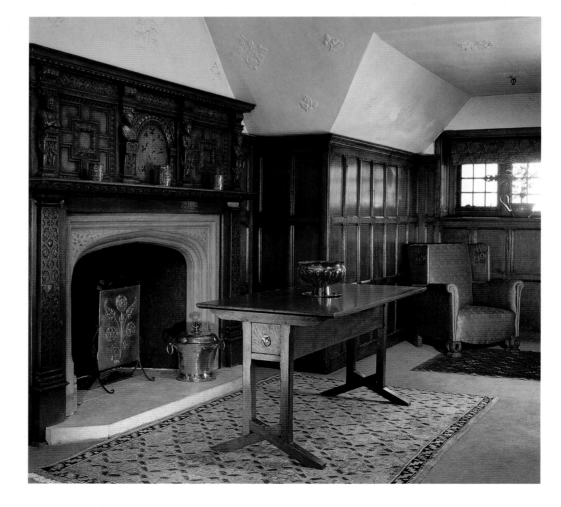

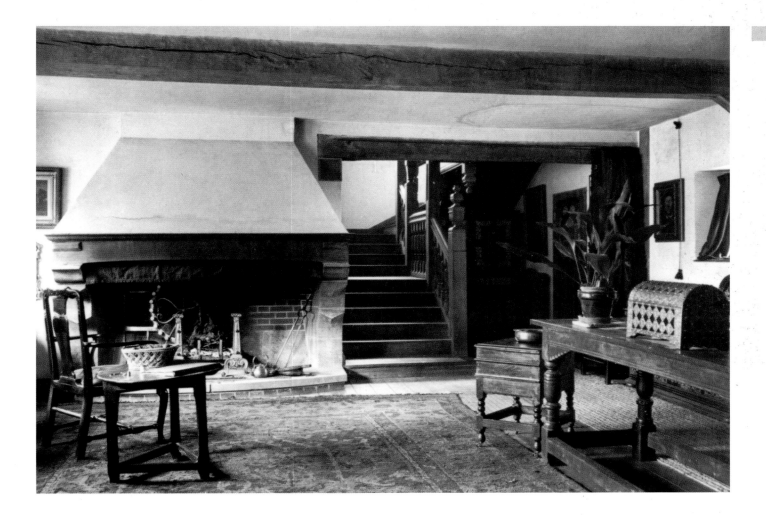

His attention to detail was legendary. At Blackwell, for example, the door handles and iron window latches are differentiated by some small and often subtle detail in each of the many rooms. As Muthesius remarked, "In Baillie Scott's work each room is an individual creation, the elements of which do not just happen to be available but spring from the overall idea. Baillie Scott is the first to have realized the interior as an autonomous work of art."

C.F.A. Voysey, who described his ideal interior as "a well-proportioned room, with white-washed walls, plain carpet and simple oak furniture," ornamented only by "a simple vase of flowers," also took control of every element of an interior and employed a number of favorite decorative motifs and symbols, such as a stylized heart. His whitewashed rooms boasted large, welcoming, tiled fireplaces, with white or natural oak-beamed ceilings. He believed that homes should have "light, bright, cheerful rooms, easily cleaned and inexpensive to keep." He dismissed the once-fashionable sepias and sludgy greens as "mud and mourning" and in his own house, The Orchard (1899), used his favorite color scheme of green, red, and white, with easily cleaned, durable, slate tiles on the hall and kitchen floor, green cork tile flooring throughout the first floor, and curtains of bright red.

Above: *The living hall at Munstead Wood as it was in 1907. The staircase leading up to an oak-beamed first-floor gallery was one of Gertrude Jeykll's favorite features: "It felt firm and solid," she said, "the steps low and broad."*

A Voysey house has distinctive qualities of honesty, candor, and simplicity; it provides both physical and spiritual shelter. Voysey's own definition of comfort was "Repose, Cheerfulness, Simplicity, Breadth, Warmth, Quietness in a storm, Economy of upkeep, Evidence of Protection, Harmony with surroundings, Absence of dark passages, even-ness of temperature and making the house a frame to its inmates. Rich and Poor alike will appreciate its qualities."

Charles Rennie Mackintosh took the principle of the integrated interior further, designing friezes, cutlery, silverware, hall-chimes, carpets, and light fixtures for his houses. Like most Arts and Crafts

Below: *Charles Rennie Mackintosh's beautifully designed White Bedroom at Hill House (1902–4) still looks strikingly modern.*

Above: *This bedroom in Carl Larsson's house in Sweden is a fine example of the Scandinavian interpretation of the Arts and Crafts ideal.*

buildings, his interiors reflected his clients' pattern of living, but his geometric precision stamped each commission with his own mark. Hill House near Glasgow is a shining example of his fierce commitment to total stylistic unity. The somewhat severe exterior contrasts completely with the delightful interior spaces—particularly the hall, the drawing room, the study-library, and the main bedroom, over which Mackintosh had complete control. The visionary decorative schemes are the result of an inspired collaboration with his wife Margaret. The elongated lines and delicate geometry in the white-painted principal bedroom made a stunning modern statement. He recessed the bed demurely beneath a barrel-vaulted ceiling, creating an area designed to be screened off from the rest of the room. Downstairs in the drawing room, strikingly decorated with a pale pattern of abstract roses, Mackintosh filled one of the gloriously light bays with a long, low window seat (under which he installed heating) flanked by fitted racks for books and magazines; in the other he created a separate space to house the piano. The effect is magical.

The Greene brothers designed their houses inside and out, and are justly celebrated for creating rooms rich with beautifully crafted wood and glowing with art-glass windows and light fittings. They created a serene and dignified interior at the Gamble House in Pasadena, taking a coordinated

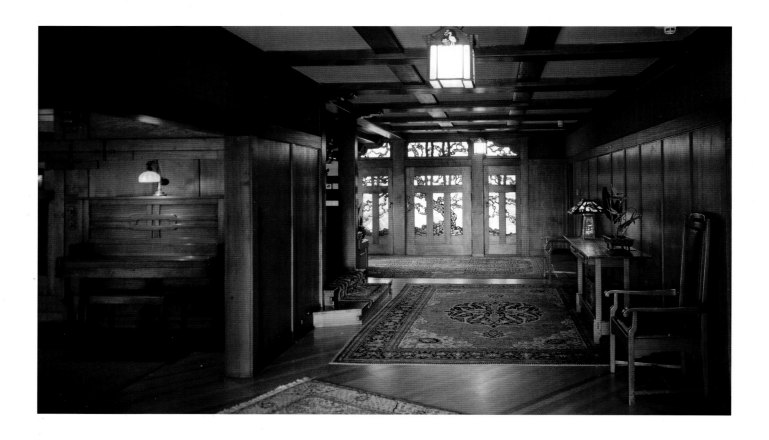

Above: *Wood paneling predominates in the entrance hall of the David Berry Gamble House at Pasadena, looking towards the front doors designed by Charles Greene and made by glass artist Emil Lange.*

approach to the layout and furnishing of the rooms and designing all the furniture, art-glass windows, and mahogany-framed light fittings themselves. Though they actively involved their client, Mary Gamble, in decisions and took her interests and lifestyle into account when planning the interiors, the final result is very much their own creation. The warm tones of wood—Oregon pine, American white oak, redwood, white and red cedar, Honduras mahogany—dominate. The hall and drawing room are paneled with Burma teak, which covers the walls to frieze height, and the rooms open into each other, or to the outside, in a way that recalls the connecting pavilions of a Japanese villa. The whole house glows. In the drawing room a long timber-framed settee sits in the window bay, and an emphatically wide inglenook, with a curved Oriental wooden truss, spreads across one wall, embracing a pair of settles, glass-fronted cabinets, and a table to create a private "room within a room." David Gamble's study, off the entry hall, is furnished with a Morris chair and the desk from his study in Cincinnati, and sturdy Craftsman furniture was ordered for the bedrooms of the Gambles' teenage sons.

The Greenes' father was a doctor who specialized in respiratory diseases; consequently they always paid careful attention to the free flow of air in bedrooms. At the Gamble House, the cross-ventilated family bedrooms each opened onto a sheltered outdoor room, or sleeping porch,

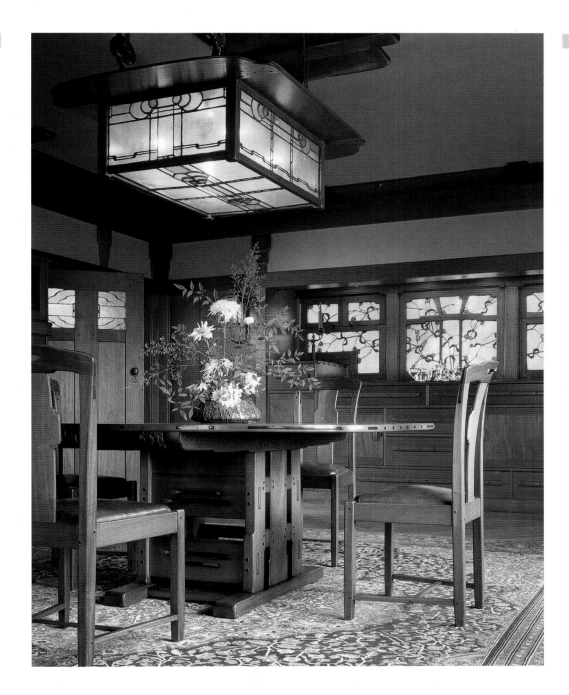

Right: *The dining table in the Gamble House is bathed in glowing light, while the bright Californian sun is softened by the colored glass panels in the windows.*

furnished with rattan armchairs and recliners for use during the day or on particularly warm Californian nights. A generous provision of five bathrooms was made to serve the ground and first-floor bedrooms and, although dressing rooms were not provided, the master bedroom had a large walk-in closet, and maple vanity units were built in to the guest bedroom. Mary Gamble's fine collection of Rookwood vases was displayed on cedar shelves in the master bedroom, which was decorated in dark, earth colors.

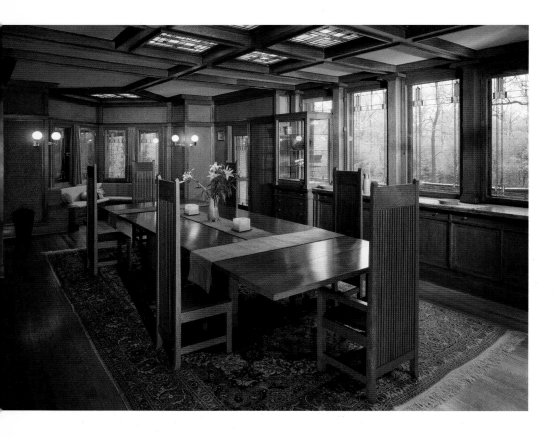

Above: *The interior of the Ward W. Willits House, Highland Park, Illinois, designed by Frank Lloyd Wright in 1902.*

Frank Lloyd Wright sought to define and design the perfect living space for contemporary life and in doing so revolutionized the single-family private house. He created interpenetrating spaces by abolishing corners between dining and living areas, making a single L-shaped space that pivoted around a dominant central fireplace, designed "to give a sense of shelter in the look of a building." In a long career, he designed more than three hundred residences, creating not just the outer shell of the building but its decorative interiors as well: art-glass windows and skylights, light fixtures, furniture, carpets and textiles, wall murals—indeed all integral ornament. His carefully conceived built-in furniture and tall spindlebacked chairs, which clearly owe a great debt to Charles Rennie Mackintosh, simplified his functional, open-plan interiors while also unifying the whole design.

Built-in furniture made efficient use of the space. It was orderly and economical and had the added advantage of discouraging his clients from cluttering his spaces with any furniture from previous homes that they might be tempted to introduce. "I tried to make my clients see that furniture and furnishings … should be seen as minor parts of the building itself, even if detached or kept aside to be used on occasion." In the Robie house in Chicago, for example, the shape of the sofa, with its wide table arms, echoes the ceiling above, and the trim on the furniture matches the moldings on the walls. Wright's interiors were designed to echo the overall design of the house and open freely, one to another, with ingenious transitions, marked by art-glass windows, subtle changes of level or changes of texture on the wall or floor. From the drama of the barrel-vaulted ceiling in the dining room of the Dana-Thomas house to the soaring multilevel spaces of the living room at Taliesin, they are breathtakingly modern.

Wright used geometry to link the different elements and glass to break open boxlike spaces, and he sought ways to dissolve corners. As early as 1900 C.R. Ashbee had recognized his genius. "Wright is to my thinking," he confided in his journal, "far and away the ablest man in our line of work that I have come across in Chicago, perhaps in America. He not only has ideas but the power of expressing them, and his Husser House, over which he took me, showing me every

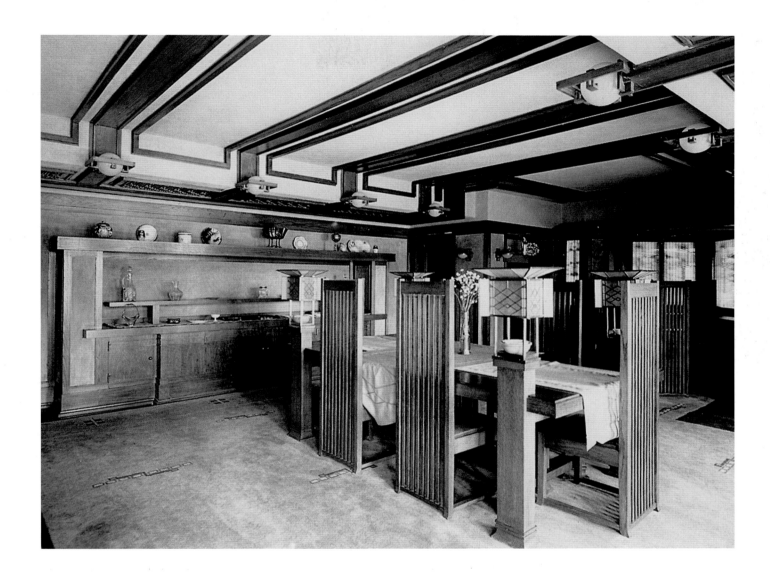

detail with the keenest delight, is one of the most beautiful and individual of creations that I have been in in America."

"What I call integral ornament," Frank Lloyd Wright explained in a special edition of *House Beautiful* published in 1955, when he was eighty-eight, "is founded upon the same organic simplicities as Beethoven's Fifth Symphony, that amazing revolution in tumult and splendor of sound built upon four tones, based upon a rhythm a child could play on the piano with one finger. Supreme imagination reared the four repeated tones, simple rhythms, into a great symphonic poem that is probably the noblest thought-built edifice in our world. And architecture is like music in this capacity for the symphony."

Above: *The dining-room furniture Frank Lloyd Wright designed for the Robie House in Chicago is among his most famous ensembles. Photograph by Henry Fuermann, c. 1910.*

FURNITURE

Left: *A Gimson cabinet, made at the Daneway Workshops by Ernest Smith, c. 1903–7. Alfred Bucknell made the handles on the outside, John Paul Cooper those on the inside.*

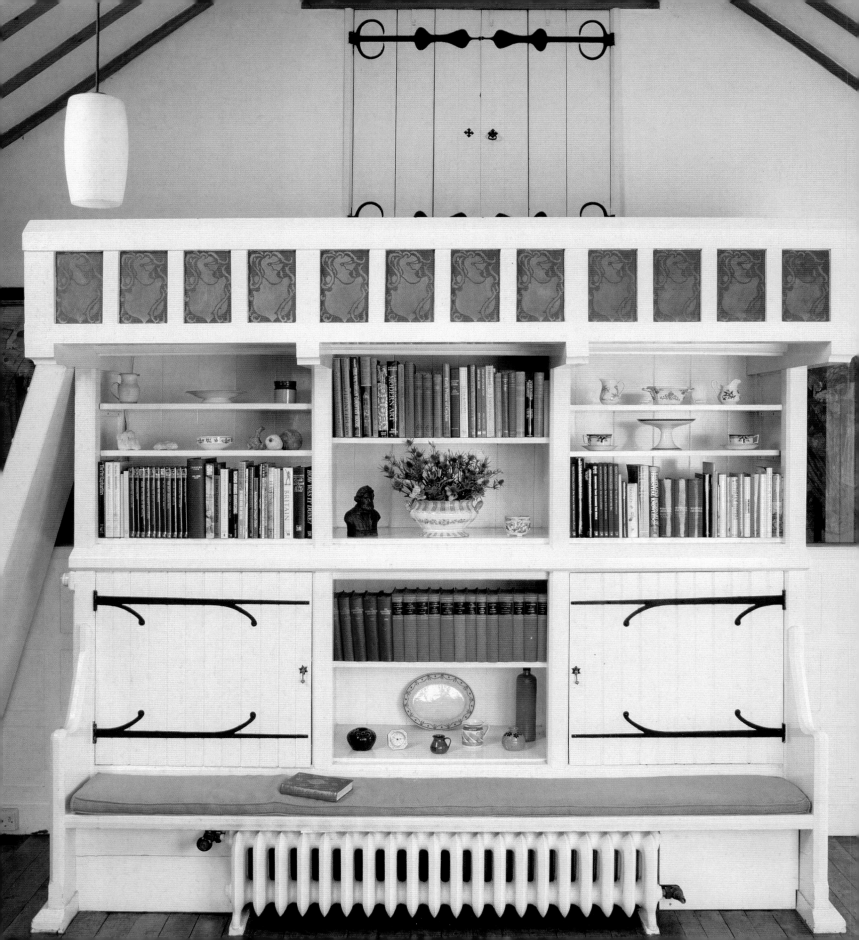

THE EXPRESSION OF GOOD FEELING

"So I say our furniture should be good citizen's furniture, solid and well made in workmanship, and in design should have nothing about it that is not easily defensible, no monstrosities or extravagances, not even of beauty, lest we weary of it.... Moreover I must needs think of furniture as of two kinds ... one part of it ... the necessary workaday furniture ... simple to the last degree.... But besides this ... there is the other kind of what I shall call state-furniture; I mean sideboards, cabinets and the like ... we need not spare ornament on these but may make them as elegant and elaborate as we can with carving or inlaying or painting; these are the blossoms of the art of furniture."

WILLIAM MORRIS, *The Lesser Arts of Life,* 1882

Above: *Detail of marquetry from a cabinet by Charles Robert Ashbee.*

RTS AND CRAFTS FURNITURE can be found at each end of the spectrum described by William Morris: from the familiar plain and solid oak pieces, perhaps with beaten copper handles and hinges, or distinctive panels of stained glass, to the elaborately decorated sideboards and cabinets that Morris considered the "blossoms" to be "used architecturally to dignify important chambers and important places."

THE FIRM, OR MORRIS, MARSHALL, FAULKNER & CO.

T ALL BEGAN, like so much in the Arts and Crafts movement, with William Morris, who, disenchanted with the furniture he found readily to hand when he began looking for pieces to furnish his student rooms in Red Lion Square, London, designed and made some for himself along monumental medieval lines. There was a vast settle (which proved too large to transport up the stairs to the first-floor rooms he shared with Edward Burne-Jones, and had to be

Left: *Morris's enormous white settle was originally designed for his rooms in Red Lion Square, but Philip Webb adapted it and made it the centerpiece of the first-floor drawing room at Red House. He added a canopy, creating a miniature "minstrel's gallery," which also, rather more prosaically, provided access to the doors leading into the roof-space behind.*

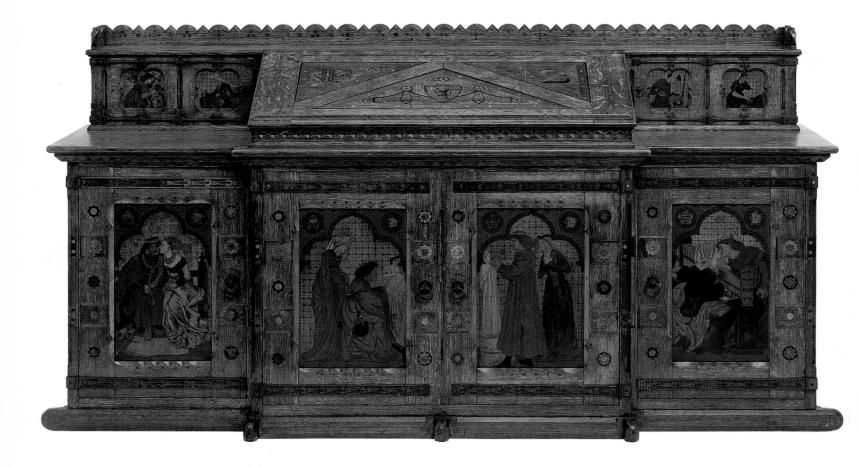

Above: *King René's Honeymoon Cabinet, built 1860–2, was designed by John Pollard Seddon with panels by Ford Madox Brown, Dante Gabriel Rossetti, and William Morris.*

winched in through a window), some colossal chairs, and a round table "as firm and heavy as a rock," according to Dante Gabriel Rossetti. A few years later, in April 1861, married now and with a beautiful new house in Kent to furnish, Morris banded together with these and other friends to found the firm of Morris, Marshall, Faulkner & Co.—"Fine Art Workmen in Painting, Carving, Furniture and the Metals." The furniture designs were provided by Philip Webb, the architect of Red House, and the painters Dante Gabriel Rossetti and Ford Madox Brown. The latter already had some experience of designing simple and robust furniture for Charles Seddon & Co. and is credited with originating the green stain for oak that was so generally used for art furniture. Webb's first recorded furniture design, dated 1858, was rather more elaborate. Heavily influenced by Augustus Pugin (whose *Gothic Furniture in the Style of the Fifteenth Century* had been published in 1835), he designed a massive wardrobe, which was painted by Burne-Jones with a scene from Chaucer's *Prioress's Tale*, as a wedding present for Morris and Janey. Architects such as Pugin and G.E. Street, in whose offices Webb had trained, had already pioneered the use of plain rectangular forms, solidly executed in unvarnished oak along the lines developed by medieval joiners of rails and posts, then elaborately ornamented. Pugin's Gothic-style furniture was made up for his clients by commercial firms such as J.G. Crace Limited of Wigmore Street, London, and Webb would have been familiar with many of these pieces.

Madox Brown took a rather different approach, designing simple, plain pieces that concentrated on "adaption to need, solidity, a kind of homely beauty and above all absolute dissociation from all false display, veneering and the like." Rossetti, meanwhile, found romance in English country designs of the mid-eighteenth century and adapted them into one of the staples of the Firm, the rush-seated "Sussex chair."

The Firm began life at 8 Red Lion Square, with a workroom referred to by Rossetti as "the Topsaic laboratory" on one floor and a shadowy showroom filled with "bewildering treasures" on another. Here Morris hoped to evoke the spirit of a medieval workshop, where there was pride in work and joy in working together. His lofty aims for simplifying life are exemplified in his much-quoted exhortation: "Have nothing in your houses that you do not know to be useful or believe to

Below: *A pair of enduringly popular chairs, designed around 1865, which sold through the Firm and came to epitomize the Morris look: on the left the "Sussex" chair, in ebonized beech with a rush seat, and, on the right, the "Rossetti" chair, also in ebonized wood, though some, with red painted details on the turning, were made to special order.*

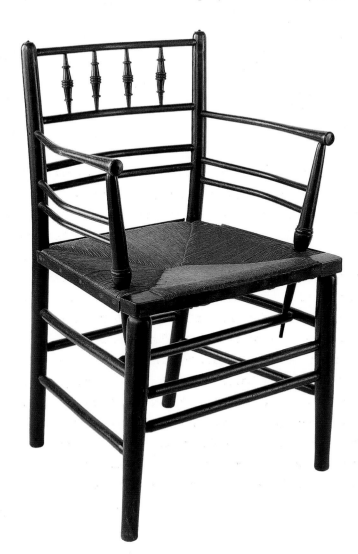

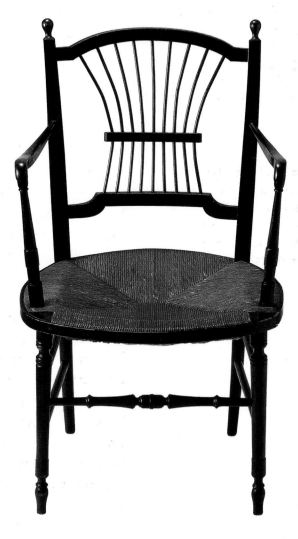

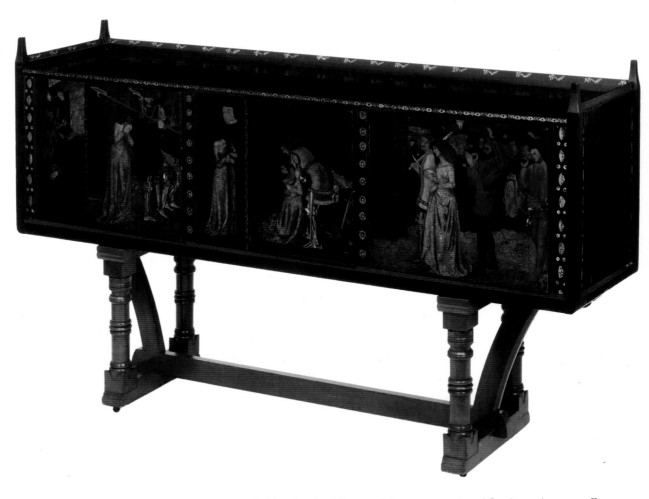

Above: *The elaborate "St George Cabinet" was one of the Firm's showpieces at the International Exhibition of Art and Industry in 1862. Philip Webb designed the cabinet, using mahogany, oak, and pine, but it was Morris himself who decorated the gilded surface with scenes from the legend of St. George. It was priced at 50 guineas but, despite attracting some favorable notice, failed to sell.*

be beautiful." Morris was appalled by the shoddiness of the mass-produced furniture then on offer and felt sure he could offer a better, handmade alternative. By drawing on his hobbies of woodcarving and embroidery and capitalizing on his own experience of decorating Red House, he was rapidly able to combine his genius for design with his talent for business and thus turn himself into a creative shopkeeper who made and sold the things he himself would like to buy.

The Firm's first chance to shine came at the International Exhibition at South Kensington in 1862, where a sofa by Rossetti and half a dozen other pieces, including a cabinet painted with scenes from the life of St. George, as well as chests, chairs, an inlaid escritoire, and bookcases, were on display. The press had a field day: one reviewer claimed the work of the Firm "would be all very well as curiosities in a museum, but they are fit for nothing else."

Despite this reaction, and Philip Webb's assertion that business was conducted "like a picnic," the Firm flourished. In 1865, the workshops were moved to 26 Queen Square and showrooms opened in Oxford Street—right next door, in fact, to John Dando Sedding's offices, where two young architectural students, Ernest Barnsley and Ernest Gimson, would later embark on their own Arts and Crafts path. Morris knew Gimson and had introduced him to Sedding, and it is perfectly possible that this proximity exerted a powerful influence on the two Cotswolds architects, for their own short-lived furniture venture—Kenton & Co.—had strong parallels with the Firm.

The famous "Morris chair," which was to become such a signature piece of the Arts and Crafts movement, first appeared in the showroom in 1866. The initial design was based on a chair found in a Sussex carpenter's shop and adapted by Philip Webb from a sketch made by the Firm's manager, Warington Taylor. Webb incorporated a movable back that could be set at different angles and Morris sold the easy chair in two versions—ebonized or plain wood—with a cushioned seat and back, covered either in chintz or "Utrecht velvet." The Morris chair was still being made in 1913, advertised through the Firm's catalog at 10 guineas, or £8 with the cheaper cotton covers.

The Firm successfully mixed traditional and new ideas, methods, and materials. Much of the early furniture was made in Great Ormond Yard, just around the corner from Queen Square, although after 1881 furniture manufacture—along with tapestry and wallpaper production—moved to larger workshops at Merton Abbey in Surrey. Nine years later a new furniture factory was acquired from Holland & Son in Pimlico, and this flourished under the management of George Jack, one-time

Above: *This adjustable oak swing toilet mirror was made for Morris, Marshall, Faulkner & Co. around 1860 and may have been designed by Philip Webb, though Ford Madox Brown, who was responsible for several sturdy domestic pieces, is equally likely to be responsible.*

Left: *This example of the Morris Adjustable Chair, designed by Philip Webb for the Firm in 1866, is covered with "Bird" design upholstery.*

assistant to Philip Webb and well known for his work as a carver, who now became chief designer for Morris & Co. Jack was responsible for many of the elaborate and highly finished monumental mahogany pieces, often with inlaid decoration, now associated with the Firm. These sat alongside some of Webb's simpler and more functional pieces, which remained in the Firm's catalog well into the twentieth century, though it would be true to say that the furniture side of the business lost some of its impetus even before the death of Morris in 1896.

William Morris never visited the USA, although Morris & Co. products were being sold by American agents from the late 1870s and had a profound impact on design in many fields, including furniture. By 1901 Gustav Stickley was offering seven Morris chair models, with minor differences, through *The Craftsman*, and Morris's ideas and influences can be seen in the work of leading American Arts and Crafts designers from Charles Rohlfs to Frank Lloyd Wright.

Morris & Co. was bought in 1905 by F.C. Marillier and Mrs. Wormald. The firm survived World War I and the interwar period, finally closing for business in 1940.

MORRIS'S INFLUENCE

IT HAS BEEN SUGGESTED that the Arts and Crafts movement had more real influence on twentieth-century furniture design than it had on the great mass of furniture buyers in its own day. Certainly it is true to say that it has emerged as the major force in the history of British design during the last one hundred and thirty years. The insistence of its father-figure, William Morris, on the dignity and joy of labor, his emphasis on handcrafted methods and of honesty to function and material meant that, however well-designed, most of his work and that of the other leading exponents of the Arts and Crafts movement was necessarily expensive and—less comfortably for the socialist Morris—exclusive. His writings, lectures, and practical example, however, had a tremendous influence on a younger generation of architects and designers in the last quarter of the nineteenth century, who developed his ideas and continued the enthusiasm for Arts and Crafts-inspired work.

M.H. Baillie Scott, for example, looked to "simple furniture" to create clear and open space, particularly in smaller homes, where he designed built-in window seats, settles, and dressers, aiming to eliminate clutter. His freestanding furniture was available through John P. White's Pyghtle Works in Bedford. In 1901 its catalog included a hundred and twenty solid, simple, starkly masculine pieces by Baillie Scott. "The furniture," ran the catalog sales pitch, "has been designed and made to meet the

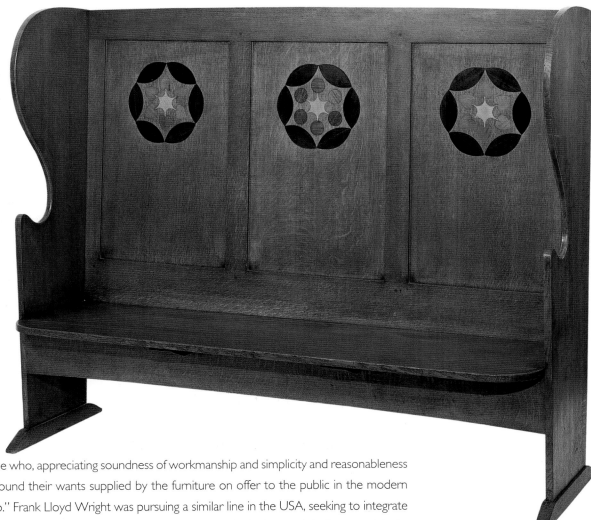

requirements of those who, appreciating soundness of workmanship and simplicity and reasonableness in design, have not found their wants supplied by the furniture on offer to the public in the modern cabinet-maker's shop." Frank Lloyd Wright was pursuing a similar line in the USA, seeking to integrate the furnishings with the architecture of his houses. To create continuity he used similar materials for both and echoed the architectural grammar of the house in built-in cabinets and seating.

THE GUILDS

THE ARTS AND CRAFTS MOVEMENT was, primarily, an attempt at social reform with an emphasis on group work in guilds of craftsmen and designers. The first of these—A.H. Mackmurdo's Century Guild—was formed in 1882. It carried out a number of decorative schemes between 1882 and 1888 and showed furniture at exhibitions both in London and the provinces. Because of its policy of cooperative work, it is difficult to attribute designs with certainty to individual

Above: *Oak settle, with inlay of Macassar ebony, cherry, chestnut, and pewter, designed by M. H. Baillie Scott and made at J. H. White's Pyghtle Works in Bedford in 1901.*

Above: *Oak writing desk by the founder of the Century Guild, A.H. Mackmurdo, c. 1886.*

members of the Guild, but it is likely that most of the furniture—which included chairs, desks, sofas, and cabinets—was designed by Mackmurdo himself with contributions by other Guild members: hinges by Bernard Creswick, for example, or a painted panel by Selwyn Image, or carved ornament designed by Herbert Horne. Century Guild furniture found favor among the critics. *The Builder* spoke of a piano as "a good unpretending piece of work in excellent taste." That taste was simple, depending on proportion, balance, and a sharp contrast of verticals and horizontals, with a classical note prompted by Mackmurdo's early studies of Italian Renaissance architecture, though it could shade off into eccentric stylization, anticipating the sinuous forms of Art Nouveau.

Two years later, in 1884, the Art Workers' Guild was founded by a group of artists and architects led by William Lethaby, and in 1888 a splinter group from the Art Workers' Guild formed the Arts and Crafts Exhibition Society, which organized annual exhibitions in the New Gallery in Regent Street with accompanying lectures and demonstrations. In a talk entitled "Furniture and the Room" E.S. Prior began: "The art of furnishing runs on two wheels—the room and the furniture. As in the bicycle, the inordinate development of one wheel at the expense of its colleague has not been without some great feats, yet too often has provoked catastrophe; so furnishing makes safest progression when, with a juster proportion, its two wheels are kept to moderate and uniform diameters. The room should be for the furniture just as much as the furniture for the room." Across the Atlantic, the members of the American Arts Workers' Guild designed buildings, silverware, and metalwork, along with furniture complete with panel paintings similar in style to that of Morris.

What each guild provided was a platform for displaying and, at a time when there were few retail outlets, for selling, Arts and Crafts pieces. In the first few years of its existence the Arts and Crafts Exhibition Society exhibited furniture by C.R. Ashbee (who later opened his own shop in Brook Street, London, displaying the work of the Guild of Handicraft), Sidney Barnsley, Ernest Gimson, Reginald Blomfield, Ford Madox Brown, George Jack, and W.R. Lethaby. It also, most unusually, attributed each piece to the individual designer rather than the firm that produced it. The critics were intrigued:

"If we want to produce a nice chest of drawers—say—we must begin at the bare boards, and not at the surface ornament. Nay, perhaps the most valuable lesson of all, to learn, is that it is not *prettiness* that endues a thing with highest charm, but character. A *striking* proof of this is Mr. Madox Brown's delightful deal 'Workman's chest of drawers and glass,' at the Arts and Crafts Exhibition the other day—quite a plain thing with only a jolly, depressed carved shell above the glass and chamfered to the edges of the drawers—made in deal and stained green—that is all! It was just a commonplace thing handled imaginatively, and it gave me as much pleasure as anything in the exhibition. It made me feel that it takes a big man to do a simple thing: for the big artist takes broad views, he gives use its proportionate place, he knows the virtue of restraint, *and he has character to impart*."

The furniture exhibited was unlike anything commercially produced at the time. "The exhibition is full of things which seem to have been done because the designer and maker enjoyed doing them," wrote one critic in *The Builder*, "not because they were calculated to sell well." And yet, despite being expensive, they did sell well.

KENTON & CO.

THE FIRM OF KENTON & CO., named after a street in Bloomsbury just around the corner from its premises, was set up in 1890 by the Barnsley brothers—the affable Ernest and the shyer Sidney—with Ernest Gimson, W.R. Lethaby, and the slightly older architects Reginald Blomfield and Mervyn Macartney, "with the object of supplying furniture of good design and good workmanship." All of them had trained in the two most notable nurseries of Arts and Crafts architecture, the offices of John Dando Sedding and Richard Norman Shaw. Though Kenton & Co. proved to be a short-lived experiment it was a valuable one, for it provided direct experience both of designing furniture and of managing men in workshop conditions—experience Gimson and Barnsley were able to put into practice when they set up on their own in rural Gloucestershire.

Each of the architects contributed capital of £100 to the venture, with a further £200 being provided by a sixth sleeping partner, a retired cavalry officer called Colonel Mallett. Macartney

Below: *"Wonderful furniture of a commonplace kind,"—an impressive oak dresser by W.R. Lethaby, c. 1900.*

already had some experience supplying furniture designs to Morris & Co., and the new firm was set up very much in the same spirit as Morris's venture. There was no uniform or house style at Kenton & Co. All five architects produced their own designs without meddling: "We made no attempt to interfere with each other's idiosyncrasies," Blomfield recalled in his *Memoirs of an Architect*, "with the result that each followed his own inclination."

It was through his work for Kenton & Co. that Gimson forged his characteristically geometric style and method of surface decoration, so similar to Shaker designs. Lethaby's pieces were also very simple, often of box form—dressers, cupboards, blanket chests, and cabinets in walnut or oak, which he had scrubbed to give a pale, silky finish. They were meant to be placed on stands in the manner of the seventeenth century and were inlaid with designs of plants, boats, animals, or abstract geometric patterns. Gimson was impressed and called this "wonderful furniture of a commonplace kind." It was strikingly modern, revolutionary in its simplicity, and radical in its rethinking of both form

Right: *A mahogany cabinet, veneered with ebony, walnut, and holly, designed by Ernest Gimson for Kenton & Co. in 1890–1, now in the Musée d'Orsay in Paris. The first of a series of elaborately decorated pieces partly inspired by Spanish varguenos and seventeenth-century spice cabinets with small drawers.*

and material. The great sideboard, now in the Victoria and Albert Museum, that Lethaby designed in 1900—of unpolished oak inlaid with unpolished ebony, sycamore, and bleached mahogany—is typical of his furniture design. The twisting foliage of the inlay on the doors springs directly from Morris's flowing patterns, and contrasts dramatically with the more classical work of Reginald Blomfield and Mervyn Macartney, who followed "the elegant motives of the eighteenth century." Sidney Barnsley's bold geometric patterns of shape, color, and texture betrayed a Byzantine influence. He designed his pieces according to basic construction principles, relying on inlays of mother-of-pearl or ivory for decoration.

The Kenton & Co. furniture was made up by a team of professional cabinet-makers. In keeping with the Arts and Crafts belief that a workman inevitably produced better work and gained more personal satisfaction from seeing a single job through from start to finish, each piece was made by a single craftsman. *The Builder* wrote approvingly "all the work is designed by members of the company and made under their personal guidance by their own workmen and each piece of furniture is made entirely by one man and stamped with the initials of the designer and workman. The recognition of the workman was of course a step that has our entire sympathy."

The youthful venture lasted only eighteen months and its high point was undoubtedly the exhibition held at Barnard's Inn in the London Inns of Court in December 1891. C.R. Ashbee attended and

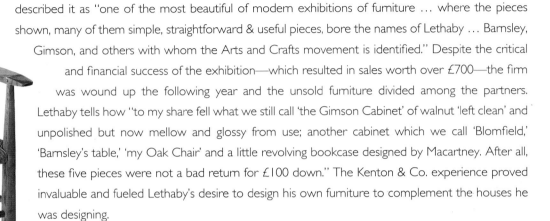

described it as "one of the most beautiful of modern exhibitions of furniture ... where the pieces shown, many of them simple, straightforward & useful pieces, bore the names of Lethaby ... Barnsley, Gimson, and others with whom the Arts and Crafts movement is identified." Despite the critical and financial success of the exhibition—which resulted in sales worth over £700—the firm was wound up the following year and the unsold furniture divided among the partners. Lethaby tells how "to my share fell what we still call 'the Gimson Cabinet' of walnut 'left clean' and unpolished but now mellow and glossy from use; another cabinet which we call 'Blomfield,' 'Barnsley's table,' 'my Oak Chair' and a little revolving bookcase designed by Macartney. After all, these five pieces were not a bad return for £100 down." The Kenton & Co. experience proved invaluable and fueled Lethaby's desire to design his own furniture to complement the houses he was designing.

Following the collapse of the company most of the craftsmen moved with Ernest Gimson and the Barnsley brothers to the Cotswolds, where they produced work that firmly yoked the English rural traditions of craftsmanship to the ideas of William Morris and the ideals of the Arts and Crafts movement.

Above: *A ladderback armchair designed by Ernest Gimson in 1885–90 and made from ash with a rush seat.*

GIMSON & THE BARNSLEYS IN THE COTSWOLDS

THE SOLID OAK FURNITURE made by the Barnsleys and Gimson in the Cotswolds is in the direct tradition of William Morris, Philip Webb, and Ford Madox Brown: good citizen's furniture, certainly. Gimson had met Morris personally a number of times in his youth and valued his advice. Morris had come, at the invitation of Gimson's father—a businessman with a keen interest in the arts and good handiwork—to address the Leicester Secular Society, and had stayed at the Gimsons' house. In *Random Recollections of the Leicester Secular Society*, Ernest's elder brother Sydney recalled how nervous they both were on meeting the great man:

"Ernest and I went to the station, and two minutes after his train had come in, we were at home with him and captured by his personality. His was a delightfully breezy, virile personality. In his conversations, if they touched on subjects which he felt deeply, came little bursts of temper which subsided as quickly as they arose and left no bad feeling behind them ... his lectures were wonderful in substance and full of arresting thoughts and apt illustrations."

Morris took a close interest in the young architect's career, opening up possibilities for him in London, lending encouragement, and fostering the ideal of a Utopian existence in the country.

While still an architectural student, Gimson had briefly apprenticed himself in 1890 to Philip Clissett, a country chairmaker at Bosbury near Ledbury in Herefordshire. There he had learned how to turn a simple rush-seated ash chair, and he applied this knowledge to the business of design. Though he did not actually make any more furniture with his own hands, he worked closely with his craftsmen and would often modify a design during the course of the work. Sidney Barnsley differed from Gimson in this important respect, for he enjoyed the physical business of making his own furniture by hand just as much as the designing. Gimson and Barnsley did, however, share a dream of establishing a community in the country with themselves as a nucleus around which, they hoped, other craftsmen would gather.

Following the collapse of Kenton & Co., Sidney Barnsley persuaded his brother Ernest to leave his architectural practice in Birmingham and join him and Gimson in Ewen, near Cirencester. It was quite an upheaval for Ernest, who was married with two young daughters, but he persuaded his unenthusiastic wife, Alice,

Above: *A lovely sturdy oak bench chest made by Ernest Gimson.*

to leave her newly built home in Birmingham and take up residence at Pinbury Park, an Elizabethan house on the Gloucestershire estate of Lord Bathurst. He had arranged to lease it at £75 a year on the understanding that he would carry out repairs. He and his family occupied the main house, while Gimson and Sidney Barnsley moved into adjacent cottages converted from former farm buildings.

In a shared workshop the three men began to make solidly constructed domestic furniture, eschewing machines and making a feature of the joinery by showing off the wooden pins, dovetails, and mortise-and-tenon joints. It wasn't for everyone. *The Builder*, in an issue dated October 1899, condemned the work as clumsy and inelegant, attacking the Arts and Crafts style:

> "In the reaction which is taking place against display and over-lavish ornamentation, the new school of designers appears to be losing the sense of style, and of the dignity of design which accompanies it, altogether. The object now seems to be to make a thing as square, as plain, as devoid of any beauty of line as is possible and to call this art."

They worked with local woods—oak, elm, ash, deal, and fruitwoods—which they left unadorned or chose to decorate simply by chamfering the edges of the pieces (a technique that had originated with wheelwrights and became popular with Gimson and the Barnsleys).

In 1895 Sidney married his cousin, Lucy Morley, who proved a strong and supportive wife to the plain-living Sidney, who not only made all his own furniture but chopped his own wood so that he could be warmed twice: once in the chopping and again when he burned the wood. They sought to get close to the land and to live a true country life. "It was wonderful [after] old smoky London to find yourself in those fresh clean rooms," recalled the designer Alfred Powell, "furnished with good oak furniture and a trestle table that at seasonable hours surrendered its drawing-boards to a good English meal, in which figured, if I remember right, at least on guest nights, a great stone jar of best ale."

In 1902 their landlord Lord Bathurst returned to take up residence at Pinbury Park but agreed to build three cottages on his land at the nearby village of Sapperton (twenty miles from Chipping Campden, where C.R. Ashbee was installing his Guild of Handicraft) and offered the farm buildings at Daneway for conversion into a spacious workshop and showrooms. Ernest Gimson and Ernest Barnsley had entered into a short-lived formal partnership, designing and manufacturing furniture, but Sidney chose to work alone, in an outbuilding adjacent to his new cottage at Sapperton which he converted into a workshop. He selected all his own timber and his designs have a rugged quality that reflects the rigor and dedication of his solitary way of working. Because he employed no one to assist him, his output was inevitably smaller. He outlined the plan to his old friend Philip Webb in a letter dated July 1902:

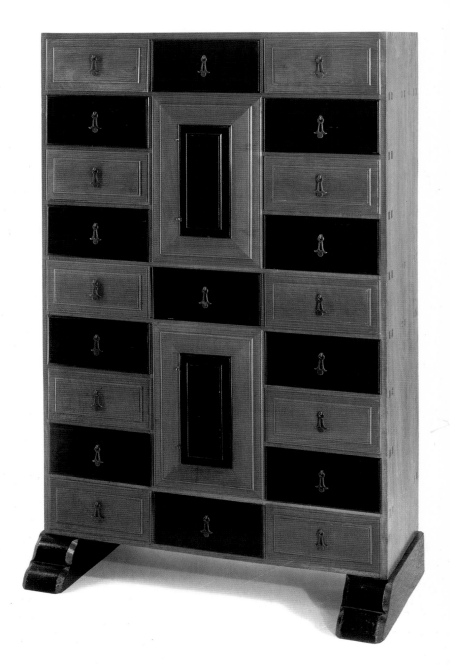

Right: *A walnut and ebony cabinet designed by Ernest Gimson c. 1905 with alternating panels on the drawers to form a geometric pattern. The cabinet was illustrated by Walter Shaw in* The Modern Home, *a showcase for Arts and Crafts furniture.*

"My brother and Gimson have already started workshops at Daneway having four or five cabinet makers and boys so far, with the hope of chairmakers and modellers in the near future. I am remaining an outsider from this movement and still going on making furniture by myself and handing over to them any orders I cannot undertake, and orders seem to come in too quickly now as we are getting known."

None of the three ever issued a catalog of designs. Instead Gimson sent photographs—which he expected to be returned—to prospective clients. Both fretted about the possibility of their work being copied.

The Daneway workshop went from strength to strength under the foremanship of Peter van der Waals, a Dutchman recruited by Gimson and Ernest Barnsley in 1901. Waals firmly believed that the form, quality, and color of the woods used—oak, occasionally walnut, and chestnut—should dictate the design of the furniture. Sir George Trevelyan, who worked with Waals after Gimson's death, asserted:

"Gimson would be the first to acknowledge the immense debt he owed to [Waals] as a colleague. Though Gimson was, of course the inspiration and genius, he used Waals from the outset in close co-operation. The association of these two men was an essential factor in the evolving of the Cotswold tradition."

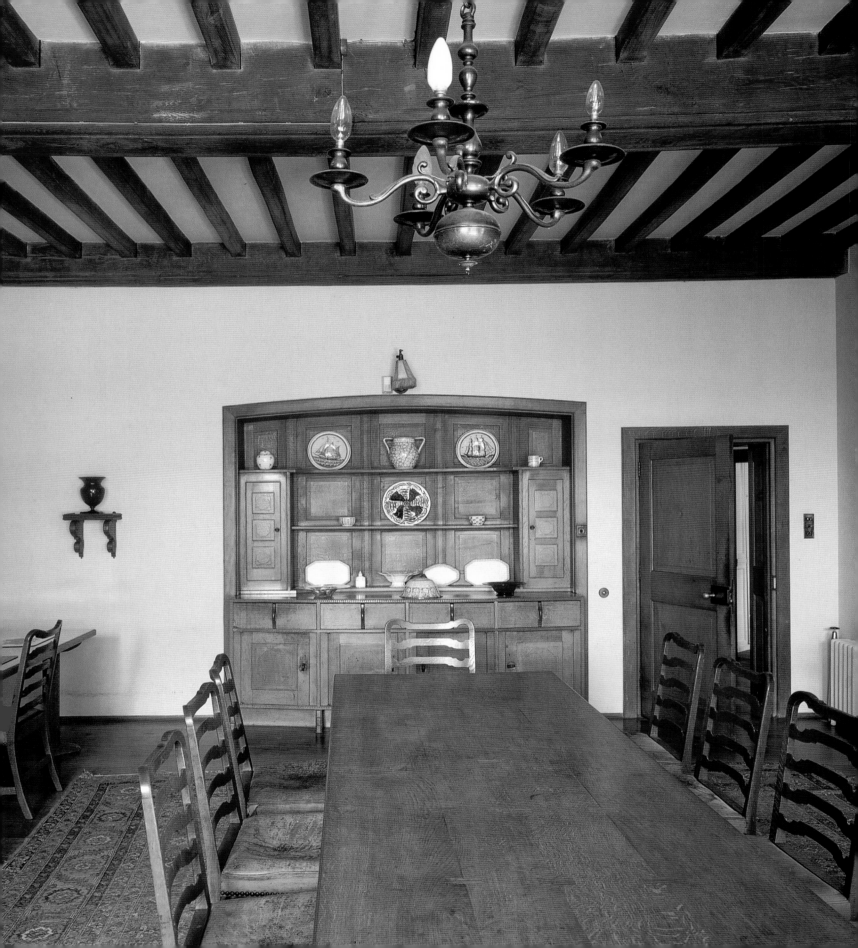

Things were not so harmonious between Gimson and Ernest Barnsley. They had fallen out amid some bitterness, with Barnsley complaining that Gimson "wouldn't compromise in any sort of way." The partnership collapsed and Ernest Barnsley concentrated his efforts on his architectural work, particularly at Rodmarton Manor, while Gimson carried on and expanded the Daneway workshop. By 1914 Peter Waals was in charge of nine woodworkers, four metalworkers, and three apprentices at Daneway. Gimson had leased Hill House Farm to house his workers and paid them an average of 10d an hour for cabinet makers (although Waals received 1s 2d an hour) and the apprentices 3d an hour. By 1918 Waals was receiving £5 for a fifty-hour week. Their costs and the quality of their materials inevitably put their furniture—an average prewar piece cost £12—beyond the reach of local people.

The Kenton & Co. practice of stamping the maker's initials on a piece of furniture was discontinued, with the result that it is very difficult to tell the work of Sidney Barnsley and Ernest Gimson apart. Both men used traditional woodworking techniques such as chamfering or gouging (which Sidney called "tickling" the wood) to add visual interest to their plainer pieces, but they also produced more highly decorated cabinets, sideboards, and church furniture, using mother-of-pearl or ivory inlays. Alfred Powell, who, with his wife Louise, decorated some of Gimson's pieces with oil paintings, claimed:

> "Much insight into his inner life was to be had at Daneway House among all his furniture. At first glance all was of extraordinary interest. Then one saw the beauty of the work, the substance, the development of the various woods, of the ivory, the silver, the brass, of inlays of coloured woods & shell. It was inevitable that you should find in the work now and then a humorous use of peculiar materials, an enjoyment of surprise."

In 1906 (and again in 1916) Gimson shared a stand with May Morris at the Arts and Crafts Exhibition held at Burlington House. He exhibited furniture, some of which she had decorated, in a specially designed bedroom setting. But his real chance to shine came in 1907, when Ernest Debenham offered him the chance to exhibit over eighty items (forty-five of which were furniture) for sale in his new London department store.

For Nikolaus Pevsner, Gimson was the "greatest artist" among his generation of furniture designers: "His chairs give an impression of his honesty, his feeling for the nature of wood, and his unrevolutionary spirit." Gimson died, aged only fifty-five, in 1919. Following his death, Peter Waals set up his own workshops at Chalford, Gloucestershire, producing his own designs and some of Gimson's.

Left: *The furniture in the dining room at Rodmarton Manor was designed by Sidney Barnsley and Peter Waals. The Barnsley built-in dresser is a complicated piece that employed one of his favorite decorative techniques: gouging on the horizontal and vertical edges.*

GUILD OF HANDICRAFT

IN THE SAME YEAR that the Arts and Crafts Exhibition Society was founded, Charles Robert Ashbee, a twenty-five-year-old architect, romantic, and socialist, opened the Guild and School of Handicraft in the East End of London with a capital of £50. Ashbee had been living in the pioneer University Settlement house at Toynbee Hall, an educational institution set up for the working man, where he taught classes on the writings of Ruskin for some years in the 1880s. His readings on the virtues of manual labor inspired his students to decorate the dining room at Toynbee Hall, and it was from these students that he drew the nucleus of his Guild of Handicraft, basing it on the model of the medieval guild system. Life was bleak in the East End and Ashbee wanted to offer something that would improve the lot of the working man. In the event, the School lasted only a few years, but the Guild flourished. In 1890 its expansion encouraged Ashbee to find new premises in a dilapidated Georgian building, Essex House, in the Mile End Road, and in 1902 he ambitiously relocated his Guild to the rural market town of Chipping Campden in the Cotswolds, with the aim of providing his seventy or so workers and their families with better conditions and happier, healthier, simpler lives. By the end of the century Guild craftsmen in the field of furniture were carving, modeling, and cabinet-making, as well as carrying out restoration and undertaking complete decorative schemes. The work of the designer, painter, and craftsman was acknowledged on each piece.

Ashbee's own most original designs were for silver and jewelry, but he made some interesting experiments in furniture, some of the pieces combining a variety of techniques such as woodcarving, metal engraving, and tooled leather. The earliest pieces made by the Guild of Handicraft, such as the oak cabinet painted in red and gilt with a quotation from William Blake's "Auguries of Innocence," are extremely simple in form. In addition to furniture from Ashbee's own designs the Guild made for other designers, notably M.H. Baillie Scott. As well as elegant cabinets and superb piano cases, they made a range of much plainer furniture, including bedsteads and washstands, with handmade handles and modestly carved decoration, that was close in style and price to the furniture commercially produced by Heal & Son.

Large commercial concerns such as Heal's and Liberty's were not slow to imitate the Guild's innovative style, and their undercutting of its prices eventually brought about its demise. The Guild made successive financial losses in 1905 and 1906 and, clearly in trouble, the business was formally wound up at the end of 1907, although some Guildsmen—including Jim Pyment who continued to make furniture alongside the carvers Alec and Fred Miller in the old silk mill where the Guild had set up its workshops—chose to remain in Chipping Campden.

Right: *This writing cabinet by C.R. Ashbee and the Guild of Handicraft was first exhibited at the Woodbury Gallery, London, in fall 1902.*

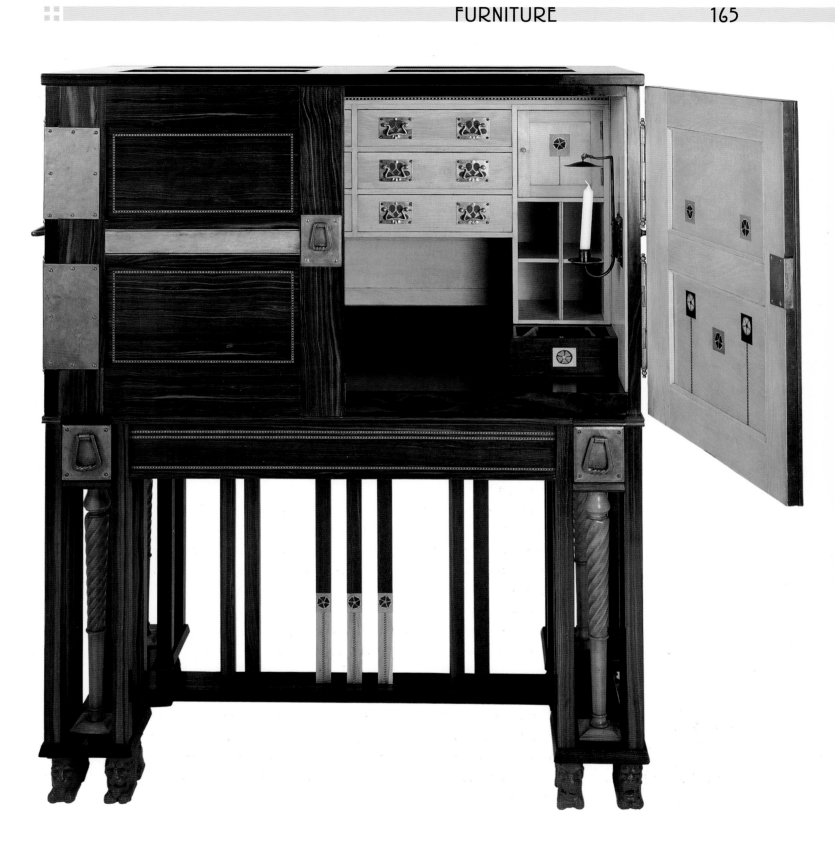

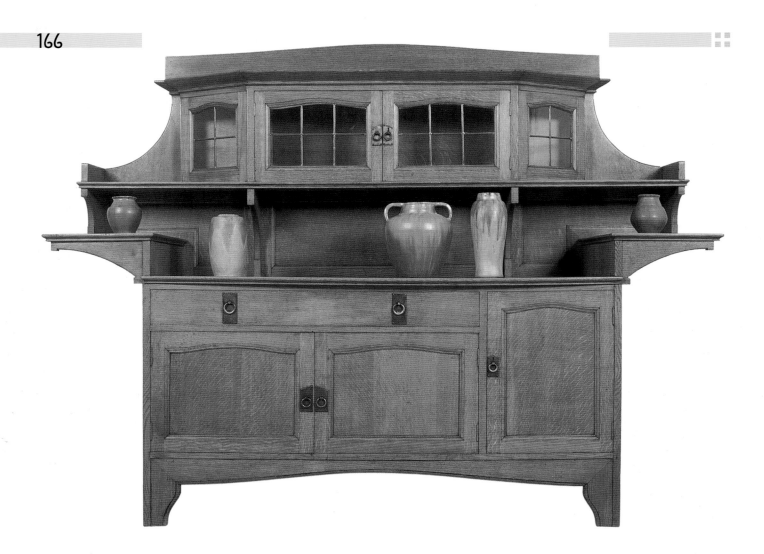

Above: *Liberty offered this sideboard in their "New Studio" range from 1898.*

Above: *Liberty offered this sideboard in their "New Studio" range from 1898.*

LIBERTY'S

Arthur Lazenby Liberty was a shrewd businessman with his finger on the fashionable pulse. He had worked his way up from apprentice draper to become the owner of a Regent Street department store in a mere sixteen years. In 1883, recognizing the potential in art furnishings, he opened a decoration studio under the management of the designer Leonard F. Wyburd at Chesham House, 140–50 Regent Street, and set out to provide furniture and furnishings to meet the demand for fashionable Aesthetic interiors, evolving a style that combined commercial Art Nouveau with the design vocabulary of the Arts and Crafts movement. Liberty both "borrowed" from Arts and Crafts designers (for his own range, much of which was designed by Wyburd, but clearly influenced by William Morris and C.F.A. Voysey) and commissioned them as well. The firm stocked designs by Voysey and George Walton and carried a line of eighty-one pieces of furniture designed by

M.H. Baillie Scott. It also stocked and sold Richard Riemerschmid's elegant oak chair, designed in 1899, as well as a very similar, somewhat cheaper, chair produced in the Liberty workshops with chamfered decoration on the legs and side supports.

From 1887 the firm's cabinet-making workshop was turning out simple side chairs, carvers, stools, and country-style furniture in oak with metal handles, strap hinges, and occasionally inset tiles by William De Morgan, and sub-contracting more complicated pieces to a series of manufacturers. Cheaper than the guilds, Liberty's posed a very real threat to them and contributed to their commercial demise in the 1900s. The store traded on the Arts and Crafts ethic—peppering its illustrated catalog with a series of quotations from Ruskin and applying mottoes to furniture much as Morris had—and its visual appeal, while dispensing with the central (and expensive) concept of the artist-craftsman and completely ignoring the movement's social message. And it proved hugely popular. Ironically Liberty's can be credited with both introducing a wider public to the (watered-down) ideal of the Arts and Crafts movement and hastening its end. For the Arts and Crafts style had to compete with its eclectic range—the catalogs romped through historical periods, offering ''Elizabethan,'' ''English Renaissance,'' ''Domestic Gothic,'' and ''Tudor'' styles (even a ''Cromwellian'' dining room) alongside the ''Quaint'' furniture that most closely approximated to Arts and Crafts style and drew on its motifs.

Above: *Leonard F. Wyburd designed this oak washstand for the Liberty Furniture Studio, c. 1894. The tiles are by William De Morgan.*

HEAL & SONS

THE LONG-ESTABLISHED FIRM of Heal & Son produced conventional Victorian furniture, largely beds and bedding, though a new department for sitting-room furniture had been opened in the 1880s. Ambrose Heal, the great-grandson of the store's founder who joined the firm in 1893, changed the course of the whole enterprise. Like Arthur Liberty, he was a shrewd businessman, and though he was largely in tune with the ideals of the Arts and Crafts movement, he was unembarrassed about using modern methods. As William Morris had quickly discovered, the maker of handcrafted furniture spent a very great deal of his time ''ministering to the needs of the

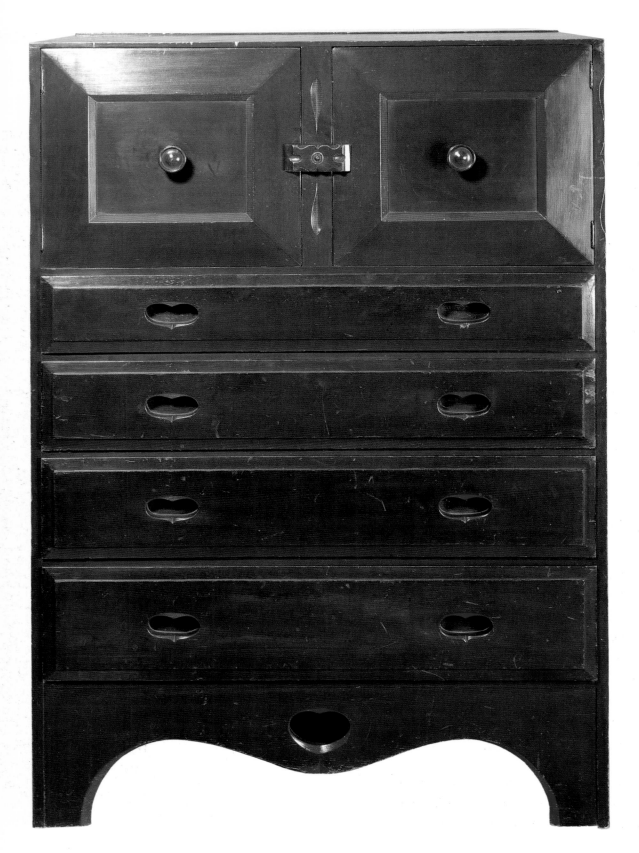

Left: *The influence of Ford Madox Brown's stained joiner furniture in sturdy forms is apparent in this painted chest of drawers from Heal & Son, 1900.*

Right: *This high-back oak chair, c. 1898–9, is a classic Charles Rennie Mackintosh.*

swinish rich," but Heal & Son's "Plain Oak Furniture" and "Simple Bedroom Furniture" ranges (which owed a heavy debt to Gimson and the Barnsleys) enabled earnest young couples to fill their homes with the kind of pieces their reading of Morris's *News From Nowhere* had made them yearn for. Heal displayed his furniture in novel "room sets" within the store, and mounted a showcase housing exhibition at Letchworth in 1905 containing cottage furniture of his own design. Available in a range of prices, the pieces were made from cherry, walnut, chestnut, or oak, characterized by simple, stylish design and crafted details—ebonized bandings and chip-carved plain handles. To underscore further the association with Morris and the Utopian dream of a better, simpler life, he called these ranges "Kelmscott" and "Lechlade."

Nikolaus Pevsner, who praised Heal's for its "pleasant bedsteads," detected a new modernism in its style and drew parallels between its plain waxed oak surfaces and the lightness of Voysey's wallpapers. "The close atmosphere of medievalism has vanished," he wrote, "living amongst such objects, we breathe a healthier air."

CHARLES RENNIE MACKINTOSH

THE SCOTTISH ARCHITECT CHARLES RENNIE MACKINTOSH had an exceptional client in Catherine Cranston, who gave him a creative and a financial free hand in designing her four Glasgow tea rooms— at 114 Argyle Street, 205–9 Ingram Street, 91–3 Buchanan Street, and the Willow Tea Rooms in Sauchiehall Street. Mackintosh was not a commercial furniture designer: each of his pieces was designed to integrate with the space and function of the specific room for which it was intended. It was for Miss Cranston that he designed his now famous high-back chair with pierced oval back, his ubiquitous ladderback chair, and his novel curved lattice-back chair with colored glass inserts.

Beauty mattered to Mackintosh as well as—perhaps more than—function, and his extreme modernism is evident in the exaggeratedly high backs of his dining chairs, which are based on simple geometric forms. His pioneering designs drew

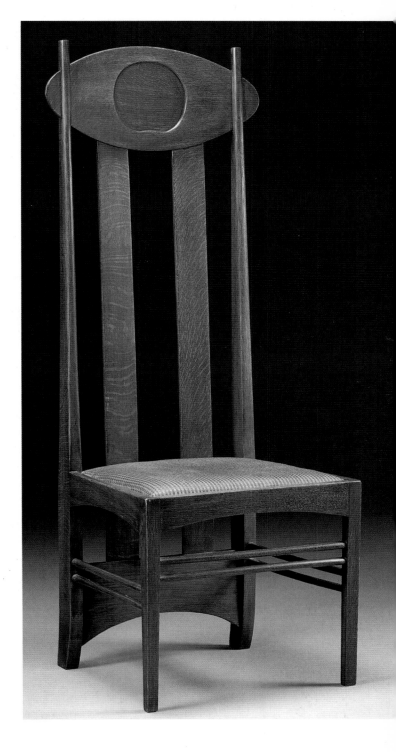

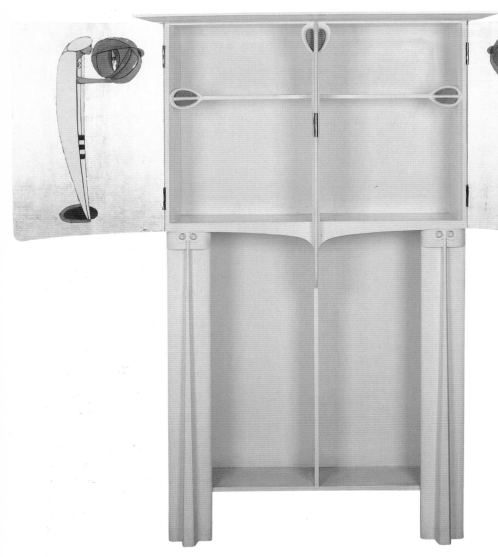

Above: *A Charles Rennie Mackintosh cabinet made for 14 Kingsborough Gardens, Glasgow, in 1902.*

on Art Nouveau, Celtic ornament, and the economy of Japanese art. He championed aesthetic unity in interiors and elevated common objects to the status of art, finding support and praise in Europe, where his work was highly regarded and extremely influential, and in America. In 1900, designs by Mackintosh and his wife Margaret, a fellow member of the Glasgow Four, were rapturously received at the eighth Secession Exhibition in Vienna and he was commissioned by the director of the Wiener Werkstätte to design a music salon for his house.

The couple set up home in Florentine Terrace, Glasgow, in 1906, and together made the interior glow with an ethereal, jewel-like quality. "Margaret has genius, I have only talent," Mackintosh generously said of his wife. They collaborated on the designs of several other house interiors, including Hill House for the publisher William Blackie.

C.F.A. VOYSEY

HARLES FRANCIS ANNESLEY VOYSEY began designing furniture in earnest in the 1890s. An elegant reticence characterizes his best work, along with an almost playful simplicity and careful proportioning. The wood he favored was untreated oak, planed and left—as he would meticulously note on his drawing—"free from all stain or polish." The freshness and

individuality of the pieces comes across in the play of form and shape rather than in any ornament and, although it is not unusual to find some low-relief carving on a Voysey piece, applied metal decoration, sparingly used, such as brass strap hinges and brass and leather panels (as on the Kelmscott cabinet) was a more common form of decoration.

He wanted his furniture to suit the everyday needs of the people who used it and as an architect and a designer constantly stressed the importance of honesty, originality, and simplicity. "We cannot be too simple," he stated in

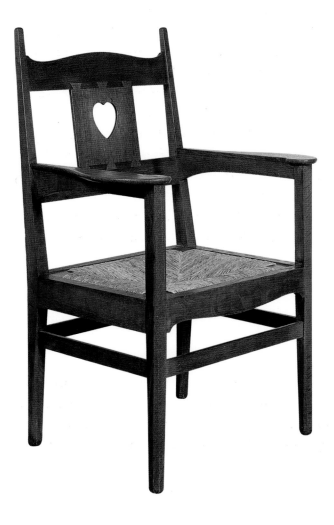

Left: *The design of this oak dining chair, made in 1902, is distinguished by a broad splat pierced with a single heart shape in characteristic Voysey style.*

Above: *A Voysey oak cabinet with double doors and strap hinges made especially to house and display Morris's Kelmscott Chaucer. Made by F. Coote in 1899.*

1909. "We are too apt to furnish our rooms as if we regarded our wallpapers, furniture and fabrics as far more attractive than our friends." He wanted his houses, inside and out, to exude a feeling of warmth, welcome and friendship, if not always deep repose (his very first design for the "Swan" chair uses a lovely free curving line in its shape but would not prove a very comfortable seat for a long period). If some of his chairs offered slender support, his tables tended towards sturdy functionalism. "Good craftsmanship," he wrote, "is the expression of good feeling, as good feeling leads to right and honest workmanship." His furniture was made for him by a select number of craftsman firms, including F.C. Nielsen and A.W. Simpson of Kendal. Voysey designed a house, Littleholme in Kendal, for Simpson in 1909 and the two men profited from a mutual exchange of ideas.

FURNITURE IN EUROPE

IN 1902, INSPIRED BY A VISIT to Ashbee's Guild of Handicraft, Josef Hoffmann returned to Austria and, together with Koloman Moser, a fellow member of the Vienna Secession, founded the Wiener Werkstätte. By 1905 the workshop employed over a hundred craftworkers and produced everything for the artistic interior, from metalwork, ceramics, glass, bookbinding, wallpapers, textiles, and enamelwork to elegant elongated furniture that owed much to the work of the Glasgow Four, and to Charles Rennie Mackintosh in particular. The furniture they produced was uncompromisingly modern and was condemned as "decadent" by the traditionalists of the British Arts and Crafts movement.

Mackintosh's influence can be felt in the designs that emerged from the Deutscher Werkbund, established in Munich by Hermann Muthesius, Friedrich Naumann, and Henry van de Velde in 1907 and inspired in part by the British Arts and Crafts movement. The Deutscher Werkbund accepted the need to design not just for handcraft but for mass production and produced furniture that was readily recognizable for its clean lines, blunt forms, and prime utilitarian considerations. A Werkbund exhibition in London in 1914 inspired the formation of the Design

Above: *Liberty sold this strikingly modern walnut chair by Richard Riemerschmid, 1899.*

Far right: *An oak chair with checker-pattern rushed seat by Peter Behrens, who went on to become a founder of the Deutscher Werkbund in 1907.*

and Industries Association, which was motivated by British government concerns for design reform with the declared aim of encouraging a public demand for "what is best and soundest in design."

Richard Riemerschmid, the principal designer and one of the founders of the Dresden and Munich Werkstätten, produced sinuous Art Nouveau-inspired designs for furniture that was largely handcrafted, although in 1906 he produced a line of suites called *Maschinenmobel* ("machine-made furniture") that was a huge commercial success. Riemerschmid was a member of the Deutscher Werkbund and enthusiastically embraced the modern age. The cross-fertilization of British and European design ideas is demonstrated by his influence on Harry Peach, a founder member of the Design and Industries Association, who, at his Leicester-based furniture firm of Dryad, made strong cane chairs in modern shapes prompted by the work of Riemerschmid. The chairs were popular in hotels, hospitals, and on ships, though they suffered from the competition of Lloyd Loom in the 1930s.

M.H. Baillie Scott attracted a number of European commissions for which he provided furniture: a music room for A. Wertheim of Berlin, a living-room interior executed by the Werkstätten, and a bedroom-boudoir with furniture made from alder and pear wood stained black and enlivened by mother-of-pearl and ivory inlay, which was exhibited at the Werkstätten exhibition in 1903. Carl Malmsten, the prize-winning Swedish designer of textiles, fabrics and furniture, visited Ernest Gimson's and Sidney Barnsley's furniture workshops in the early years of the century and shared their passion for handcrafted work, as did other contemporary Scandinavian furniture designers, including Alf Sture and Arne Halvosen in Norway. It was the Swedish painter Carl Larsson, however, whose illustrations of his country house, Sundborn, in his book *Ett Hem* (1898) came to epitomize Swedish domestic ideals and set the Arts and Crafts style for a generation.

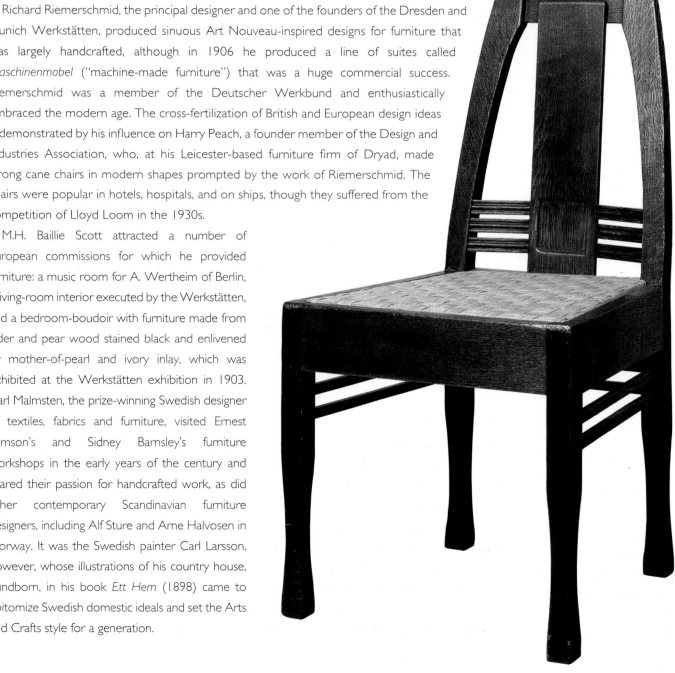

GUSTAV STICKLEY & THE CRAFTSMAN WORKSHOPS

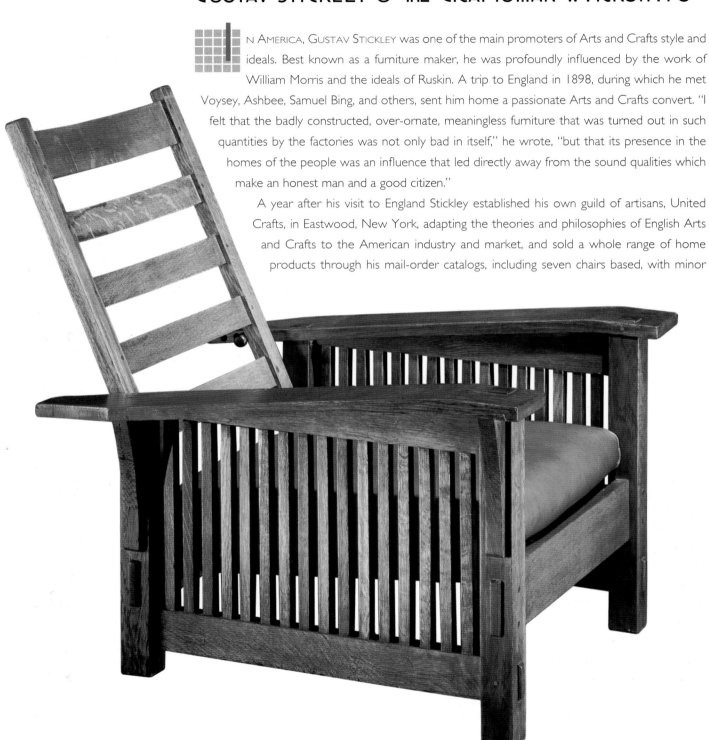

N AMERICA, GUSTAV STICKLEY was one of the main promoters of Arts and Crafts style and ideals. Best known as a furniture maker, he was profoundly influenced by the work of William Morris and the ideals of Ruskin. A trip to England in 1898, during which he met Voysey, Ashbee, Samuel Bing, and others, sent him home a passionate Arts and Crafts convert. "I felt that the badly constructed, over-ornate, meaningless furniture that was turned out in such quantities by the factories was not only bad in itself," he wrote, "but that its presence in the homes of the people was an influence that led directly away from the sound qualities which make an honest man and a good citizen."

A year after his visit to England Stickley established his own guild of artisans, United Crafts, in Eastwood, New York, adapting the theories and philosophies of English Arts and Crafts to the American industry and market, and sold a whole range of home products through his mail-order catalogs, including seven chairs based, with minor

Left: An oak "drop-arm" spindle "Morris" chair by Gustav Stickley, 1905. Stickley offered reasonably priced chairs, tables, desks, beds, and cabinets, usually made of white oak, quarter-sawn to show the grain, to the American middle classes through his Craftsman catalogs.

Right: A fine oak dropfront desk by Gustav Stickley, c. 1903.

differences, on the Morris model, one of which was a lady's Morris chair. He patented the first of these in October 1901. The largest model he described as "a big, deep chair that means comfort to a tired man when he comes home after the day's work." His magazine, *The Craftsman*, publicized both his products and his philosophy. His stated aim was "to do away with all needless ornamentation, returning to plain principles of construction and applying them to the making of simple, strong, comfortable furniture."

Unrepentant about his businesslike approach, Stickley tried to combine high ideals of craftsmanship with the latest machinery to make "furniture that shows plainly what it is, and in which the design and construction harmonize with the wood." He employed hundreds of workers using modern machines, and through *The Craftsman* he declared his intention to produce "a simple, democratic art" that would provide Americans with "material surroundings conducive to plain living and high thinking." His designs included little decoration and were in many ways crude—fidelity to the wood, more often than not oak, was most important. He based his simple, squat forms on seventeenth-century colonial furniture, intending to evoke the "simple life" of the early American settlers, and it proved very successful.

In 1903 Stickley employed the immensely talented architect Harvey Ellis to provide new designs for furniture and interiors. Ellis introduced ornamental inlays of stylized floral patterns in

Left: *A rare and important inlaid oak chair by Harvey Ellis for Gustav Stickley. Ellis, a brilliant but unstable architect, designed for Stickley for only a year in 1903, during which he introduced a more sophisticated European style reminiscent of Olbrich and Van de Velde.*

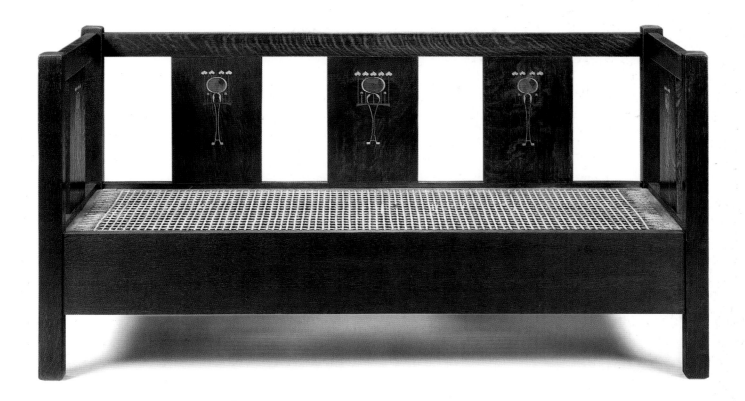

copper, pewter, and colored woods and took the furniture beyond the English styles, elongating and lightening pieces with taller proportions, thinner boards, broad overhangs, and arching curves. His work brought the influence of Charles Rennie Mackintosh and Europe to the American Arts and Crafts movement. Unfortunately, the successful collaboration between the two men would last less than a year, cut short in 1904 by Ellis's untimely death, aged only fifty-two. Stickley, meanwhile, forged ahead, expanding production to include metalwork accessories, lighting, and textiles, and in 1904 he changed the business name to Gustav Stickley's Craftsman Workshops. From 1905–9 he made more attenuated "spindle" furniture, influenced by Frank Lloyd Wright. It was lighter and more elegant but more easily copied and was soon sold by other furniture manufacturers (including his own brothers), leading to his bankruptcy in 1915 and the amalgamating of his firm with his brothers' rival company, L. & J.G. Stickley, to form the Stickley Manufacturing Co.

Today, Gustav Stickley is best known for his "Mission" furniture, so-called because it was associated with the furnishings of eighteenth-century Spanish colonial churches. "A chair, a table, a bookcase or bed [must] fill its mission of usefulness as well as it possibly can," he asserted. "The only decoration that seems in keeping with structural forms lies in the emphasizing of certain features of the construction, such as the mortise, tenon, key, and dovetail."

Above: *An oak settle, inlaid with copper, pewter, and exotic woods, designed by Harvey Ellis for Gustav Stickley, c. 1903. Stickley produced different versions of this form, including a cube armchair and a smaller settee.*

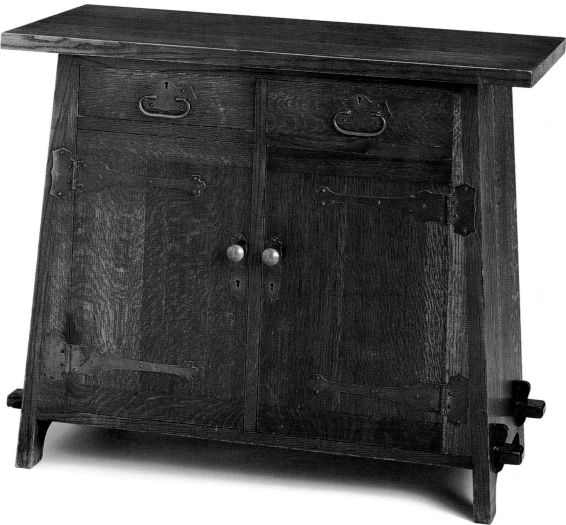

Left: *This sober-looking oak and copper cellarette, c. 1904–5, made and sold through the Roycroft Shop opens to reveal an interior fitted on one door with a tray for bottles and glasses and, on the other, with an ice bucket.*

ELBERT HUBBARD & THE ROYCROFTERS

ANOTHER IMPORTANT OUTLET for American Arts and Crafts furniture in the same period was provided by the craftsmen at Elbert Hubbard's Roycroft Arts and Crafts community in East Aurora, New York, founded in 1892. The furniture the Roycrofters produced was heavy and solid, not unlike Stickley's Mission-style pieces though more Gothic in manner, an influence underscored by the Gothic-style carved letters of the Roycroft name or the orb and double-barred cross symbol with which the pieces were marked. In 1901 *House Beautiful* described a Roycroft chair as "honest and simple enough in construction, but somewhat too austere in design, and altogether too massive to be pleasing." Hubbard sold his furniture range—available in ash, mahogany, or dark, fumed oak—through his shop and catalogs and for some represented the extreme commercial wing of the American Arts and Crafts movement.

CHARLES ROHLFS

AN IMAGINATIVE AMERICAN FURNITURE DESIGNER, Charles Rohlfs opened his workshops in Buffalo, New York, in 1891. His early Gothic-style furniture was exhibited at Marshall Field & Co. in Chicago in 1899 and attracted this praise from Charlotte Moffitt, writing in *House Beautiful*:

> "In the collection shown in Chicago of this queer, dark, crude, mediaeval furniture is a desk, a very marvel of complexity, with endless delights in the way of doors, pigeon-holes, shelves, and drawers.... When closed—that is when the writing shelf is raised and fastened with its rough hasp of dark steel and crude wooden pin—all the drawers and shelves in place, and the doors closed, it looks like nothing so much as a miniature Swiss cottage."

Rohlfs himself described his furniture as having "the spirit of today blended with the poetry of the medieval ages." Later, he combined the sturdy shapes of Arts and Crafts furniture with the sinuousness of Art Nouveau decoration and ornament and, following the international recognition he won at the Esposizione Internazionale in Turin in 1902, he was commissioned to design a set of chairs for Buckingham Palace. His work is too original and too playful to slot neatly under the Arts and Crafts banner, but the solid handcrafting and loving attention to detail earn him a place at its sturdy table.

Right: *A characteristically elongated and elaborately carved oak rocking chair, designed by Charles Rohlfs in 1901.*

CHARLES P. LIMBERT

THE FORMER FURNITURE SALESMAN Charles Limbert started his manufacturing company in Grand Rapids, Michigan in 1894, and in 1902 began making Charles Rennie Mackintosh-inspired geometric furniture out of oak. He used quality materials and produced fine furniture—with the help of the machine, a debt he played down in his company catalogs, which assert: "Limbert's Holland Dutch Arts and Crafts furniture is essentially the result of hand labor, machinery being used where it can be employed to the advantage of the finished article." Limbert drew inspiration from Japan, Austria, and England and the firm became known for incorporating decorative cutouts in the backs and canted sides of a number of its pieces and for its use of angled supports.

Below: *A two-door cabinet with poppy design by Arthur and Lucia Kleinhans Mathews for the Furniture Shop in San Francisco, 1906–20.*

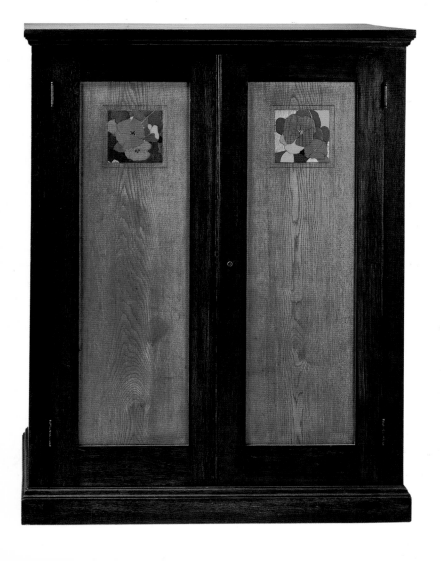

ARTHUR & LUCIA KLEINHANS MATHEWS

THE HUSBAND-AND-WIFE TEAM of Arthur and Lucia Kleinhans Mathews started the Furniture Shop of San Francisco in 1906, offering a complete interior design service to a city rebuilding itself after the huge earthquake and fire of that year. Arthur was responsible for the design and Lucia for the color schemes and carvings on the decorated furniture they supplied, along with wood paneling, murals, paintings, picture frames, and decorative accessories. Both had studied in Paris and their inspiration can be traced back to French classicism, to produce an opulent style far removed from the sturdy functionalism of Stickley and Hubbard. Work was brisk after the earthquake, and they and their team of skilled cabinet-makers, carvers, and decorators executed both large interior schemes and single pieces of furniture, which were often decorated with flowers or Californian landscapes. Their work anticipates Roger Fry's Omega Workshops, a British experiment that followed the Arts and Crafts movement, and produced work that was often of a very high standard.

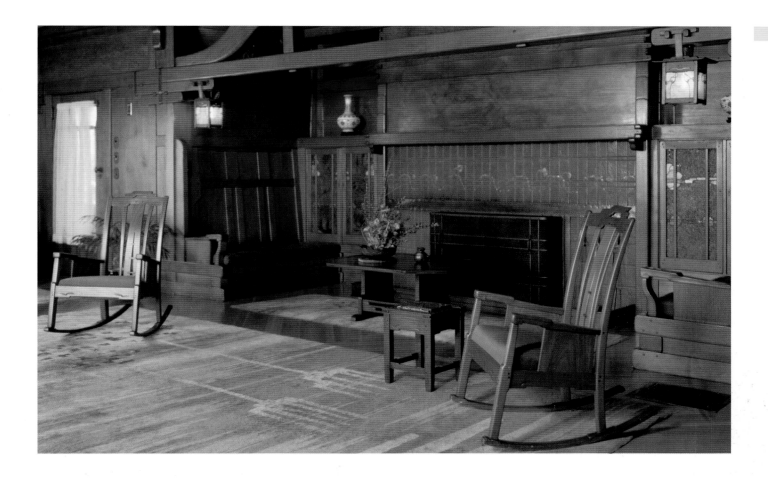

GREENE & GREENE

Above: *Two Greene & Greene rocking chairs on either side of the fireplace in the drawing room of the Gamble House.*

S OME OF THE MOST EXQUISITE American Arts and Crafts furniture was produced by the Greene brothers to complement the houses they were designing in California. They were much admired by C.R. Ashbee who, following a visit to Charles Greene in his workshop in 1909, wrote of how "they were making without exception the best and most characteristic furniture I have seen in this country. There were beautiful cabinets and chairs of walnut and lignum vitae, exquisite dowelling and pegging, and in all a supreme feeling for the material, quite up to our best English craftsmanship.... I have not felt so at home in any workshop on this side of the Atlantic."

Charles Sumner and Henry Mather Greene had absorbed the Arts and Crafts ideals on two visits to England, in 1901 and 1909. They translated them into the "ultimate bungalows" they designed and the elegant, exciting custom-made furniture that went inside them. Highly accomplished woodworkers themselves, they worked closely with another pair of brothers, the cabinet-makers Peter and John Hall, who executed the Greenes' designs from 1906, with Charles supervising production. Rounded corners and softened edges were a typical feature of the Greenes' furniture, along with a painstaking attention to detail and the use of the highest quality materials.

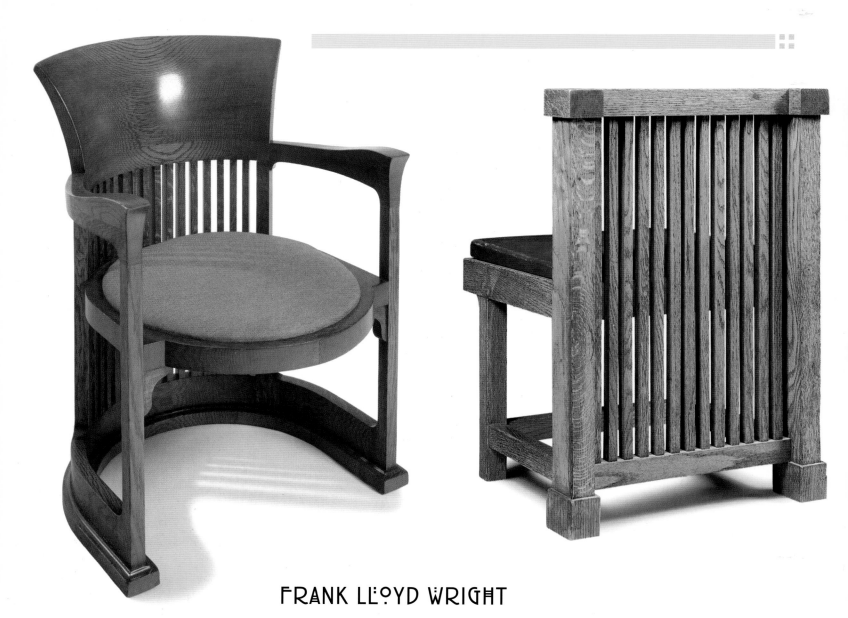

FRANK LLOYD WRIGHT

IN THE 1880s AND 1890s Frank Lloyd Wright began to design his own furniture to fit in with his concept of organic architecture, building in cabinets and shelving, and seating units around fireplaces. He designed his first dining-room table for his own Oak Park home, with tall spindle-backed chairs inspired by Voysey, Mackintosh, and Gimson (later copied by Gustav Stickley and others). He made his furniture from the same materials and with the same finishes as the buildings themselves, in keeping with the "grammar" of the house, relating everything to the whole so that "all are speaking the same language."

A founder member in 1897 of the Chicago Arts and Crafts Society, he took the Morris ideal and reinvented it in a twentieth-century idiom, which certainly did not preclude the aid of machines. Indeed, he celebrated rather than demonized the machine, believing it to be "capable of carrying to

fruition high ideals in art—higher than the world has yet seen!" Furthermore he praised the way "the machine ... has made it possible to so use [wood] without waste that the poor as well as the rich may enjoy today beautiful surface treatments of clean, strong forms." His starkly functional style made few concessions to comfort. He relied on the juxtaposition of shape, form, and space rather than applied ornament and used new constructional techniques and new materials to great effect. His furniture tends to be composed of strong horizontals and severe verticals: it is starkly geometric and exceedingly beautiful.

His styles evolved to match his architectural vocabulary, becoming simpler, more cylindrical, and more minimal in keeping with the economy of the low-cost "Usonian" houses he began to design in the 1930s. In 1955 Wright created his own line of furniture for the Heritage-Henredon Furniture Company. Modular pieces made of mahogany in basic circular, rectilinear, and triangular shapes, they were simple and functional and made his work available to people who did not live in a Wright-designed home.

Opposite right: *An oak spindle side chair designed by Frank Lloyd Wright for the Lawrence Memorial Library, Springfield, Illinois, c. 1905–10.*

Right: *A typically elegant high-backed oak chair designed by Frank Lloyd Wright in 1902.*

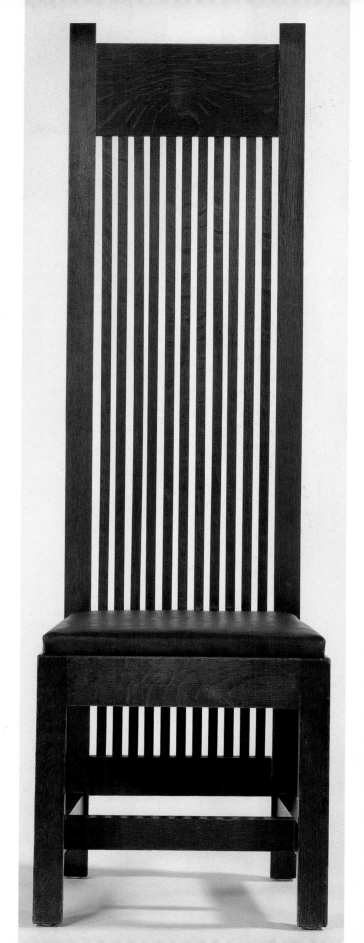

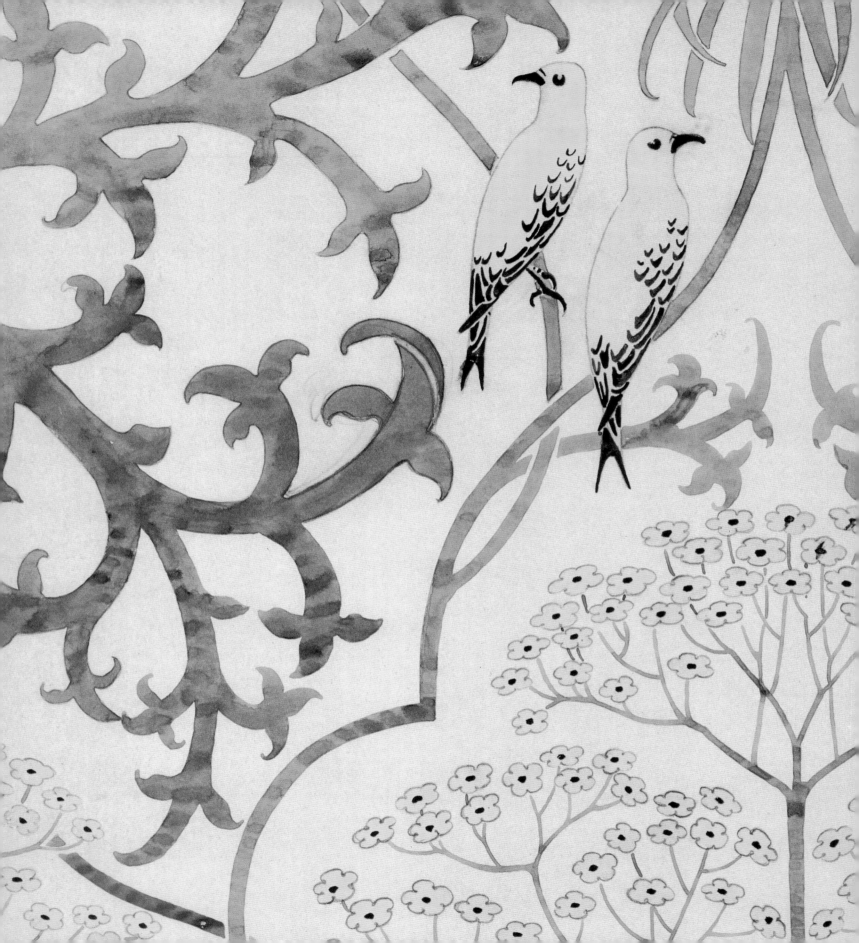

5

TEXTILES & WALLPAPER

Left: *"Fool's Parsley," a wallpaper design by C.F.A. Voysey who, though primarily an architect, was one of the most prolific and distinguished English pattern designers, influencing the direction of design in England and on the Continent. The bird motif, together with the heart, became in effect the Voysey trademarks.*

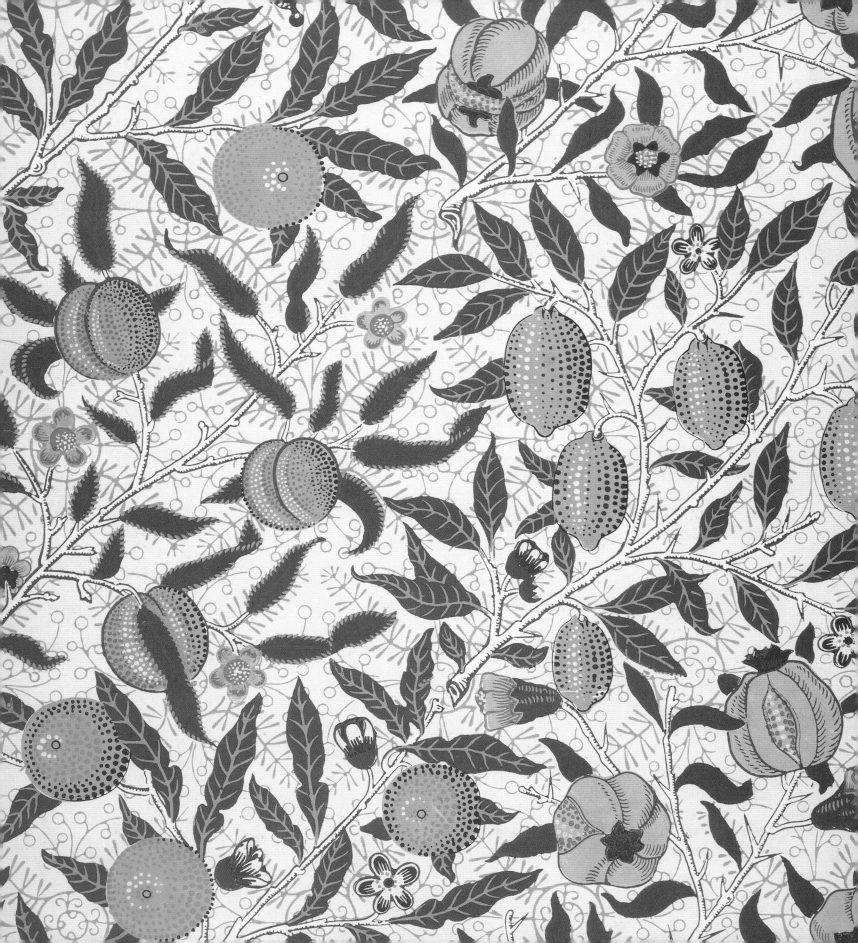

SATISFYING THE MIND & THE EYE

"In the Decorative Arts, nothing is finally successful which does not satisfy the mind as well as the eye. A pattern may have beautiful parts and be good in certain relations; but unless it is suitable for the purpose assigned it will not be a decoration."

William Morris, 1877

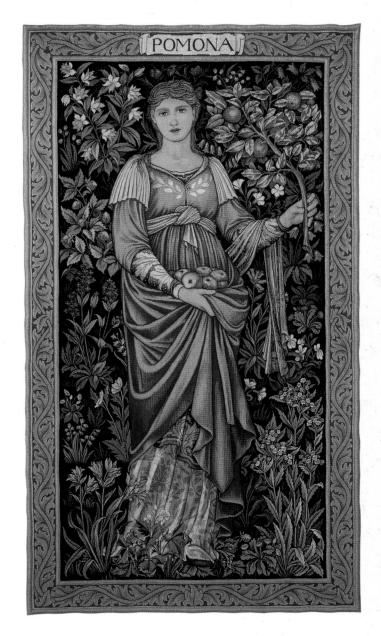

 THE ARTS AND CRAFTS MOVEMENT fueled a new middle-class fashion for interior decoration and firms like Morris & Co. and Liberty's—using a range of designers from Walter Crane to C.F.A. Voysey—provided the woven and printed textiles, carpets, wallpapers, and tapestries needed to furnish the "Artistic" home. The Victorian penchant for heavily draping and swathing furniture and windows gave way to a lighter, fresher fashion for less elaborate effect. William Morris's own and other Morris-inspired lightweight chintzes replaced the heavy velvet upholstery; window coverings were simplified and curtains were now arranged on simple wooden or brass poles; while a single oriental or Morris-made carpet was spread over a polished or stained wooden floor. Morris's genius for rich pattern-making and his experiments with natural animal and vegetable dyestuffs created distinctive fabrics and wallpapers that became the keynote of an Arts and Craft home on both sides of the Atlantic. "Aesthetic" colors like peacock blues, russet browns, madder reds, subtle yellows, and sage greens predominated in his luxuriously dense patterns based on natural motifs, while Voysey popularized a lighter palette in designs of almost stencil-like simplicity featuring stylized versions of flowers, foliage, birds, and animals on pale backgrounds.

Above: *Edward Burne-Jones designed the figure for "Pomona" and J.H. Dearle the background for this silk and wool tapestry for Morris & Co., c. 1900.*

Left: *Morris's "Pomegranate" wallpaper design, 1862, was available from the Firm in a choice of three different background colors.*

Above: *An embroidered linen cushion cover with linen appliqué, embroidered with colored silks and needleweaving borders, designed and made by Jessie Newbery, c. 1900.*

EMBROIDERY

A BURGEONING CRAFT in the last quarter of the nineteenth century, embroidery was enthusiastically taken up by women encouraged to make their home surroundings ever more beautiful. The Royal School of Art Needlework came into being and firms such as Morris & Co. and Liberty's in England, the Maison de l'Art Nouveau in Paris, and Gustav Stickley's Craftsman outlets in the USA sold specially dyed silks, wools, linens, and canvas with marked-out designs, which could be made up into curtains, cushions, or table runners. "Simplicity is characteristic of all Craftsman needlework which is bold and plain to a degree," an article in *The Craftsman* reminded its female readers, underscoring the Stickley message that textiles should be used to complement a decorative scheme, not overwhelm it.

What began with a simple daisy design worked by Janey Morris on a piece of cheap blue serge grew into a successful section of Morris & Co., which, by 1885, when May Morris took over the running of the department, produced floral designs for everything from tablecloths to cot quilts. The Morris connection also extended to the Royal School of Art Needlework in South Kensington, for Janey's sister, Bessie Burden, became chief instructress there. In Scotland, Jessie Newbery, wife of

the principal of the Glasgow School of Art, established embroidery classes in 1894 and encouraged her students to use embroidery as a means of self-expression.

Once again, the revival started with William Morris. In the late 1850s while living with Edward Burne-Jones in Red Lion Square, Morris had a wooden embroidery frame made—a copy of an old example—and began the painstaking process of teaching himself the art of embroidery by unpicking old pieces to discover how they had been made. He favored wool over silk and eschewed chemical dyes. He wanted to realize a romantic ideal of recreating an English medieval interior and soon enlisted the aid of his housekeeper, Mary Nicolson (known as Red Lion Mary), teaching her the stitches he had only just mastered himself. A year later, after his marriage to Janey, he sketched out a simple daisy design for his wife to work on a piece of indigo-dyed blue serge she had found by chance in a London shop. "He was delighted with it," Janey wrote, "and set to work at once designing flowers—these we worked in bright colors in a simple, rough way—the work went quickly and when we finished we covered the walls of the bedroom at Red House to our great joy." Georgina Burne-Jones, who helped as well, reported that "Morris was a pleased man when he found that his wife could embroider any design that he made, and he did not allow her talent to remain idle." He taught her and her sister Bessie his embroidery techniques and set them to work on an ambitious scheme for a dozen embroidered and appliquéd hangings he had devised for the drawing room of Red House. These depicted female figures—"illustrious women" drawn from the works of Chaucer—that had bold black outlines like stained glass and could almost have passed for cartoons. Other female friends, notably Lucy and Kate Faulkner, were taught "what stitches to use and how to place them" and put to work producing "embroidery of all kinds" using yarns Morris had dyed in subtle shades specifically for the Firm. Many commissions for altar frontals and medieval-style hangings came from churches that were also ordering stained-glass windows from the Firm. Designs for both were provided by Edward Burne-Jones, and Catherine Holiday, wife of the painter and stained-glass artist Henry Holiday, worked many of Burne-Jones's designs in outline stitch.

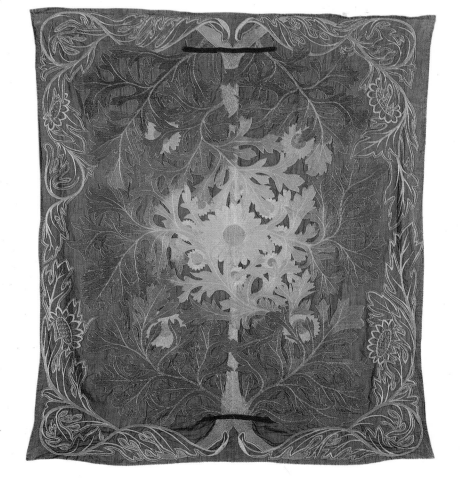

Below: *"Sunflower" hanging, c. 1876, designed by William Morris and embroidered in silks on a linen ground by Catherine Holiday, one of the most accomplished craftswomen of the period.*

It was around this time that Gertrude Jekyll, recently a student of the South Kensington School of Art, met Morris, who encouraged her interest in embroidery. She went on to design her own patterns, heavily influenced by him, featuring pomegranates, periwinkles, dandelions, and mistletoe. Her designs attracted commissions from the Duke of Westminster and Sir Frederick Leighton, though she was eventually forced by her failing eyesight to abandon such close work and turned instead—and with great success—to garden design.

In 1872 the Royal School of Art Needlework was founded and run by a committee of philanthropically minded aristocratic ladies, led by Lady Victoria Welby and Mrs. Anastasia Dolby, under the presidency of Princess Christian of Schleswig-Holstein, "to give amateurs and gentlewomen instructions in fine needlework and to reproduce from good designs the old English needlework on handmade linen, so often spoken of as Jacobean work." They wanted to provide suitable employment for needy gentlewomen and generally improve the standard of ornamental needlework. Twenty young ladies were chosen from the "impoverished genteel class" to occupy the small apartment above a hat shop in Sloane Street that provided the School with its first premises. Within three years it had expanded, moved to permanent purpose-built premises in Exhibition Road, South Kensington, and had a new patron—the Queen. There were separate workrooms devoted to embroidery, appliqué, and goldwork, as well as an "artistic room" where crewel embroideries from the designs of the artists employed by the School were carried out. The female workers put in an eight-hour day, later reduced to seven, and were paid on a sliding scale from 10 pennies an hour for the most skilled work to 4 pennies an hour for the least skilled. Both William Morris and Walter Crane—who referred to textiles as "the most intimate of the arts of design" because of their close association with daily life—were closely involved with the School, as, glancingly, were Edward Burne-Jones, Val Prinsep, G.F. Bodley, Sir Frederick Leighton, Alexander Fisher, and Selwyn Image. Crane's wife Mary was, in common with most women of her class, a skilled amateur embroiderer and it is probable that his introduction to textiles came from her. He was soon enthused and produced a number of striking designs, including the large and distinguished embroideries that hung at the entrance to the School's stand at the Philadelphia Centennial Exposition of 1876 and had such a powerful impact on Candace Wheeler and Louis Comfort Tiffany.

In 1875 Morris teamed up with Thomas Wardle, a silk dyer with works in Leek in Staffordshire. The two men collaborated on patterns and color schemes, consulting old herbals and reviving Elizabethan recipes for vegetable dyestuffs. Soon the Firm was offering a printed embroidery "kit" of ready-traced patterns for sale and commissions for wall-hangings mounted steadily. Morris's increasingly sophisticated embroideries were designed to be worked by the ladies of a household. Lady Margaret Bell and her daughters Florence and Ada spent eight years executing his designs for

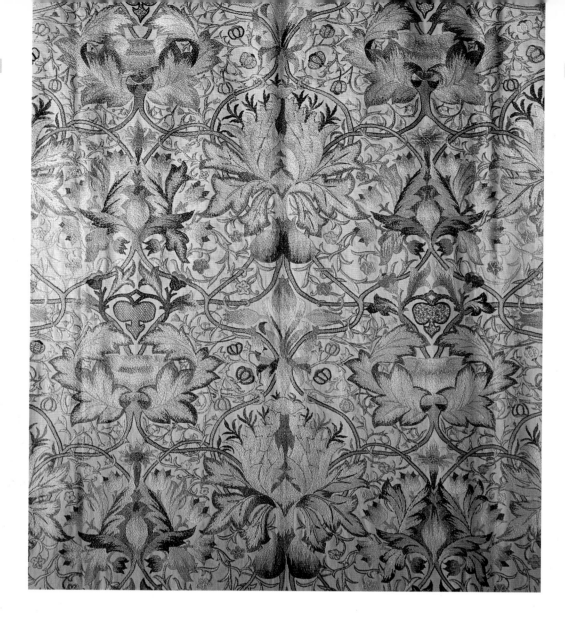

Right: *"Artichoke," designed by William Morris and embroidered in silk by Margaret Beale and her three eldest daughters, c. 1896, for the north bedroom at Standen,*

the wall-hangings he provided for Rounton Grange in Yorkshire, which was designed and built by his old friend Philip Webb in 1872–6. Similarly, Madeline Wyndham, whose husband Percy had just commissioned Philip Webb to design Clouds House for them, executed an elaborate embroidered curtain for a bookcase that was also exhibited at the Philadelphia Centennial Exposition. Mrs. Alexander Ionides and her female relatives embroidered curtains to Morris's design for her London home at 1 Holland Park. Her neighbor Margaret Beale, whose husband James commissioned a weekend country house from Philip Webb—Standen—that would enshrine all that was best in Arts and Crafts, was a fine needlewoman and embroidered one of Morris's best early hangings, a repeating pattern of lotus blossom in subtle Morris shades of peach and brown. Over a number of years, Mrs. Beale and her daughters filled Standen with embroidered versions of several Morris designs, including "Pomegranate," "Vine," and "Artichoke" (which now hangs in the north bedroom).

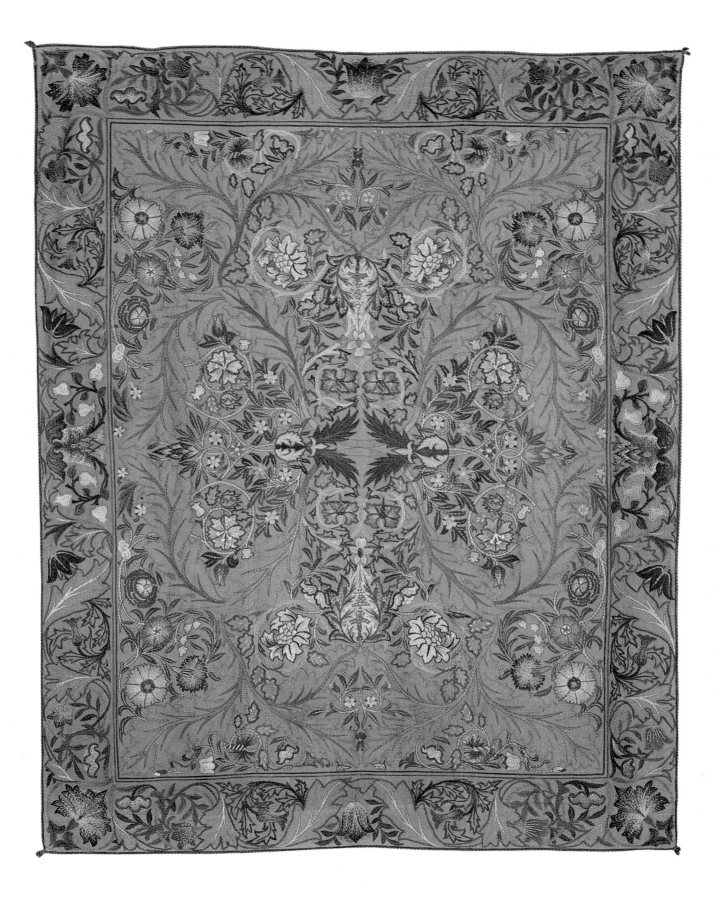

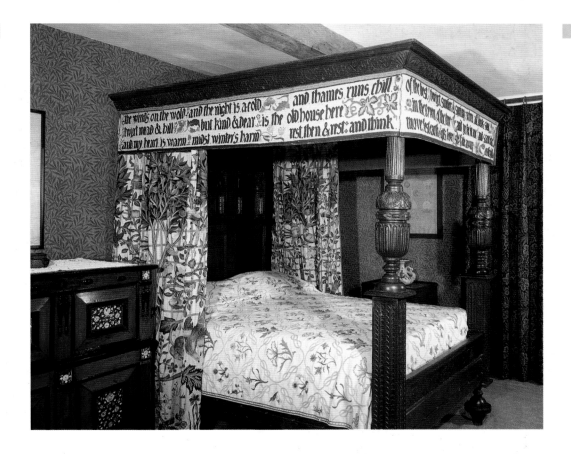

Left: *"Acanthus" designed by William Morris in 1880, and embroidered by his daughter May.*

Above: *The bed hangings surrounding William Morris's bed at Kelmscott Manor were designed and worked by his daughter May, assisted by Ellen Wright and Lily Yeats, c. 1893. Morris's own poem "On the Bed at Kelmscott" appears as an inscription on the valance. His wife, Jane, embroidered the bed cover.*

In 1885 Morris handed over the management of the embroidery section to his twenty-three-year-old daughter May, whom Henry James had discovered embroidering at Queen Square, alongside her sister Jenny, when the two girls were just seven and eight years of age. May recruited girls from the local Hammersmith school as apprentices and was also assisted by W.B. Yeats's sister Lily, Mary De Morgan (sister of the potter), and George Jack's wife. The work was carried out in May's drawing room at 8 Hammersmith Terrace, a short walk away from her parents' Kelmscott House, and was displayed and sold through the Firm's store in Oxford Street. In 1894 an "Orchard" portière, executed for the firm by Mrs. Theodosia Middlemore, was sold for £48, which represented about fourteen-and-a-half weeks' work. The previous year May had published her seminal *Decorative Needlework* and in 1910 she undertook a lecture tour of the USA.

The success of the Royal School of Art Needlework paved the way for pioneering regional organizations. Thomas Wardle's wife, Elizabeth, founded the Leek Embroidery Society in Staffordshire in 1879, which soon gained a reputation for the quality of its rich ecclesiastical embroideries on tussore silk, brocade, and velvet. In 1885 thirty-five members of the Society collaborated in an ambitious scheme to make a full-sized facsimile of the Bayeux Tapestry, which, once completed, went on tour and was eventually bought by the Reading Museum and Art Gallery. In contrast, in Haslemere in Surrey, the members of Godfrey Blount's Peasant Art Society were

using hand-woven linens, vegetable-dyed and appliquéd, to create simple but effective hangings in the traditional Arts and Crafts manner. The focus of the Arts and Crafts movement on rural and folk crafts precipitated a revival of interest in a number of traditional techniques, including smocking, patchwork, and quilting. Walter Crane, a leading practitioner, also designed clothes for himself and his family. His children were dressed according to the principles of "utility, simplicity, picturesqueness" in a sort of peasanty artistic costume. This form of "aesthetic dress" had become popular among an enlightened group of women who refused to wear the tight uncomfortable clothes of the period and favored instead loosely flowing gowns, embroidered in crewel wools and smocked at the yoke, waist, and sleeves. The Rational Dress Society was founded in 1881, encouraging women literally to loosen their stays and adopt "a style of dress based upon considerations of health, comfort, and beauty."

The art of embroidery was raised to such a high standard that a number of leading designers, architects, and artists prominent in the Arts and Crafts movement designed for the medium at some point in their careers. C.F.A. Voysey and M.H. Baillie Scott designed textiles and wrote on the techniques of embroidery. Baillie Scott employed the innovatory technique of using different colors and textures together in his designs, often for appliqué, with satin stitches and metal threads. Walter Crane, Christopher Dresser, and Lewis F. Day all wrote books on repeating design. From 1881 Lewis F. Day was artistic director of the Lancashire furnishing fabric firm of Turnbull & Stockdale and in *Art in Needlework* (1900) he wrote: "Embroidery is often thought of as an idle accomplishment. It is more than that. At the very least it is a handicraft; at the best an art." Ernest Gimson's varied activities also included embroidery designs, drawn from nature in rhythmic flowing patterns. His designs for washstand runners and samplers were often executed in white silk on white linen by his wife, sister, and sisters-in-law.

In Dublin, Evelyn Gleeson founded the Dun Emer Guild in 1902, as a focus for home industries, including lacemaking and embroidery, employing indigenous traditions and rich colors and textures.

Meanwhile, in Birmingham, Mary Newill was teaching embroidery in the new Art School's "art laboratories" alongside painters and illustrators such as Arthur Gaskin, Henry Payne, and Charles Gere. Inspired by the writings of Ruskin and the work of the Pre-Raphaelites, the Birmingham Group, as they came to be known, illustrated late-romantic poetry and medieval romances with their mural decorations, book illustrations, enameling and embroideries, these last often employing simple, homely materials. Like Morris and the Guild of Handicraft they were concerned with decorative unity.

Real innovation, however, was to be found in the work of Scottish and Irish designers. Women such as Phoebe Traquair, a skilled needlewoman who was also an enameler, bookbinder, and muralist, and Jessie Newbery, a teacher of embroidery at the Glasgow School of Art, led the field. Phoebe Traquair's ambitious "Denys" series of four gold and silk embroidered screens depicting allegorical figures was shown at the Arts and Crafts Exhibition Society in 1903. Other pieces, reflecting her interest in myth and legend, nature and history, were exhibited in Europe and at the St. Louis International Exhibition in America. Jessie Newbery's teaching style emphasized design over technique. "I specifically aim at beautifully shaped spaces," she wrote, "and try to make them as important as the patterns." She had three particularly gifted students in the Macdonald sisters, Frances and Margaret, and Ann Macbeth. The young students designed their own distinctive clothes

Below: *An embroidered cream silk panel from a lampshade with beads, ribbons, and braids, by Margaret Macdonald Mackintosh, wife of Charles Rennie Mackintosh, c. 1903.*

Left: *St. George and the Dragon textile, 1905, by the extraordinarily talented Phoebe Traquair, a notable example of a woman attaining recognition and prestige in the Arts and Crafts movement.*

Below: *"Lemon-daylily," a block-printed plain weave cotton, designed and produced by Candace Wheeler and Associated Artists New York, in the 1890s.*

and worked with homely inexpensive fabrics such as burlap, flannel, linen, and unbleached calico to produce practical but stunning items—bags, belts, collars, casement curtains, and cushion covers—in what became known as the "Glasgow" style. They popularized the use of appliqué to fill in large areas of color and used soft silvers, pearly grays, pinks, and lilacs for their bold floral motifs, achieved with the simplest possible stitching. Ann Macbeth went on to teach at the Glasgow School of Art, where she established an embroidery class for children, with the aim of instilling in them a feeling for color and design from an early age. She executed a number of ecclesiastical commissions, including an embroidered panel depicting St. Elizabeth and the altar frontal for St. Mary's Cathedral, Glasgow. She also designed for Liberty's and, in 1911, published the influential instructional manual *Educational Needlecraft*. Another important Scottish school of embroidery was started by Lady Lilian Wemyss and Miss Wemyss to give occupation to the poor in the East Fife area. The Wemyss Castle School carried out all types of embroidery and became a flourishing concern.

The work of Louise Lessore attracted particular notice. A year after marrying Sidney Barnsley's friend the ceramicist Alfred Powell, she designed the altar frontal for E.S. Prior's St. Andrew's church at Roker in Sunderland. The *Art Journal* reviewed the work in 1907, stating: "What she has done beautifully with her needle is part of a unity of design and execution in which the crafts of the weaver, the embroiderer, the wood-carver, metal-worker, and artist in stained glass have been freely employed.... In the work of the loom and of the needle, beauty and grace of the living flowers of the earth are translated into fair and happy art."

The impact of the Royal School of Art Needlework exhibit at the Philadelphia Centennial Exposition in 1876 sparked an interest in "art needlework" in the USA and prompted a revival of embroidery as a fine art. An ever-growing privileged and leisured class of American women—sometimes referred to as the "picnic generation"—with time and money on their hands, traveled to England on vacation and took classes at the Royal School in Kensington, where they also studied the embroideries in the South Kensington Museum. There was a growing interest in the development of the Aesthetic movement and the first comprehensive exhibition of Japanese art in the USA in 1876 was one of the prompts that led Candace Wheeler to found the Society of Decorative Art in 1877. The first branch, established in New York City as an "American Kensington School," was quickly followed by others in Boston, Philadelphia, and Chicago. Mrs. Oliver Wendell Holmes Jr., the daughter-in-law of the poet, was one of the most prominent needlewomen in Boston, famed for her landscape panels embroidered in silk on silk, which she exhibited through the Decorative Art Society as well as in a picture gallery in Boston. Members of the Society exhibited regularly and offered cash prizes for the best designs submitted for window-hangings, screens, portières, and table covers. In 1881 the total prize money topped $3,000. The Society strove to raise the standards of decorative

arts and promote a better appreciation of them. It wanted to create a new awareness of the role of interior design and provide middle-class women with both a creative outlet and a respectable means of earning money. "A woman who painted pictures, or even china, or who made artistic embroideries, might sell them without being absolutely shut out from the circle in which she was born and had been reared," wrote Candace Wheeler, in her autobiography *Yesterdays in a Busy Life*, adding the proviso however that "she must not supply things of utility—that was a Brahmanical law."

In 1879 Candace Wheeler joined forces with Louis Tiffany, George Coleman, and Lockwood de Forest to form Louis Comfort Tiffany & the Associated Artists, in which she was responsible for the execution of textiles. "We are going after the money there is in art, but the art is there all the same," Tiffany wrote. In 1882–3 they were commissioned to decorate the White House for President Chester Arthur. For a time they became very fashionable and their Fourth Avenue studios were visited by the great and the good, including Oscar Wilde, Ellen Terry, and Henry Irving. Other clients included Samuel Clemens (Mark Twain) and the British actress Lillie Langtry, for whom they made a silken bed canopy "with loops of full-blown, sunset colored roses" and a coverlet of "the delicatest shade of rose-pink satin, sprinkled plentifully with rose petals fallen from the wreaths above."

Above: *An embroidered silk portière, with glass beads and sequins, designed by Candace Wheeler, c. 1884, and made by Cheney Brothers at Hartford, Connecticut.*

Above: *"Seaweed and Dragonflies" embroidered table cover designed and made by the Society of Blue & White Needlework, Deerfield, Massachusetts, c. 1915.*

In 1896 the Society of Blue and White Needlework was founded in Deerfield, Massachusetts, to preserve early embroidery techniques. Local women were trained by Ellen Miller and Margaret Whiting to execute designs adapted from examples in the local historical society on tablecloths, bed curtains, and covers. Though most of their yarn was blue and white they experimented with natural dyes (chemical dyes were never used) to produce further colors and exhibited their work at Arts and Crafts Society exhibitions in New York, Chicago, and Boston. They even experimented with eastern influences: "Rub Oriental art through the Puritan sieve," explained Margaret Whiting, "and how odd is the result; how charming and how individual."

In keeping with his unified approach to design, Frank Lloyd Wright took a keen interest in the different textiles used in his houses. He favored simple, natural finishes—linens, cottons, and wools in flat weaves or fine velvets and leather for covering chairs. Pattern, if used at all, was geometric. His first wife was an excellent needlewoman and he included custom-designed linens, geometric in design, in several of his early Prairie-style houses. Carpets and floor coverings would be similarly simple and made from natural fibers.

In Austria and Germany hand-printed textiles, among them silks designed by Lotte Frömmel-Fochler and Carl Otto Czeschka, brocades by Josef Hoffmann, and hand-printed linens by Josef Zotti, along with bead bags produced at the workshops of the Wiener Werkstätte, were considered the height of fashion. Meanwhile, in Scandinavia, a revival of folk art and weaving techniques was in full swing. The designer Frieda Hansen, best known for her large woven wall-hangings depicting stylized flowers and motifs taken from Norwegian sagas, founded the Norwegian Tapestry Weaving Studio in Oslo in 1897, and Fanny Churberg set up the Friends of Finnish Handicrafts along Morrisian lines with the aim of preserving peasant traditions in textiles and embroidery.

WOVEN TEXTILES

I N 1881 WILLIAM MORRIS acquired the Merton Abbey Tapestry Works in Surrey and opened his own factory on the banks of the River Wandle, which supplied the copious amounts of water required for the business of madder and indigo dyeing. There he reinstated and perfected the technique of indigo discharge printing, creating some of his best-known block-printed textiles, including "Strawberry Thief," "Evenlode," and "Bird and Anemone." He also experimented with dyes. A young American visitor, Emma Lazarus, captured the atmosphere of the dye-house at Merton in an article entitled "A Day in Surrey with William Morris," which appeared in *The Century Illustrated Magazine* in July 1886:

Below: *William Morris enlisted the help of Philip Webb, who drew the birds in this design for a furnishing fabric entitled "Strawberry Thief." First produced in 1883, it went on to become one of Morris's most successful creations.*

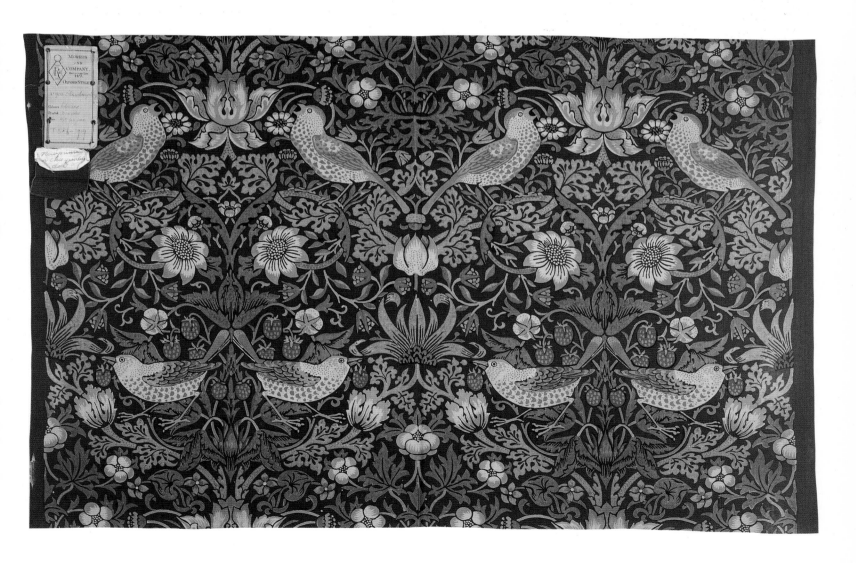

"In the first out-house that we entered stood great vats of liquid dye into which some skeins of unbleached wool were dipped for our amusement; as they were brought dripping forth, they appeared of a sea-green color, but after a few minutes' exposure to the air, they settled into a fast, dusky blue. Scrupulous neatness and order reigned everywhere in the establishment; pleasant smells of dried herbs exhaled from clean vegetable dyes, blent with the wholesome odors of grass and flowers and sunny summer warmth that freely circulated through open doors and windows."

At Merton Morris was able to continue production of his woven and less expensive printed textiles. Designs such as "Small Stem," "Large Stem," and "Coiling Trail" were printed on a fine wool and used for curtains, while the glazed cotton design "Jasmine Trellis" was suitable for lightweight curtains and loose chair covers. In fine weather the brightly colored cottons were laid out to dry in the meadow behind the workshop. Morris spent long hours in the South Kensington Museum (now the Victoria and Albert Museum) sifting through its growing collection of historic textiles and

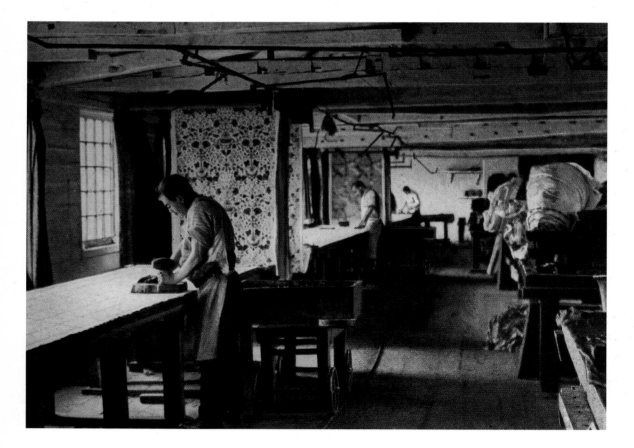

Left: *Morris & Co. employees printing chintz with hand blocks at Merton Abbey, where the Firm's workshop relocated in 1881.*

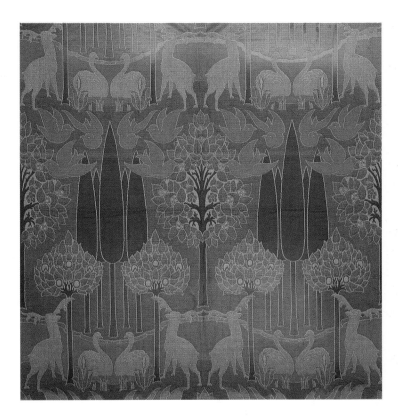

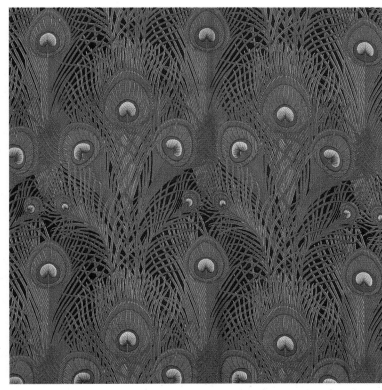

drawing inspiration from early Rhenish examples and, in particular, those from Persia, Turkey, and Italy. His great skill lay in the repeating pattern and early designs such as "Acanthus," "African Marigold," and "Honeysuckle" make clever use of a turnover or "mirror" repeat. Some fine designs were provided for the Firm by Henry Dearle, who had joined Morris as a boy of eighteen and so immersed himself in his master's style that for a while some important panels, portières, and screens by him were wrongly considered to have been the work of Morris. Dearle's finest tapestry, known as "Greenery," was woven in 1892 and bought by Percy Wyndham for the hall at Clouds. A second version of it now hangs in the Metropolitan Museum, New York.

Walter Crane's most successful textile designs, both critically and commercially, were for weaving. He enjoyed the challenge posed by the technical limitations and wrote elegantly in *Line and Form* (1900) about the difficulties of producing "curves by small successive angles," admitting that a certain "squareness of mass becomes a desirable and characteristic feature." Morris & Co. reproduced his design for "The Goose Girl" in traditional arras tapestry in 1881.

Above left: *A woven wool hanging designed by C.F.A. Voysey and manufactured by Alexander Morton & Co., c. 1897.*

Above right*: "Peacock Feathers," a roller-printed cotton, designed by Arthur Silver of the Silver Studios and printed by Rossendale Printers for Liberty & Co., c. 1887.*

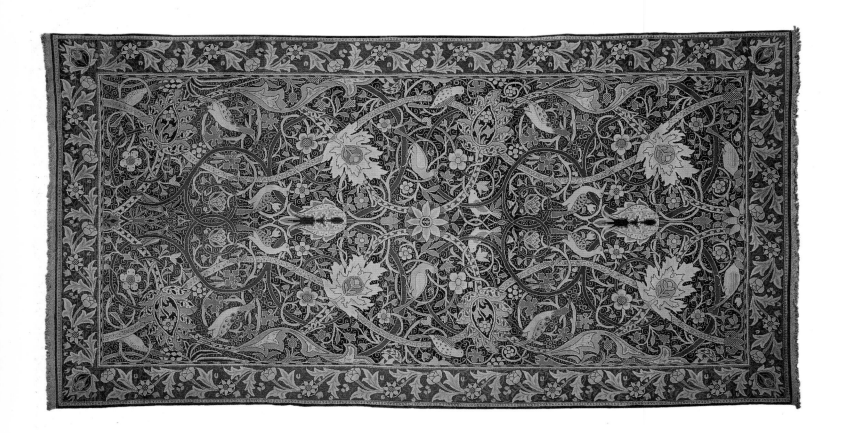

Above: *The "Bullerswood"*
carpet by William Morris, c. 1880.

CARPETS

WILLIAM MORRIS embarked on his first hand-tufted carpet on a loom in a back attic at Queen Square in 1878. He was pleased with the result, and the loom moved with him to Kelmscott House on the bank of the Thames at Hammersmith. It was installed in the coach-house for a couple of years before the whole carpet-making operation was moved to "a long cheerful room" in the Merton Abbey works. Taking Persian carpets as a starting point, Morris created designs, as for his other textiles, based on repeated patterns drawn from nature. He had, however, been experimenting with designs for machine-made carpets before this date and had registered his first two designs on Christmas Eve 1875.

Carpets were not fitted right up to the skirting as is normal today but laid over plain or stained floorboards, and Morris's designs were composed in much the same way, with a central pattern or "field" enclosed by a decorative border. His most inexpensive machine-woven carpets (retailing at

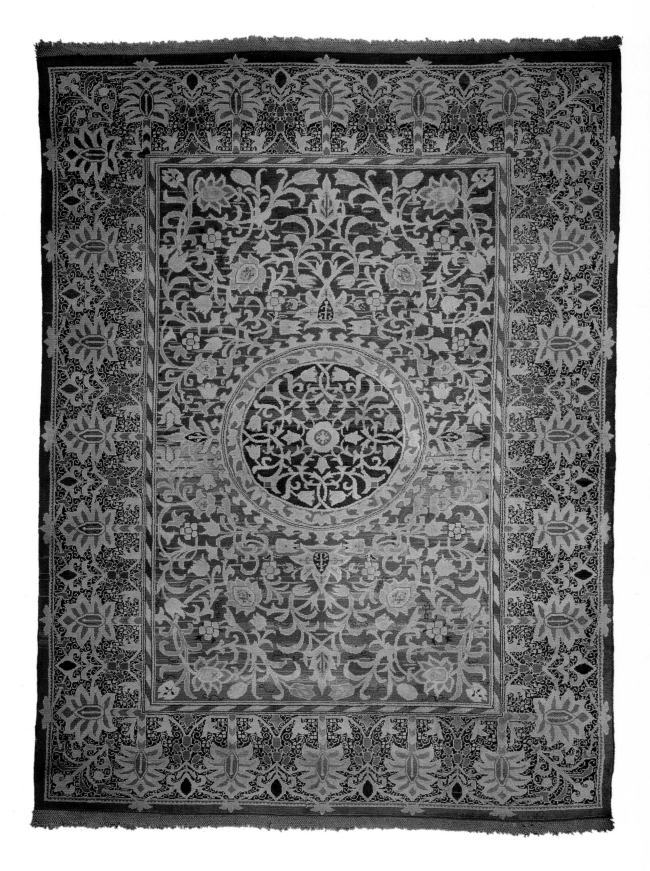

Right: *This large Morris carpet was among the many textiles and wallpapers designed by William Morris that were used in the Glessner House in Chicago.*

approximately 4s per square yard, rather than 4 guineas for a hand-knotted carpet) were intended for use on stairs, in bedrooms, and in the homes of the less well off. They were made for Morris & Co. by the Wilton Royal Carpet Factory, who also produced Axminster and Kidderminster carpets in William Morris designs, and they proved very popular. "Wiltons must be classed as the best kind of machine-woven carpets," ran the sales pitch in the Morris & Co. brochure for the Boston Foreign Fair in 1883. "The patterns they bear are somewhat controlled as to size and colour by the capability of the machine…. If well made the material is very durable, and by skilful treatment in the designing, the restrictions as to colour are not noticeable." They were snapped up in the USA.

The hand-knotted "Hammersmith" carpets, on the other hand, marked with a letter "M" with a hammer and waves to represent the Thames, were individual works of arts on a par with the Firm's richest embroidered hangings and tapestries. Owners—who included wealthy industrialists like Sir Isaac Lowthian Bell, aristocrats such as George Howard and the Hon. Percy Wyndham, and wealthy American clients such as John and Frances Glessner—often hung them on walls rather than laying them on the floor. The Hammersmith carpet Morris designed for the drawing room at Clouds was put up for sale in 1932 when Dick Wyndham disposed of the house and its contents. It did not find a buyer immediately, but soon after it was exhibited at the Victoria and Albert Museum it was acquired by Cambridge University. It still graces the floor of the Combination Room in the Old Schools.

In the quest for decorative unity, Morris's carpets, whether rich or simple, "expressed the proportions of the room." They were intended to harmonize with the Morris & Co. fabric used to cover the chairs and for the curtains: the whole effect was a return to Crane's ideal of "rich and suggestive surface decoration."

Handmade carpets were also designed by A.H. Mackmurdo, whose Century Guild wall rugs were sold through Morris & Co. and advertised through the Guild's magazine *The Hobby Horse*. "There is room for the highest qualities in the pattern of a carpet," wrote Walter Crane in 1887, "… the sincere designer and craftsman … with his invention and skill applied to the

Below: *"Tulip and Lily" Kidderminster carpet from Morris & Co., c. 1875.*

accessories of everyday life may do more to keep alive the sense of beauty than the greatest painter that ever lived." Liberty's sold carpets machine-made by the Carlisle carpet and textile firm Alexander Morton & Co. from designs by C.F.A. Voysey and Lindsay Butterfield.

In the USA, Arts and Crafts designs were used on carpets produced by the Bigelow Carpet Co. of Massachusetts. Architects such as George Grant Elmslie and Frank Lloyd Wright designed rugs and carpets for a number of their houses, notably in Elmslie's case the Henry B. Babson house, and in Wright's the Dana-Thomas, Robie, May, Coonley, and Hollyhock residences. Elmslie used beige, rust, and brown backgrounds to set off pale green and turquoise Arts and Crafts motifs, while Wright used solid, earthy tones enlivened by small amounts of geometric pattern, chevrons, and linear borders, designed to continue the other motifs and splashes of color already assembled in his interiors. Oriental rugs were used throughout most of the Gamble House but Charles Sumner Greene did design five custom rugs for the living room, including the fireplace nook, which continued the "Tree of Life" motif used in the stained glass of the entrance, though somewhat abstracted into a fork-like pattern. The colors ranged from shades of olive green and brown through blues and ocher with splashes of rose and mauve.

WALLPAPER

THE MASS PRODUCTION of wallpapers had begun in Britain in the 1840s, revolutionizing interior wall decoration. Up to this point, walls were usually painted, sometimes marbled or grained to look like wood or stenciled and enlivened with a decorative border. Fabric such as watered silk or printed damask was used a good deal on the walls of wealthier homes, but once wallpaper began to be commercially produced by firms such as Jeffrey & Co. it was soon seen on the walls of most Victorian households. By 1860, new technological advancements had pushed production up to nineteen million rolls of wallpaper a year. The publication of Owen Jones's influential book *The Grammar of Ornament* in 1856 had had a huge impact. It became a pattern book for British taste and design, and Gothic, Oriental, Moorish, and classical motifs began to appear on wallpapers, along with the diamond, or diaper, motif used most famously by Augustus Pugin on his wallpaper designs for the Houses of Parliament.

It was the publication of Charles Eastlake's influential *Hints on Household Taste* in 1868 (an American bestseller when published there in 1872, running to seven editions), that promoted a single, cohesive style in the home and paved the way for the Arts and Crafts style that was following

Above: *This "Tree of Life" carpet was designed by Charles Sumner Greene, 1908–9, to go in the fireplace nook of the living room in the Gamble House.*

fast behind. As ever, Morris & Co. was shaping the public taste. William Morris's flat, rhythmical, handprinted patterns, based on medieval motifs and on nature, were strikingly fresh and modern. "Wallpapers," he explained in a lecture on pattern designing, "must operate within a little depth. There must be a slight illusion—not as to the forms of the motif, but as to relative depth." He demonstrated this in "Daisy," for example, where the pattern is pleasantly balanced and clearly ornamental, with no recession and no imitation of accidental details. This wallpaper, along with other early designs such as "Fruit" and "Trellis," was inspired by the flowers and fruit found in his garden at Red House (just as his later long-leaved "Willow," which became one of his most enduringly popular decorative designs, was inspired by the willow-bordered river that ran through his country property, Kelmscott Manor).

Between 1862 and 1896 the Firm produced a vast range of patterns in warm, subtle colors—sage green, rusts, ochers, plums, peacock blue, and gold—achieved by avoiding the new chemical methods

Right: *William Morris's "Acanthus" wallpaper design, 1875, was hand printed using wood blocks.*

in favor of traditional vegetable dyes. They proved immensely popular with the public: Margaret Beale ordered all the wallpapers for Standen from Morris & Co., which also supplied a fair number of chintzes for hangings and curtains, hanging "Daffodil" in the morning room and "African Marigold" and "Severn" elsewhere in the house, and Morris's papers were eagerly pasted onto the walls of Richard Norman Shaw's Bedford Park estate houses by their artistic occupants. "Do not be afraid of large patterns," Morris counseled in 1888, "if properly designed they are more restful to the eye than small ones: on the whole, a pattern where the structure is large and the details much broken up is the most useful … very small rooms, as well as very large ones, look better ornamented with large patterns."

Another important contributor to the field was Walter Crane, who provided elaborate wallpaper designs for Jeffrey & Co., the firm Morris had entrusted with the printing of his first wallpaper designs in 1864, and which had, a year before, printed Owen Jones's series of elaborate papers designed for the Viceroy's Palace in Cairo. Crane was commissioned by Jeffrey & Co.'s entrepreneurial director Metford Warner, "a man of taste

Right: *This repeating pattern of heavily stylized irises was designed by Walter Crane as a wallpaper frieze in 1877.*

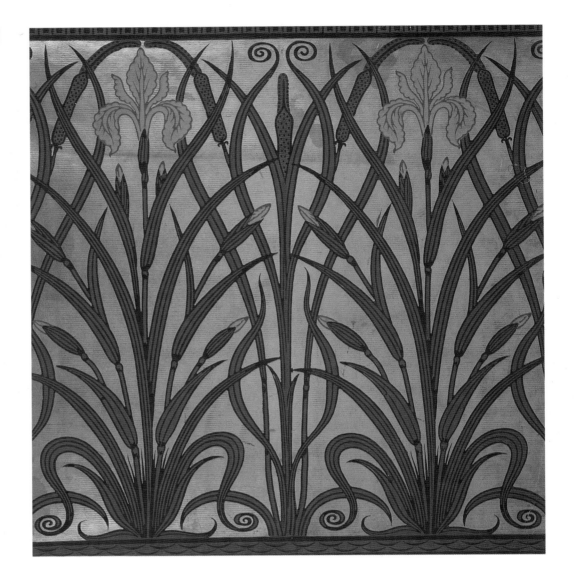

and judgment, who," according to Crane, spared "no pains to get the proper effect of a pattern." He was certainly innovative and commissioned designs for papers from E.W. Godwin (who took his inspiration from a Japanese silk patterned with a flowering bamboo motif), William Burges, B.J. Talbert (who also contributed stylized Anglo-Japanese designs), Albert Moore, and Charles Eastlake—none of whom had designed wallpaper before. But it was Crane's work, more than that of any other designer, that established the reputation of Jeffrey & Co. as high-quality manufacturers of wallpapers, friezes, nursery papers, and figurative panels. Crane's designs attracted a great deal of attention from both the popular and the trade press and won awards at international exhibitions in London and Paris, though his wallpapers, like Morris's, were sometimes criticized for being too assertive. As Lewis F. Day retorted in 1903: "I am not sure that I want anyone's personality to call out to me from the walls and the floor of my room." Another critic complained that Crane's

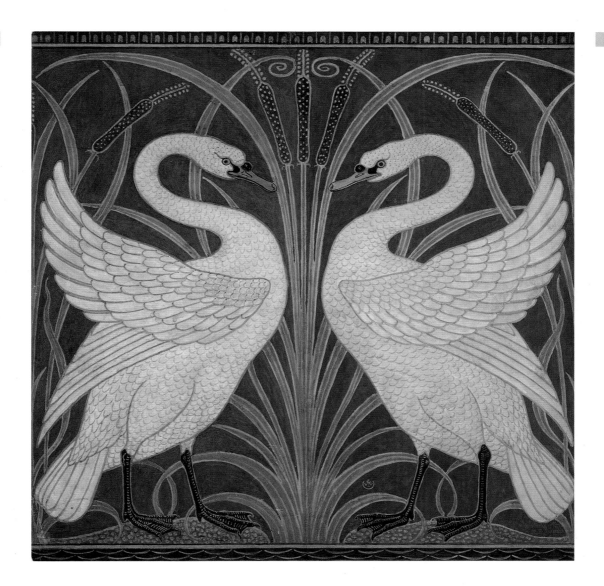

wallpapers were "not retiring enough, they dominate the room by their richness and importance." Crane, however, refused to bow to "the fluctuating harlequin of fashion and trade" and produce "vulgar, commercial work" and some of his hand-printed wallpaper designs, such as "Cockatoo" and "Pomegranate," are beautifully balanced, stunningly colored pieces, though a little would certainly go a long way.

In the middle of a long-running debate raging at this time about whether or not to include animals and birds on wallpapers, Walter Crane cheerfully included human shapes in his friezes and nursery papers and animate forms from macaws to peacocks in many of his wallpapers, although even he conceded that it would be "out of the question to hang pictures on a wall papered with the 'Peacock Garden'."

"The introduction of any members of the Animal Kingdom in wallpapers," thundered the *Building News* of 1872, "involving as it necessarily does, such amount of repetition, is always dangerous. Even

Above: *A watercolor and pencil design by C.F.A. Voysey for a textile or wallpaper, 1919. Exceedingly prolific, Voysey was producing designs for almost fifty years, a period longer than the designing life of William Morris.*

birds, which are the least objectionable, have their difficulties." Morris, with one early exception, omitted birds or small animals from his wallpaper designs, unlike C.F.A. Voysey who, as *The Studio* observed, was "inclined to admit plants and beasts in patterns on condition that they were reduced to mere symbols." This ensured that he arrived at patterns that were happily near to nature and at the same time full of decorative charm. Nikolaus Pevsner, who compared Voysey's wallpapers and chintzes with Morris's "Honeysuckle" to demonstrate the decisive step away from nineteenth-century "historicism," claimed for Voysey a new world of light and youth: "The graceful shapes of birds flying, drifting, or resting, and of tree-tops, with or without leaves, are favorite motives ... and there is an unmistakable kindliness in his childlike stylized trees and affectionately portrayed birds."

In *Hints on Household Taste* Charles Eastlake had popularized a decorative scheme that divided the wall into three horizontal sections: frieze, wallpaper above the dado line, and a darker treatment—including, after 1890, "Anaglypta," an embossed paper devised by Frederick Walton, the inventor of linoleum—to the areas subject to wear and tear below the dado. Walter Crane's wallpaper designs conformed to this pattern initially, but by 1886 he had begun to pioneer the division of the wall into only two parts. "It is usual to accompany the field of the wallpaper with a special frieze and a dado making a complete wall decoration," he wrote in a lecture on applied design. "Although I have made many designs for both, I have come to the conclusion that most rooms look best with the main pattern of the field carried from the skirting to the frieze."

Crane offered general advice on home decoration in his book *Ideals in Art: papers theoretical, practical, critical* (1905) and made specific recommendations for the use of his wallpapers. "Lily" he described as "useful in halls and passages," while "Rose Bush" "would be appropriate for a drawing or living room." But, since the majority of his designs were hand-printed and therefore costly, his advice was presumably directed at the rich and fashionable who would be the only ones able to implement it. It is an irony that the socialist Crane, like Morris, catered to the rich rather than the masses. Prices of wallpapers in 1875 ranged from between 3d and 9d a roll for the servant's quarters, up to 7s 6d to 15s a roll for hand-printed papers for the drawing room.

The first port of call for the artistically minded masses would have been Liberty & Co., which sold designs by Archibald Knox, Harry Napper, M.H. Baillie Scott, Arthur Silver, Lindsay Butterfield, and Voysey. Voysey also designed for Essex & Co., and proved so popular that *The Studio* claimed his name was to wallpaper as "Wellington" was to the boot. He was well known in Europe, where his designs were reproduced and his influence was widespread.

Morris & Co. papers were widely available in the USA (a combination of Morris wallpapers and fabrics can still be seen in the master bedroom of the Glessner House in Chicago), though popular designs were also provided by L.C. Tiffany, Christian Herter, and Candace Wheeler, who, with her

daughter Dora, won four prizes in a competition launched by the New York wallpaper manufacturing firm Warren, Fuller, & Lange in 1881. (Dora Wheeler's winning entry, "Peony," owed much to Morris.) A number of manufacturers, including the York Wall Paper Company, marketed patterns based on Morris's designs, as did M.H. Birge & Sons of Buffalo, New York—one of the leading producers of artistic wallpapers, although, as the century turned, the company moved toward a series of Art Nouveau designs with embossed and metallic effects. The craze for Art Nouveau that was sweeping Europe was evidenced in the wallpaper designs of Hector Guimard and Alphonse Mucha, but gradually a lighter, more geometric style prevailed, best exemplified by Josef Hoffmann.

The last decade of the nineteenth century saw a move away from intense patterns to a simpler style, more in keeping with the evolving Arts and Crafts home and best exemplified by Voysey's designs. Flowers, fruit, birds, and foliage were still the main motifs, but the forms were more delicate and the backgrounds lighter. Many Arts and Crafts homes—including Morris's Kelmscott Manor— did not have wallpaper at all, preferring to leave walls or wooden panels painted plain white. This was a decorative scheme favored by M.H. Baillie Scott, who hardly ever used wallpaper (although three elaborate designs by him appeared in *The Studio* in April 1895). Instead he recommended plain colors on the walls, though the ceilings might be stenciled and painted, and the oak boarding, doors, and window sills treated with beeswax polish. "When in doubt," he wrote, "whitewash might well be taken as a maxim to be followed in the decoration of the modern house."

Above: *This "Peacock Frieze" wallpaper, used in the Main Hall at Blackwell, was designed by W. Dennington in 1900 and produced by Shand Kydd Limited.*

STAINED GLASS & LIGHTING

Right: *The Firm's highly prestigious commission to design The Green Dining Room, 1866–7, for the South Kensington Museum came from the museum's progressive director, Henry Cole. Edward Burne-Jones designed the stained glass and the gilded panels, taking the months of the year as his theme.*

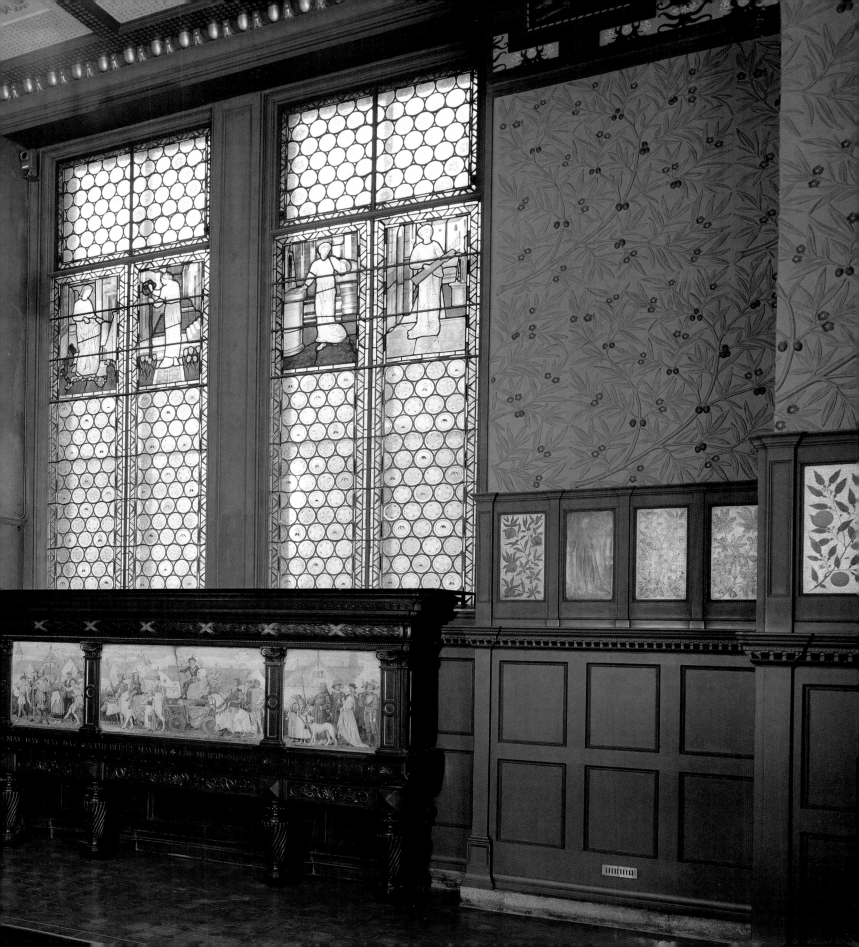

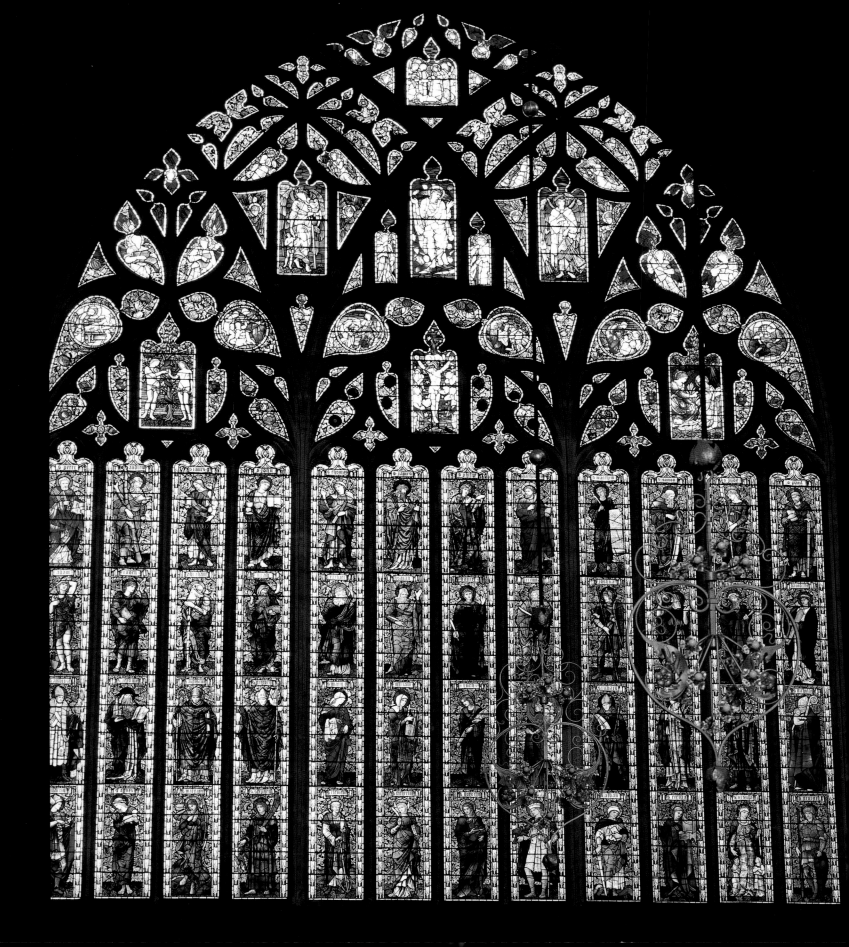

TRANSLUCENT MOSAICS

"The worth of stained glass must mainly depend on the genuineness and spontaneity of the architecture it decorates: if that architecture is less than good, the stained-glass windows in it become a mere congeries of designs without unity of purpose."

WILLIAM MORRIS

STAINED GLASS

THE EARLY ARTS AND CRAFTS MOVEMENT, under the influence of William Morris, did much to revive and popularize the essentially Gothic art of stained glass. Ecclesiastical glass reached its greatest beauty of color, design, and luminosity during the fourteenth century but the combination of the Gothic revival and the Arts and Crafts movement in the nineteenth resulted in a renewal of interest in the use of stained glass both in churches and domestic settings. Practitioners such as William Morris, Edward Burne-Jones, and Walter Crane were great enthusiasts. Indeed the early reputation of the Firm rested on its stained glass, though not its profits, as is made plain by this exasperated letter written by the Firm's manager Warington Taylor to Philip Webb in 1866: "Over £2,000 work in glass done. This should have returned at least 25% therefore over £500 profit. You know well enough there was not £200 profit on glass." Part of the problem was that the jobs were not costed properly and the design fees were not charged separately. The Firm's medal-winning entry at the 1862 International Exhibition in London had ensured a steady stream of commissions from ecclesiastical architects like G.F. Bodley, so Warington Taylor restructured the charging system, recommending a rate of £2 10s to £3 a foot for the glass, plus a separate fee for the original designs. These were most often provided by Edward Burne-Jones, although Dante Gabriel Rossetti provided thirty-six, and Ford

Above: *M.H. Baillie Scott gave careful thought to every detail of the design of Blackwell, 1898–1900, including the stained glass.*

Left: *The Great East Window in John Dando Sedding's great Holy Trinity Church in Sloane Street, London, by Edward Burne-Jones and William Morris, c. 1890.*

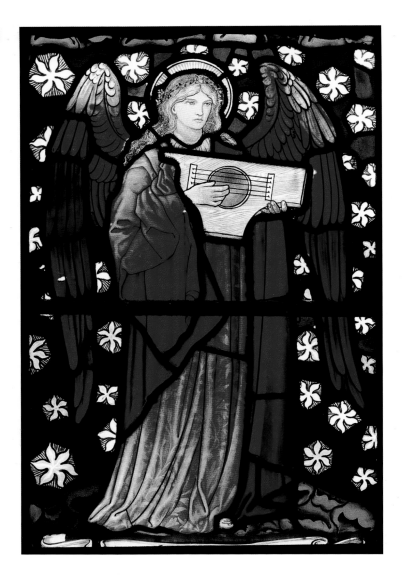

Above: *A minstrel angel with a dulcimer by William Morris, for St. Peter and St. Paul Church, Cattistock, Dorset, 1882. Morris employed a number of recurring themes in his work, including the "Legend of Good Women" and musical minstrels, both secular and, as in this case, angelic.*

Madox Brown over a hundred. Morris, William De Morgan, and Charles Faulkner also contributed designs.

The Firm received secular commissions for stained glass as well. The most important and valuable of these were from St. James's Palace for the decoration of the Armoury and Tapestry Room and the South Kensington Museum for the Green Dining Room. The latter provided a powerful and continuing public advertisement for their work.

Morris kept a rigorous control over the production of the Firm's stained glass, personally choosing the colors and vigilantly inspecting every piece of glass before the windows were made up. He was well acquainted with the large traceried windows of York Minster and Merton College Chapel at Oxford and, as a young man, had visited Chartres and the beautiful late thirteenth-century church of St. Urbain at Troyes, which he considered to be "the most satisfactory example of the art of glass-painting." The Firm employed its own glass painters, including George Campfield, a recruit from the Working Men's College who became foreman of the glass works, and a glazier named Holloway, who was taught how to paint directly onto the thick glass keeping as close as possible to the artist's original design. Morris used two types of glass: "pot-metal" glass, in which the coloring matter is fused with the glass when fired, and "flashed" or "ruby" glass, in which a white body is covered with a colored skin, a perilous procedure best performed by professionals like James Powell & Sons of Whitefriars, from whom Morris obtained all his ruby glass.

William Morris's early glass has a touching and haunting quality. It uses bold areas of pure, bright color in its depictions of figures of saints standing before elaborate backgrounds of hedges or screens of fruit-bearing saplings. Morris himself was often responsible for these backgrounds and for the tight clusters of daisies and violets at the feet of the saints. The inspiration is clearly fourteenth-century but it seemed so close to the Gothic ideal that it greatly alarmed the established trade, which set up a petition attacking the 1862 Exhibition windows and accusing Morris of having, in fact, just touched up and remounted genuine old glass. The petition came to nothing, however, and Morris & Co. continued to produce stained glass—in a characteristic free-flowing style, both in lead lines and painting, using strong vibrant colors, Gothic lettering, and naturalistic forms—until the Firm's dissolution in 1940. Of Morris's many

legacies, his stained glass, which can be found in churches and cathedrals up and down Britain and as far afield as India and Australia, is one of the greatest.

Outside the Firm, other important Arts and Crafts names in this field include Henry Holiday, who worked with the architect William Burges and started his own stained-glass studio in 1891, Walter Crane, who collaborated with James Silvester Sparrow, and Christopher Whall. Crane had much to say on the subject. Lead lines, for example, "ought to be fairly complete and agreeable as an arrangement of line even without the color," while color should be used boldly to create a "network of jeweled light," a "translucent mosaic" as he described it in his book *The Bases of Design* (1898), avoiding the use of white, since it led to "holes in the window." Crane's bold color arrangements and juxtaposition of dark and light pieces of glass create a rich overall effect. Crane's glass was manufactured by Messrs. Britten &

Above: *"Chaucer's Good Women: Chaucer Asleep," by Edward Burne-Jones for Morris, Marshall, Faulkner & Co., c. 1864.*

Gibson, who also made E.S. Prior's "Early English" slab glass, which, unlike normal commercial glass, had an uneven surface. This was because it was blown into a flat mold and then cut into slabs that were naturally thicker at the center than at the edge, which lent a translucent, jewel-like effect, much sought out by Christopher Whall.

Whall, who taught architectural glass at the Central School of Arts and Crafts in London from 1896, was the leading glass designer of his generation and his book *Stained Glass Work* was considered the standard text on the subject. In the final chapter, he pays tribute to Edward Burne-Jones, stating: "To me there is no drapery more beautiful and appropriate for stained glass work in the whole world of art, ancient or modern, as that of Burne-Jones, and especially in his studies and drawings and cartoons for glass." Whall's influence was widespread. Alfred Child, who worked within the Arts and Crafts framework of Evelyn Gleeson's Dublin-based Dun Emer Guild, was a former Whall apprentice, and Henry Payne, though based in Birmingham, benefited from his advice. Whall's work inspired the American stained-glass artist Charles Connick, who was responsible for the windows in Ralph Adam Cram's All Saints Church, Ashmont, Massachusetts. Whall wanted to move away from stylized figures and urged designers to abandon the practice of reusing the same cartoon and instead draw from life and from the model.

As the Arts and Crafts movement developed in the 1890s other painters and designers, many members of the Century Guild, Art Workers' Guild, or other similar societies, undertook work in stained glass. At the Century Guild, stained-glass designs were provided by Clement Heaton and Selwyn Image; at the Art Workers' Guild by Lewis F. Day; in Chipping Campden, Ashbee could rely on Philippe Mairet and Paul Woodroffe, who later set up a stained-glass studio of his own at his house at Westington, Gloucestershire, which was reconstructed for him by Ashbee. Along with Frances Macdonald and Charles Rennie Mackintosh, another husband-and-wife team important in the field of stained glass would emerge from the Glasgow School of Art: Ernest Archibald Taylor, who married Jessie M. King, was very involved in stained-glass design. In Birmingham, historically a

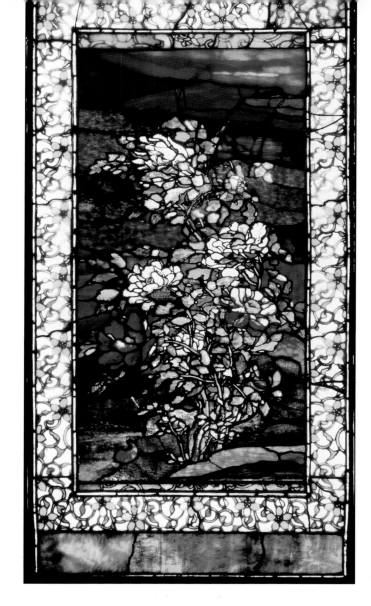

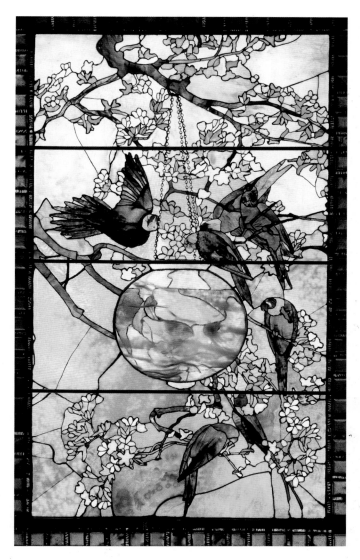

center of stained-glass production, the artist Mary Newill was active. Her work, like that of the others in the Birmingham Group, shows the influence of the Pre-Raphaelites.

In the USA the influence of Morris & Co., which had exhibited at the huge Boston Foreign Fair of 1883, was felt in the work of John La Farge. La Farge was drawn to the work of the Pre-Raphaelites and Morris's flat-pattern-making approach to decoration, although it is the influence of the Japanese prints he collected that can be seen to have had the most lasting impact on the flat, asymmetrical flower designs he incorporated into his stained-glass windows. In 1875 he began to experiment with stained glass and developed a new style that he called American opalescent art glass (reportedly after seeing light pass through an inexpensive tooth-powder bottle). His invention inspired the technical experiments of his more famous successor, Louis Comfort Tiffany. La Farge designed magnificent windows for private clients, including the wealthy Vanderbilts and Whitneys in New York, and Sir

Above left: *An important leaded-glass window depicting peonies blown in the wind, with Kakemono border by John La Farge, 1893–1908. La Farge was influenced by Japanese prints and developed his opalescent glass at about the same time as Tiffany, his chief competitor, whose leaded and plated glass window showing parakeets and gold fish bowl of 1893 is shown* **right.**

Above: *A three-part leaded-glass window designed by Charles and Henry Greene for the Adelaide Tichenor House, Long Beach, California, c. 1904.*

Far right: *Philip Webb, who gave meticulous thought to every aspect of the design of Red House, designed and painted this leaded-glass window, c. 1860.*

Right: *A characteristic stained-glass detail from a cabinet door designed by Charles Rennie Mackintosh for the Glasgow School of Art, 1896–1909.*

Lawrence Alma-Tadema in London, and was responsible for the panels in H.H. Richardson's Trinity Church in Boston, his Crane Library in Quincy, Massachusetts, and the William Watts Sherman house in Newport, Rhode Island.

In Britain, the abolition of window tax in 1851 and the lifting of the duty on glass in 1857 had encouraged the use of larger panes of glass and revived bay and bow windows, although M.H. Baillie Scott still favored old glass over modern sheet glass since "it meets the eye with a friendly twinkle instead of a sullen glare, and the main beauty of all undulations, especially in polished surfaces, is that they given broken reflections instead of glare." But it was the increasing use of stained and art glass in domestic settings that characterized an Arts and Crafts home. There are jeweled windows in Morris's Philip Webb-designed Red House, and architects such as Baillie Scott and Charles Rennie Mackintosh designed front doors and cupboard doors with beautiful glass panels. In the USA, Frank Lloyd Wright and the Greene brothers designed striking leaded glass windows to complement and complete their houses. They were concerned to create not merely the shell of a building but its decorative arts as well. The elaborate stained glass "Tree of Life" triptych that fills the entrance to the Gamble House is typical of their work.

Art-glass windows and light fixtures were important details designed with the same care and attention as the whole building. Charles Rennie Mackintosh's rectilinear glass designs for the Willow Tea Rooms in

Below: *James Powell at his Whitefriars Glassworks executed these designs for four champagne glasses by Philip Webb, c. 1860. All the glasses used by Morris at Red House were designed by Webb. Some were simple and unadorned, the glass pale and greenish, though large decanters were more elaborate.*

Glasgow exerted a direct influence on Frank Lloyd Wright and provided a fruitful interchange with European designers such as Koloman Moser and Josef Hoffmann. Frank Lloyd Wright used skylights and walls made entirely of windows to flood a room with light and break up boxlike interiors—an excellent example can be found in his own Oak Park house and studio, where he installed art-glass skylights.

Arts and Crafts designers also turned their attention to practical domestic items. In an essay entitled "Table Glass" in *Arts and Crafts Essays by Members of the Arts and Crafts Exhibition Society*, George Somers Clarke claimed that "few materials lend themselves more readily to the skill of the craftsman than glass." He makes a plea for "graceful designs" and gives as an example "the old decanter, a massive lump of misshapen material better suited to the purpose of braining a burglar than decorating a table," which "has given place to a light and gracefully formed vessel, covered in many cases with well-designed surface engraving." The table glass designed by Philip Webb for Powell's of Whitefriars conforms to this new model of gracefulness and is powerfully simple and striking. In Europe Richard Riemerschmid and Peter Behrens were designing glassware for Benedikt von Poschinger in Oberzweiselau, and the Wiener Werkstätte was producing wine glasses with matching decanters decorated with colored enamels.

Right: *A decorated Favrile glass vase from Tiffany Studios, c. 1894. Tiffany was one of the most creative and prolific designers of the late nineteenth century and developed his technique for "Favrile" blown-glass vases and bowls in 1893, taking the name from an old English word meaning "hand made."*

Christopher Dresser took glassware to a new plane. Unafraid of machine production and one of the most radical and prolific designers of the nineteenth century, he bridged the divide between Morris and Modernism, anticipating the Bauhaus aesthetic, and made a vital contribution to glassware design. In the 1890s, as he neared retirement, Christopher Dresser designed the "Clutha" glassware range for the Glasgow firm of James Couper & Sons, who sold the blown vases of twisted opaque green glass, often shot with streaks of gold or cream, through Liberty's.

Below: *This hand-beaten brass lamp made at the Birmingham Guild of Handicrafts was probably designed by Arthur Dixon, c. 1893.*

LIGHTING

THE SINGULAR EFFECT ACHIEVED by thoughtful and innovative lighting is a defining aspect of an Arts and Crafts house. Domestic lighting underwent a revolution in the nineteenth century as the developments in paraffin and oil lamps were rapidly superseded by gas and then, in the 1880s, by electricity. Gas-lighting had been an advance on candles and paraffin lamps, but involved pipes, wall brackets, and sconces, all of which had to be fixed to the walls and ceilings and came with a continual soft hissing noise and noxious fumes that were harmful to plants. As early as the 1850s ingenious designers had devised table lamps with long rubber tubes attached to the gas pipe to allow for some mobility, but it was the development by Thomas Edison in October 1879 of the first practical incandescent filament bulb that did away with gas pipes and naked flames, opening up new possibilities for designers.

Early electric lamps were still relatively dim and ceiling pendants were often suspended from pulleys so they might be lowered when in use. Because of its expense and initial inefficiency, electricity was not in common use until the end of the century, but its advent had a radical effect on lighting styles. The gaslit gloom of Victorian interiors was replaced by a fresher, cleaner style, and the new forms of lighting had a profound effect on interior decoration. Entire walls might be composed of continuous, uncurtained art glass in delicate geometric or flowing Art Nouveau designs, while luminous ceiling lamps, positioned above wooden grilles in complex patterns of squares and circles stretched with thin translucent paper, filtered their soft light. The new style of light fitting was seen at its most daring perhaps in the abstract patterned shades designed by Charles Rennie Macintosh for Hill House. A more typical Arts and Crafts light fitting would be a simple wood or metal frame, inset with plain etched glass or stained glass patterned with simple geometric or floral motifs.

Charles Ashbee had electricity installed in his house, the Magpie and Stump in Cheslea, in 1895, hanging translucent enamel shades by strands of twisted wires from roses of beaten metal. Philip Webb was the architect of one of the first houses to be designed for electric lighting from the outset: Standen, in East Grinstead, Sussex. James Beale and his wife Margaret took a keen interest in all the details. On July 7, 1894, Webb wrote to Margaret on the subject of lighting: "I carefully considered as to what might be done for the electric lights in the drawing-room, and concluded that embossed copper sconces standing on the picture rail would be the best form for the finish of

these bracket supports—something like this sketch." Margaret Beale approved the design and six sconces were made up by the metalworker John Pearson, each of them slightly different. Webb even added a cautionary note on their cleaning: "The copper plates should not be scoured, but only occasionally rubbed with wash leather." Many of the other fittings were provided by W.A.S. Benson, a founder member of the Art Workers' Guild and leading Arts and Crafts metalworker and cabinet-maker, whose contribution to the field was summed up by Hermann Muthesius in the 1880s when he wrote: "[Benson] created lamps that were to have a revolutionary effect on all our metalware. Benson was the first to develop his design directly out of the purpose and character of the metal as a material. Form was paramount to him. He abandoned ornament at a time when, generally speaking, even the new movement was fond of ornament." After years of upward-reflecting gas flames, Benson created metal shades that deflected the light downward, softening the comparatively harsh electric light. He produced a range of translucent light fittings, plus standard and table lamps using copper, tubular brass, polished steel, and opaque glass.

In the USA two designers came quickly to the fore. The first was Louis Comfort Tiffany, who had been producing stained-glass windows, door panels, and tiles to bring warmth and light into a wood-paneled interior since 1883. In 1892 he bought his own glass furnace at Corona, near New York, and soon began producing the leaded stained-glass light shades that are now immediately recognizable as icons of the Arts and Crafts interior. These were vastly popular with the public and were soon copied. The Quezal Art Glass and Decorating Company and Steuben Glass Works—both run by former Tiffany employees—produced very similar lines of elaborate glass lampshades; the latter called their

Above: *W.A.S. Benson: hanging electrolier made of copper and brass, c. 1910.*

range "Aurene," in a conscious echo of Tiffany's "Favrile" iridescent glass. The Grueby Faience Company supplied ceramic bases which, before electrification, housed a fuel canister. But soon Tiffany was using the flowing natural forms of his lamps to disguise electrical wires and colored leaded-glass shades to soften electric light, which—after candles, kerosene, and gas—was considered too harsh. Chemical advances at the turn of the twentieth century meant that glass could be tinted and layered to create new effects, novel surfaces, and textures from matt to a burnished glow. Tiffany experimented enthusiastically with chemical soaks or vapors, perfecting the "Cypriote" finish, which imitated the pitted surface of the ancient excavated Roman glass he had in his own extensive collection, and "Lava," which had thick rivers of gold dripping down a black body. In the studio where he conducted his experiments, he also created magnificent pictorial windows—richly colored landscapes, plant studies, and bible scenes—intended for churches and large public buildings, as well as more modest scenic panels that middle-class Americans could order through manufacturers' pattern books and Tiffany Studios catalogs.

Gustav Stickley and Elbert Hubbard produced plain wooden Arts and Crafts lamps and rugged lanterns, with matte metal frameworks and forged iron chains, at their Craftsman and Roycroft workshops, but a true Arts and Crafts original was Dirk Van Erp, who had emigrated to America from Holland. He began making lamps, candlesticks, and other lighting accessories entirely by hand out of hammered copper shell casings which he brought home from the naval shipyard where he was working. These he fitted with distinctive translucent mica shades which lent a soft amber glow, complementing the copper bases. He began by selling the lamps through craft shops and fairs, where

Above: *A fine "Arrowhead" leaded-glass and bronze table lamp from the Tiffany Studios, c. 1900–10. Trained as a painter, Tiffany began studying the techniques of glassmaking when he was twenty-four and enjoyed international acclaim for his work.*

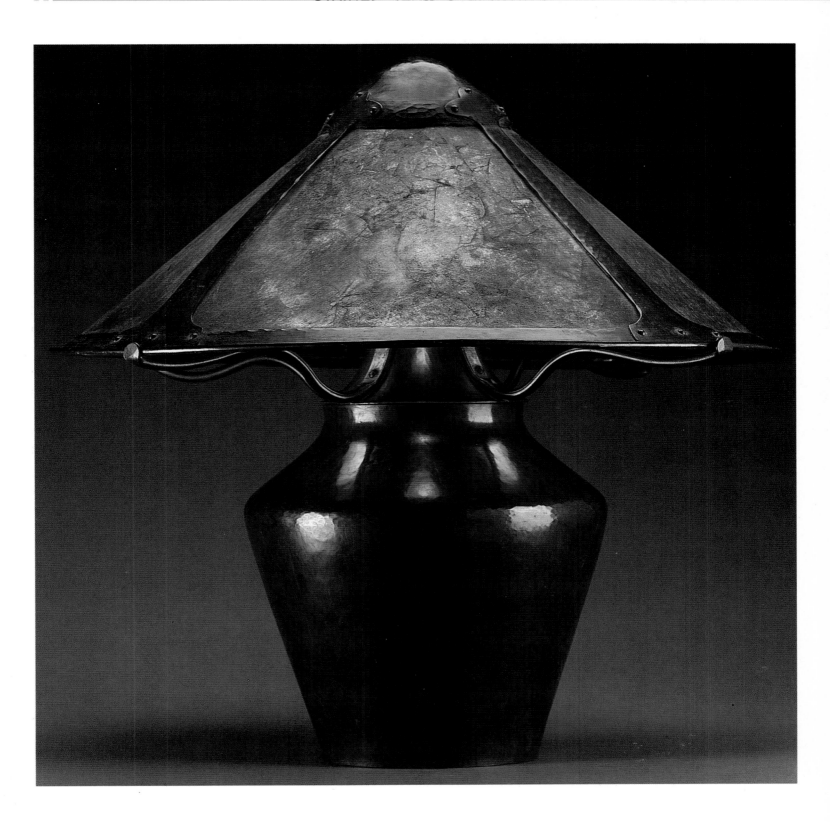

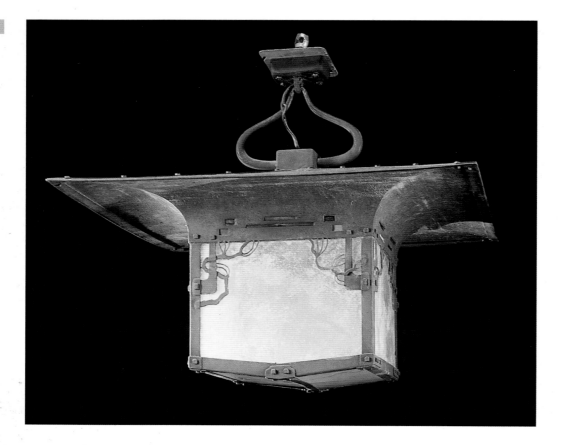

they were received so enthusiastically that he felt emboldened to leave the shipyard and set up the Copper Shop in Oakland, California, in 1908. His pieces are now among the most sought-after and prized Arts and Crafts objects.

American Arts and Crafts architects such as Greene and Greene and Frank Lloyd Wright considered custom lighting an integral part of their designs. In the Greenes' Gamble House, the regularly spaced rectangular lanterns with their leaded-glass shades in warm ochers, oranges, and golds define the separate spaces by the pools of buttery light they shed, while in the Blacker house the light is directed up from six-sided lanterns decorated with art glass patterned with lilies, which echo the pond outside, to reflect off a ceiling decorated with lilies and ripples of water covered in gold leaf. In the Robinson house the dining-room chandelier could be raised or lowered by a system of weights, and in the Thorsen house in Berkeley the light was recessed into the ceiling. Wright's lighting, too, was often indirect. He wanted it to be "made a part of the building. No longer an appliance nor even an appurtenance, but really architecture. This is a new field," he confessed in his essay "In the Cause of Architecture" in 1928. "I touched on it early in my work and can see limitless possibilities of beauty in this one feature … it will soon be a disgrace to an architect to have left anything of a physical nature whatsoever in his building unassimilated in his design as a whole." He did not want "glaring fixtures" but light "incorporated in the wall, which sifts from behind its surface opening appropriately in tremulous

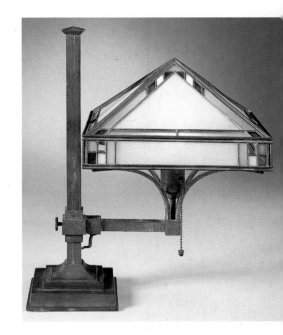

pattern, as sunlight sifts through leaves in the trees." He achieved this effect by creating "decks," or long, deep shelves just below the ceiling, that hid the light fixtures or diffused the light through geometric clear and colored iridescent art-glass skylights as in the May, Dana-Thomas, and Robie houses, among others.

In Europe, Josef Hoffmann and Otto Prutscher at the Wiener Werkstätte and Richard Riemerschmid at the Dresden and Munich Werkstätten produced simple modern designs for electric light fittings and domestic glassware in geometric, almost architectural forms, manufactured by glass companies in Bohemia. In France the work of the highly talented Emile Gallé touched Tiffany with an Art Nouveau wand, while in Sweden Anna Boberg made beautiful glassware at the Reijmyre Glassworks and Gunnar Wennerberg, best known for his ceramic designs, used overlays and different textures to create ravishing new effects in glass at the Kosta factory.

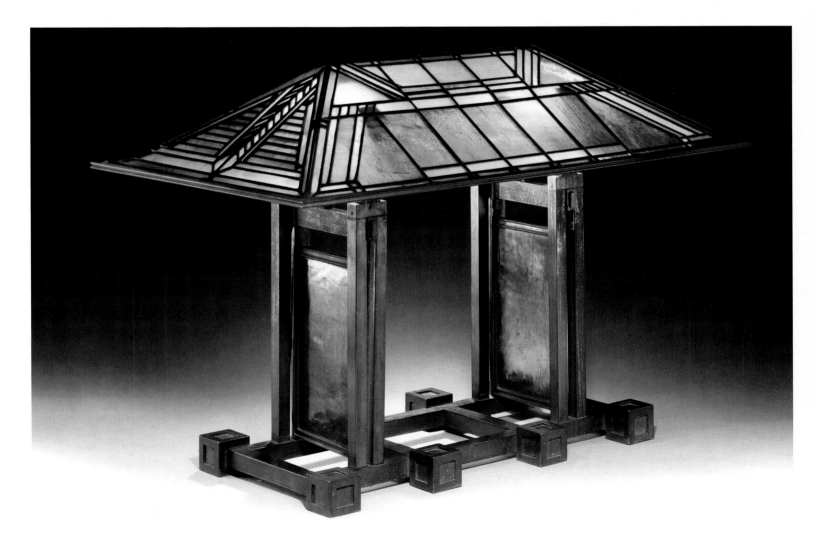

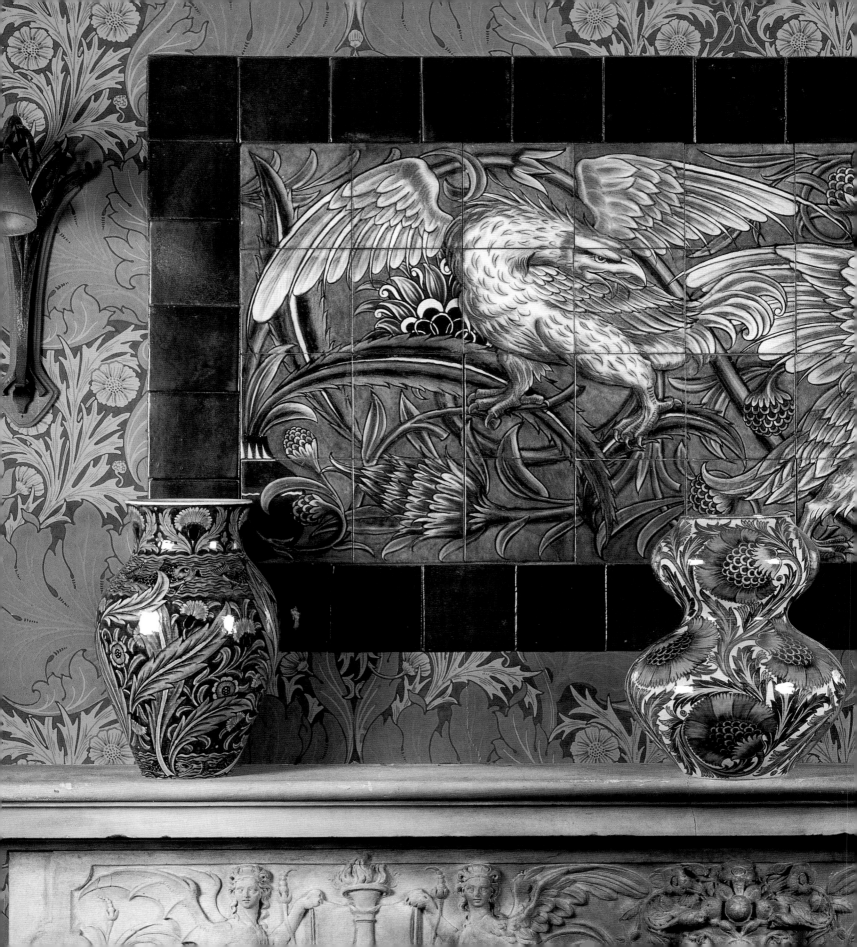

POTTERY & CERAMICS

Left: *The companion set to this rare tiled frieze by William De Morgan was made for Czar Nicholas I of Russia's yacht. On the mantelpiece stands a row of fine De Morgan Persian vases.*

7

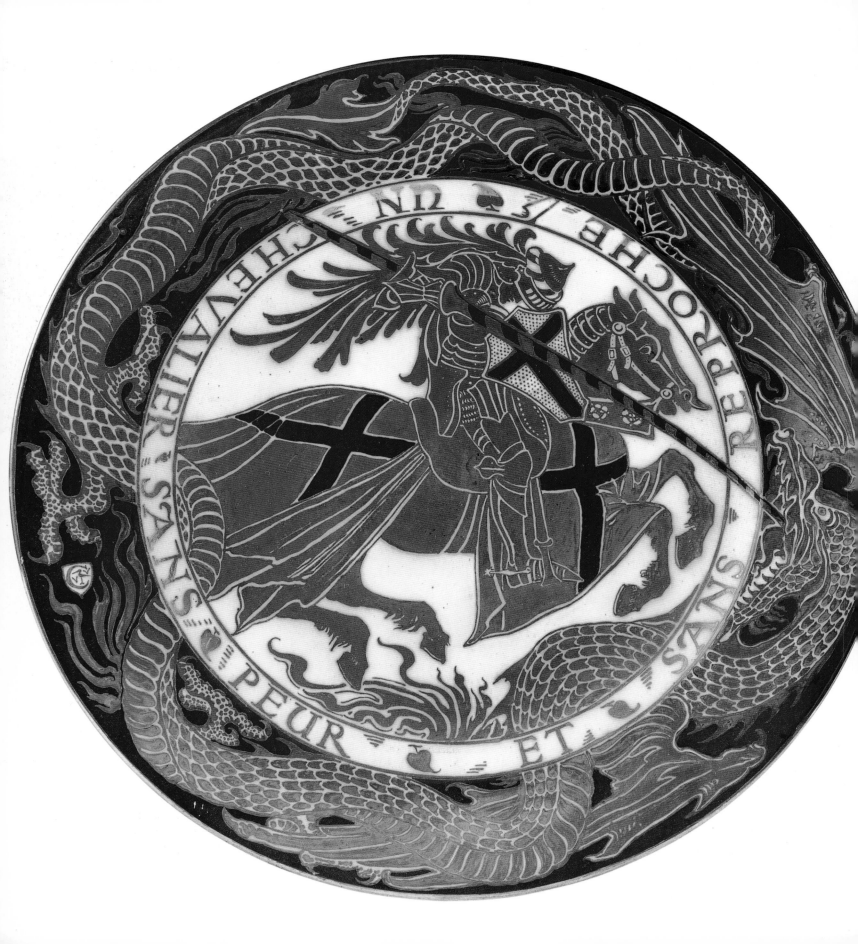

ART FROM THE EARTH

Above: *This "Primrose Tile," dating from 1864, is typical of the simple, floral patterned tiles Morris & Co. offered for sale until the early 1870s.*

"The pride of the potter is that his clay shall yield to the furnace: flowing and mingling in matchless beauty and endless variety. But the glazes must also acknowledge the artistic restraint by which his whole work is controlled. I endow either porcelain or pottery with brilliant color, pulsing with life and radiance or with tender texture, soft and caressing: color and texture which owe their existence and their quality to the fire—this is art."

CHARLES F. BINNS, writing in *The Craftsman*, 1903

THE ENTHUSIASM FOR ARTS AND CRAFTS PIECES led to the foundation of numerous "studio" potteries and glassworks in both Britain and the USA. Some were set up by individual artist-potters such as William De Morgan, Harold Rathbone, or the eccentric George Edgar Ohr, while others were under the umbrella of well-established and well-respected commercial potteries including Minton, Doulton, and Wedgwood, who started smaller studio departments producing "fine art" pieces from designs by Arts and Crafts luminaries such as C.F.A. Voysey, Lindsay Butterfield, and Walter Crane. The long tradition of making fine pottery and porcelain in Britain—especially in Staffordshire and Derbyshire—was built on by Arts and Crafts designers. In the field of ceramics, makers were able to realize Morris's ideal of designing and making an object from raw material to finished product. Clay was an everyday and inexpensive material, and art potters could work quite simply without reliance on industry or manufacturers.

The closing years of the nineteenth century saw a boom in the American art-pottery market and the opening of a number of new businesses that joined the already established Fulper and Rookwood Potteries: Hugh C. Robertson reopened the family's Chelsea Keramic Art Works as Chelsea Pottery US in Massachusetts in 1891, and William H. Grueby set up the Grueby Faience Company in Boston in 1894. Much of the American art-pottery movement was philanthropic in its ideals. Often enterprises— such as the Marblehead Pottery, the Arequipa Pottery, and the Paul Revere Pottery—were started with the wider social aim of providing education or congenial occupation for poor or convalescing women,

Left: *A charger designed by Walter Crane for Pilkington & Co, 1907, painted by Richard Joyce.*

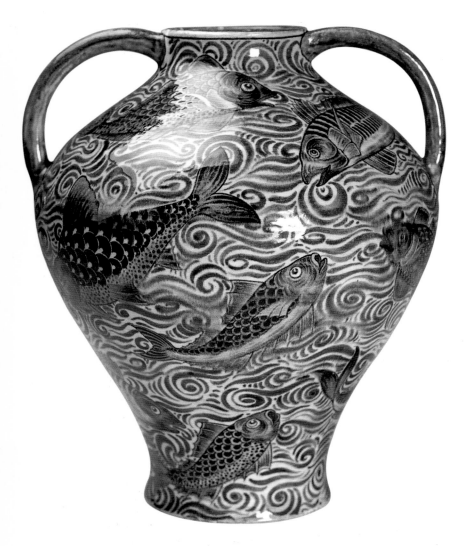

Above: *A William De Morgan two-handled vase with fish design and Persian coloring, c. 1880.*

and juggled the constraints of profit and philanthropy with varying results. Women designers such as Mary Louise McLaughlin of Cincinnati and Adelaide Alsop Robineau of Syracuse, New York, made outstanding contributions to a field that admitted and encouraged female participation. The standard of American ceramics was extremely high, and many of the emerging potters benefited from the teaching of Charles Fergus Binns—the father of studio pottery—at the New York School of Clayworking and Ceramics. All this activity was welcomed and applauded by the popular press. An article of 1899 in *House Beautiful* congratulated American manufacturers on finding individuals and companies "conducting their work in a spirit that demands first of all that results shall be honest and beautiful…. In the manufacture of pottery, oftener perhaps than in other crafts, one meets with this renascent spirit; possibly because its subtle chemistry offers an opportunity to the scientist as well as to the artist. It is a fascinating and absorbing art, claiming the utmost devotion, but lavishly rewarding the man who can discover its secrets."

The housing boom of the 1880s and 1890s led to an increase in the demand for tiles, which were easily washable, hygienic, and decorative. William De Morgan revived the art of hand-painting tiles while Lewis F. Day and C.F.A. Voysey designed for the leading British manufacturers such as the Pilkington Tile & Pottery Co. and Minton & Co., developers of the encaustic tile in 1840. "This branch of art-manufacture [encaustic tiles] is one of the most hopeful, in regard to taste, now carried on in this country," wrote Charles Eastlake in the late 1870s. "It has not only reached great technical perfection as far as material and color are concerned, but, aided by the designs supplied by many architects of acknowledged skill, it has gradually become a means of decoration which, for beauty of effect, durability, and cheapness, has scarcely a parallel." Both Doulton and Minton supplied blank tiles for fashionable young ladies to decorate. In the USA the father-and-son business of J. & J.G. Low Art Tile Works in Chelsea, Massachusetts, produced high-gloss tiles in the European style from 1878 to around 1900, and Ernest Batchelder became well known for his striking medieval tile designs, but it was William Grueby's company that came to dominate the market.

BRITISH POTTERY

WILLIAM FREND DE MORGAN was the most influential British designer working in the field. He had turned to ceramics from stained glass and used exotic colors—ruby reds, delicate golds, and the vivid peacock blues and greens of Iznik and Persian wares, which provided inspiration for his expensive handmade tiles decorated with mythic animals, such as the sea dragon, and with ships, birds, or plants. Originally associated with Morris & Co., he set up his own pottery and showroom in Chelsea in 1872, experimenting with luster glazes, enamel, and decorating ready-made factory blanks. In 1882 he moved to a new purpose-built pottery near Morris at Merton Abbey, where the two men frequently collaborated on tile projects. But it was his ten-year partnership with Halsey Ricardo, beginning in 1888 when he set up a factory at Fulham, that prompted some of his richest work. De Morgan's poor health meant that he often spent extended periods abroad, and he found himself spending so much time in Florence that he set up a studio there and supplied the Italian pottery Cantagalli with designs.

Above: *A design for a tile panel for an ornamental terrace by Halsey Ricardo for the William De Morgan Tile Company, c. 1890.*

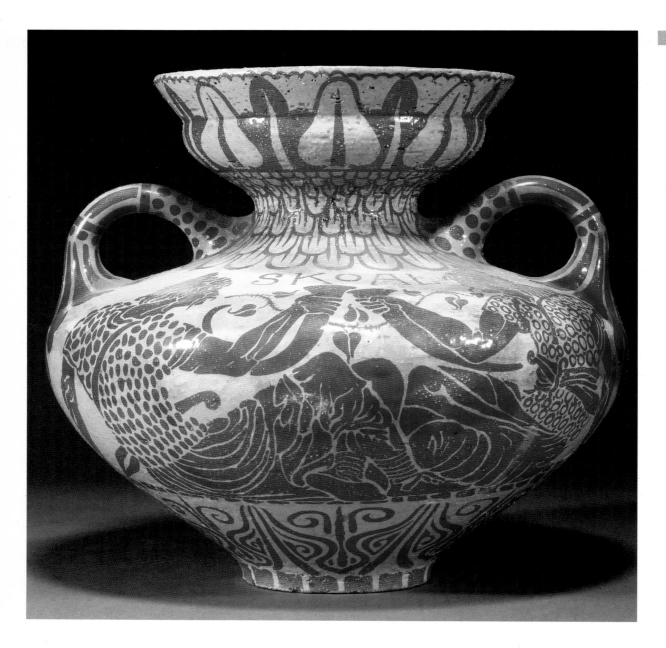

Above: *A twin-handled pottery vase, designed by Walter Crane for Maw & Co. in 1893, decorated with medieval warrior figures drinking from cornucopia.*

Edward Burne-Jones made designs for tiles sold through Morris & Co., such as the "Sleeping Beauty" set commissioned in 1864 by the painter Myles Birket Foster to decorate the overmantels in the bedrooms of his new home, The Hill, at Witley in Surrey. Lucy Faulkner may have copied Burne-Jones's designs onto the tiles and painted them; William Morris was certainly responsible for the design and painting of the surrounding swan pattern.

Walter Crane's move into the field of art pottery provided the opportunity to experiment with different shapes and to work with new luster glazes. His hand-painted designs, such as the striking "Swan" vase in the Victoria and Albert Museum, were, however, expensive "one-offs" made for prestigious displays at international exhibitions and were never meant for a mass market. He was

commissioned, along with Day, Voysey, and Frederick Shields to provide designs for the Pilkington Tile & Pottery Co., which was formed in 1891 with William Burton, formerly a chemist at Wedgwood, as manager. Burton was joined by his brother Joseph in 1895 and together they experimented with the wide range of rich glazes that became the hallmark of the company. In 1903 Burton decided to diversify into decorative glazed pottery and launched his "Royal Lancastrian" range, which used "shapes, based on either the forms of the Greek, Persian or Chinese pottery, on some suggestions of natural growth, or on the forms actually evolved from plastic clay in the hands of the potter." He commissioned Crane, Day, and Voysey, giving them complete freedom to interpret the romantic and chivalric themes he wanted for his Lancastrian wares.

The eccentric Martin Brothers—Robert, Charles, Walter, and Edwin—of Southall, London, were responsible for some of the most unusual art pottery to come out of England. Their jugs and vessels, often made in the shape of slyly grinning, grotesque, hybrid creatures, proved popular and became highly fashionable—probably their best-known client was Queen Victoria.

The Della Robbia Pottery, was established at Birkenhead in 1894 by the painter Harold Rathbone and the sculptor Conrad Dressler. Rathbone's highly individual pieces emulated the richness of Italian majolica by their use of sgraffito (incised designs) and colored enamels, and suggested through the name of the pottery an aesthetic affinity with the Renaissance. He encouraged his employees to express themselves through their work and develop their own talents and for twelve years produced a wide range of functional and decorative wares with a strong architectural feel. A Liberty catalog dated 1896 sang the firm's praises: "The Founders of the 'Della Robbia Pottery' aim … by encouraging 'handwork' to secure freedom of touch and the charm of individuality. The designs … are executed by Young Apprentices, and are in the main of *their own device.…* Girls are employed for the painting process.… As a stimulus for superior work, a certain Small Sum is offered in prizes, in addition to the weekly wage."

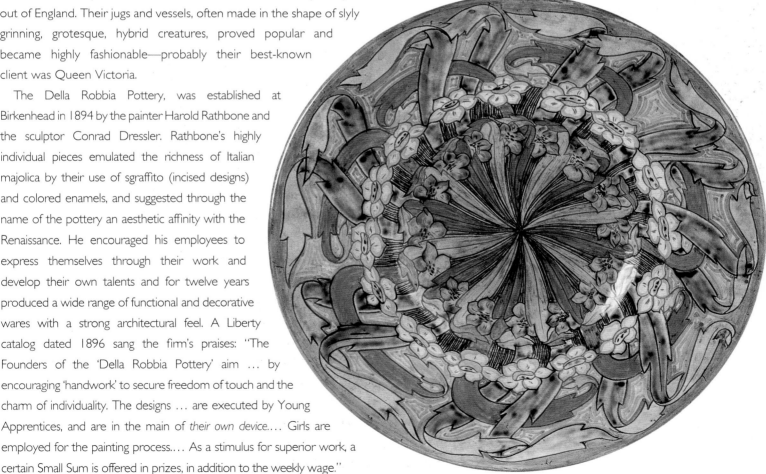

Below: *A Della Robbia platter designed by Cassandra Walker, c. 1905.*

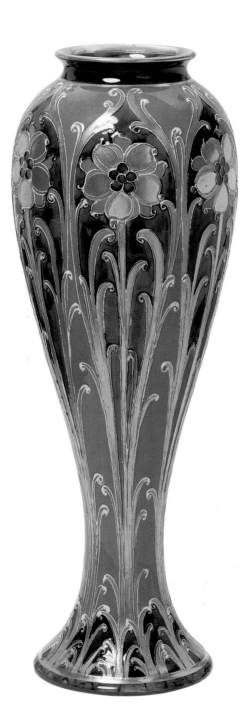

In the village of Compton in Surrey, where the painter George Frederick Watts had settled late in his life, pottery classes organized by his wife Mary proved so successful that the Compton Potters Art Guild, producing ornamental garden wares in porous terracotta along Celtic lines, was set up in 1896. Its pots, sundials, and fountains, including some designed by Archibald Knox, were sold by Liberty's.

The Ruskin Pottery was established in 1898 at West Smethwick near Birmingham by William Howson Taylor, son of the remarkable principal of Birmingham School of Art, Edward Richard Taylor. E.R. Taylor was a friend of Morris and Burne-Jones and a pioneer in the teaching of craft skills, and he provided some of the decorative designs for the pottery. W.H. Taylor was preoccupied with experimental glazes and became famous for his "high-fired" effects and the difficult techniques of "soufflé," luster, and "flambé" glazes.

Sir Edmund Elton was a talented self-taught potter who developed a distinctive crackled metallic finish at the Sunflower Pottery set up at Clevedon Court, his family's Somerset estate, in 1879. Bold and original Sunflower Pottery pieces were sold through Howell & James, a department store in Lower Regent Street, London, which was the leading stockist of modern British pottery until 1883, when Liberty's, which up to then had concentrated on Oriental ceramic imports, began to move into the field.

These small potteries, which drew on local expertise and hired staff from other ceramic studios, had an influence on the bigger factories such as Doulton, Wedgwood, and Minton, which began to emulate them by producing "one-off" decorated products and introducing craft studios. Doulton worked with well-known designers, sculptors, and painters connected with the nearby Lambeth School of Art, including a number of women such as Hannah Barlow, Eliza Simmance, and Mary Mitchell. Wedgwood employed some of the finest modelers, decorators, and craftsmen and, in 1903, took on Louise Powell and her husband Alfred Powell, Birmingham-based associates of the Gimson circle, to shape and decorate luster and tin glaze ware. Tableware patterns by the Powells often featured small repeating flower and leaf designs. They attracted favorable notice from Gordon Forsyth, superintendent of the Stoke-on-Trent Schools of Art, who wrote an official report on "The Position & Tendencies of the Industrial Arts" following the 1925 Paris Exhibition:

"Wedgwood's make excellent pottery and Mr. and Mrs. Powell are excellent artists. They no doubt design the shapes they decorate, and their work always shows a keen appreciation of suitable treatment of various articles of everyday use. Their best work is found in lordly bowls and plaques.... They are based on the brave and honest pattern work of William Morris, and have a delightfully English style.... English pottery would be very much poorer without their splendid contributions to the artistic side of the craft."

ENGLISH POTTERY. MADE FOR, AND OBTAINABLE ONLY FROM, LIBERTY & CO., OR THEIR AGENTS.

Introduced by Liberty & Co., made in practical shapes by hand, the surface enriched with glazes.

No. BB 1. 6 ins. diameter. 14/6

No. BB 2. 4 ins. high. 10/6

No. BB 3. 6 ins. diameter. 9/3

No. BB 4. 6 ins. high, 6/9 9½ ,, 16/6

No. BB 5. 6 ins. high. 5/-

No. BB 6. 11 ins. diameter. 18/6

No. BB 7. 7½ ins. high. 12/9

No. BB 8. 6 ins. diameter, 6/6 7 ,, 7/6 8½ ,, 9/6

No. BB 9. 9 ins. high. 17/6

No. BB 10. 8 ins. high. 15/6

No. BB 11. 11½ ins. high. £1.2.6

No. BB 12. 9 ins. high. 9/6

LIBERTY & CO [Inventors and Makers of] [Artistic Wares and Fabrics] LONDON & PARIS

5

From 1883 Liberty's began featuring in its catalog English art pottery from dozens of smaller firms, including Aller Vale, Foley, Poole, Moorcroft, Brannum, and Farnham, all of which experimented with hand-throwing, sgraffito work, luster decoration, and unusual glaze effects and came to rely on the department store to retail their wares. Liberty's also provided the London retail outlet for Henry Tooth's Derbyshire-based Bretby Art Pottery. Tooth had first worked with Christopher Dresser—an important influence on a number of potters at this time, including William Ault—at John Harrison's Linthorpe Pottery. Later Liberty's also stocked Royal Doulton, Wedgwood, and Pilkington's Royal Lancastrian.

The Arts and Crafts ideal was not so prevalent in European art pottery, which either embraced Art Nouveau or leaned toward the geometrical Modernism of the Wiener Werkstätte, although Liberty's did sell a range of homely, tin-glazed earthenware made by the Dutch firm Plateelfabriek Zuid-Hollandsche at Gouda, and dark green, blue, and red luster-glazed pottery from Hungary's Zsolnay ceramic works at Pecs.

Above: *A page from the Liberty catalog of 1912 illustrating their range of Moorcroft pottery.*

AMERICAN POTTERY

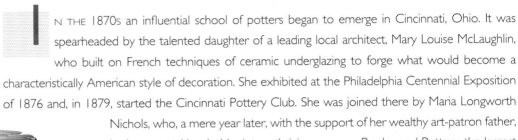

Below: *A green earthenware vase with a flower decoration by Hattie E. Wilcox, made by the Rookwood Pottery, c. 1900.*

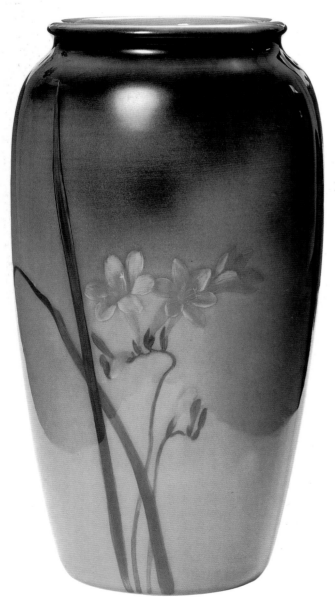

IN THE 1870s an influential school of potters began to emerge in Cincinnati, Ohio. It was spearheaded by the talented daughter of a leading local architect, Mary Louise McLaughlin, who built on French techniques of ceramic underglazing to forge what would become a characteristically American style of decoration. She exhibited at the Philadelphia Centennial Exposition of 1876 and, in 1879, started the Cincinnati Pottery Club. She was joined there by Maria Longworth Nichols, who, a mere year later, with the support of her wealthy art-patron father, had converted her hobby into a thriving concern. Rookwood Pottery, the largest and most influential art pottery in the USA, was founded with the specific aim of constructing and decorating art pottery by hand and enjoyed both commercial and critical success. Rookwood pieces, which included impressive overmantels and fireplace surrounds, concentrated on naturalistic landscapes and flower designs, employing an underglaze decorative technique derived from the French that required mild firing to maintain the warm-colored glaze. Oscar Lovell Triggs, a writer and socialist, called Rookwood "an ideal workshop" in his book *Chapters in the History of the Arts and Crafts Movement* (1902). "The fullest possible freedom is given to the workmen," he enthused, "they are encouraged to experiment, to express their own individuality, and to increase their culture by study and travel. The spirit of the factory is that of cooperation and good fellowship."

The sizable Japanese display at the Philadelphia Centennial Exposition had a profound effect on Maria Longworth Nichols and, in 1887, she invited the Japanese ceramicist Kataro Shirayamadani to join the firm. He stayed on until his death in 1948, becoming one of the company's principal designers. Rookwood introduced pale cool colors with names like "sea green" and "aerial blue" and, following the award of a Grand Prix at the 1900 Paris Exhibition, became highly fashionable. By moving with the times, the firm continued to flourish and even weathered the Depression, maintaining production until 1960.

Among the many designers who worked for Rookwood, the name Artus Van Briggle stands out. One of Rookwood's most talented decorators, he worked for the company for thirteen years, taking regular sabbaticals to Paris where he drew inspiration from the French Art Nouveau movement and the Oriental collections at the Musée des Arts Decoratifs and Sèvres. In 1902 he moved to Colorado Springs, where he started his own pottery studio, producing matt-

glazed pieces in sculptural Art Nouveau forms until his career was cut short by tuberculosis and an early death in 1904.

William Henry Grueby founded his own business, the Grueby Faience Company, in 1894. At first it produced architectural bricks and tiles, but in 1897 he added an "art wares" section and developed his innovative matt green glaze. The "peculiar texture" of this rich, monotone surface was compared in the company brochure to "the smooth surface of a melon or the bloom of a leaf" and sources of inspiration were cited as "certain common forms in plant life, such as the mullen leaf, the slender marsh grasses, the lotus or tulip, treated in a formal or conventional way." The work won medals and international acclaim at the 1900 International Exposition in Paris. It was also commercially successful, for Grueby adapted handcraft techniques to mass production, standardizing patterns and

Above: *An earthenware vase by Artus Van Briggle, modeled with a frieze of arrowroot leaves and blooms, in a sheer turquoise glaze, 1906.*

Above: *A tulip tile and two vases from the Grueby Pottery, c. 1908.*

Far right: *An early Fulper tapering vase with two cut-out buttressed handles and Flemington Green flambé glaze.*

taking the creative decisions away from the men—many of them art students—who hand-constructed the pieces, which were then decorated with established designs by semi-skilled female students.

A collaboration with Tiffany Studios led to the production of lamps, sold through the Grueby brochure, which boasted: "A fine piece of pottery is essentially an object of utility as well as of decoration. In no way does the Grueby ware fulfill these two purposes more completely than in its lamp forms, whether for oil or electricity. The Grueby-Tiffany lamp combines two recent products of the Applied Arts, the support for the bronze fitting being a Grueby jar made for that special purpose, completed by a leaded or blown-glass shade of Tiffany design and workmanship."

Louis Comfort Tiffany experimented with pottery at his Corona factory and produced a range that was mass-produced (in modest numbers) from hand-thrown originals. It was offered for sale—sometimes unglazed so that customers could choose their own finish—at Tiffany's Fifth Avenue store. It was never as popular as his art glass and lamps, though nowadays Arts and Crafts collectors prize the pieces, which make bold use of organic forms.

Newcomb Pottery, an educational enterprise associated with the H. Sophie Newcomb Memorial College in New Orleans, was founded in 1895. Men were trained to throw pots by hand, and young women—including the gifted Sadie Irvine—to decorate them in an abstract Japanese style. The artists were encouraged to sign their work. The pottery ceased production in 1931.

The Fulper Pottery Company was an old, thriving, and well-established company when the grandson of the founder introduced a new line of ceramic wares—which he called "Vasekraft"—in time for the Christmas market in 1909. The range included lamps, desk and smoking accessories along with vases. Relatively inexpensive (around 1914 the price of a typical table lamp was $35), they were immediately snapped up by an American middle class keen to invest in a piece of well-made art pottery. The shapes were cast in molds, then individually glazed by hand, with a distinctive effect achieved by combining or overlapping different glazes—matt, gloss, or metallic—on the same piece. The company pioneered the use of crystalline glazes. Its pottery lamps, advertised as "Art pottery put to practical uses," were unusual because both the base and the shade were ceramic. An advertisement in *Vogue* in 1913 claimed, "Vase Kraft Lamps and Pottery are much admired for their rich subdued colorings. They lend an air of refined elegance to the surroundings in which they are displayed." Over time many of the ceramic shades (often inset with glass) have become brittle and broken, which explains their relative rarity today. The factory closed in 1929.

William Day Gates started the Gates Pottery of Terra Cotta in Illinois in 1885, producing architectural terra cotta, but in 1900 he introduced a line of ceramic vases and garden ornaments called Teco Art Pottery. "The constant aim," he claimed, "has been to produce an art pottery having originality and true artistic merit, at a comparatively slight cost, and thus make it possible for every lover of art pottery to number among his treasures one or more pieces of this exquisite ware." He commissioned designs from

architects Frank Lloyd Wright and William James Dodd, as well as the sculptor Fritz Wilhelm Albert, and developed a sea-green matt glaze, which he applied to molded (rather than hand-thrown) pots, thus keeping his prices down. Teco ware concentrated on form and color rather than surface decoration and the pieces are distinctively geometric, architectonic, and monumental in design.

The Chelsea Keramic Art Works was a family firm founded by James Robertson outside Boston in 1872, which made classically inspired vases often decorated with applied carved sprigs of flowers, leaves, birds, or bees. His two talented sons, Alexander and Hugh Cornwall Robertson, are names to reckon with in the field of American art pottery. Hugh's pursuit of exotic glazes—he was famous for his Chinese red glaze called *sang-de-boeuf* and his blue-decorated white Chinese crackle glaze—bankrupted the firm in 1889, although he reopened with fresh financial backing two years later, moving the company in 1896 to Dedham, Massachusetts. The Dedham Pottery received honors and recognition at the International Exposition in Paris in 1900 and the St. Louis World's Fair in 1904. It remained in business until 1943.

One of the most outstanding women in the American Arts and Crafts movement was the extraordinarily talented Adelaide Alsop Robineau, a china decorator and maker of complicated porcelain pieces, whose work was sold by Tiffany & Co. In 1911 she won the Grand Prix at the Esposizione Internazionale at Turin for her high-fired porcelain "Scarab Vase," which she made at the University City Pottery, Missouri. Also known as "The Apotheosis of the Toiler," the vase was said to have taken her over a thousand hours to produce.

Frederick Hürten Rhead was born in England but emigrated to the USA in 1902, bringing with him and popularizing the highly ornate sgraffito process he had learned from Harold Rathbone and Conrad Dressler at the Della Robbia Pottery in Birkenhead. He was art director of the Roseville Pottery in Ohio before joining Adelaide Alsop Robineau and the influential French

Far left: *An earthenware Teco vase, designed by William Day Gates of the Gates Potteries, c. 1905–10.*

potter Taxile Doat at the University City Pottery, where he produced some of his finest work. In 1911 he was persuaded to help set up the Arequipa Pottery in California, established in a sanatarium to help rehabilitate nervous or tubercular women. Contemporary photographs show Arequipa Pottery workers seated on cane chairs in the bosky outdoors, decorating pots. Men were hired to throw or mold pots and the patients were trained to decorate and glaze them, often using a design process Rhead called the "raised line," in which slip was trailed onto the surface in decorative patterns and accentuated by other glazes. Rhead stayed on in California and founded his own pottery in 1914 but, although a talented and influential potter, he was not a businessman and the firm folded three years later. "An indefinite idea in the mind of a wealthy person of questionable taste is not easily executed," he moaned, "especially if that person is prepared to pay neither a deposit nor an adequate remuneration for the finished product."

The Marblehead Pottery, like Arequipa, was initially conceived in 1904 as a craft therapy program for patients convalescing in the New England coastal town after which it was named. The work was simple,

Above: *An urn-shaped vase, decorated with a sgraffito design of wisteria vines in turquoise blue over teal blue, on a high glass blue-black ground, by Arthur Eugene Baggs at the Marblehead Pottery, 1925.*

elegant, and restrained, following Grueby in its use of glazes, but leaning more toward Frank Lloyd Wright, Charles Rennie Mackintosh, and the Viennese school in its elongated abstractions of natural forms. The chief decorator was a woman called Hannah Tutt and the firm's director was Arthur Eugene Baggs, a former student of Charles Binns at the New York School of Clayworking and Ceramics. In 1919, by which time it was an independent commercial concern, its brochure spoke of "dignity, simplicity, and harmonious color" and claimed: "The aim has been to make the decoration a part of the form, not merely a pretty ornament stuck on at haphazard." It boasted a range of colors from "a beautiful old blue known as Marblehead blue, a warm gray, wisteria, rose, yellow, green, and tobacco brown. All are soft, harmonious tones which lend themselves well to the display of flowers."

In 1911 the Paul Revere Pottery grew out of the Saturday Evening Girls' Club in Boston and gave the daughters of Jewish and Italian immigrants a chance to earn money producing breakfast and tea sets, lamps, vases, and tiles. The girls were trained in throwing, design, and glaze chemistry, and the venture was sustained by a continuing subsidy from its founder, Mrs. James J. Storrow.

Samuel A. Weller's pottery in Zanesville (popularly known as "Clay City"), Ohio, became the American leader in mass-produced low-priced art pottery when it marketed the distinctive metallic glaze developed by the French chemist Jacques Sicard in 1901. The iridescent pottery he produced for Weller—who also employed Frederick H. Rhead—was known as "Sicardo."

The Overbeck Pottery of Cambridge City, Indiana, was started in 1911 by four Overbeck sisters: Elizabeth, who was responsible for the throwing, Mary Frances, who did the decorating, Hannah who was the designer, and Margaret, the driving force, who unfortunately died in the year the firm was established. They worked "in a pleasant old house among the apple trees" producing wheel-thrown pieces decorated with stylized natural motifs. Other important Arts and Crafts concerns included the Grand Feu Art Pottery, established in 1913 by Cornelius Walter Brauckman in Los Angeles, and the California Faience Co., founded by William Victor Bragdon and Chauncey R. Thomas in 1915. Both relied on form and glaze rather than decoration for appeal, and both were influenced by the work of Taxile Doat.

Far left: *"Mission," a glazed matt vase from the Grand Feu Art Pottery, c. 1913, one of four pieces given to the Smithsonian Institution by the firm's founder, Cornelius Walter Brauckman.*

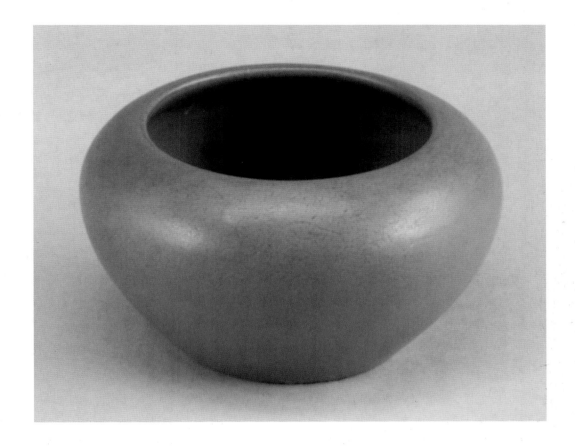

Above: *A small vessel with closed-in rim covered in a fine leathery blue-gray matte glaze from California Faience, c. 1915.*

Final mention must go to Ernest Allan Batchelder, who established his own school and tile factory in Pasadena, in 1909, just as southern California's construction industry was booming and the need for architectural tiles for bungalow fireplaces was at its height. He had studied at the School of Arts and Crafts in Birmingham and was devoted to hand labor and Arts and Crafts principles, shaping his tiles in plaster molds before decorating them with unique glazes. He wrote: "The evil of machinery is largely a question of whether machinery shall use men or men shall use machinery," and his *Principles of Design* (1904) situated both Japanese and Native Indian Art within an Arts and Crafts ethic. He was influenced by medieval and Gothic motifs and sought order in design, achieved through a balance of harmony and rhythm. He also made vessels such as *jardinières* featuring animals, birds, and intertwining floral designs. The boom, which had led to huge demand for his tiles, was followed by the Depression, which finished the firm, though Batchelder survived by scaling down his production to a small home-based operation, which he continued until the early 1950s.

METALWORK & JEWELRY

Left: *Door hinge detail of the entrance to "Garden Corner," Chelsea Embankment, London, refurbished by C.F.A. Voysey in 1908.*

8

BEAUTIFUL, USEFUL, & ENDURING

"Metalwork and jewelry in the past were always looked upon as holding a peculiar intermediate position between the Fine and Industrial Arts. The fine arts were those primarily occupied with the expression of ideas, the industrial arts had for their primary object utility, but the expression of ideas was still considered of importance, it was that which gave them their humanizing influence. The Arts and Crafts movement was perhaps above all things a humanizing movement on the part of the artists to give back to the handicrafts the humanitarian aspect which they had lost."

JOHN PAUL COOPER

OHN PAUL COOPER, W.A.S. Benson, Christopher Dresser, Archibald Knox, Charles Rennie Mackintosh, and C.R. Ashbee are among the British luminaries who led the renaissance in metalwork skills and techniques that flourished in England and Scotland at this time. Meanwhile, in the USA, Dirk Van Erp, Gustav Stickley, and Louis Comfort Tiffany were experimenting with traditional materials such as copper, tin, and pewter and using techniques such as enameling on copper to create rich iridescent tones.

The Arts and Crafts ideal of a small workshop producing handmade artefacts was realized by men like Ernest Gimson, the architect, who set up Alfred Bucknell, the son of his local blacksmith, in his own smithy in the wheelwrights' yard at Sapperton in Gloucestershire in 1903. Gimson needed metal fittings for the furniture he made at his Daneway workshops and it naturally followed that he would expect them to be made to the same high standard. Bucknell was in charge of three or four men working in iron, brass, polished steel, and silver producing firedogs, door handles, locks, bolts, window latches, strap hinges, candlesticks and sconces, and other items to Gimson's designs. Charles Voysey also designed his own metal fittings, from letterboxes to keyhole covers, often incorporating motifs such as birds or hearts, both of which were used in his design for the hinges on the cabinet he designed to hold the Kelmscott Chaucer. Architects such as M.H. Baillie Scott and W.R. Lethaby (author of *Leadwork old and ornamental and for the most part English*, published in 1893), who

Above: *Detail of a firedog in polished steel, designed by Ernest Gimson, c. 1905.*

Far left: *Philip Webb designed the firegrate, fender, fire irons, and paneled surround of the fireplace in the Dining Room at Standen in 1894. The repoussé mild steel cheeks and smoke cowl were made by John Pearson. The grate, plate rack, and fender were created by Thomas Elsley, a London blacksmith often employed by Webb.*

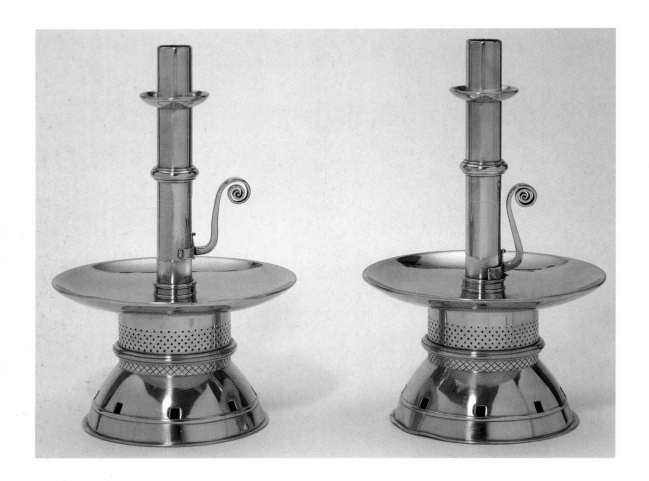

Above: *Philip Webb designed this pair of copper candlesticks around 1860 for Edward Burne-Jones.*

wanted larger pieces such as cast-iron firegrates made to their own design, sought out and found sympathetic manufacturers in Thomas Elsley and H. Longdon & Co., both of London, Yates & Heywood of Rotherham, Yorkshire, and the Coalbrookdale Iron Company. Baillie Scott was good on door details and fireplaces. "In the treatment of wrought-iron work," he wrote, "the best forms will be found to be those which suggest that this cold and hard substance was once, in the heat of the furnace, soft and ductile. And so with brass, and the leadiness of lead." In his work in Hampstead Garden Suburb he fitted simple wrought-iron latches and delightfully shaped tee-hinges to the thick wooden-planked cottage doors he used. For a grander house such as Blackwell in the Lake District he custom-designed all the metalwork, as well as the furniture, stained glass, and fabrics, prompting Hermann Muthesius in *The English House* to praise his "new idea of the interior as an autonomous work of art … each room is an individual creation, the elements of which spring from the overall idea."

Decorative ironwork was put to bold use by Arts and Crafts architects such as Louis Sullivan, who designed rich and fantastic metal ornament, combining Renaissance and Gothic influences, to adorn

the Carson Pirie Scott department store in Chicago, and Charles Rennie Mackintosh, whose heraldic cast-iron features can be seen on both the interior and exterior of the Glasgow School of Art. The influence of Mackintosh can be felt in Antoni Gaudi's intricate and delicate cast-iron decorations on a number of his buildings in Barcelona and can also be traced in the sinuous Art Nouveau railings of Hector Guimard that still adorn the Paris Metro.

One of the most prolific ironworkers operating in the USA was Samuel Yellin, who opened a metalworking shop in Philadelphia in 1909 specializing in hand-hammered repoussé designs for architectural practices. His monumental gates and grilles were influenced by medieval originals although he used the latest methods and employed two hundred workers in his workshop and showroom.

Smaller workshops and guilds were more the Arts and Crafts norm, however. They were started up by artists working in the field of jewelry, silver, and copperware and many flourished, buoyed up on the wave of the Celtic revival, although they would be swamped by competition from the large commercial manufacturers, including Liberty & Co., which were quick to muscle in on the market, producing machine-made Arts and Crafts silver and copperware, embellished with enamel decoration and finished to look as though it might be hand-hammered, though usually it was not.

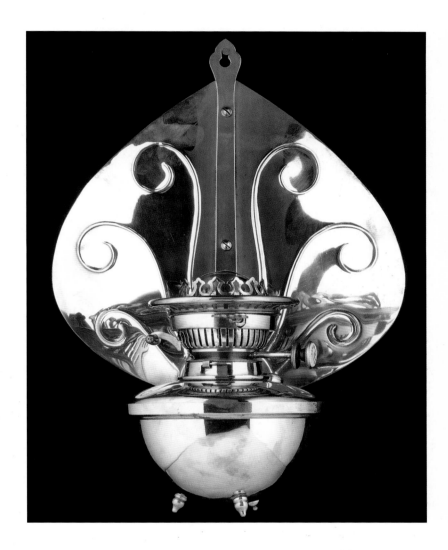

Above: *A copper and brass hanging light by W.A.S. Benson.*

It is this hand-hammered finish that generally distinguishes an Arts and Crafts piece. Structural elements, such as rivets or nail heads, were often left visible to provide plain, honest decoration. In an article entitled "Metalwork" written in 1899, W.A.S. Benson—one of the period's foremost metalworkers—discussed the question of surface texture, contrasting "the natural skin of the metal solidified in contact with the mould" with carved or chased work and beaten or wrought work. Benson was a close friend of Edward Burne-Jones and William Morris, who helped him to set up a workshop in Fulham, producing simple turned metalwork, which he expanded two years later to include a foundry, adding a Kensington showroom and eventually an even larger showroom near Morris & Co. on New Bond Street. It was Benson who provided slender pendant light fittings for Standen (one of the first houses to have its own electricity generator) and other Morris & Co. commissioned interiors. He patented his own reflector shades and lanterns and took over as

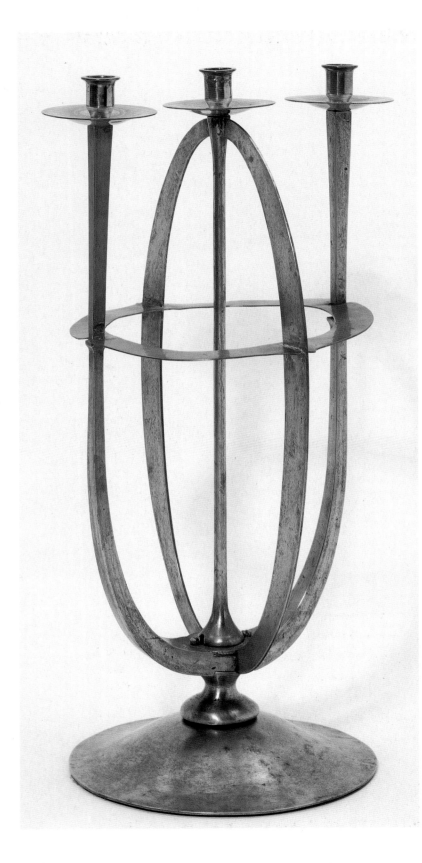

director of Morris & Co. on the death of Morris in 1896, while continuing to run his own firm until he retired in 1920. Business flourished for Benson even during World War I—an event that marked the end of so much that was good in the Arts and Crafts movement—for his workshop was commissioned to make various war items, including a brass model for torpedo sights that the jeweler J. Paul Cooper also worked on. After the war, Benson was commissioned to execute the presentation sword of honor for Field-Marshal Sir Douglas Haig.

Like William Burges, George Walton, Henry Wilson, and other Arts and Crafts designers, Benson had been influenced by Augustus Pugin's Gothic metalwork designs for goblets, candlesticks, and lanterns, simply decorated with precious metals and jewels, that featured in the two books—*Designs for Gold and Silversmiths* and *Designs for Brass and Ironwork*—published in 1836. However, his later machine-made pieces lean toward the modernity of Christopher Dresser and the angularity of European design. Indeed his work sold well in Paris through Samuel Bing's Maison de l'Art Nouveau.

Christopher Dresser's artistic energies extended to embrace most fields of Arts and Crafts design, but he excelled in his metalwork, from the cast-iron garden and hall furniture—umbrella and coat stands—he designed for manufacture by the Shropshire iron founders Coalbrookdale to the electroplate teapots and coffee services he designed for production by James Dixon & Sons of Sheffield. He had trained as a botanist and brought his almost mathematical interest in plant structure to his designs for silver, metalwork, glass, and pottery. His ideas were ahead of their time and anticipated many of the forms of Bauhaus silverwork, which was itself considered advanced and avant garde in the 1920s. "If the work be beautiful then it is ridiculous to estimate its value as though the material of which it is composed were of greater worth than the amount of life, thought, and painstaking care expended upon its production," he

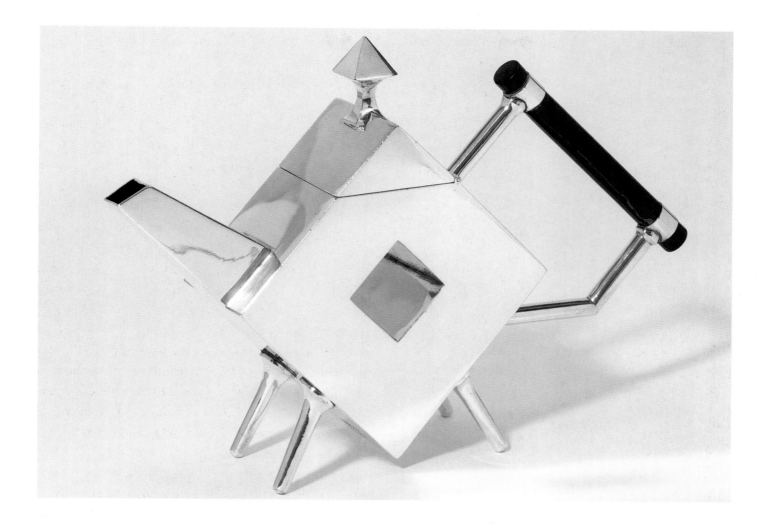

asserted in 1873. Three years later he visited Japan and returned enthused and inspired. The Japanese were "the only perfect metalworkers which the world has yet produced," he declared, "for they are the only people who do not think of the material, and regard the effect produced as of far greater moment than the material employed." He incorporated Japanese decoration in his own designs and agreed to design a collection for Tiffany & Co. in New York. The cult of Japanese art, which had begun in Europe in the 1850s, was encouraged and taken forward by Arthur Liberty, who stocked highly colored decorative objects such as small silver hinged boxes cloisonné-enameled in an Anglo-Japanese style specially for the export market.

In the regions the best metalwork came out of newly formed schools—institutions such as the Keswick School of Industrial Art in the Lake District, where Harold Stabler taught, Liverpool University Art School which boasted R. Llewellyn Rathbone, and the Newlyn Industrial Class set up

Above: *Christopher Dresser—always ahead of his time—designed this stunning geometric teapot in 1880. It was made by James Dixon & Sons of Sheffield.*

Far left: *One of a pair of polished iron and copper candlesticks known as "The Cawder Candlesticks," made by George Walton, c. 1903.*

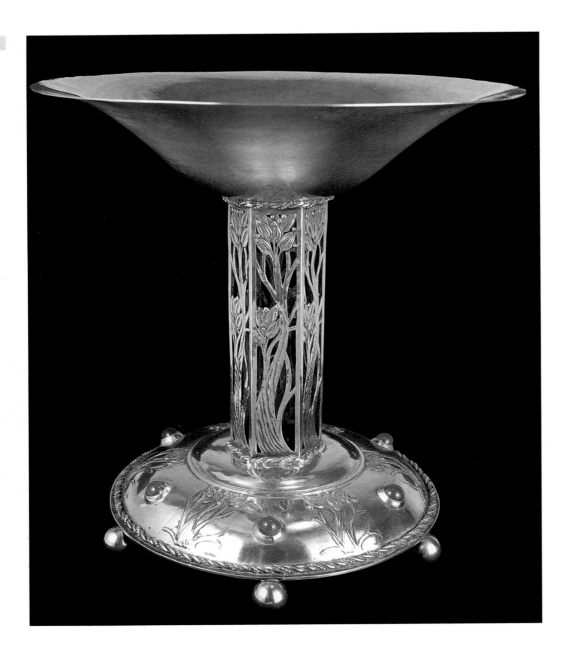

by John D. MacKenzie to teach repoussé copper enameling (and embroidery) in Cornwall—and, of course, the guilds.

C.R. Ashbee found work for between twenty and twenty-five metalworkers and jewelers at his Guild of Handicraft in Chipping Campden. As well as the large vases and dishes in copper and brass, embossed with scrolling patterns of plants and fish, that they had produced in London, he expanded production to include jewelry, cutlery, plates, and other domestic ware, often medieval in inspiration, and adorned with simple decoration and stones such as rubies and pearls. Most of the designs were Ashbee's own, although he encouraged Guildsmen to experiment and choose their own stones or enamels.

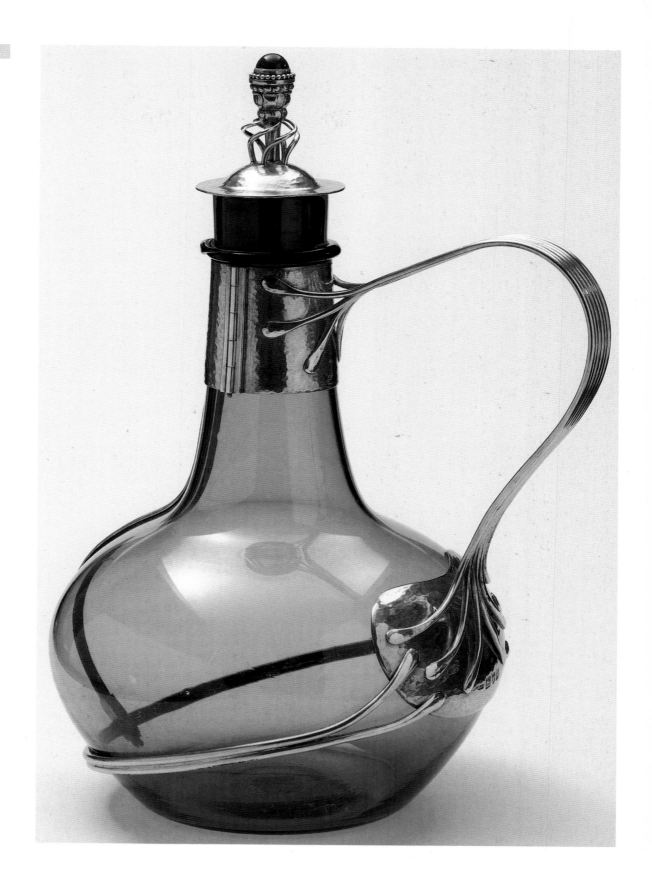

Right: *A silver-mounted green glass decanter by C.R. Ashbee, c. 1904, marked for the Guild of Handicraft. The bottle was probably made by Powell of Whitefriars.*

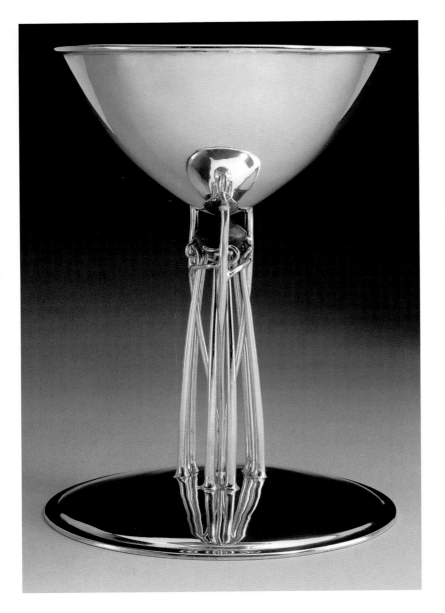

Above: *Silver cup designed by Archibald Knox for Liberty & Co., c. 1900.*

He recruited workers to the Guild very much at random. Will Hardiman, the first of his silversmiths, was a Whitechapel barrow boy; another metalworker, W.A. White, was persuaded to leave his job in a cheap bookshop and join the Guild after he had attended one of Ashbee's Toynbee Hall classes. Few were conventionally trained: they learned skills such as small casting and enameling very much on the job and yet these creative craftsmen were responsible for some of the most elegantly made hammered hollowware, jewelry, and other metalwork of the period. They produced the handmade beaten or hammered doorplates and firedogs that would become such a popular feature of an Arts and Crafts interior and were responsible for the metalwork fittings for the Grand Duke of Hesse's palace at Darmstadt, which they executed to Baillie Scott's designs. Ashbee quickly established the Guild of Handicraft's reputation for innovative design and marketed the fluid and graceful silver, metalwork, and jewelry they produced through the retail premises he had leased at 16a Brook Street in the West End of London. The Guild became famous for four classic silver designs: green-glass, silver-collared decanters; muffin stands; loop-handled bowls; and fruit stands. However, the unique style of the Guild of Handicraft soon found imitators—notably Liberty's, which Ashbee blamed very much for the collapse of his enterprise.

Liberty's sold Arts and Crafts-style gold, silverware, and jewelry in its new "Cymric" collection, which was launched in May 1899, much to the disgust of Ashbee, who firmly believed that the company was undercutting and plagiarizing his handmade items. The Cymric range of spoons, tankards, bowls, salt cellars, clasps, and jewelry proved so popular with women that Liberty's added a pewterware line in the late 1890s under the "Tudric" name. The Cymric range was handmade by the Birmingham-based firm of W.H. Haseler, and Liberty's put the project under "the fostering care" of a new manager, a Welshman called John Llewellyn. He had recently joined the firm from the fashionable Regent Street

Left: *A hot-water jug in "Tudric" pewter, designed by Archibald Knox for Liberty & Co., 1904.*

store Howell & James, and his Celtic roots are reflected in the names chosen for the two ranges. The press reaction was favorable. An article in *The Queen* praised the flower vases, bowls, and tea caddies in the Tudric range, calling them "a delight to those whose artistic instincts have been duly cultivated."

Arthur Liberty cultivated the public's taste by using some of his best designers—including Archibald Knox, Arthur Gaskin, Jessie M. King, the twenty-year-old Rex Silver, Alfred H. Jones, Bernard Cuzner, and Oliver Baker. Together they produced a wide range of jewelry, jewelry boxes, household items including tea sets, jugs, vases, candlesticks, and clocks, and decorative pieces such as cigarette cases and mirror frames decorated with turquoise enamelwork. Knox, who was one of Liberty's most prolific, imaginative, and innovative designers, came from the Isle of Man and, while

Above: *A silver casket by Alexander Fisher, c. 1900, flanked by a pair of "Conistor" Liberty silver candlesticks, 1906.*

attending the Douglas School of Art, had specialized in the study of Celtic ornament. He was the inspiration behind Liberty's Celtic revival, enthusiastically supported by John Llewellyn and Liberty himself. The extent of his contribution in the field is only just coming to light, unfairly obscured by the Liberty house policy that required all designers to be anonymous.

The Birmingham Guild of Handicraft was established in 1890 along idealistic lines very similar to Ashbee's Guild of Handicraft. Montague Fordham was the Guild's first director and the architect Arthur Dixon, who had worked for a year at Ashbee's School of Handicraft in Whitechapel (and presented him with an elegantly simple brass table lamp as a wedding present), was responsible for much of the design work. The workshop was run along cooperative lines, employing about twenty craftsmen, and produced fresh and distinctive Arts and Crafts pieces, including jewelry and belt buckles, teapots, lampshades, and light fittings, beaten from copper, brass, and silver sheet and fixed with rivets. No machinery, apart from a lathe, was used. Indeed, the members' motto was "By Hammer and Hand" and in this way, working from their premises in the medieval Kyrle Hall in Sheep Street, Birmingham, they made austere rather than ornate items: firedogs, fenders, and chased and

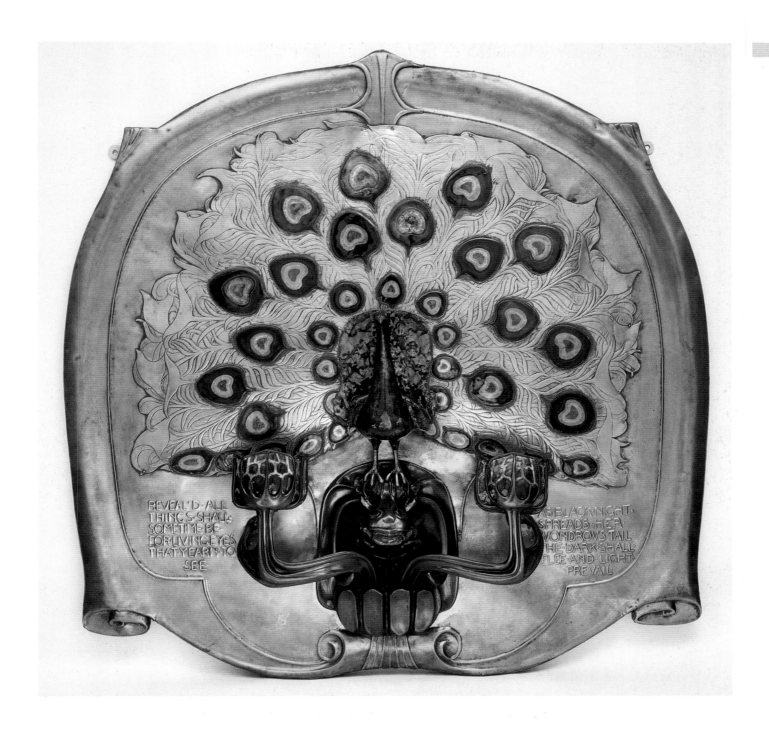

Inside the sconce image:

REVEAL'D ALL
THINGS SHALL
SOMETIME BE
FOR LIVING EYES
THAT YEARN TO
SEE

AS BLACK NIGHT
SPREADS HER
WONDROVS TAIL
HE DARK SHALL
FLEE AND LIGHT
PREVAIL

embossed door furniture—fingerplates, lockplates, and hinges made from flat pieces of brass, copper, and gunmetal. The pieces were largely anonymous, hallmarked with the Guild's stamp, and they were exhibited at the Arts and Crafts Exhibition Society in London in 1893, and the following year in Liverpool, Birmingham, and Paris. The Guild published a quarterly, hand-printed magazine entitled *The Quest* and maintained close links with the Birmingham Art School, where Arthur Gaskin

Above: *Peacock sconce in steel, bronze, silver, and brass, designed and made by Alexander Fisher, c. 1899.*

Above: *A pair of copper and wicker table lamps by Gustav Stickley, c. 1909.*

studied and later taught and where Bernard Cuzner headed the metalwork department. In his *First Book of Metalwork* (1931) Cuzner cautioned: "Of the two evils, affected roughness and mechanical smoothness, the first is more deadly by far."

The machine question was debated differently in the USA, where the Arts and Crafts ideal was more loosely interpreted and the emphasis on handmade articles was not so rigorous, although leading practitioners like Gustav Stickley prized craftsmanship above all. Disenchanted with the stamped hardware available, he founded his own metalworking shop. He wanted his hinges, key escutcheons, and handles to have the same structural and simple qualities as his furniture and he set up a smithy to forge them, along with lamp fixtures, chafing dishes, coal buckets, and other fireplace furniture. Stickley's copper, brass, and wrought-iron metalwork is characteristically handcrafted with obvious hammer marks and repoussé designs of simple and stylized floral patterns, English in derivation, made in copper and wrought iron. Later he extended his operation to include larger architectural elements, such as balustrades and fireplace hoods, which brought him closer to achieving his ideal of a fully integrated Arts and Crafts interior provided by Stickley & Co.

Metalwork of all kinds, but lamps in particular, became a popular means of expression and were prolifically produced by many American studios. The Dutch-born Dirk Van Erp opened his Copper Shop in Oakland, California, in 1908, moving in 1910 to San Francisco when he joined with the Canadian craftswoman Elizabeth D'Arcy Gaw. She stayed only a year as his design partner, but introduced a new level of sophistication. Van Erp's expertise was in metalworking, hammering, and the application of subtle patinas. The Copper Shop flourished and until 1929 retailed copper, brass, and iron accessories, along with copper lamps with mica shades. His success found imitators. Another immigrant, the German Hans W. Jauchen, opened a copper showroom in San Francisco in the 1920s in partnership with Fred T. Brosi. He called it Old Mission KopperKraft and produced and sold machine-made lamps that drew heavily on Van Erp's initial designs.

More in keeping with the Arts and Crafts ideal was the metalwork shop set up by Arthur Stone in Gardner, Massachusetts, along the lines of an English guild, with an apprenticeship system. Stone, who was a skillful craftsman well known for his chasing, piercing, fluting, and repoussé work, drew on Celtic, Gothic, Moorish, and Renaissance influences as well as natural forms—the barbed leaves of the arrowhead were a favorite motif—and produced beakers, tankards, flagons, porringers, and punch bowls.

Right: *A copper vase, with a flattened spherical collared rim, designed and executed by Dirk Van Erp, c. 1915.*

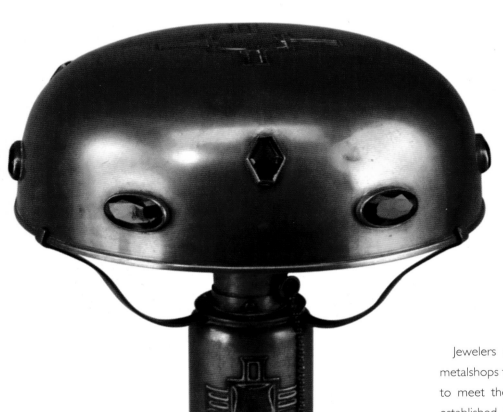

Above: *A hammered copper ink well with quatrefoil textured band by Karl Kipp, c. 1908.*

Jewelers such as Lebolt & Company in Chicago opened metalshops to produce hand-hammered coffee and tea services to meet the market's demand. The Heintz Art Metal Shop, established in 1905 in Buffalo, New York, by Otto L. Heintz, supplied decorative accessories and art-metal vases in bronze with handsome sterling silver overlays for over twenty years. Toward the end Heintz substituted copper for silver because it was softer and could be worked more quickly.

One of the most successful ventures was the Roycrofters Copper Shop, established by Elbert Hubbard in 1903, which produced, until 1938, hand-hammered copper vases, trays, bowls, candlesticks, lighting fixtures, and other small, functional objects such as bookends, for middle-class Americans to purchase on their visits to the Roycroft Community, or order from the Copper Shop's successful catalog. Many Roycroft copperware designs were stamped with borders to emulate leather stitching, or pierced with a bold geometric design. Hubbard put Karl E. Kipp, an Austrian former banker, in charge of production from 1908–11,

and he was responsible for turning the Copper Shop into a hugely profitable operation, employing thirty-five craftsmen and producing a range of over a hundred and fifty items, many inspired by the Modernist designs of Koloman Moser. Kipp left briefly in 1911 to set up his own studio, the Tookay Shop, where he signed his pieces with an encircled "KK," but was persuaded to return by Hubbard's son after the death of his parents aboard the *Lusitania* in 1915.

Another important Roycroft designer was Dard Hunter, who, in 1908, visited the Wiener Werkstätte and, upon his return, introduced geometric motifs in his copper-mounted table lamps and chandeliers, moving away from the more familiar organic shapes of most American Arts and Crafts metalwork. These European influences owed a lot to Charles Rennie Mackintosh, whose work had greatly informed that of Josef Hoffmann, Koloman Moser, and Carl Otto Czeschka. The members of the Wiener Werkstätte combined fine and applied arts and crafts to convey a whole new outlook on design. No everyday object was too banal, and they experimented with an infinite variety of materials from gold and precious jewels to papier mâché and glass beads, producing extraordinary and ultrafashionable work until 1931, when the workshops went into final liquidation.

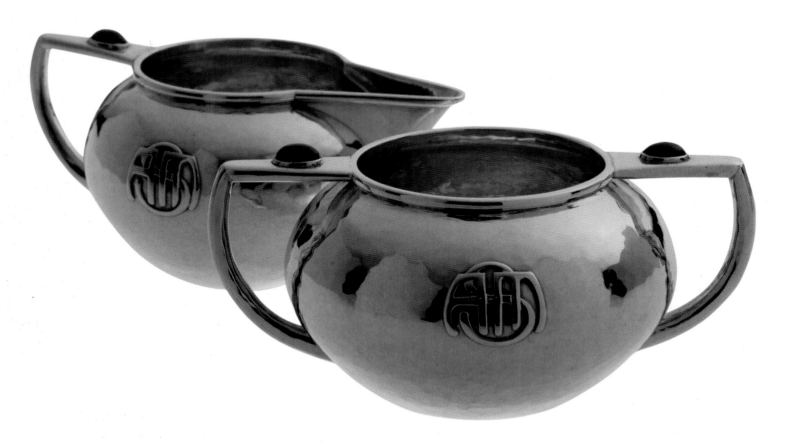

Above: *A matching cream jug and sugar bowl designed by Clara Pauline Barck Welles at the Kalo Shop, c. 1908.*

The cultivated and stylish metalwork designer Robert Riddle Jarvie sold his work, including candlesticks and lanterns, through the Kalo Shop opened in Chicago by Clara Barck Welles. She was an indefatigable promoter of women's causes as well as a teacher, employer, designer, and retailer of handcrafted jewelry influenced by Ashbee and Art Nouveau, trays, jugs, and other classically simple household wares in silver and other metals. The Kalo Shop—the name derives from the Greek word *kalos*, meaning "beautiful," and its motto was "Beautiful, Useful, and Enduring"—continued to operate until 1970.

The best-known American designer in the field was undoubtedly Louis Comfort Tiffany, whose success in the field of art glass had led him to open a foundry in Corona, New York, to supply fittings and bases for his lamps. He also set up a small enamel department in 1898, staffed by a handful of young women and apprentices, who produced small items for as little as $10 and more ambitious and elaborate enameled lamp bases for as much as $900. A critic for *The Commercial Advertiser* commented on the "remarkable achievements in enamel on copper, in line with the other experiments made by Mr. Tiffany, wherein he has secured all the detail, sumptuous coloring and textures of the best of the European workers, retaining a personality quite his own. This enamel is on lamps, plaques, and small boxes, and is most effective."

NATURAL, SHIMMERING BEAUTY

ARTS AND CRAFTS JEWELRY is characterized by its workmanship and the simplicity of the semi-precious stones employed. Translucent moonstones, used in combination with mother-of-pearl and amethyst, were popular with Arts and Crafts jewelers, as were pearls, opals, and opaque stones like coral and turquoise, malachite and lapis lazuli. C.R. Ashbee, who was self-taught, loved to use the kind of cheap colorful stones—aquamarines, moonstones, and topaz—despised by the rest of the trade. His designs followed clear, simple lines and reached back for inspiration to Renaissance masters such as Benvenuto Cellini. It was the Guild of Handicraft's metalwork and jewelry that established its

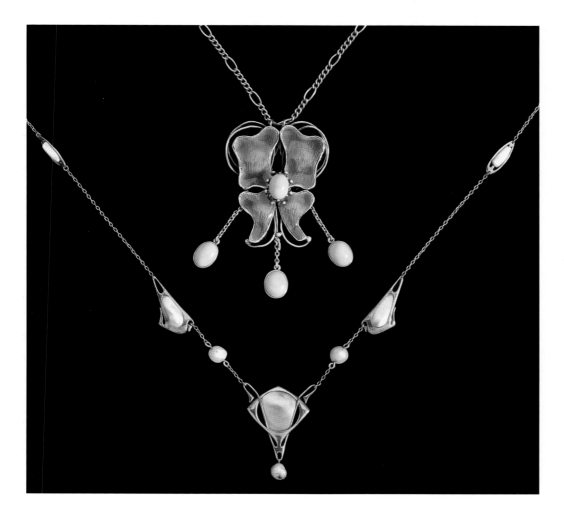

Above: *An aluminium buckle with green pastes and bird designs made around 1901 by the Scottish metalworker Talwyn Morris, who was linked to the Glasgow School.*

Left: *An enameled pendant and chain designed by C.R. Ashbee for the Guild of Handicraft, c. 1905, Above it is a Liberty & Co. necklace attributed to Archibald Knox, c. 1900.*

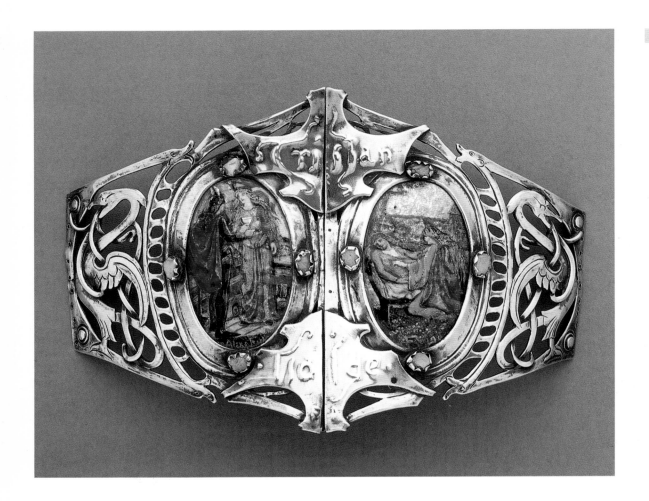

Above: *Alexander Fisher took the Tristan and Isolde story as his inspiration for this white-metal and enamel belt buckle, 1896.*

reputation for cutting-edge modernity. In *The Studio*, Aymer Vallance recognized that Ashbee's work was new and based on the idea that "The value of a personal ornament consists not in the commercial cost of the materials so much as in the artistic quality of its design and treatment." The Guild's customers were modern women such as Christabel Pankhurst, who wore a silver brooch designed by Ashbee in the form of a stylized flower head, set with an amethyst, a cabochon emerald, and pearls, which together made up the suffragette colors.

This new style of jewelry was worn in conjunction with the novel fashion for artistic dress: long, flowing, softly gathered silk teagowns that allowed the uncorseted wearer a degree of freedom hitherto unimagined. Against the background of these "Aesthetic dresses" with their straight, uncluttered lines, an Arts and Crafts enameled pendant, belt buckle, or cloak clasp could be seen to full advantage, with startling effect.

Alexander Fisher was the widely acknowledged master of the revived "Limoges" technique of enameling. He taught enameling at the Central School of Arts and Crafts in London from 1896, and became its most influential exponent in Britain, experimenting with firing techniques to produce a greater range of colors and pictorial depth, and reviving the medieval chalice and casket. Writing in his

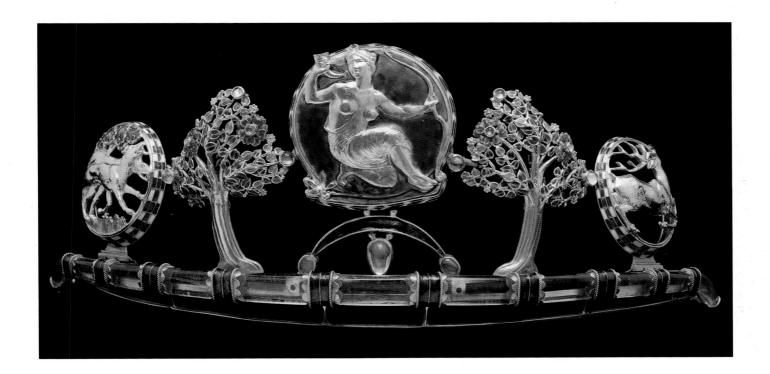

Above: *The Diana diadem, depicting the goddess of hunting in the centre of the diadem, enameled and set with moonstones by Henry Wilson c. 1908.*

book *The Art of Enamelling on Metal* (1906) he maintained that enamel could reflect the "velvet of the purple sea anemone, the jewelled brilliance of sunshine on snow, the hardness greater than that of marble, the flame of sunset, indeed, the very embodiments in colour of the intensity of beauty." He also taught in his London studio, attracting aristocratic pupils for whom enameling became an artistic hobby as well as talented craftsmen and women for whom it became a rigorous professional discipline. For a brief period he entered into a partnership with the architect, designer, metalworker, and enameler Henry Wilson, a former pupil of J.D. Sedding. Wilson's metalwork style was a mix of Byzantine and late Gothic. He experimented with wirework and jewelry, going on to teach at the Central School of Arts and Crafts and from 1901 at the Royal College of Art. The immensely talented John Paul Cooper was one of his pupils. Cooper is best known now as a goldsmith, silversmith, and jeweler but he, too, began his working career in Sedding's congenial architectural office, where he first met Wilson, along with Ernest Gimson, Christopher Whall, and many other Arts and Crafts practitioners.

Cooper was responsible for almost fourteen hundred pieces of jewelry, along with silver frames, brooches, buckles and other metalwork, including domestic plate and hollowware, spoons, teapots, fruit stands, and liturgical silver. In about 1899 he began to work with the material he is most

Right: *A silver brooch set with opals, pink tourmalines, emerald pastes and pearls, part of a set, which includes a pendant necklace, by Arthur and Georgie Gaskin, c. 1914.*

associated with: shagreen, or treated sharkskin—a durable and scratch-resistant material imported from China, which he bought from the London-based firm W.R. Loxley and used on boxes and other pieces mounted in silver. These sold well and became very popular. Cooper made a remarkable gold ring in the form of a castle for the actress Ellen Terry, whose octagonal funeral casket, made to contain her ashes and decorated with repoussé panels of birds and foliage, was also his work. It is now in St. Paul's Church, Covent Garden, London.

In 1901 Cooper took up an appointment as head of the metalwork department at the Birmingham School of Art, an influential post he held for five years until pressure of work forced him to devote more of his time to production, based in his workshop at his house in Westerham in Kent. Between 1902–6 he received numerous commissions from Ernest Gimson for silver and brass handles to be mounted on his furniture.

Birmingham had been a traditional home of the jewelry trade since the eighteenth century although, according to one critic, it was at this time "a locality where a large amount of very deplorable jewelry is produced … and the reason why the vast mass of the trade jewelry manufactured in Birmingham is bad is that in style and outline it is utterly devoid of artistic inspiration." However, the Birmingham School of Art and the recently opened Vittoria Street School for Silversmiths and Jewellers were about to reverse the declining fortunes of the trade and encourage the establishment of a number of important silversmithing workshops in the town, specializing in bold, high-quality work in the Craft Revival or French Art Nouveau style.

The head of the new Vittoria Street school was the painter, enameler, and jewelry designer Arthur Gaskin, who, from 1902 until his retirement to the Cotswolds in 1924, influenced generations of students with his characteristic use of flowers and leaves in silver or gold, set with

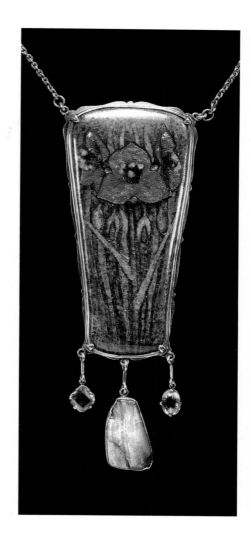

small colored stones, or decorated with pale opaque enamels. Gaskin formed a highly successful partnership with his wife Georgina Cave France. They favored polished semi-precious stones in their natural state rather than elaborately facet-cut precious stones: in 1915 they made a necklace from stones they collected on a Suffolk beach during a family holiday, including cornelians, agates, and quartz of various colors. Their work attracted notice and prestigious commissions such as the one from the Birmingham City Corporation for an elaborate enameled and jeweled necklace for Queen Alexandra. In an article entitled "The Jewelry of Mr. and Mrs. Gaskin" in *The Studio* the writer praised the originality of their "simple floral designs" and observed how "they did not, and possibly could not, then achieve the mechanical perfection of the trade jeweller."

Other artistic couples also made their mark in the field: Harold and Phoebe Stabler in Liverpool collaborated on setting and enameling, creating lovely gold pieces set with cabochon (rounded) amethysts, turquoise, mother-of pearl, and freshwater pearls. In their workshop in Chiswick, London, Edith and Nelson Dawson worked on their tiny jewel-like enamels mounted in silver, often depicting flowers or insects in minute detail. Both had studied enameling under Alexander Fisher. In 1901 they set up the Artificers' Guild, which was later acquired by Montague Fordham. One of Dawson's workshop employees, Edward Spencer, stayed with the Guild when Fordham bought it and he was responsible for ambitious and elaborate pieces of jewelry including a gold, silver, diamond, and opal "Tree of Life" necklace, complete with a gold phoenix rising from opal flames.

Above: *A gold and silver enameled pendant and chain by Edith and Nelson Dawson, 1900.*

Left: *A pair of silver and enamel buckles designed by Archibald Knox for Liberty & Co., c. 1902.*

Right: *"Cupid the Earth Upholder," a gold and enamel pendant by Phoebe Traquair, 1902.*

The Arts and Crafts style of translucent enameling and heavily hammered silverwork was once again widely copied by commercial firms, which evolved a type of silverwork, often with a spurious "hand-worked" hammered finish, that was decorated with panels of shaded enamel. Liberty's was quick to board the bandwagon, but other firms including Charles Horner of Sheffield, William Hutton of Birmingham, and Murrle, Bennett & Co. of London mass-produced pieces of indifferent quality but outstanding design, thanks to the work of unsung figures such as Archibald Knox at Liberty, Kate Harris at William Hutton, and F. Rico and R. Win at Murrle, Bennett.

Jewelry was a field in which women excelled. To the roll call of Edith Dawson, Georgie Gaskin, Phoebe Stabler, and Kate Harris can be added the Scottish jewelry designers Jessie M. King, Frances and Margaret Macdonald, and the Dublin-born Phoebe Traquair, an exceptional colorist whose

Above: *Silver and enamel two-piece buckle, pierced with a design of stylized Art Nouveau flowers, designed by Jessie M. King for Liberty & Co., marked "Birmingham, 1905–1906."*

lovely enameled jewelry drew on romantic Celtic legend. They designed for a new market, interested less in flashy ostentation and more in subtlety and sophisticated good taste, for the new Aesthetic woman—for themselves.

By 1902 Louis Comfort Tiffany's Tiffany Studios were producing a good deal of remarkable jewelry, with decided Art Nouveau leanings. Indeed, Alphonse Mucha—whose designs were heavily pirated in the USA — is thought to have collaborated with Tiffany on a number of pieces of jewelry. The Unger Brothers and William Kerr, both based in Newark, New Jersey, also produced a range of Art Nouveau jewelry designs. In Europe, jewelry designers such as Joseph Maria Olbrich, the leader of the Secessionists, and Richard Riemerschmid of the Dresden and Munich Werkstätten, produced work that, in its geometrical restraint and linear qualities, showed a growing appreciation of the Glasgow Four and the work of Charles Rennie Mackintosh in particular. The jewelry produced by the Wiener Werkstätte at the turn of the century incorporated formalized motifs taken from the natural world and included designs by Carl Otto Czeschka and Dagobert Peche, which were executed by trained craftsmen employed in the goldsmiths' department. The painter Emil Nolde designed a number of pieces of jewelry, mainly in silver or non-precious metal and semi-precious stones, and the catalogs of the Deutscher Werkbund—founded to bring order, unity, and commercial support to scattered groups—showed exquisite gold and silverwork by the Berlin-based goldsmith Emil Lettré. The Europeans signaled their modernity—and their move away from the Arts and Crafts ethic—not just in their designs but also in their materials, as in the chromium plating used by the Bauhaus designer Naum Slutksy, and in their unembarrassed embrace of the machine and all technological advances. From now on the emphasis would be on functionality and liberating design from the suffocating strictures of superfluous ornamentation.

9

THE PRINTED WORD

Right: *"A Book of Verse,"* William Morris's gift to Georgiana Burne-Jones on the occasion of her thirtieth birthday.

A GARDEN BY THE S

For which I let slip all delight,
Whereby I grow both deaf and blind
Careless to win, unskilled to find,
And quick to lose what all men se

et tottering as I am and weak
Still have I left a little breath
To seek within the jaws of death
An entrance to that happy place
To seek the unforgotten face
Once seen once kissed, once reft f
Anigh the murmuring of the sea

THE BALLAD OF CHRISTINE.

OF silk my gown was shapen,
Scarlet they did on me
Then to the sea-strand was I borne
And laid in a bark of the sea.
O well would I from the World away

But on the sea I might not drown
To me was God so good,
The billows bore me up aland
Where grew the fair green-wood

There came a knight a riding by
With three swains along the way
And took me up the little-one
On the sea-strand as I lay

He took me up, and bore me home
To the house that was his own,
And there so long I bode with him
That I was his love alone.

But the very first night we lay abed
Befell this sorrow and harm,
That thither came the king's ill men,

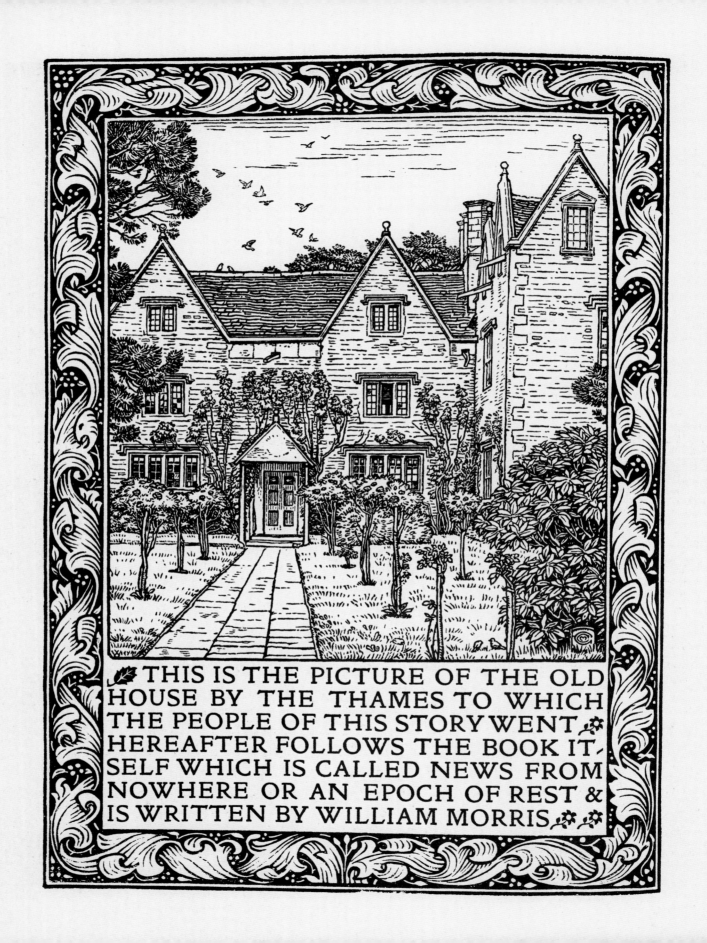

THIS IS THE PICTURE OF THE OLD
HOUSE BY THE THAMES TO WHICH
THE PEOPLE OF THIS STORY WENT
HEREAFTER FOLLOWS THE BOOK IT-
SELF WHICH IS CALLED NEWS FROM
NOWHERE OR AN EPOCH OF REST &
IS WRITTEN BY WILLIAM MORRIS

PRINTING & THE "IDEAL BOOK"

"The picture-book is not, perhaps, absolutely necessary to man's life, but it gives us such endless pleasure, and is so intimately connected with the other absolutely necessary art of imaginative literature that it must remain one of the very worthiest things towards the production of which reasonable men should strive."

WILLIAM MORRIS, 1893

THE ARTS AND CRAFTS PERIOD produced a number of fine private presses. Among them, in Britain, were the Doves Press (1900–17), set up by Emery Walker and William Morris's Hammersmith neighbor T.J. Cobden-Sanderson, for whom art was "every man's duty carried one stage further into beauty," and the Ashendene Press (1894–1935) set up by C.H. St. John Hornby, who would later become a partner in the firm of W.H. Smith. St. John Hornby was responsible for a stunning folio edition of Dante set in a typeface he devised himself, which he called Subiaco. Camille Pissarro's son, Lucien, who settled in England and was himself a painter and illustrator, ran the Eragny Press (1894–1914). Writing in 1900 in *The Ideal Book*, or *Book Beautiful*, Cobden-Sanderson claimed that these small presses contributed to "the wholeness, symmetry, harmony, beauty, without stress or strain" of life.

Importantly, women were involved. Middle-class women, still tied to the home, were able to learn the craft—from male professionals in the trade—of hand-tooling bindings. In 1898 a group of women, including Elizabeth MacColl, Florence and Edith de Rheims, and Constance Karslake formed a federation called the Guild of Women-Binders. In Edinburgh, Sarah Prideaux and Katherine Adams had their own bookbinding workshops, and W.B. Yeats's sisters Elizabeth and Lily, a former embroidery student of May Morris, founded the Dun Emer Press (1903–7) in Dublin.

Writing rather floridly in his essay on bookbinding in *Arts and Crafts Essays by Members of the Arts and Crafts Exhibition Society* Cobden-Sanderson put the case for "A well-bound beautiful book," claiming that it "is individual … instinct with the hand of him who made it; it is pleasant to feel, to handle, and to see; it is the original work of an original mind working in freedom simultaneously with

Above: *Initial letter from Felix Shay's posthumous biography of Elbert Hubbard of East Aurora, published in 1926, using Hubbard's original artwork.*

Left: *The frontispiece for William Morris's Utopian* News from Nowhere, *published in 1893, which shows Morris's beloved country home, Kelmscott Manor, near Lechlade, Gloucestershire. This drawing of the east front was by C.M. Gere.*

Above: *A bookbinding by the craftswoman, Phoebe Anna Traquair, of embossed leather with spine entitled* Biblia Innocentum *and front cover decorated with scenes of the Creation of the World, Edinburgh, 1897–8.*

hand and heart and brain to produce a thing of use, which all time shall agree ever more and more also call 'a thing of beauty'."

The most important press of the period, however, the one that would have the most seismic effect on the future standards of book design, was undoubtedly William Morris's Kelmscott Press, set up in a rented cottage at 16 Upper Mall, Hammersmith, London, in 1891. "The mere handling of a beautiful thing seemed to give him intense physical pleasure," wrote Morris's first biographer J.W. Mackail, who, as the son-in-law of his closest friend Edward Burne-Jones, had ample opportunity to observe his subject. William Morris had always found books beautiful. As undergraduates at Oxford in the 1850s, he and Burne-Jones had spent long hours poring over "the painted books in the Bodleian." One of his favorite pastimes had been to scour antiquarian booksellers for finds and he bestowed generous gifts on friends, giving the impecunious Burne-Jones a fine edition of Malory's *Morte d'Arthur*. Thirty years later, dissatisfied with the poor quality of modern printing and design, he founded the Kelmscott Press with a view to reviving early Renaissance methods of book production and type design. It was a new passion at a relatively late

stage in his life and represented an extraordinary labor of love. As with all his previous enterprises, he researched his subject thoroughly and poured all his energies into producing the best possible finished book. He had ink imported from Germany, paper specially made by hand from a fifteenth-century Venetian model, and he designed three of his own typefaces—Golden, Troy, and Chaucer—based on a Roman typeface designed by Nicholas Jenson, a fifteenth-century Venetian printer. Morris even designed the watermarks for the handmade paper and for a while experimented with making his own ink.

In 1895 the American publisher W. Irving Way persuaded Morris to print an American edition of Dante Gabriel Rossetti's *Hand and Soul*, for distribution by Way & Williams. It was the only Kelmscott Press book printed for the American market but it opened the way for the aesthetic revolution that followed in the field of American typography and printing. It also inspired the book designer Bruce Rogers and the printer Daniel Berkeley Updike, both of whom had worked at one

Below: *Daniel Berkeley Updike,* The Altar Book, *published in only 350 copies by the Merrymount Press in Boston in 1896.*

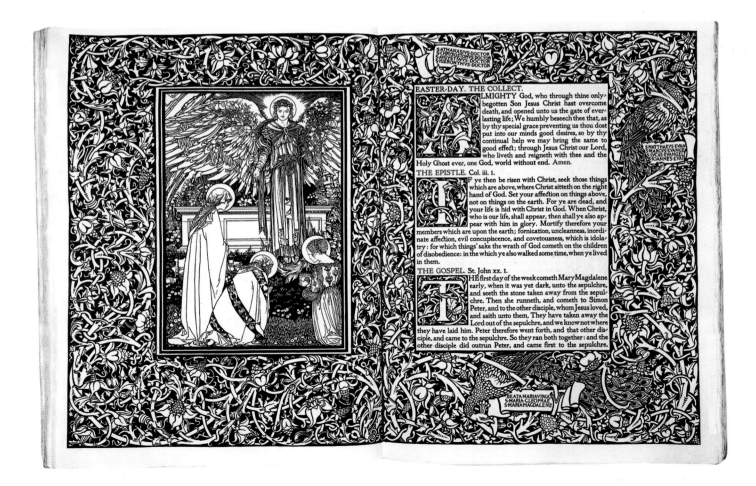

THE POEMS OF JOHN KEATS

ENDYMION: BOOK I.

A THING OF BEAUTY IS A JOY FOR EVER: ITS LOVELINESS INCREASES; IT WILL NEVER PASS INTO NOTHINGNESS; BUT STILL WILL KEEP A BOWER QUIET FOR US, AND A SLEEP FULL OF SWEET DREAMS, & HEALTH, & QUIET BREATHING ❧ THEREFORE, ON EVERY MORROW, ARE WE WREATHING A FLOWERY BAND TO BIND US TO THE EARTH, SPITE OF DESPONDENCE, OF THE INHUMAN DEARTH OF NOBLE NATURES, OF THE GLOOMY DAYS, OF ALL THE UNHEALTHY AND O'ER-DARKENED WAYS MADE FOR OUR SEARCHING: YES, IN SPITE OF ALL, SOME SHAPE OF BEAUTY MOVES AWAY THE PALL FROM OUR DARK SPIRITS. SUCH THE SUN, THE MOON, TREES OLD & YOUNG, SPROUTING A SHADY BOON FOR SIMPLE SHEEP; & SUCH ARE DAFFODILS

Above: *Title page of the Kelmscott Press Edition of* The Poems of John Keats, *published in 1894.*

time for Houghton, Mifflin & Co. and their subsidiary Riverside Press. Updike's *The Altar Book*, with illustrations by Robert Anning Bell, three years in the preparation and published in 1896, bears comparison with Morris's Kelmscott Chaucer.

"I began printing books," Morris wrote to an American friend in 1895, "with the hope of producing some which would have a definite claim to beauty, while at the same time they should be easy to read and should not dazzle the eye, or trouble the intellect of the reader by eccentricity of form in the letters.… As to the fifteenth-century books, I had noticed that they were always beautiful by force of the mere typography, even without the added ornament, with which many of them are so lavishly supplied. And it was the essence of my undertaking to produce books which it would be a pleasure to look upon as pieces of printing and arrangement of type."

Among the fifty-three titles produced by the Kelmscott Press were Morris's own writings, including *A Dream of John Ball*, Ruskin's *On the Nature of Gothic*, *The Poems of John Keats*, and, most famously, an illustrated edition of Chaucer. The Kelmscott Chaucer has been described as one of the greatest English books ever produced. It is certainly one of the most beautiful. Containing eighty-seven illustrations by Burne-Jones as well as Morris's beautifully decorated initials and intricately patterned borders, it took four years to produce. Thirteen copies were printed on vellum and forty-eight were bound in white pigskin with silver clasps; a special cabinet was designed by Charles Voysey to hold the book. Of the 425 copies that were finally printed, Morris only just lived to see one, for in 1896, after years of robust energy and astonishingly hard work, his health began to decline dramatically and, on October 3, at the comparatively young age of sixty-two, he died. His doctor, Sir William Broadbent,

Above: *Walter Crane designed the title page for William Morris's* The Story of the Glittering Plain or the Land of Living Men, *which was published by the Kelmscott Press in 1896, the year Morris died.*

famously declared the cause of death to be "simply being William Morris and having done more work than most ten men."

The Kelmscott Press did not long outlive Morris. After its closure, C.R. Ashbee, who had already published a number of books through the Guild of Handicraft, bought one of the Kelmscott's Albion presses, took on some of Morris's craftsmen, and set up the Essex House Press, printing beautiful books such as *The Treatises of Benvenuto Cellini on Goldsmithing and Sculpture* (1898) on handmade paper using Caslon Old Face to achieve the same powerful effect as Morris had with his Chaucer. However, competition from American small presses, and from machine-printed books in a hand-press style, put the Essex House Press under serious financial pressure from the outset. (The second of the Kelmscott Albion presses was bought by Theodore Low de Vinne and Bruce Rogers, who shipped it to the USA and started up one of the many hand-press workshops that mopped up Ashbee's American market.) In 1904 Ashbee cut the hours of his Chipping Campden printers, putting them on half-time working, but soon there was another blow: the order for his two-volume edition of the Bible was cut from three hundred to a mere one hundred copies. Despite having asked William Strang to produce sixty woodcuts, Ashbee had to abandon the edition and was soon dismantling the Press altogether.

He recorded "rather a sorrowful afternoon," in his journal as he described taking stock of "the goods of the Essex House Press" with "old Binning," his chief compositor, who had worked with Morris before joining the Guild and been in the business for over twenty years. Presciently he wrote: "I think the book collectors of a day to come will probably prize some of the books—probably the wrong

ones but certainly some," and so it proved. Books such as the Essex House Press edition of Shakespeare's *Poems*, bound in red morocco and outlined in gilt, and Ashbee's own *Endeavour towards the teaching of John Ruskin and William Morris*, bound in green morocco with an onlaid and tooled pattern, which then he could hardly give away, now fetch substantial prices when they come up for auction.

One notable figure who was, for a while, on the fringes of the Arts and Crafts movement, was the artist-craftsman Eric Gill, a typographer and lettercutter of genius, who also mastered the arts of wood-engraving and sculpture. He was interested in the movement and went several times to the Arts and Crafts Exhibition Society show in 1903, exhibiting with them himself in 1906. Commissions came in from Arts and Crafts architects including Ernest Prior and Charles Harrison Townsend (who was responsible for the Whitechapel Gallery and the Horniman Museum), for the lettering on the new Medical School in Cambridge and the lettering of the lichgate for Townsend's church of St. Mary at Great Warley in Essex. Gill found himself part of a brotherhood of architectural craftsmen who saw lettering not as an afterthought but as intrinsic to a building. In 1903 St. John Hornby invited him to paint the name W.H. Smith & Son on the fascia of his first Paris bookshop and then to paint all Smith's signs over a two-year period, creating one of the most recognizable "brands" of the period. Ambrose Heal also valued the "recognition factor" that Gill's plain but beautifully proportioned lettering gave to Heal's, employing him to design the distinctive lettering for the shop, its catalogs, and headed paper.

Gill was in tune with the wider aims of the Arts & Crafts movement—the striving for a simple existence, living in the country, where one made useful things by hand that improved both one's own life and the wider world. He shared the Ruskinian optimism about the creativity of the worker and the social aims of improving the lot of working people. From 1905 he lived for two years in Black Lion Lane, Hammersmith, in the center of an Arts and Crafts community that included May Morris, the metalworker Edward Spencer of the Artificers' Guild, and the Emery Walkers, who all lived in Hammersmith Terrace. Walker's Doves Press was, at the time, completing its most

11

Above: *An illustration from* Conradin: A Philosophical Ballad, *published by C.R. Ashbee's Essex House Press in a limited edition of 250 printed on paper and this single example on vellum in 1908.*

Above: *Design for the coat of arms of Thomas à Becket by Eric Gill for Messrs. Burns & Oates Limited, London, 1914, showing three Cornish choughs.*

ambitious project, *The English Bible*, printed in five volumes bound in white vellum. The Hammersmith years and the ideas he gleaned there enriched Gill's life in the country, first at Ditchling in Sussex and later at Capel-y-ffin in the Black Mountains of Wales, where he could implement his "idea that life and work and love and the bringing up of a family and clothes and social virtues and food and houses and games and songs and books should all be in the soup together."

The Arts and Crafts period encompassed a golden age in children's book illustration, as figures like Kate Greenaway and Randolph Caldecott came to prominence alongside Walter Crane, whose highly decorative illustrations for nursery rhymes and fairy tales provided idealized glimpses of model Aesthetic interiors and helped to shape the taste of the artistic middle class. Greenaway worked in a studio at the top of a romantic house in Hampstead designed for her by her near neighbor, the Arts and Crafts luminary Richard Norman Shaw, producing illustrations of tidy children in Queen Anne costumes that proved enormously popular, attracting the praise even of Ruskin. Meanwhile, new illustrators including Aubrey Beardsley, Charles Ricketts, and, in the USA, Will Bradley, were incorporating the sinuous lines of Art Nouveau into their book and poster illustration, producing a distinctive, decadent style.

LITTLE JOURNEYS
to the Homes of
ENGLISH AUTHORS
By ELBERT HUBBARD

DONE into a PRINTED BOOK
by the ROYCROFTERS at their
SHOP in EAST AURORA, Erie
County, New York, U. S. A. MCM

Left: *Frontispiece and title page from Walter Crane's* The Baby's Own Aesop, *published by Frederick Warne, London, c. 1877.*

THE EXAMPLE OF MORRIS'S KELMSCOTT PRESS inspired not just Elbert Hubbard's Roycroft Press in East Aurora, New York, but more than fifty small presses that came into existence in the United States from 1895–1910, including the Riverside Press, Copeland & Day, the Merrymount Press of Boston, the University Press of Cambridge, Massachusetts, the De Vinne Press in New York, the Blue Sky Press in Chicago, and Will Bradley's Wayside Press in Springfield, Massachusetts. All reflected the influences of the Arts and Crafts movement in their emphasis on craftsmanship, their use of fine handmade materials and the dense medieval appearance of the type. Editions were limited, signed, and illustrated with woodcuts or wood engravings.

Above: *Title page, illuminated by hand by Maud Baker, of the Roycroft edition of* Little Journeys to the Homes of English Authors *by Elbert Hubbard, published in a limited edition of less than 150 in 1900.*

Right: *Title page from Elbert Hubbard's edition of Coleridge's "The Rime of the Ancient Mariner," published in East Aurora, New York, 1899.*

SO THIS THEN IS YE

RIME

of ye

ANCIENT MARINER

WHEREIN

Is told Whilom on a Day an Ancient Sea-Faring Man Detaineth a Wedding-Guest & Telleth him a Grewsome Tale.

Written by *SAMVEL TAYLOR COLE-RIDGE*

For ye better Understanding of ye Gentle Reader, Various Pictures are here Inserted by one *William W. Denslow*

Ye First Edition Corrected and Improved

Done into a Booke by ye merrie ROYCROFTERS at ye *ROY-CROFT SHOP*, at ye Sign of ye *Hippocampus*, adjacent to ye Deestrick Academy for ye Younge, which is in *East Aurora*, New York, United States of America. *1899*

Above: *Design on the signature page of* Little Journeys to the Homes of English Authors, *by Elbert Hubbard, 1900.*

True to Arts and Crafts principles, Roycroft books used handmade paper, chamois or vellum bindings, hand-illuminated initials, bordered title pages, and Gothic typefaces, to convey a medieval impression. The first Roycroft book was *The Song of Songs: Which Is Solomon's*, printed in January 1896. The hand tooling on the binding was done in the Roycroft leather shop (which also produced wallets, manicure cases, photograph frames, and bookends and was headed by a German craftsman with Art Nouveau leanings called Frederick C. Kranz, who joined Roycroft in 1903); a young woman called Lucy Edwards, who joined in 1898, oversaw the hand-painted illuminations.

The typographical revolution extended to Europe, where designers such as Rudolf Koch, Peter Behrens, and Henry van de Velde turned the British revival of calligraphy to great effect, creating a new typography based on Fraktur types, and publishing books, posters, and magazines in the new *Jugendstil*, or Art Nouveau style.

Above: *Title page of* The House Beautiful *by William Channing Gannet, Auvergne Press, River Forest, Illinois, designed by Frank Lloyd Wright, who was commissioned by the publisher, William Herman Winslow, after he had designed a house for him in 1893.*

Left: *Morris's tailpiece to the Poems of John Keats, 1894.*

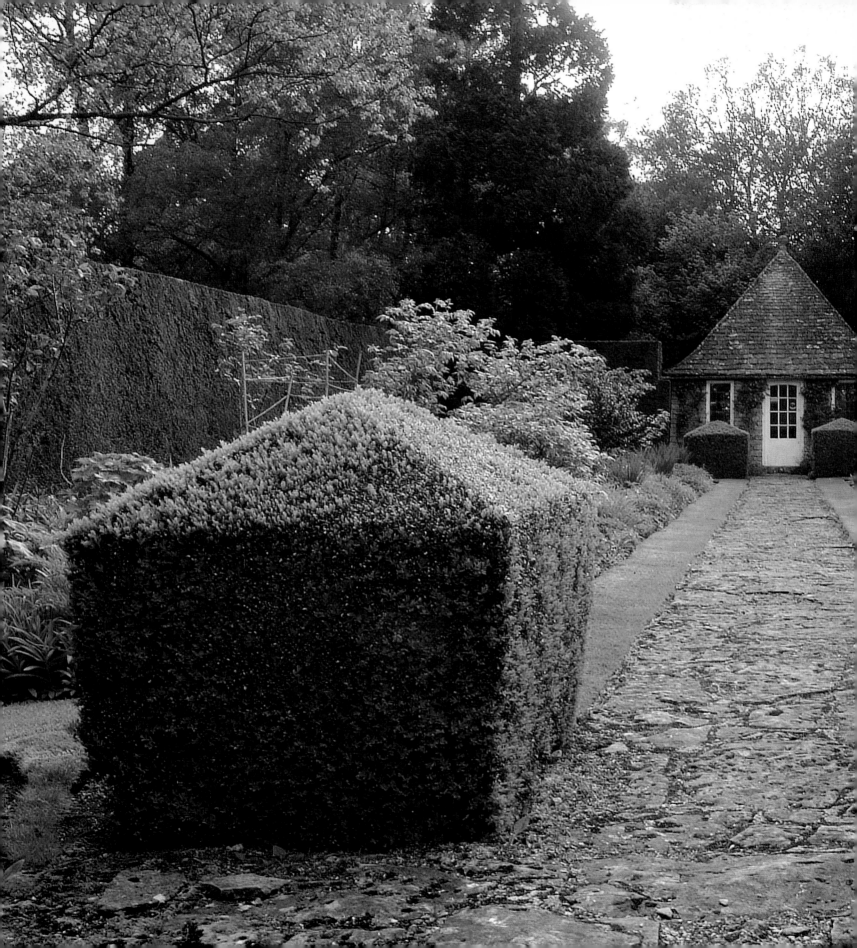

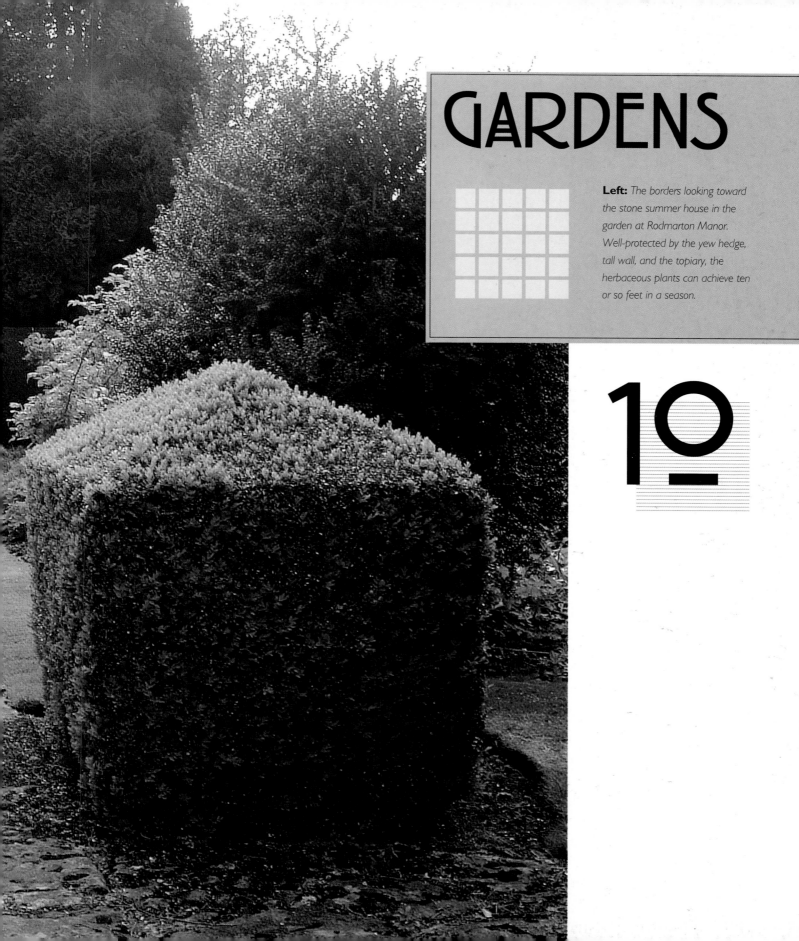

GARDENS

Left: *The borders looking toward the stone summer house in the garden at Rodmarton Manor. Well-protected by the yew hedge, tall wall, and the topiary, the herbaceous plants can achieve ten or so feet in a season.*

10

MORE OR LESS WILD

"A garden scheme should have a backbone—a central idea beautifully phrased. Thus the house wall should spring out of a briar bush—with always the best effect, and every wall, path, stone and flower bed has its similar problem and a relative value to the central idea."

EDWIN LUTYENS, writing to his wife Lady Emily, 1908

THE IDEAL ARTS AND CRAFTS GARDEN found inspiration in a rustically romantic old England, turning away from the hard-edged geometry of the rigidly planned Victorian garden to embrace the tumbling profusion of old-fashioned flowers such as poppies, foxgloves, roses, lavender, lupins, irises, delphiniums, phlox, sunflowers, and pinks. While the poor used their gardens to grow food for subsistence, the rich employed teams of gardeners to groom what was essentially a status symbol. Now a burgeoning new middle class saw the garden as an extension of the home, something to be decorated and a place that provided a respectable channel for the creative energies of the lady of the house.

The pioneering garden designers William Robinson and Gertrude Jekyll were already steering fashion away from the elaborate formality and extreme symmetry of the high Victorian garden, dependent on vast seasonal bedding schemes, toward natural groupings and an idealized rural profusion of sweet-smelling flowers such as hollyhocks and wallflowers. "I believe," Robinson wrote, "that the best results can only be got by the owner who knows and loves his ground. The great evil is the stereotyped plan...." He enjoyed much popular and financial success with his books *The Wild Garden* (1870) and *The English Flower Garden* (1883), which promoted the kind of indigenous British plants that inspired William Morris's textile and wallpaper designs: roses on trellis, hollyhocks, sunflowers, and fiery nasturtiums. Passionate and persuasive, Robinson put his ideas into practice in his own garden at Gravetye Manor, a handsome Elizabethan gabled mansion house that he bought in 1885, at the age of forty-seven, with the proceeds of his writing. The house was exceptionally situated in rolling country in West Sussex and it was there, over a period of fifty years, that he

Above: *Gertrude Jekyll's main border at Munstead in 1900, depicted here in a watercolor by Helen Allingham.*

Left: *Gertrude Jekyll's gloriously crowded borders tumble across the aster walks leading up to the north face of Munstead Wood.*

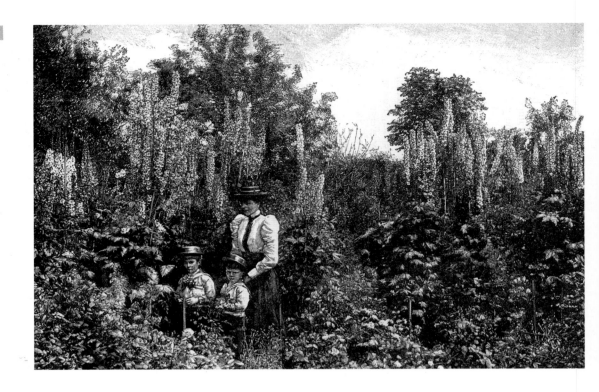

created his famous garden. He planted tea roses in the flower garden, cutting them back to the ground in severe winters so that he would be rewarded the following season with magnificent flowers right through to October. He planted pansies in "colonies and bold groups … never in lines and never dotted about singly" and favored mixed plantings of roses, agapanthus, forget-me-nots, campanulas, and carnations. A vast oak pergola, covered in a froth of white wisteria, connected the formal garden to Robinson's "alpine meadow" situated on a steep slope to the south of the house, where he naturalized anemones, scillas, erythroniums, fritillaries, and great drifts of daffodils, which ran down to the fringe of the lake where he had planted white willow. He held strong views and was not interested in discoursing in Latin, insisting that every plant should have an English name. He instructed his head gardener Ernest Markham not to cut the grass until late into the summer to allow the seed to ripen and encouraged the village children to come and play on a sloping bank on the east side of the house. Every year on his birthday they would come and dance around the maypole for him—even though his birthday fell in July—and at ninety-five he was drawing up ambitious plans to move the old orchard and plant a new one.

Robinson's ideas were enthusiastically embraced in Britain, where nostalgia for a simple country life had been fanned by picturesque images of plumply thatched cottages with open rose-framed doors by painters like Helen Allingham. Only a generation earlier, such dwellings would have been looked upon with suspicion and distaste as insanitary hovels, but now they became desirable, even fashionable, and were purchased as weekend retreats by better-off members of the middle class and newly wealthy industrialists, who eagerly embraced the Arts and Crafts ethos of a return to the

natural garden. Robinson was also widely read in the USA, where his ideas were put into practice by the Arts and Crafts proselytizer Charles Fletcher Lummis in his wild flower garden at El Alisal in southern California, which he liked to refer to as "the Carpet of God's Country."

"On my own little place there are, today," he boasted in 1905, "at least forty million wild blossoms by calculation. Short of the wandering and unconventional foot-paths, which are almost choked with the urgent plant life beside them, you cannot step anywhere without trampling flowers—maybe ten to a step, as a minimum."

As architects began to take a greater interest in landscaping their sites, a fierce contemporary debate arose concerning the relative merits of the formal versus the natural garden. John Dando Sedding's *Garden Craft Old and New* (published posthumously in 1891) and Reginald Blomfield's *The Formal Garden in England* (1892) championed the case for the architect as overall garden designer, arguing for a return to first principles and the reintroduction of early seventeenth- and eighteenth-century architectural details such as sundials, fountains, and gazebos. Topiaries and trellised walks became a feature of Arts and Crafts gardens, and medieval flowers such as pinks and old roses became fashionable. Architects used

masonry and wisteria-covered pergolas to create outdoor rooms: Edwin Lutyens floored them simply with lawn, while E.S. Prior paved them with brick or stone. Prior rhapsodized in 1901 about providing "a sunny wall, a pleasant shade, a seat for rest, and all around the sense of the flowers, their brightness, their fragrance." Ponds and fountains became a feature. Plain oak and elm benches, terracotta flowerpots, and stone troughs were also frequently to be found on terraces that "settled" the house into its site and provided important social space for the taking of tea out of doors. The crevices in lovely old stone terrace walls could be crammed with rock plants such as gypsophila and cerastium, which would cascade down and soften the hard edges of retaining walls.

In 1901 three articles on "Garden-Making" written by E.S. Prior were published in *The Studio*. These included plans for the kind of modest "oblong garden" that corresponded to the reality of

Above: *The timber bridge designed by Philip Webb to link the library wing with the garden beyond the moat at Great Tangley Manor.*

the thin suburban plot owned by most middle-class householders. The rise of the middle class had seen a corresponding rise in hobby gardening, encouraged and supported by numerous periodicals carefully aimed at the lady amateur.

The architect Baillie Scott considered a well-designed garden to be "almost as important as a well-designed house.... We can hardly do better," he wrote, "than to try and reproduce some of the beauties of the old English gardens, with their terraces and courts and dusky yew hedges, which make such a splendid background to the bright colors of flowers." This was exactly what William Morris and his architect Philip Webb had sought to achieve at Red House, and later at Kelmscott Manor, where Morris created romantic gardens of topiary hedges, grass walks, and sweeping lawns, with wattled trellises for clambering roses and carefully preserved fruit trees.

Below: *Plants grown in the Conservatory at Standen included bougainvillea, oleander, and plumbago. Mimosa was another particular favorite with the Beales.*

Conservatories, which were associated with the artificial style of hothouse gardening, were rare in Arts and Crafts gardens, which promoted the idea of natural not forced abundance, although Standen in Sussex is a notable exception. James Beale commissioned the London garden designer G.B. Simpson to lay out the grounds surrounding the Standen site in 1890 before he had even commissioned his architect, Philip Webb. Beale's wife Margaret was a keen gardener and corresponded regularly with her Sussex neighbor William Robinson. Following the Arts and Crafts model as described by Herman Muthesius, her garden operated as an extension of the house and was divided into a series of "outdoor rooms, each of which contained and performs a separate function. Thus the garden extends the house into the midst of nature.... This means that the regularly laid out garden must not extend merely to one side of the house, but all the way round it, so that the house appears from all angles to rest on an adequate base." This effect was often achieved by terracing, if the site sloped, with parapets created by box hedging, which like that other Arts and Crafts favorite, yew, lent itself to topiary. For Muthesius, "the point about topiary work is its orderly architectonic form.... Clipped hedges are the walls by means of which the garden-designer delimits his areas. They also lend themselves to rhythmic repetition," establishing "certain points in the geometric composition of the garden. Topiary work is ... the

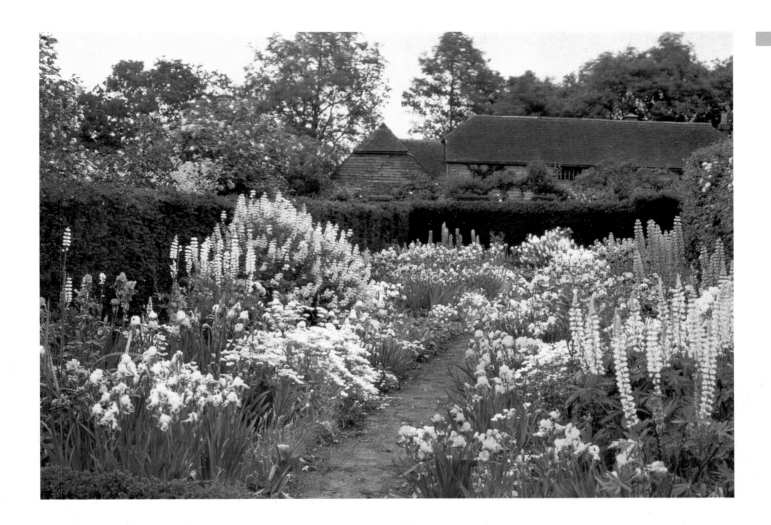

Above: *June borders of lupin and iris in the garden at Munstead Wood enlivened the pages of* Country Life *in 1912.*

indispensable means of establishing form." Needless to say William Robinson despised such "vegetable sculpture." "Nothing is more miserable for the gardener," he wrote, "or uglier in the landscape, than a garden laid out with clipped Yews."

Gertrude Jekyll was greatly influenced by William Robinson. For her the purpose of a garden was "to give delight and to give refreshment of mind, to soothe, to refine and to lift up the heart." She too abhorred Victorian formality. Born into a comfortably wealthy family, her idea of "a small garden," as set out in her *Gardens for Small Country Houses* (1912), was not perhaps one that a Garden Suburb dweller might recognize as he surveyed the view from his back windows. The elaborate scheme she includes for the "small" garden at Millmead in Bramley, Surrey, measuring 77ft across and 400ft in length, would have been hugely labor-intensive, but she did do much to encourage gardening, especially among children, and, with her artist's eye for color and form, lifted it to an art form. "When the eye is trained to perceive pictorial effect," she wrote in *Colour Schemes for the Flower Garden* (1908), "it is frequently struck by something—some combination of grouping, lighting, and colour—that is seen to have that complete aspect of unity and beauty that to the artist's

Above: *A profusion of plants growing out of the walls above the curved steps in the garden at Hestercombe.*

eye forms a picture. Such are the impressions that the artist-gardener endeavours to produce in every portion of the garden."

Gertrude Jekyll had trained at the South Kensington School of Art, knew William Morris and John Ruskin, and had it not been for failing eyesight she might have continued her career as an artist, embroiderer, and silverworker. Instead, after her father's death and upon her move to Surrey with her mother, she embarked on a new career, bringing her artistic training and knowledge of color theory to her rich but controlled planting schemes. She proved to be a phenomenally hard worker. Over the course of her career, she wrote over two thousand articles for periodicals, fifteen books (ten of them in the space of nine years), took and developed her own garden photographs, designed or advised on over one hundred and fifty gardens, and, when she found no flower vase suited her particular purpose, designed her own "Munstead glasses."

She is perhaps best known for her professional association with the architect Edwin Lutyens. Together they collaborated on some of the finest garden designs of their time for great houses including Deanery Garden and Folly Farm, both in Berkshire, and Hestercombe House, beautifully situated with wide views of the Vale of Taunton in Somerset. Lutyens provided the architectural shape and Jekyll the planting. The commission for Hestercombe came from Lord Portman, who gave the estate to his

Above: *The garden at The Deanery, Sonning, Berks, the house Edwin Lutyens designed for Edward Hudson, proprietor of* Country Life.

grandson, the Hon. E.W.B. Portman, as a wedding present. In 1903 Lord Portman invited Lutyens and Jekyll to make a garden on a new site, comprising three giant terraces, to the south of the house. Lutyens gave the garden a new architectural symmetry using pools, ponds, a pergola, an orangery, and a rotunda, the three entrances to which were planted with fragrant roses. As her eyesight began to fail, so Gertrude Jekyll's sense of smell became more acute and she liked to use fragrant plants such as rosemary and myrtle at entrances, so that people brushed against them as they passed. For the same reason, she planted lavender, catmint, and roses in the paved Dutch garden. In 1908 *Country Life* claimed the garden at Hestercombe proved "that an architect can be in unison with Nature, that a formal garden can form part of a landscape." At its peak between World Wars I and II, eighteen gardeners were employed to tend the garden, though it fell into serious neglect during World War II when the house was occupied by the US army. Serendipitously, Gertrude Jekyll's own handwritten planting plans were discovered pinned up in a potting shed in the 1970s and the garden has now been restored to its former glory thanks, in part, to a £200,000 grant from English Heritage.

The commission for The Deanery at Sonning in Berkshire came, like so many early Lutyens commissions, from a friend and near neighbor of Gertrude Jekyll's. Edward Hudson was the proprietor of *Country Life* and by publishing rapturous descriptions of their work in his magazine had

ensured a wide audience of further potential clients for the pair. The house and garden they created for Hudson has been called a masterpiece of understatement. Jekyll's naturalistic planting softens Lutyens' geometric precision, creating a charming peaceful garden on several levels. In particular, her habit of planting alpines and drought-tolerant plants on steps and in drystone walls created drifts of soft whites, pinks and purples against the soft gray of the walls, in which Lutyens would leave deliberate spaces for her skillful planting.

In 1897 C.F.A. Voysey was commissioned to design a house and garden by the publisher Sir Algernon Methuen in Haslemere, Surrey. New Place fits around the contours of a steeply sloping site with a garden arranged as a series of rooms, terraced to include a formal walled garden, a tennis lawn, a brick arcade covered over with *Azara microphylla*, and a bowling green, complete with thatched arbor to shelter the players awaiting their turn to play.

Voysey's talent was for devising and sculpting space. His horticultural instructions for the garden at New Place are sketchy to say the least. "Flowers big and tall," he indicated for one border on his garden plan. "More or less wild," he instructed elsewhere, although he did have strong views on color. Green he always recognized as the most soothing: "nature never allows her colors to quarrel," he said in a lecture published in *The Arts Connected with Building* (1909). "Her purple trees, with their gossamer of delicate spring green, dwell lovingly with the blue carpet of hyacinths. Harmony is everywhere." In 1904 Methuen, a keen gardener and an expert on alpines, invited Gertrude Jekyll to refine the planting and she added a rose garden, used pale mauve *Abutilon vitifolium* to complement Voysey's gray stone, and grouped white peonies with blue delphiniums in the borders. Green trellis was planted with hydrangeas, escallonias, *Robinia hispida*, *Sophora tetraptera*, and *Fremontodendron californicum*.

Voysey's contemporary, M.H. Baillie Scott, who also worked with Gertrude Jekyll, was, of all the Arts and Crafts architects, the one who gave most serious thought to the small suburban garden. He had always been concerned with the idea of creating a unity between the house and the garden. "One may note," he wrote in an article published in the *Builder's Journal* about Springcot, a holiday cottage and garden he created in 1903, "first of all the importance attached to vistas—vistas arranged with definite terminal effects. One may also observe the usefulness of shade in the garden as well as light, and how embowered paths may be contrasted with the brightness of open spaces." He organized these vistas on a criss-cross pattern. "In passing through these enclosed ways, one loses all conception of the garden's scheme till, at the intersection of a path, one suddenly perceives through vistas of roses and orchard trees some distant garden ornament, or perhaps a seat or a summer house: and so one becomes conscious of a scheme arranged and of well-considered effects. As in a dramatic entertainment, parts of the garden full of tragic shade are followed by open spaces where flowers laugh in the sun."

Above: *An illustration of M.H. Baillie Scott's Undershaw in Guildford.*

Baillie Scott collaborated on two schemes with Gertrude Jekyll and, like her, rebelled against the prevailing Victorian schemes for bedding out gaudy plants at regular intervals. He "composed" his plantings rather as an artist does a picture, relying on color and mass and a profusion of cottage garden flowers—delphiniums, daisies, lavender, hollyhocks, pinks, asters, campanulas, and clambering roses draped across pergolas and trellises. He blurred the distinctions between kitchen and formal gardens, proposing the "scarlet runner bean" as an alternative to red geraniums in a planting scheme and extolling the beauty of "the grey-green foliage and great thistle-like heads of the globe artichokes, the mimic forest of the asparagus bed, and the quaint inflorescence of the onion."

Baillie Scott's early training at the Royal Agricultural College at Cirencester gave him a practical approach to the subject and he took his inspiration from old cottage gardens, writing in his book *House and Gardens*: "Many old cottage gardens, which are to be seen in our villages, show the possibilities of homely beauty which belong to such a union of use and beauty in the garden, and such a garden, worked in the spare time of its owner with a rough and ready love which is his traditional inheritance, will be profitable as well as pleasant." He did not see the need to distinguish between pleasure gardens and kitchen gardens, rather he promoted the idea of uniting use and beauty, responding to nature rather than "striving to mold her to an artificial ideal."

For Baillie Scott the purpose of a small garden was "to grow fruit and vegetables for the household, and also to provide outdoor apartments for the use of the family in fine weather."

Above: *The Well Court at Snowshill Manor takes its name from the central feature, an ancient Venetian well-head. Wade designed the garden as a series of separate courts, sunny ones contrasting with shady ones and different courts for varying moods. "The plan of the garden," he stated, "is much more important than the flowers in it. Walls, steps, and alley ways give a permanent setting, so that it is pleasant and orderly in both summer and winter."*

Larger plots, however, were a different matter. Here he allowed lawns for tennis, croquet, or bowls, took in orchards, and made a kitchen garden, separate rose and flower gardens, all connected by straight paths with perhaps a pergola.

One such garden is to be found in Gloucestershire. The garden at Snowshill Manor was created by Baillie Scott for the architect and collector Charles Paget Wade in 1920. Wade wanted his garden to be an extension of the house, and had architectural rather than horticultural priorities. "A delightful garden can be made in which flowers play a very small part," he asserted, "by using effects of light and shade, vistas, steps to changing levels, terraces, walls, fountains, running water, an old well head or a statue in the right place."

Baillie Scott's true interests lay in smaller country houses, however, and it was natural that he should become increasingly involved in the Garden City movement, designing cottages at Letchworth and houses and gardens for Hampstead Garden Suburb, the brainchild of Henrietta Barnett. It was essential to her that each house in the Suburb should have its own plot of land and that horticulture should be energetically practiced. She herself always "felt perfectly happy when her Canon [her husband Canon Samuel Barnett] was occupied taking plantains out of the lawn."

Summarizing her aims for the Suburb in an article in *Contemporary Review*, she concluded that "each house be surrounded by its own garden and that there be agencies for fostering interest in gardens and allotments and for the co-operative lending of tools." It pleased her enormously that one of the first of many clubs set up within the Suburb was a horticultural society, formed in May 1909. It used the newly built Hampstead Garden Suburb Institute as its headquarters and flourishes still.

Another notable Arts and Crafts garden is to be found at Rodmarton Manor, near Cirencester, built over twenty years from 1909 for the Hon. Claud Biddulph by Ernest Barnsley, "using only local materials and without any kind of mechanical assistance," in defiance of industrialization. Barnsley

Below: *A view of Rodmarton Manor as seen from the White Borders. Work commenced on the garden as the house was being built and, over the years, was subject to alteration and redesign by Margaret Biddulph.*

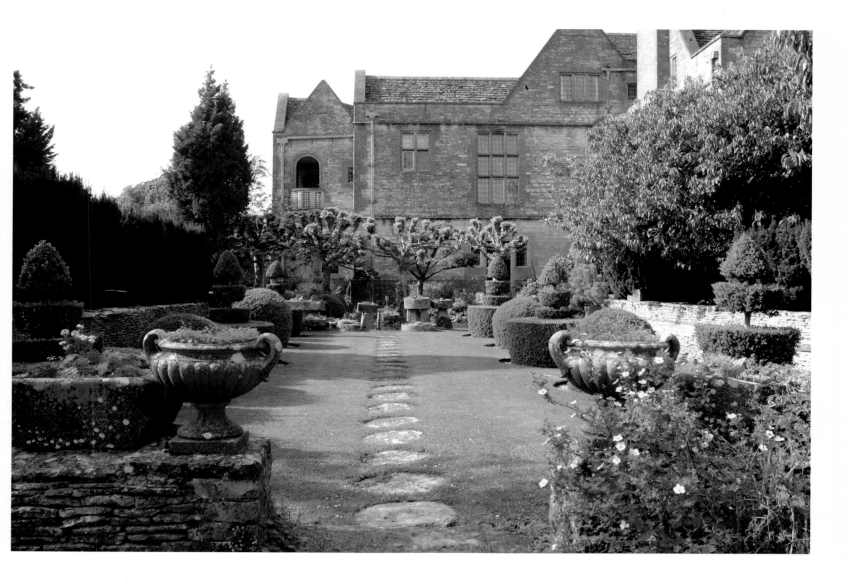

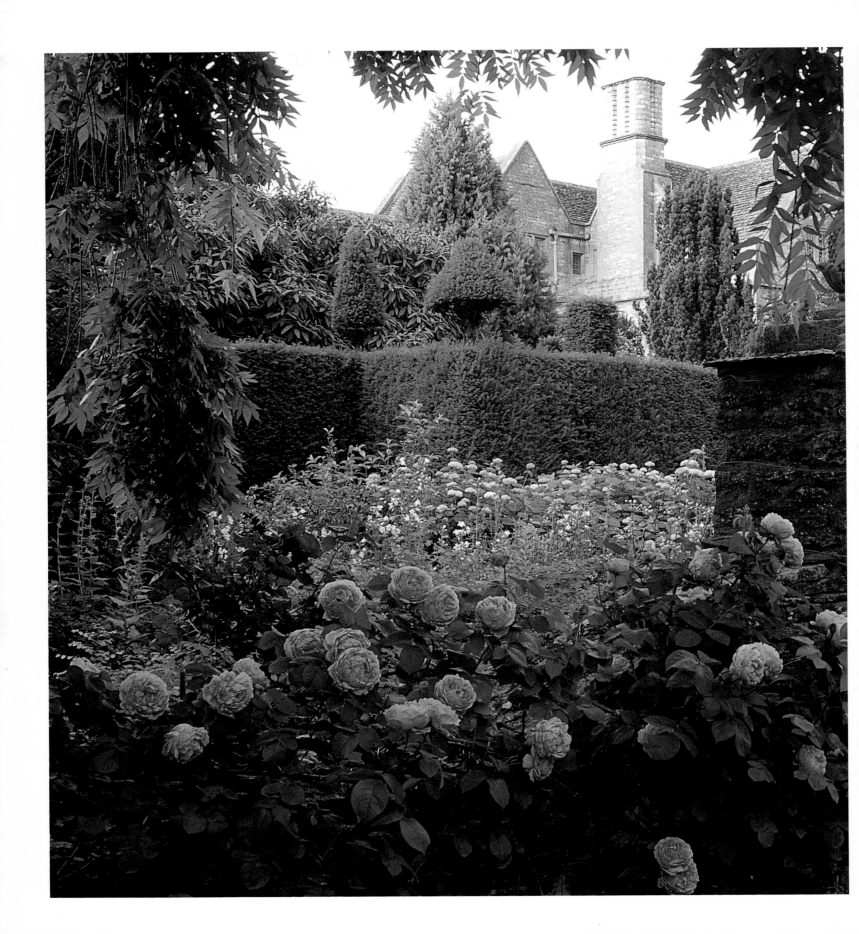

designed the garden—almost eight acres in all—in collaboration with William Scrubey, the head gardener, and his client's wife Margaret Biddulph, a trained horticulturalist, as a sequence of outdoor rooms, made intimate and secret by long straight walls, tall yew hedges, and screens of pleached limes. The design provided a crisp contrast between the soft informality of the Winter Garden and the architectural shapes of the Topiary Lawn and delightful surprises as concealed areas opened up to view, including the Long Garden with its picturesque summerhouse and secluded stone benches from which visitors could admire the four long herbaceous beds planted with asters, roses, phlox, sedum, and daylilies. Adjacent to this an enormous walled kitchen garden, originally lined with espaliered fruit trees, enclosed vegetable and flower beds. The lovely stone front of the house was planted with climbing roses, clematis, and wisteria. In 1931 *Country Life* described the newly completed house and garden as almost "a village in itself…. In fact, the whole place bears an astonishing testimony to the life and vigor which Mr. and Mrs. Biddulph have given to a tiny village by their enthusiastic encouragement of the arts and crafts."

Gertrude Jekyll designed three gardens for American clients who visited her at Munstead and asked her to provide plans to suit their different plots and needs. The first, for Mr. and Mrs. Glendinning B. Groesbeck in Perintown, Cincinnati (1914), is sited on a steeply sloping valley and takes its inspiration from Italy. Edward Hudson brought the second pair of American clients to Munstead in 1924: Mr. and Mrs. Stanley Resor traveled each summer and wanted a garden for their "Cotswold Cottage" in Greenwich, Connecticut, that they could enjoy in the spring and on their return in the fall. Finally, Miss Annie Burr Jennings sought Gertrude Jekyll out in 1926 and asked her to provide plans for an old-fashioned garden to surround the Old Glebe House garden in Woodbury, Connecticut. Jekyll designed borders of hollyhocks, dahlias, antirrhinums, irises, and peonies.

Far from the cozy cottage profusion of England, however, American Arts and Crafts architects and garden designers, considered and were inspired by the natural world on their doorstep. They incorporated indigenous plants like cacti, and planted native species such as California poppies, California wild oats, and Spanish lily, seeking to create a specifically American garden style. In his *Craftsman Houses* (1913) Gustav Stickley explored the universal need for a garden, writing, "In practically all of us is a deep, distinctive longing to possess a little corner of that green Eden from which our modern and materialistic ways of living have made us exiles."

Frank Lloyd Wright's interest in the overall relationship between the house and its landscape naturally extended to the garden, which he sought to include in his overall view of "organic" architecture and make into a working part of the house. "Let your home appear to grow easily from its site," he said in a public lecture delivered in 1894, "and shape it to sympathize with the surroundings if Nature is manifest there, and if not, try and be as quiet, substantial, and organic as

Far Left: *The garden at Rodmarton, looking toward the house from the Cherry Orchard.*

she would have been if she had the chance." He put these ideas into practice most dramatically at Fallingwater in Pennsylvania (1935–9), where the house juts out over a natural waterfall on Bear Run, mature trees grow through the building and a huge bedrock boulder breaks through the floor of the main room just in front of the hearth. In earlier projects, such as the Robie house in Chicago (1906), and the Avery Coonley house in Riverside, Illinois (1906–9), Wright made the garden a working part of the house. In the Robie house, the children's playroom and the billiard room open directly onto a compact sunken garden court, while the garden enfolds and surrounds the Avery Coonley house. Wright wanted to dissolve the distinctions between outside and in, and he did this with entire walls composed of glazed screens. Living rooms—and even bedrooms—opened onto verandas and terraces, landscaped with simple troughs and urns, cement-rendered to echo the building.

Below: *The Greenes were particularly concerned to place their houses within the landscape. The Japanese influence is evident in the garden of the Gamble House.*

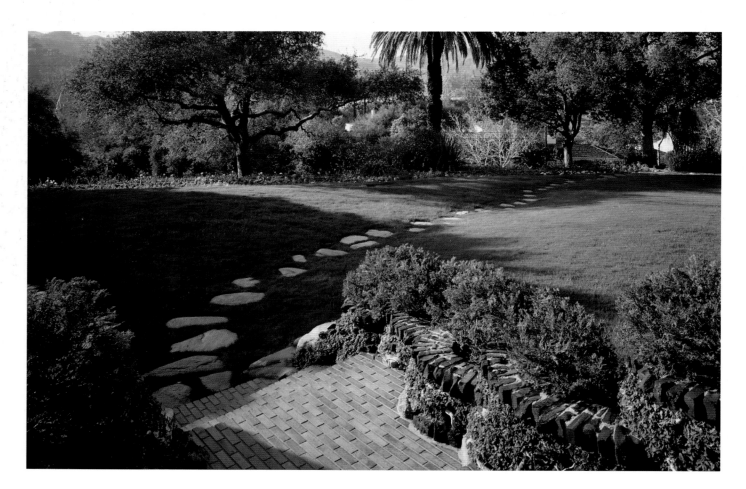

Oriental gardens were an important source of inspiration for Charles and Henry Greene, who used stepping stones and quiet pools, delicate lanterns, and formal tubs as motifs in the garden of the Gamble House (1907–8). Inside, the natural imagery is signaled in the richly colored "Tree of Life" art-glass panel that fills the massive front door, and echoes of the real vines outside resonate in the stylized depiction in the stained glass windows. The Greenes were always concerned to place their buildings sympathetically within the landscape and to incorporate existing trees in the overall design. They used the garden to link the house to the site, anchoring their low-built bungalows with vine-covered pergolas and connecting the outside and in with trellised gateways or loggias and curving Japanese paths. Inspired by the American novelist Edith Wharton's *Italian Villas and Their Gardens* (1904) they created an Italianate water garden in the garden of the Cordelia A. Culbertson house, built in Pasadena in 1911, and Charles laid out the formal gardens of the Fleishhacker family estate in Woodside with a Roman pond and water garden in 1920.

Edith Wharton's book enjoyed huge success in the USA, as did Louise Beebe Wilder's highly influential *Color in my Garden* (1918). Written in a lyrical style, it appealed to the pioneering spirit of Americans. "Much of my youthful life," she wrote, "was spent in old gardens, blossomy inclosures with generations of bloom and sweetness behind them, eloquent of long years of happy human occupancy; and no one is more alive to their charm than I; but during the past twenty years it has fallen to my lot to make three gardens on wholly unimproved ground, and I am ready to testify that there is a deal to be said for a new garden—at least from the standpoint of the owner. It is the fair page, the fresh canvas—opportunity. It affords scope for the age-old joy of creating something—beauty we hope—out of raw materials and the stuff of our dreams."

Above: *Black and white photograph of Villa Marcault from* American Gardens, *1902.*

SOURCE BOOK

UNITED KINGDOM

BIRMINGHAM

Birmingham Museum and Art Gallery
Chamberlain Square
Birmingham, B3 3DH
Tel: +44 (0)121 303 2834
Fax: +44 (0)121 303 1394
www.bmag.org.uk
Open: Monday to Thursday and Saturday
10–5, Friday 10–5, Sunday 12.30–5
Houses some fine examples of Arts and Crafts art and artifacts.

CUMBRIA

Blackwell the Arts and Crafts House
Bowness-on-Windermere
Cumbria, LA23 3JR
Tel: +44 (0)1539 446139
Fax: +44 (0)1539 488486
www.blackwell.org.uk
Open: Seven days a week 10–5, February
to December
Built by M.H. Baillie Scott (1897–1900); recently restored and now open to the public.

Brantwood
Coniston, Cumbria, LA21 8AD
Tel: +44 (0)1539 441396
Fax: +44 (0)1539 441263
www.brantwood.org.uk
Open: Daily 11–5.30, all year round
Important as the "lakeland landscape" garden of John Ruskin (1872–1900).

DEVON

The Barn
Fox Holes Hill, Exmouth
Devon, EX8 2DF
Tel: +44 (0)1395 224411
Fax: +44 (0)1395 225445
Built by Edward Prior (1897), this is now a country house hotel.

GLOUCESTERSHIRE

The Cheltenham Art Gallery and Museum
Clarence Street, Cheltenham
Gloucestershire, GL50 3JT
Tel: +44 (0)1242 237431
Fax: +44 (0)1242 262334
www.cheltenhammuseum.org.uk
Open: Monday to Saturday 10–5, Sunday
2–4, all year round
Has a gallery devoted to Arts and Crafts furniture and holds regular events featuring William Morris and others.

The Guild of Handicrafts Trust
The Silk Mill, Sheep Street
Chipping Campden, Gloucestershire
Tel: +44 (0)1386 841100
Founded by C.R. Ashbee, having its headquarters in the Silk Mill from 1902 to 1908.

Kelmscott Manor
Kelmscott, Lechlade
Gloucestershire, GL7 3HJ
Tel: +44 (0)1367 252486
Fax: +44 (0)1367 253754
www.kelmscottmanor.co.uk
Open: Wednesdays 11–5 and third Saturday
in each month 2–5, April to September
Country home and beautiful garden of William Morris (1871–96), now owned by the Society of Antiquaries.

Owlpen Manor
Uley, Nr Dursley
Gloucestershire, GL11 5BZ
Tel: +44 (0)1453 860261
Fax: +44 (0)1453 860819
www.owlpen.com
Open: Daily (except Mondays) 2–5, April
to September
Tudor manor restored by Norman Jewson in 1926 housing important Arts and Crafts collections.

Rodmarton Manor
Cirencester
Gloucestershire, GL7 6PF
Tel: +44 (0)1285 841253
Fax: +44 (0)1285 841298
www.rodmarton-manor.co.uk
Open: Wednesday, Saturday and Bank
Holiday Mondays 2–5, May to August
Built by Ernest Barnsley and his Cotswold group of craftsmen (1909 onward).

HEREFORDSHIRE

All Saints Church
Brockhampton, Near Fownhope
Herefordshire, HR1 4PS
Open: Daily 9–5
W.R. Lethaby's architectural masterpiece.

HERTFORDSHIRE

The Garden City Museum
296 Norton Way South, Letchworth
Hertfordshire, SG6 1SU
Tel: +44 (0)1462 482710
Fax: +44 (0)1462 486056
Open: Monday to Saturday 10–5
Once the medieval Hall House designed and built for himself by Barry Parker and now the Garden City Museum.

KENT

Great Maytham Hall
Rolvenden, Cranbrook
Kent, TN17 4NE
Tel: +44 (0)1580 241346
Fax: +44 (0)1580 241038
Open: Wednesday and Thursday 2–5, May to
September. *Designed by Sir Edwin Lutyens (1910).
This was the house and garden that inspired
Frances Hodgson Burnett's* The Secret Garden.

Red House
Red House Lane, Bexleyheath
Kent, DA6 8JF
Tel: +44 (0)20 8304 9878
www.nationaltrust.org.uk
Open: Wednesday, Thursday, Friday, Saturday
and Sunday 1 March to 21 December.
Admission by booked guided tour with
limited free flow entry after 3.30pm. *Designed
by Morris and the architect Philip Webb (1859);
acquired by The National Trust in 2003.*

LONDON

Geffrye Museum
Kingsland Road London, E2 8EA
Tel: +44 (0)20 7739 9893
www.geffrye-museum.org.uk
*Room interiors showing English domestic
styles from 1600 to the present day.*

Kelmscott House
26 Upper Mall, Hammersmith
London, W6 9TA
Tel: +44 (0)20 8741 3735
Fax: +44 (0)20 8748 5207
www.morrissociety.org/kelmscott_house.html
Open: Basement only Thursday and Saturday
2–5. *Morris's home (1878–96) and now
headquarters of the William Morris Society.*

Holy Trinity Church
Sloane Street, Chelsea
London, SW1X 1DF
Tel: +44 (0)20 7730 7270
Fax: +44 (0)20 7730 9287
www.holytrinitysloanestreet.org
*Richly decorated with stained glass by Edward
Burne-Jones, William Morris and Christopher
Whall, and examples of arts and crafts
metalwork, sculpture, and other elaborate
decorative details.*

Victoria and Albert Museum
Cromwell Road, South Kensington
London, SW7 2RL
Tel: +44 (0)20 7942 2000
www.vam.ac.uk
Open: Daily 10–5, Wednesdays and the
last Friday of the month 10–10
*Holds important examples of the work of
William Morris, Edward Burne-Jones and
leading members of the Arts and Crafts
movement. See especially the Green Dining
Room and the recreated rooms in the new
English Galleries.*

William Morris Gallery
Water House, Lloyd Park, Forest Road
London, E17 4PP
Tel: +44 (0)20 8527 3782
Fax: +44 (0)20 8527 7070
www.lbwf.gov.uk/wmg/home.htm
Open: Tuesday to Saturday 10–5 and the
first Sunday in the month 10–12
*Morris's home (1848–56), now housing some
stunning collections illustrating Morris's life
and work.*

Bedford Park Chiswick, *and* Hampstead Garden
Suburb *are both worth strolling around.*

NORTHUMBERLAND

Cragside
Rothbury, Morpeth
Northumberland, NE65 7PX
Tel: +44 (0)1669 620150
Fax: +44 (0)1669 620066
Open: Daily (except Mondays), April
to October
*Built by Richard Norman Shaw (1864–95),
now managed by the National Trust.*

Lindisfarne Castle
Holy Island, Berwick-upon-Tweed
Northumberland, TD15 2SH
Tel: +44 (0)1289 389244
Fax: +44 (0)1289 389349
Open: Saturday to Thursday, March
to November
*Restoration and conversion by Sir Edwin
Lutyens (1903); now managed by the
National Trust.*

SOMERSET

Hestercombe Gardens
Cheddon Fitzpaine, Nr Taunton
Somerset, TA2 8LG
Tel: +44 (0)1823 413923
Fax: +44 (0)1823 413747
www.hestercombegardens.com
Open: Daily 10–6 (excluding Christmas)
*Jekyll and Lutyens' finest surviving garden,
recently restored.*

SUNDERLAND

Church of St Andrew
Roker, Co Durham
*Arts and Crafts masterpiece built by E.S. Prior
(1906–07), with choir stalls and paneling by
Ernest Gimson, tapestry reredos by Edward
Burne-Jones.*

SURREY

Goddards
Abinger Lane, Abinger Common
Dorking, Surrey
Tel: +44 (0)1628 825925
Open: Wednesday afternoons by appointment only, April to October
Built by Sir Edwin Lutyens (1898–99); available for rental through the Landmark Trust.

Munstead Wood
Heath Lane, Busbridge
Godalming, Surrey
Open: Gardens (from which exterior views of the house can be seen) 2–6, at the end of April, May, June
Lutyens' first important architectural commission, designed for its owner Gertrude Jekyll, who created the gardens, open occasionally as part of the National Gardens Scheme.

SUSSEX

Ditchling Museum
Church Lane, Ditchling
Sussex, BN6 8TB
Tel: +44 (0)1273 844744
www.ditchling-museum.com
Open: Tuesday to Saturday 10.30–5, Sunday 2-5, mid-February to mid-December
Small museum with a good Arts and Crafts display, especially related to Edward Johnson, Eric Gill, and the Ditchling community, lighting and furniture by Brangwyn.

Gravetye Manor
East Grinstead
Sussex, RH19 4LJ
Tel: +44 (0)1342 810567
Fax: +44 (0)1342 810080
www.gravetyemanor.co.uk

House once owned by William Robsinson, pioneer of the natural garden, where many of his ideas were realized. Now a "Relais et Chateaux" country house hotel.

Great Dixter
Northiam, Rye
East Sussex, TN31 6PH
Tel: +44 (0)1797 252878
Fax: +44 (0)1797 252879
www.greatdixter.co.uk
Open: Tuesday to Sunday 2–5 all year round
The family home of Christopher Lloyd, with additions by Sir Edwin Lutyens (1910).

Little Thakeham
Merrywood Lane, Storrington
West Sussex
Tel: +44 (0)1903 744416
Designed by Sir Edwin Lutyens (1902); now a country house hotel.

Standen
West Hoathly Road, East Grinstead
Sussex, RH19 4NE
Tel: +44 (0)1342 323029
Fax: +44 (0)1342 316424
Open: Wednesday to Sunday and Bank Holiday Mondays 11–5, March to November
Designed by Philip Webb (1891) and decorated throughout with Morris carpets, fabrics and wallpapers; now owned by the National Trust. For details of the holiday flat ring +44 (0)1225 791199.

WEST MIDLANDS

Wightwick Manor
Wightwick Bank, Wolverhampton
West Midlands, WV6 8EE

Tel: +44 (0)1902 761108
Fax: +44 (0)1902 764663
Open: Thursday and Saturday 1.30–5, March to December
Built by Edward Ould (1887–93), with Morris & Co. interiors; now owned by the National Trust.

SCOTLAND

EAST LOTHIAN

Greywalls
Muirfield, Gullane, East Lothian, EH31 2EF
Tel: +44 (0)1620 842144
Fax: +44 (0)1620 842241
www.greywalls.co.uk
Designed by Sir Edwin Lutyens (1901); now a country house hotel.

FIFE

Earlshall Castle
Leuchars, Fife
Tel: +44 (0)1334 839205
Restoration by Sir Robert Lorimer (1892) of this sixteenth-century building and gardens; now privately owned.

GLASGOW

Glasgow School of Art
167 Renfrew Street, Glasgow, G3 6RQ
Tel: +44 (0)141 332 0521
Charles Rennie Mackintosh's masterwork.

The Hill House
Upper Colquhoun Street, Helensburgh
Glasgow, G84 9AJ
Tel: +44 (0)1436 673900
Fax: +44 (0)1436 674685
www.nts.org.uk

Open: Daily I.30–5.30, April to October
Designed by Charles Rennie Mackintosh (1902); now owned by the National Trust for Scotland.

The Hunterian Museum
University of Glasgow, Glasgow, G12 8QQ
Tel: +44 (0)141 330 4221
Fax: +44 (0)141 330 3617
www.hunterian.gla.ac.uk
Open: Monday to Saturday 9.30–5
Housing the largest single collection of works by Charles Rennie Mackintosh, including drawings, designs, furniture, and decorative art.

Charles Rennie Mackintosh Society
Queen's Cross Church,
870 Garscube Road, Glasgow G20 7EL
Tel: +44 (0)141 946 6600
Fax: +44 (0)141 945 2321
www.crmsociety.com

The Willow Tea Rooms
217 Sauchiehall Street, Glasgow, G2 3EX
Tel/Fax: +44 (0)141 332 0521
www.willowtearooms.co.uk
Open: Monday to Saturday 9–5, Sunday 12–4, all year round
Designed in 1904 by Charles Rennie Mackintosh, in every detail, from exterior and interoir down to furniture and teaspoons; restored in 1996 and re-opened as tearooms.
Also at:
97 Buchanan Street, Glasgow, G1 3HF
Tel/Fax: +44 (0)141 204 5242
Recreation of Mackintosh's White Dining Room and Chinese Room.

ORKNEY
Melsetter
Isle of Hoy, Orkney, KW16 3M2

Tel: +44 (0)1856 791352
Open: Private visits by arrangement only Thursday, Saturday, and Sunday
Built by W.R. Lethaby (1898) and boasting one of the oldest gardens in Orkney.

UNITED STATES OF AMERICA

ARIZONA
Frank Lloyd Wright Foundation
PO Box 4430
Scottsdale, AZ 85261-4430
Tel: +1 480 860 2700
Fax: +1 480 391 4009
www.franklloydwright.org
For information on houses designed by Wright open to the public, state by state.

CALIFORNIA
The Gamble House
4 Westmoreland Place,
Pasadena, CA 91103
Tel: +1 626 793 3334
www.gamblehouse.org
Open: Thursday to Sunday for guided tours
The only Greene and Greene house (built 1909) regularly open to the public.

Los Angeles County Museum of Art
5905 Wiltshire Boulevard
Los Angeles, CA 90036
Tel: +1 323 857 6000
www.lacma.org
One of the largest displays of Arts and Crafts objects, housing a particularly fine exhibition of Greene and Greene furniture.

Marston House
3525 Seventh Avenue, Balboa Park
San Diego, CA
Tel: +1 619 298 3142
Open: Friday to Sunday 10–4.30
Designed by architect Irving Gill (1905) and furnished in the style of American Arts and Crafts.

Mission Inn
3649 Mission Inn Avenue
Riverside, CA 92501
Tel: +1 909 784 0300
www.missioninn.com
Demonstrates the Spanish mode of the Arts and Crafts style.

CONNECTICUT
Mark Twain House
351 Farmington Avenue
Hartford, CT 06051
Tel: +1 860 247 0998
Fax: +1 860 278 8148
www.marktwainhouse.org
Former home of the writer Mark Twain, decorated by Associated Artists, including work by Louis Comfort Tiffany and Candace Wheeler.

DELAWARE
Delaware Art Museum
2301 Kentmere Parkway
Wilmington, DE 19806
Tel: +1 303 571 9590
www.delart.org
Open: Tuesday to Friday 10–4, Saturday 10–5, Sunday 1–5
Housing collections of British Arts and Crafts, including some Morris chairs.

FLORIDA

Morse Museum of American Art
445 North Park Avenue, Winter Park
Florida, FA 32789
Tel: +1 407 645 5311
www.morsemuseum.org
Open: Tuesday to Saturday 9.30–4, Sunday
1–4, all year round
*Contains the most comprehensive collection
of pieces by Louis Comfort Tiffany anywhere
in the world.*

ILLINOIS

Crabtree Farm
PO Box 218
Lake Bluff, IL 60044
Tel: +1 312 391 8565
*Museum and conference center with Stickley
furniture and Stickley-infuenced decorative
scheme. American and British Arts and Crafts
movement collection.*

Dana-Thomas House Foundation
300 East Lawrence Avenue
Springfield, IL 62702
Tel: +1 217 782 6776
www.dana-thomas.org
Open: Wednesday to Sunday 9–4
*Designed by Frank Lloyd Wright in 1902 for
Susan Lawrence Dana; contains the largest
collection of site-specific, original Wright art
glass and furniture. Now restored and managed
by Illinois State Historic Preservation Agency.*

Frank Lloyd Wright Home and Studio
951 Chicago Avenue
Oak Park, IL 60302
Tel: +1 708 848 1978
www.wrightplus.org/homestudio
Open: Daily 9–5
*Designed by Frank Lloyd Wright (1889–98)
and demonstrating his representations of the
Arts and Crafts ideals.*

Glessner House
1800 South Prairie Avenue
Chicago, IL 60616
Tel: +1 312 326 1480
Fax: +1 312 326 1397
www.glessnerhouse.org
Open: Wednesday to Sunday with three
tours daily
*Built by H.H. Richardson (1887) and reflecting
the William Morris style in the bedroom.*

Robie House
5757 Woodrow Avenue, Chicago, IL 60637
Tel: +1 312 702 8374
*Designed by Frank Lloyd Wright for Frederick C.
Robie; now run by the university administration.*

NEW JERSEY

Craftsman Farms
2352 Route 10 West, Manor Lane
Parsippany-Troy Hills, NJ 07950
Tel: +1 973 540 1165
Fax: +1 973 540 1167
www.stickleymuseum.org
Open: Wednesday to Sunday by
appointment only, April to November
*Created by Gustav Stickley (1911). The log
home built by Stickley that acted as the heart
of the crafts community and remains one of
the most significant landmarks of the
American Arts and Crafts movement.*

NEW YORK

Byrdcliffe Arts and Crafts Colony
The Woodstock Guild, 34 Tinker Street
Woodstock, NY 12498
Tel: +1 845 679 2079
Fax: +1 845 679 4529
www.woodstockguild.org
*America's oldest continuing art colony,
founded by Ralph Whitehead in 1903.*

Metropolitan Museum of Art
Fifth Avenue, New York, NY 10028
Tel: +1 212 879 5500
www.metmuseum.org
Open: Tuesday to Thursday, Sunday
9.30–5.30, Friday and Saturday 9.30–9
*Containing a Frank Lloyd Wright room and
fine examples of American and European
Arts and Crafts pieces.*

Roycroft Community
Main and South Grove Streets
East Aurora, NY 14052
Tel: +1 716 655 0571
*Established by Elbert Hubbard (1894) as his
own craft community based on William
Morris's Kelmscott; the fourteen remaining
buildings contain many original artefacts.*

Stickley Museum
300 Orchard Street
Fayetteville, NY 13104
Tel: +1 315 682 5500
Open: Tuesdays
*Stickley's former factory, now home to some
fine examples of period furniture.*

NORTH CAROLINA

Grove Park Inn
290 Macon Avenue
Asheville, NC 28804
Tel: +1 800 438 5800
*The Arts and Crafts ideal from exterior to
Mission furnishings, now a resort home.*

BIBLIOGRAPHY

Anscombe, Isabelle and Charlotte Gere, *Arts & Crafts in Britain and America*, Academy Editions, 1978

Anscombe, Isabelle, *Arts and Crafts Style*, Phaidon Press, 1991

Arts and Crafts Essays by members of the Arts and Crafts Exhibition Society, with a Preface by William Morris, Longmans Green and Co., 1899

Ashbee, C.R., *A Book of Cottages and Little Houses*, Batsford, 1906

Ashbee, C.R., *Modern English Silverwork*, Essex House Press, 1909

Ashbee, C.R., *The Guild of Handicraft*, Essex House Press, 1909

Aslin, Elizabeth, *Nineteenth Century English Furniture*, Faber & Faber, 1962

Backemeyer, Sylvia, *W.R. Lethaby 1857–1931*, Lund Humphries, 1984

Benson W.A.S., *Elements of Handicraft and Design*, London, 1893

Bisgrove, Richard, *The Gardens of Gertrude Jekyll*, Frances Lincoln, 1992

Blomfield, Reginald, *The Formal Garden In England*, Macmillan, 1892

Blomfield, Reginald, *Memoirs of an Architect*, Macmillan, 1932

Boris, Eileen, *Art and Labor, Ruskin, Morris and the Craftsman Ideal in America*, Temple University Press, 1986

Bowe, Nicola Gordon and Elizabeth Cumming, *The Arts and Crafts Movements in Dublin & Edinburgh, 1885–1925*, Irish Academic Press, 1998

Bowman, Leslie Greene, *American Arts & Crafts Virtue in Design*, Los Angeles County Museum of Art in association with Little, Brown and Co., 1990

Brandon-Jones, John, *C.F.A. Voysey: Architect and Designer 1857–1941*, Lund Humphries, 1978

Brooks, H. Allen, *The Prairie School: Frank Lloyd Wright and his Midwest Contemporaries*, University of Toronto Press, 1972

Buchanan, William (ed.), *Mackintosh's Masterwork the Glasgow School of Art*, Richard Drew Publishing, 1989

Burchard, John E. and Albert Bush-Brown, *The Architecture of America: A Social and Cultural History*, Victor Gollancz, 1967

Burne-Jones, Georgiana, *Memorials of Edward Burne-Jones* (2 vols), Macmillan, 1904

Calloway, Stephen, *The House of Liberty, Masters of Style & Decoration*, Thames and Hudson, 1992

Campbell, Joan, *The German Werkbund, The Politics of Reform in the Applied Arts*, Princeton University Press, 1978

Carruthers, Annette and Mary Greensted, *Good Citizen's Furniture, The Arts and Crafts Collections at Cheltenham*, Cheltenham Art Gallery and Museums in association with Lund Humphries, 1994

Carruthers, Annette, *Ernest Gimson and the Cotswold Group of Craftsmen*, Leicestershire Arts, Museums and Records Service, 1978

Clark, Robert Judson, *The Arts and Crafts Movement in America 1876–1916*, Princeton University Press, 1972

Cobden-Sanderson, T.J., *The Arts and Crafts Movement*, Hammersmith Publishing Society, 1905

Comino, Mary, *Gimson and the Barnsleys 'Wonderful furniture of a commonplace kind'*, Evans Brothers Limited, 1980

Cook, E.T. and A. Wedderburn (ed.), *The Complete Works of John Ruskin* (39 vols), George Allen, 1903–12

Crane, Walter, *The Bases of Design*, G. Bell & Sons, 1898

Crawford, Alan (ed.), *By Hammer and Hand, The Arts and Crafts Movement in Birmingham*, Birmingham Museums and Art Gallery, 1984

Cross, A.J., *Pilkington's Royal Lancastrian Pottery and Tiles*, Richard Dennis Publications, 1980

Cumming, Elizabeth and Wendy Kaplan, *The Arts and Crafts Movement*, Thames and Hudson, 1991

Davey, Peter, *Arts and Crafts Architecture*, Phaidon Press, 1995

Davison, T. Raffles, *Port Sunlight,: A Record of Its Artistic & Pictorial Aspect*, Batsford, 1916

Dawber, G., *Old Cottages, Farmhouses and other Stone Buildings of the Cotswold Region*, Batsford, 1905

Day, Lewis F., *Nature and Ornament*, Batsford, 1909

Dresser, Chrsitopher, *Principles of Decorative Design*, Cassell, Petter & Galpin, 1873

Eastlake, Sir Charles, *Hints on Household Taste*, London, 1865

Gere, Charlotte and Geoffrey C. Munn, *Artists' Jewellery, Pre-Raphaelite to Arts and Crafts*, Antique Collectors' Club, 1989

Gere, Charlotte and Michael Whiteway, *Nineteenth Century Design From Pugin to Mackintosh*, Weidenfeld & Nicolson, 1993

Grafton Green, Bridget, *Hampstead Garden Suburb 1907–1977 A History*, Hampstead Garden Suburb Residents Association, 1977

Greensted, Mary, *The Arts and Crafts Movement in the Cotswolds*, Alan Sutton, 1993

Greenwood, Martin, *The Designs of William De Morgan*, Richard Dennis Publications, 1989

Haigh, Diane, *Baillie Scott, the Artistic House*, Academy Editions, 1995

Halen, Widar, *Christopher Dresser*, Phaidon Press, 1990

Harrison, Martin, and Bill Waters, *Burne-Jones*, Barrie and Jenkins, 1973

Harrod, Tanya, *The Crafts in Britain in the 20th Century*, Yale University Press, 1999

Haslam, Malcolm, *The Martin Brothers, Potters*, Richard Dennis Publications, 1978

Heal's Catalogue 1853–1934, Middle Class Furnishings, David and Charles, 1972

Henderson, Philip, *The Letters of William Morris to his Family and Friends*, Longmans Green & Co., 1950

Hitchmough, Wendy, *C.F.A. Voysey*, Phaidon Press, 1995

Hitchmough, Wendy, *Arts and Crafts Gardens*, Pavilion, 1997

Hollamby, Edward, *Red House*, Architecture Design and Technology Press, 1991

Howard, Constance, *Twentieth-Century Embroidery in Great Britain to 1939*, Batsford, 1981

Inskip, Peter, *Edwin Lutyens*, Academy Editions, 1986

Jackson, Lesley (ed.), *Whitefriars Glass, The Art of James Powell & Sons*, Richard Dennis Publications, 1996

Jeffrey, Michael, *Christie's Arts and Crafts Style*, Pavilion, 2001

Jekyll, Gertrude with Lawrence Weaver, *Gardens for Small Country Houses*, Country Life Limited, 1912

Jekyll, Gertrude, *Wood and Garden*, Longmans, Green & Co., 1899

Jones, Owen, *The Grammar of Ornament*, Day & Son, 1856

Kelmscott Manor: An Illustrated Guide, Society of Antiquaries of London, 1996

Koch, Robert, *Louis C. Tiffany, Rebel in Glass*, Crown Publishers, 1964

Kornwolf, James D., *M.H. Baillie Scott and the Arts and Crafts Movement*, The John Hopkins Press, 1972

Kuzmanovic, Natasha, *John Paul Cooper, Designer and Craftsman of the Arts and Crafts Movement*, Sutton Publishing, 1999

Lester, Alfred W., *Hampstead Garden Suburb: The Care and Appreciation of its Architectural Heritage*, with a foreword by Sir Nikolaus Pevsner, HGS Design Study Group, 1977

Lethaby, William R., *Philip Webb and his Work*, Oxford University Press, 1935

Lethaby, William R., A.H. Powell and F.L. Griggs, *Ernest Gimson, His Work and Life*, Shakespeare Head Press, 1924

Lind, Carla, *The Wright Style: The Interiors of Frank Lloyd Wright*, Thames and Hudson, 1992

Lind, Carla, *Frank Lloyd Wright's Life and Homes*, Archetype Press Book, 1994

Lubbock, P. (ed.), *Letters of Henry James*, London, 1920

MacCarthy, Fiona, *The Simple Life: C.R. Ashbee in the Cotswolds*, Lund Humphries, 1981

MacCarthy, Fiona, *Eric Gill*, Faber & Faber, 1989

MacCarthy, Fiona, *William Morris*, Faber & Faber, 1994

Mackail, J.W., *The Life of William Morris* (2 vols), Longmans Green, 1899

Masse, H.J.L.J., *The Art-Workers' Guild*, Shakespeare Head Press, 1935

Meister, Maureen, *H.H. Richardson, The Architect, His Peers and Their Era*, The MIT Press, 1999

Moorcroft, A Guide to Moorcroft Pottery 1897–1993, Richard Dennis Publications, 1993

Morris, Barbara, *Victorian Embroidery*, Herbert Jenkins, 1962

Morris, May (ed.), *The Collected Works of William Morris* (24 vols), Longmans Green, 1910–15

Morris, William, *Arts and Crafts Essays*, Longmans Green & Co, 1899

Muthesius, Hermann, *The English House*, edited and with an introduction by Denis Sharp and translated by Janet Seligman, Crosby, Lockwood Staples, 1979

Myers, Richard and Hilary, *William Morris Tiles*, Richard Dennis Publications, 1996

Naylor, Gillian, *The Arts and Crafts Movement, a study of its sources, ideals and influence on design theory*, Studio Vista, 1971

Ohr, Clarissa Campbell (ed.), *Women in the Victorian Art World*, Manchester University Press, 1995

Parry, Linda, *Textiles of the Arts and Crafts Movement*, The Viking Press, 1983

Parry, Linda, *William Morris and the Arts & Crafts Movement, A Source Book*, Studio Editions, 1989

Parry, Linda, *William Morris*, Philip Wilson Publishers in association with the V&A Museum, 1996

Pevsner, Nikolaus, *Pioneers of the Modern Movement from William Morris to Walter Gropius*, Faber & Faber, 1936

Poulson, Christine, *William Morris on Art and Design*, Sheffield Academic Press, 1996

Pugin, A.W.N., *The True Principles of Pointed or Christian Architecture*, London, 1843, reprinted by Academy Editions, 1973

Read, Sir Herbert, *Art and Industry*, Faber & Faber, 1934

Richardson, Margaret, *Architects of the Arts and Crafts Movement*, Trefoil Books, 1983 (published in association with the Royal Institute of British Architects Drawings Collection)

Robinson, William, *The English Flower Garden*, John Murray, 1883

Rothenstein, Sir William, *Men and Memoires* (2 vols), Faber & Faber, 1931

Ruskin, John, *Seven Lamps of Architecture*, George Allen, 1894

Ruskin, John, *The Stones of Venice* (2 vols), Allen and Unwin, 1904

Sedding, John D., *Art and Handicraft*, Kegan Paul, Trench, Trubner & Co., 1893

Sedding, John Dando, *Garden Craft Old and New*, Kegan Paul, Trench, Trubner & Co., 1891

Sheldon, Alexandra, *American Arts and Crafts from the Collection of Alexandra and Sidney Sheldon*, Palm Springs Desert Museum, 1993

Smith, Bruce and Alexander Vertikoff, *Greene & Greene Masterworks*, Chronicle, 1998

Smith, Greg and Sarah Hyde, *Walter Crane 1845–1915, Artist, Designer and Socialist*, Lund Humphries, 1989

Smith, Kathryn, *Frank Lloyd Wright America's Master Architect*, Abbeville Press, 1998

Stanksy, Peter, *Redesigning the World: William Morris, the 1880s and the Arts and Crafts*, Princeton University Press, 1985

Stickley, Gustav, *Craftsman Homes: Architecture and Furnishings of the American Arts and Crafts Movement*, 1909, reprinted Dover Publications, 1979

Surtees, Victoria (ed.), *The Diary of Ford Madox Brown*, Yale University Press, 1981

Tilbrook, A.J., *the Designs of Archibald Knox for Liberty & Co.*, Richard Dennis Publications, 1995

Tinniswood, Adrian, *The Arts and Crafts House*, Mitchell Beazley, 1999

Triggs, Oscar Lovell, *Chapters in the History of the Arts & Crafts Movement*, Chicago: Bohemia Guild of the Industrial Art League, 1902

Volpe, Tod M., *Treasures of the American Arts and Crafts Movement 1890–1920*, Thames and Hudson, 1988

Wallace, Ann, *Arts and Crafts Textiles, The Movement in America* Gibbs Smith, 1999

Watkinson, Ray, *William Morris as Designer*, Studio Vista, 1967

Wilson, H., *Silverwork and Jewellery*, John Hogg, 1912

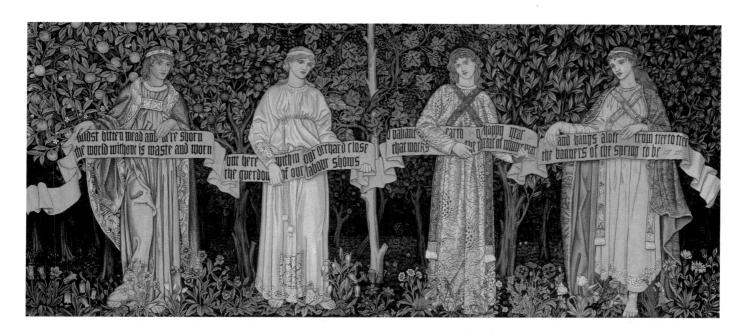

INDEX

Page numbers in *italic* refer to the illustrations

PICTURE ACKNOWLEDGMENTS

The publishers would like to thank the following for their especial help concerning illustrations for this book: Richard Dennis, John Jesse, John Scott, Alexandra Sheldon and photographers Philip de Bay, Magnus Dennis and Roger Vlitos. Grateful thanks are also due to Helen Brown and Mary Greensted at Cheltenham Museum, Sandy Kitching and team at Blackwell, Simon Biddulph at Rodmarton Manor, Bobbi Mapstone at the Gamble House, Pasadena and all listed sources for access to their collections.

Albright Knox Art Gallery, gift of Darwin R. Martin: 182(l)

Annan Gallery, Glasgow: 63 (l&r)

The Antique Trader at the Millinery Works and Jefferson Smith/Heal & Son Ltd: 29, 51(b)

The Antique Trader at the Millinery Works and Jefferson Smith: 166

Arcaid: Richard Bryant 107, 108, 116, 139, 141, 248-9, Jeremy Cockayne 126, Mark Fiennes 26, 110, 220(b), Lucinda Lambton 297, Alan Weintraub 90, 121, 122

The Art Archive: Eileen Tweedy 15

The Art Institute of Chicago, Gift of Mrs Charles F. Batchelder, 1974.524: 203

Avery Library, Department of Drawings, Columbia University: 287(t)

Birkenhead Collection: photo Magnus Dennis 46, 237, Haslam & Whiteway, London 226

Bridgeman Art Library: Fine Art Society 161, 170, Mallett's 291, V&A 156

Cardiff City Council: 41

Collection of the Carnegie Museum of Art, Pittsburgh, Pennsylvania, Du Puy Fund 1984: 179

Martin Charles: 94, 98, 100, 101, 162, 215, 250, 290, 293, 294, 296

Cheltenham Art Gallery and Museum: 17, 18, 37, 38, 49, 128, 133, CAGM/© Felicity Ashbee 35, CAGM/Bridgeman Art Library 39 73, CAGM/Philip de Bay/Bridgeman Art Library 144-5, 153, 171(r), 251, CAGM/photo Woodley & Quick 165

Chicago Historical Society: 266

Christie's Images: 45, 52, 57, 58, 64, 66, 70, 76, 80, 82, 159, 169, 174, 175, 176, 177, 182, 219(l&r), 220(t), 223, 226, 227, 228, 229(tr&b), 236, 241, 242, 244, 253, 260, 262, 267(bl), 268, 283

Cincinnati Museum Center – Cincinnati Historical Society Library: 71

Courtesy of The Charles J. Connick Stained Glass Foundation, Ltd.: Ian Justice 42

Country Life Picture Library: 104, 129, 136(t), 137, 295

Craftsman Auctions, Lambertville, New Jersey: 243, 247, 264(l&r)

The Craftsman Farms Foundation, Parsippany, New Jersey: 23, 79

Edifice: 24, 105, © Darley 27, 114, © Lewis 78, 113, 119

The Gamble House, Pasadena, CA: 51(t), 117, Interfoto, USA/Oggy Borosov 205, Tim Street-Porter 140, 304

Jenny de Gex: 48(l), 75, 89(l), 292, 305

Glasgow Museums: Art Gallery & Museum, Kelvingrove: 62

Glasgow Picture Library: Eric Thorburn 20

Sonia Halliday Photographs: 216

Haslam & Whiteway, London: 147, 151(r), 168, 171(l), 173

Hedrich-Blessing Photography, Chicago: 115

High Museum of Art, Atlanta, Georgia, Virginia Carroll Crawford Collection 1982.291: 81

By kind permission of the Parochial Church Council, Holy Trinity Church, Sloane Street/photo Courtauld Institute: 214

Angelo Hornak: 97

© Hunterian Art Gallery, University of Glasgow, Mackintosh Collection: 132

Illinois State Preservation Agency: © Frank Lloyd Wright Preservation Trust 89(r), 120

Interior Archive, London/Fritz von der Schulenburg: 131, 136(b), 138

John Jesse Ltd, London: Magnus Dennis 65, 84, 265, 271 (bl), Gate Studios (Mike Bruce) 256, 258, 267(tr), 269

Kelmscott Manor, reproduced with the permission of the Society of Antiquaries of London: photo Nigel Fisher 67, photo A.F. Kersting 193

Christian Korab, Minneapolis, courtesy the Willits-Robinson Preservation Foundation: 142

Lakeland Arts Trust: 111, 124-5, 127, 211, Paul Barker/Country Life 95, Jonathan Lynch 149(r), © Charlotte Wood 129

Andrew Lawson: 302

Los Angeles County Museum of Art, Gift of Max Palevsky/photo © 2003 Museum Associates/LACMA: 178

Matildenhohe/Hessisches Landesmuseum, Darmstadt: 135

Media Union Library, Special Collections, University of Michigan: 143

Metropolitan Museum of Art, New York, Gift of Family of Mrs Candace Wheeler, 1928 (28.34.1): photograph © 2000 197

William Morris Gallery, London: 69, photo Angelo Hornak 154, 200, 218, 276

National Monuments Record: 59

National Museum of American History, Smithsonian Institution, Washington: 246

National Museums of Scotland, reproduced by permission of Dumfries and Galloway Council and the National Trust for Scotland: 273

National Museums of Scotland © the Estate of Phoebe Anna Traquair: 83, 194, 272, 278

© reserved; collection National Portrait Gallery, London: 55

National Trust Photographic Library: John Hammond 99, Michael Caldwell 130, Nadia Mackenzie 146, L&M Gayton 191, Nick Meers 300

The Collection of the Newark Museum, Museum Purchase, 1926: 245

Oakland Museum of California, Gift of Concours d'Antiques, the Art Guild: photo M. Lee Fatheree 180

Pocumtuck Valley Memorial Association, Memorial Hall Museum, Deerfield, Massachusetts: 198

Princeton University Library, Graphic Arts Collection. Department of Rare Books and Special Collections: 279

Private Collections: 277, 285, 286(l), photo Magnus Dennis 11, 13, 230-1, 232, 234, photo Roy Macadam, Norman Mays Photography, Bramsford, Worcester 72

© Réunion des Musées Nationaux/Jean Schormans: 157

Royal Institute of British Architects, British Drawings Collection: 36, 74, 86, 102, 106

Scala, Florence/Pierpont Morgan Library, New York/Art Resource: Gift of the Fellows, 1959.23 77, 284(b)

Scala/Uffizi Gallery © 2000/courtesy of the Ministry for Cultural Heritage, Florence: 43

Alexandra and Sydney Sheldon Collection, Palm Springs: photos Taylor Sherrill 61, 263

Sotheby's, London: 31

Tadema Gallery, London: 270

The Mark Twain House, Hartford, Connecticut: 88, 196

V&A Photo Library, London: 1, 2-3, 4, 7, 8-9, 10, 14, 19, 25, 28, 32-33, 34, 40, 44, 47, 48(r), 50, 53, 56, 68, 85(l&r), 87, 142, 148, 149(l), 150, 151(l), 158, 167, 172, 183, 184-5, 186, 187, 188, 189, 192, 195, 199, 201, 202, 204, 206, 207, 208, 209, 210, 212-13, 217, 221, 222, 224, 233, 235, 238, 239, 240, 252, 254, 255, 257, 259, 261, 271(tr), 274-5, 281, 282, 284(t), 286(r), 313

Roger Vlitos: 12, 280, 287(b), 288-9, 301

Elizabeth Whiting Associates/Tim Street-Porter: 92-3, 181

The Winterthur Library, Printed Book and Periodical Collection: 54

Frank Lloyd Wright © ARS, NY and DACS, London 2003: 90, 120, 142, 182(l&r), 183, 229(b&tr), 287(t)

Picture Researcher: Jenny de Gex

Managing Editor: Sonya Newland